WOMEN ARTISTS

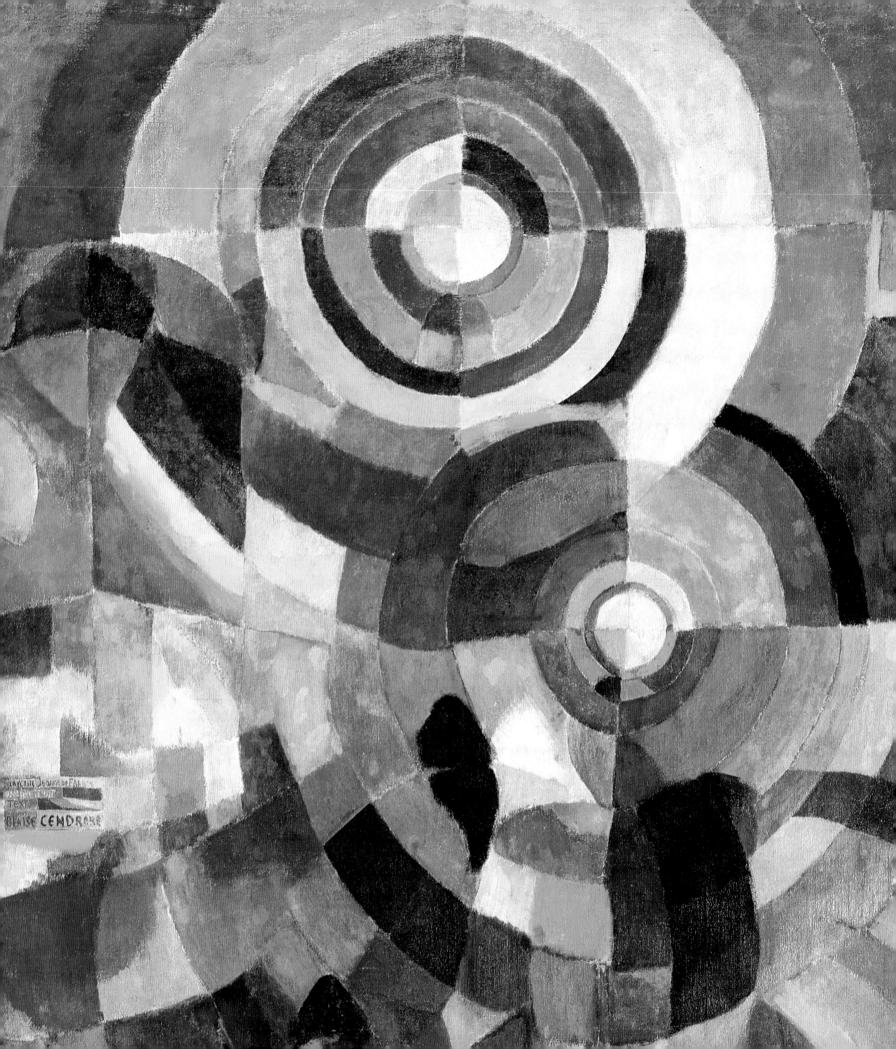

NANCY G. HELLER

WOMEN ARTISTS AN ILLUSTRATED HISTORY

THIRD EDITION

ABBEVILLE PRESS PUBLISHERS
NEW YORK LONDON PARIS

To my mother and father, who taught me that all things are possible—and to Sonia Louise and Evan Alexander, who prove it every day.

Editor: Nancy Grubb Designer: James Wageman Picture researchers: Serena Wilkie, Maya Kaimal, and Naomi Ben-Shahar Production managers: Dana Cole and Megan O'Toole

FRONT COVER
Marie-Louise-Elisabeth Vigée-Lebrun
Countess Golovin, 1797–1800 (detail)
See plate 35
BACK COVER
Helen Frankenthaler
Before the Caves, 1958 (detail)
See plate 142
FRONTISPIECE
Sonia Terk Delaunay
Electric Prisms, 1914 (detail)
See plate 95

Library of Congress Cataloging-in-Publication Data

Heller, Nancy.

Women artists. Bibliography: p. Includes index. 1. Women artists. I. Title. N8354.H45 1987 704'.042 ISBN 0-7892-0345-6 Copyright © 1987, 1991, and 1997 by Abbeville Press, Ltd. All rights reserved under international copyright conventions. No part of this book may be reproduced or utilized in any form or by any means, electronic or mechanical, including photocopying, recording, or by any information storage and retrieval system, without permission in writing from the publisher. Inquiries should be addressed to Abbeville Publishing Group, 22 Cortlandt Street, New York, N.Y. 10007. The text of this book was set in Electra. Printed and bound in Hong Kong. Third edition, 1997 10 9 8 7 6 5 4 3

CONTENTS

PREFACE 7
INTRODUCTION 11
1 THE RENAISSANCE 15
2 THE SEVENTEENTH CENTURY 29
3 THE EIGHTEENTH CENTURY 53
4 THE NINETEENTH CENTURY 73
5 THE EARLY TWENTIETH CENTURY 113
6 MID-CENTURY TO THE MID-1980s 163
7 NEW CURRENTS 211
NOTES 256
SELECTED BIBLIOGRAPHY 268
ACKNOWLEDGMENTS 274
INDEX 276

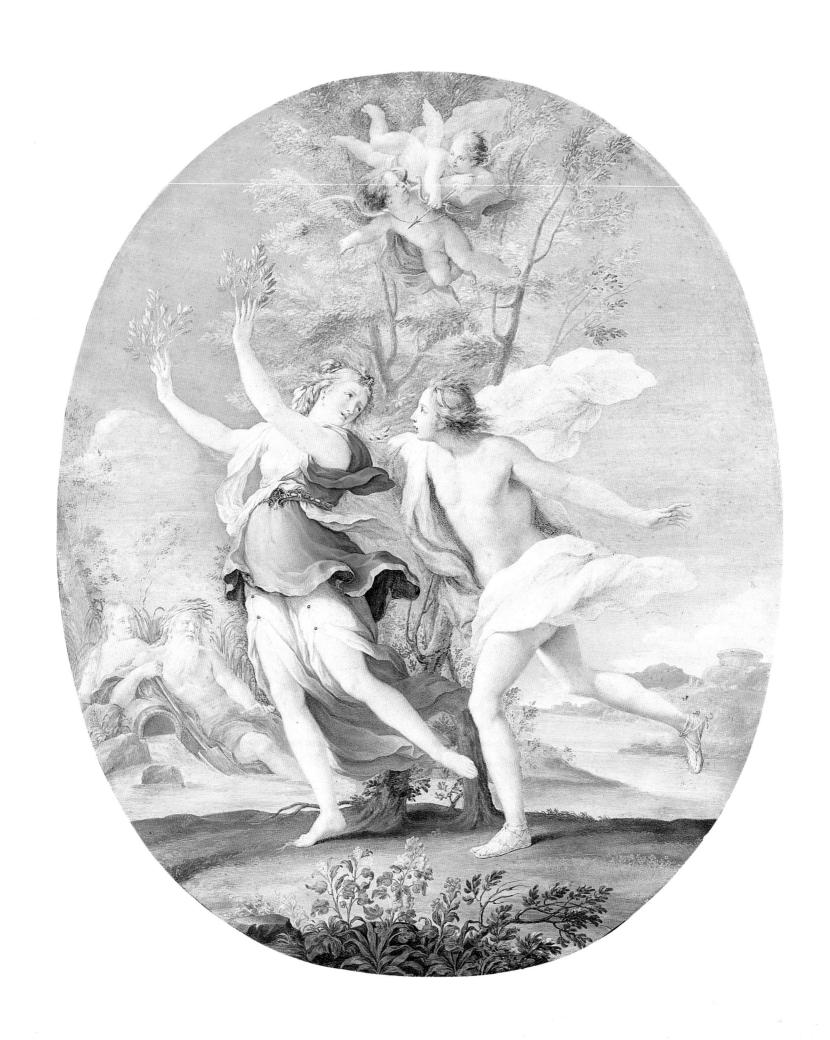

PREFACE

n December 21, 1976, the Los Angeles County Museum of Art opened a landmark exhibition—Women Artists: 1550–1950, curated by Ann Sutherland Harris and Linda Nochlin. Two months later I attended the show with my father, a printmaker, university administrator, and author who had written his own book on women artists some years before. I still vividly recall how moving it was to see assembled, for the first time, more than 150 works by 86 women from different centuries and nations, all of whom had earned a living as painters. The extremely successful exhibition received a great deal of publicity as it moved from Los Angeles to Brooklyn, Pittsburgh, and Austin. Viewers were surprised by the high quality and impressive quantity of the paintings displayed and by the careers of the artists painstakingly documented in the exhibition catalog. In their essays Harris and Nochlin expressed the hope that the exhibition would inspire increased interest in art by women, and that has, in fact, happened. Specialized courses on women artists have been established and doctoral dissertations on them approved at many universities; the number of exhibitions devoted to women artists has greatly increased; and a museum in Washington, D.C., has been dedicated exclusively to women in the arts.² During the last decade several important books have been published on women artists. Chief among these is Harris and Nochlin's catalog of their 1976 exhibition; all subsequent writers on the subject have relied on the research in that seminal text. Other noteworthy surveys are by Elsa Honig Fine, Germaine Greer, Eleanor Munro, Karen Petersen and J. J. Wilson, and Eleanor Tufts.3

However, despite the increasing awareness of the history of women artists, a great deal remains to be done. While teaching at several colleges over the past decade, I have encountered a disturbingly large number of male and female students—including fine-arts majors—who were not aware that a long line of women artists preceded Mary Cassatt. This is due, in part, to the fact that the three principal art history survey texts continue to minimize the contributions of women to Western art, although they now mention more women than ever before. For exam-

ple, the 1986 revised edition of H. W. Janson's ubiquitous *History of Art* contains 19 black-and-white illustrations of work by women artists, as opposed to 1,060 by men, plus 2 (versus 175) color plates. Furthermore, the circumstances of most contemporary women artists remain unsatisfactory. According to a 1979 survey of eleven top New York galleries, only eight percent of the artists represented were women; women are correspondingly underrepresented in museum solo and group exhibitions, in reviews of the shows they do have, in receipt of art fellowships and grants, and on college and university faculties. The hope is that as more and more people—including writers, educators, collectors, and curators—become familiar with women artists, their work will become a generally acknowledged part of art history.

The purpose of this book is to provide a richly illustrated overview of some of the most interesting professional women painters and sculptors in the Western world, from the Renaissance to the present. Due to space limitations, women working in other media—notably architecture, photography, folk art, and the so-called minor arts—are not discussed here, nor does this history encompass women artists outside Europe and North America. Even within these boundaries I have had to be selective in dealing with a period of some five hundred years, and a number of important artists have inevitably been omitted. I have avoided artists whose attributions remain unclear in favor of their contemporaries with more definitely established oeuvres. The selection process was especially challenging for the myriad living artists, whose work is still evolving and whose place in the broader art historical scheme is not yet clear. In these cases, I have picked artists who have already attracted considerable critical and popular attention and whose work I find especially intriguing.

It is my intention here to introduce nonspecialist readers to the remarkable range of styles, subjects, and techniques with which women artists have worked for the last five centuries. As court painters and sculptors, Legion of Honor recipients, and Ford Foundation Fellows, these women have figured prominently in the history of Western art. Their lives and works form a fascinating story, the highlights of which are explored in the pages that follow.

WOMEN ARTISTS

INTRODUCTION

Indeed, I would venture to guess that Anon, who wrote so many poems without signing them, was often a woman.—Virginia Woolf, A Room of One's Own, 1929 n a particularly trenchant *New Yorker* cartoon some prehistoric women are busy painting images of animals onto the walls of their cave. Suddenly one puts down her brush and asks: "Does it strike anyone else as weird that none of the great painters have ever been men?" It was a joke, of course, but one that poses a legitimate question—why is it assumed that prehistoric art was created by males? The Upper Paleolithic cave paintings and carvings were not signed, and very little is known about sex roles in Western Europe c. 15,000 B.C. According to experts, there is not yet sufficient evidence to conclude why this art was created, let alone by whom.¹

My intent here is not to argue that the Stone Age painters were women but to make the more easily documented point that women artists have been historically overlooked. There have been successful women artists recorded since antiquity. Through the centuries women have supported themselves—and often their parents, siblings, spouses, and children—as official court artists serving monarchs and popes alike, executing private and large-scale public commissions, receiving significant critical attention, founding and joining many of the principal European art academies, and teaching their own pupils. Why, then, have the majority of their reputations faded away? It is important to recognize that the reputations of many once-renowned male artists have faded, too, since fashions in art are as ephemeral as those in any other field. But women artists have always been more easily lost to history than their male counterparts. Because women traditionally changed their names when they married, documents of women artists' activities are particularly difficult to track down. For example, the nineteenth-century British battle painter Lady Elizabeth Butler is sometimes discussed under that name but at other times appears under her maiden name, Elizabeth Thompson; similarly, Vinnie Ream Hoxie, an American sculptor of the 1800s, may show up under R or H—and such multiple names are not always cross-referenced. Moreover, some records have been deliberately altered. Unscrupulous collectors, dealers, and others have not been above re-signing paintings with the names of better-known (and higher-

2. Anna Hyatt Huntington (1876–1973)
Fighting Stallions, 1950
Aluminum, 15 ft. x 12 ft. x 6 ft. 4 in.
Brookgreen Gardens, Murrells
Inlet, South Carolina

priced) artists who worked in similar styles. Moreover, work by women artists has often been reassigned to their male teachers or relatives on the assumption that no first-class art could have been produced by a female. In 1723, for example, the Dutch flower painter Margareta Haverman (only the second woman of her century elected to the French Royal Academy of Fine Arts) was expelled from that body when Academy members unaccountably decided that her "reception piece"—the major painting submitted by every new member—had been painted by her teacher, Jan van Huysum.²

Fortunately, a significant number of unaltered records still testify to the long and distinguished history of women artists. We do know that there were celebrated female painters and sculptors in ancient Greece and Rome. A Greek vase from the fifth century B.C. shows four artists at work—one of whom is a woman (plate 3). Unfortunately, the identities of the figures, and of the artist who painted them, are unknown.³ The principal source of information about women artists in antiquity is the Roman writer Pliny the Elder, who cited several Greek women painters, including Timarete, Eirene, Kalypso, Aristarete, Iaia, and Olympias. None of their works survive; but some intriguing later images portray these women, such as the anonymous fifteenth-century French illumination of Thamar (Timarete) painting a Madonna, while her studio assistant grinds colors (plate 4).⁴ Pliny also attributed to Helen of Egypt a famous battle painting from c. 300 B.C. showing the victory of Alexander the Great over the Persian king Darius III.⁵

Considering the fact that most medieval women married by fourteen and thereafter were preoccupied with childbearing, child-rearing, and endless domestic chores, it is surprising that there were any female artists active during the Middle Ages. Yet, in some respects, medieval women were better off than their counterparts in either antiquity or the Renaissance. Contemporary documents show that women of the period—especially those who did not marry—held a remarkable range of jobs, working as brewers and butchers, wool merchants and ironmongers. They also made art, but works that can be assigned to specific women artists are rare. This is because they produced mainly embroideries and manuscript illuminations—portable, fragile, largely unsigned objects, few of which have survived. The women who made these were generally either literate, wealthy women who had sufficient leisure time to perfect their artistic skills or nuns who lived in environments that offered the training, materials, space, and time necessary to produce art. The works of some medieval women painters have been identified, including manuscript illuminations by Ende, a tenth-century Spanish nun; by a German nun called Guda, who was active during the twelfth century; and by Claricia, a lay woman from Bavaria who worked in a twelfth-century convent scriptorium. There are also records of numerous female illuminators to whom no specific works have ever been attributed.

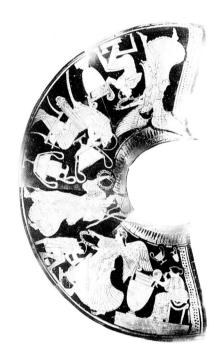

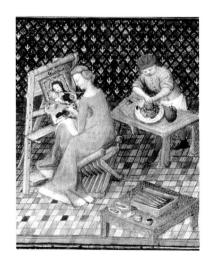

Left, top
3. The Leningrad Painter
Detail of the Caputi Hydria,
c.460–450 B.C., Greece
Polychrome terra-cotta
The Torno Collection, Milan

Left, bottom 4. Anonymous (French) Thamar Paints a Picture, 1401–2 Illuminated manuscript, dimensions unknown Bibliothèque Nationale, Paris By the fifteenth century the number of active women artists had increased significantly, but there were still no individual women who have achieved artistic reputations comparable to those of their male counterparts. Much of the information concerning women artists from this period remains incomplete or incorrect. For example, around 1405 the noted writer Christine de Pisane praised a woman named Anastaise as the best manuscript painter in Paris, a considerable accomplishment. Unfortunately, none of her work has been identified. And Sabina von Steinbach, mentioned in some modern sources as an early fourteenth-century sculptor responsible for some of the figures decorating the south portal of Strasbourg Cathedral, has turned out to be no more than a legend, based on a mistranslation.

It was not until the mid-sixteenth century that the first women artists with major international reputations emerged. That they came primarily from Italy was due in large measure to a change in the Italian attitude toward educating women. In earlier times it had been considered dangerous to teach females to read and write; generally, only those who intended to become nuns acquired such skills. But in 1528 Baldassare Castiglione published *The Courtier*. This influential volume, popular in England, France, and Spain as well as in Italy, made the radical pronouncement that all aristocrats, male and female, should be highly trained in the social arts. Specifically, women should know how to write poetry, dance, sing, play a musical instrument, make witty conversation, and paint. These skills were intended not to prepare women for careers in these fields, but to produce highly accomplished dilettantes who would be entertaining companions for aristocratic Renaissance men. Castiglione's ideas were irrelevant to women of the lower classes, but for the nobility—and for ambitious members of the middle class—they were significant.

Nonetheless, even the most privileged women in sixteenthcentury Italy were routinely denied access to the basic training necessary for professional artists. The Renaissance had altered the role played by artists in society. Once considered mere craftsmen, painters and sculptors now were perceived as cultured, creative individuals who mingled with political, religious, and intellectual leaders. Such artists were expected to have a thorough grasp of many fields, including art history, perspective, and anatomy. But women could not travel freely to study art in other parts of the world; they were not taught mathematics or science; and they were not allowed to work from nude models. Thus, most of the early female artists who rose to prominence had at least two things in common: they were relatives of male artists, which gave them relatively easy access to artistic training, materials, and studio space; and they tended to produce portraits and still lifes, for which the models were always at hand, rather than the more prestigious genres, such as religious and history painting. To a remarkable degree, these conditions continued to hold true for women artists well into the twentieth century.

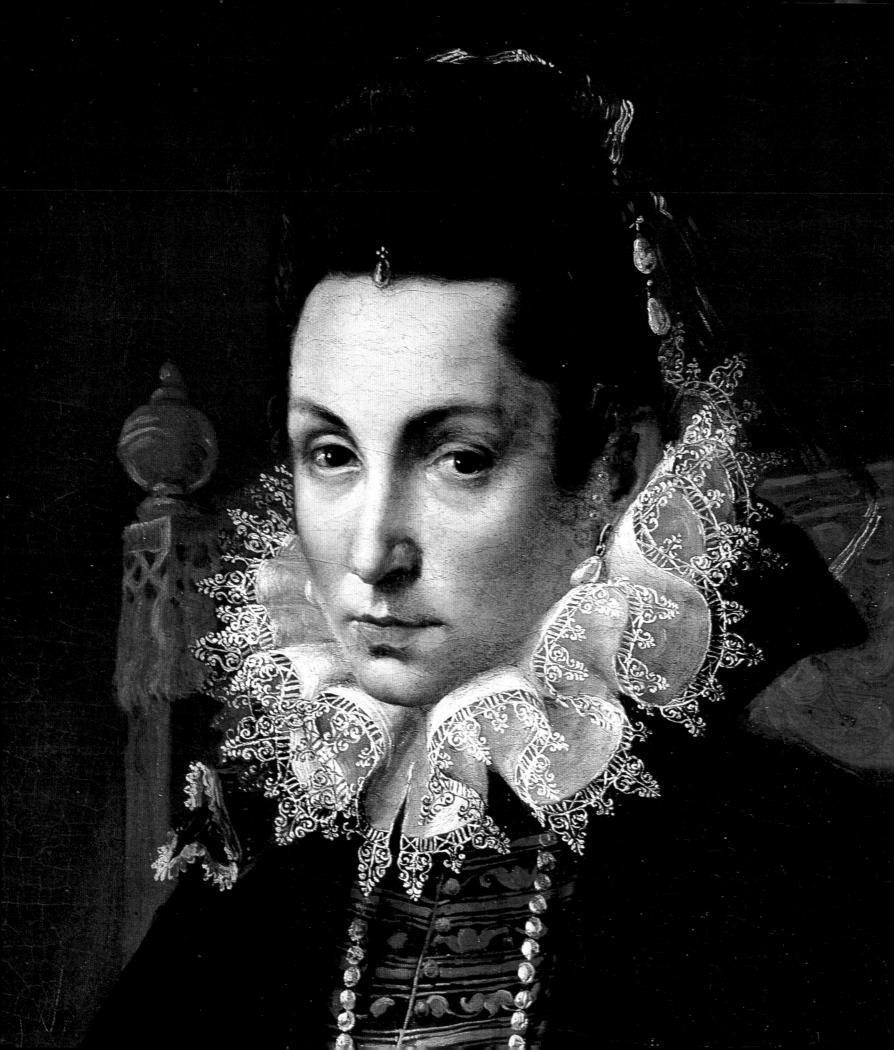

1

THE RENAISSANCE

Master Gerard, the illuminator, has a daughter about eighteen years old called Susanna. She made an illumination of the Savior, for which I paid one guilder. It is a great miracle that a mere female should do so well.—Albrecht Dürer, journal entry, 1521

because of the new emphasis on the individual which developed during the Renaissance, far more complete records exist for the art produced in sixteenth-century Europe than in earlier eras. And, while much still remains to be determined, this is the first period for which not only the names but also the biographies and significant quantities of work are known for many women artists. In Late Renaissance Italy and Northern Europe, women painters and sculptors worked in a wide range of subjects, styles, and scales, from meticulously detailed portrait miniatures to painterly, large-scale altarpieces. Like many of their male contemporaries, they achieved widespread fame in their native countries and beyond, attracting the attention of distinguished writers and patrons.

Sofonisba Anguissola was the first of these women artists to establish an international reputation, and she is the first for whom a substantial body of work is extant. Her circumstances are unusual in that her father was not an artist but a provincial nobleman in the northern Italian city of Cremona. Amilcare Anguissola subscribed to Castiglione's dictates regarding the proper education of young women and saw to it that all six of his daughters—Sofonisba, Elena, Lucia, Europa, Anna Maria, and Minerva—studied Latin, music, and painting. The family also included a son, Asdrubale, born last, the only one of the seven who did not become a painter.¹

From 1546 to 1549 Sofonisba and Elena studied with Bernardino Campi, a local portrait artist. When he moved away, Sofonisba worked with another Cremonese painter, Bernardino Gatti. This training enabled her to teach three of her younger sisters—Lucia, Europa, and Anna Maria. It also established an important precedent, encouraging other male Italian painters to accept female students. Amilcare Anguissola continued to encourage his eldest daughter in her art; he even wrote about her to Michelangelo. In response, Michelangelo sent some of his own drawings to Sofonisba, which she copied in oil, returning them to him for criticism. Sofonisba was a prolific painter: more than thirty signed pictures survive from her years in Cremona, with a total of

5. Lavinia Fontana Portrait of a Lady with a Lapdog late 1590s (detail) See plate 9 about fifty extant works either signed or securely attributed to her. Like most women artists of her time, she specialized in portraits, generally of family members; she also painted some religious subjects.

While still in her twenties, Sofonisba was sufficiently well known to be invited to join the court of Philip II in Madrid; she arrived there in 1560 and stayed at least ten years. In 1570 she married a Sicilian lord, Fabrizio de Moncada, in an elaborate ceremony staged by the Spanish monarchs, who also provided a generous dowry. But just four years after she moved to Palermo with her husband, he died, and Anguissola was called back to Spain. She decided to visit her family on the way, and during the trip she fell in love with the ship's captain, Orazio Lomellino. They were married in Genoa, soon after docking. The rest of Sofonisba's long life was divided between Genoa and Palermo, where she was visited in 1624 by the young Flemish painter Anthony van Dyck. A drawing of the elderly woman, blind but still active, appears in van Dyck's sketchbooks, along with excerpts from the advice she gave him about painting.⁴

Anguissola painted an unusually large number of self-portraits. One reason generally cited for this is the fact that, as the first well-known female artist, she was something of a celebrity, and images of her were much in demand. She varied both the size and the format of these pictures, depicting herself playing a musical instrument, holding a book, painting a religious image, and even being painted by Campi, her teacher. She was also inventive in her portraits of others: the painting of three of her sisters playing chess is an unusual group portrait and an early "conversation piece," emphasizing the interaction among the figures as they argue about their game.⁵

Anguissola's paintings of individual figures are notable for their warm colors, crisp details, and highly expressive eyes. One particularly intriguing example is an early picture of a young woman in which the sitter gathers the folds of her sumptuous gold brocade gown in one hand, as though preparing to rise. The artist's skill is demonstrated by her careful depiction of every luminous pearl in the elaborate necklace and of every facet of the jewels decorating the odd object in the woman's left hand (a "flea pelt"—the stuffed skin of a sable, worn at the waist to keep fleas away). Another exceptionally strong work is Anguissola's portrait of her sister Minerva (plate 6). Here the sitter's clothes and complexion are set off by her lovely coral beads; she also wears a medallion that depicts another Minerva—the ancient Roman goddess of wisdom and the arts. 6

Critical evaluation of Anguissola's career has varied from century to century. Giorgio Vasari, the noted Italian painter and biographer, visited her father's home in 1566 and was impressed by her art, commenting on the "breathing likenesses" she had created. Writing in the following century, Filippo Baldinucci rated her portraits equal to Titian's. By the early 1900s, however, writers tended to dismiss her work

6. Sofonisba Anguissola (1532/35–1625)
Portrait of the Artist's Sister Minerva, c. 1559
Oil on canvas, 33½ x 26 in.
Layton Art Collection, Milwaukee Art Museum; Gift of the Family of Mrs. Fred Vogel, Ir.

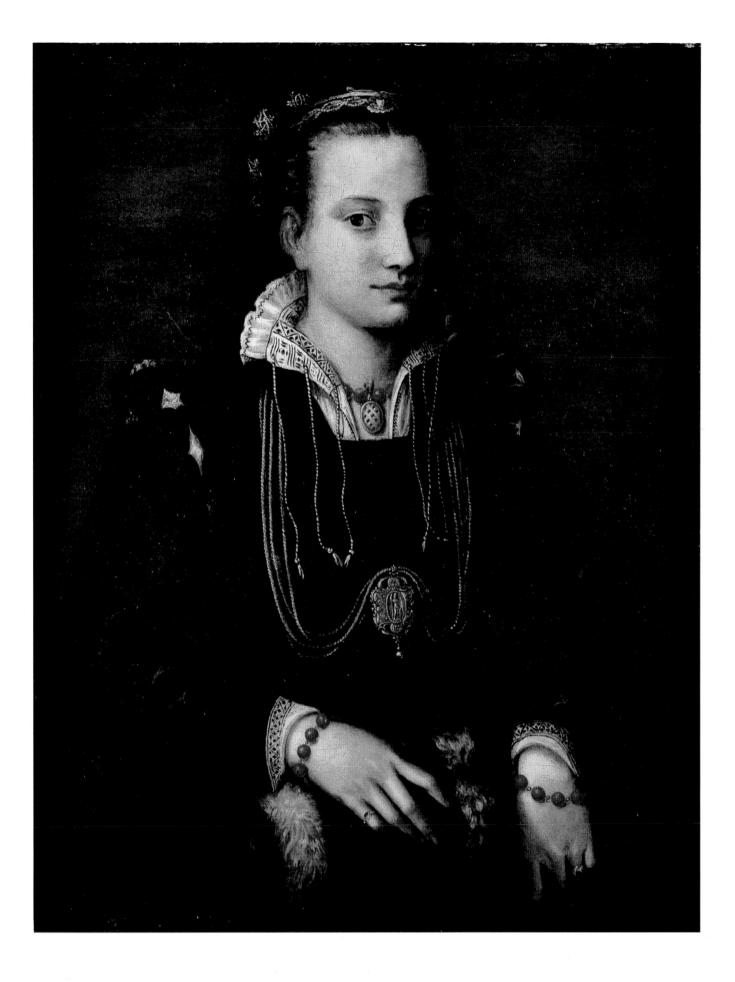

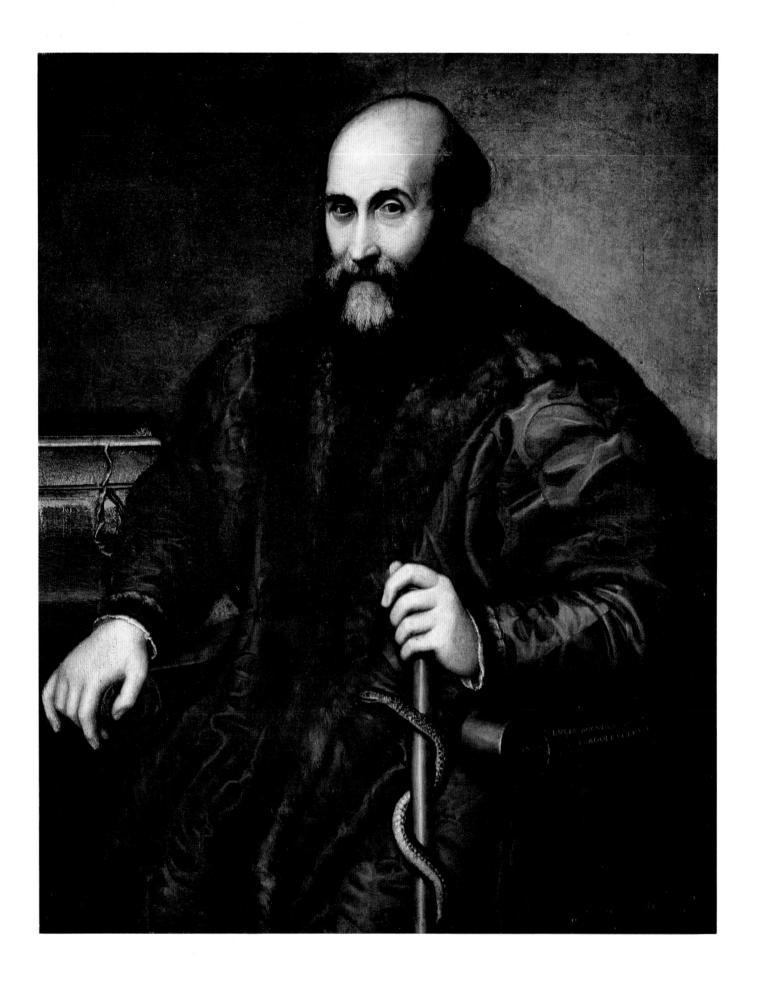

as sentimental.⁷ It is difficult to evaluate Anguissola's oeuvre as a whole, since most of the paintings from her Spanish period were destroyed in a seventeenth-century fire. Nevertheless, it is clear that she was an innovative Late Renaissance portraitist, whose international stature inspired many younger women to become professional artists.⁸

Relatively little is known about Anguissola's five artist sisters. Elena, the second eldest, stopped painting when she entered a convent. Minerva reportedly died quite young; both Europa and Anna Maria married, and both painted religious works as well as portraits. Lucia, the third-born sister, lived only into her mid-twenties, but her artistic skill is generally considered to be the equal of Sofonisba's. Only two works have been definitely attributed to Lucia—a copy of a Madonna and Child by an unknown Milanese painter and the portrait Pietro Maria, Doctor of Cremona (plate 7). 10 This is a relatively standard Renaissance portrait type, with the three-quarter-length subject shown seated against a simple monochromatic background. The artist has included a live snake twisting around the staff that Pietro Maria holds in his left hand, a reference to the caduceus identifying him as a physician. Another intriguing aspect of this portrait is its sense of subtle animation: the sitter has one evebrow cocked, his shoulders set at different levels, and his gaze fixed on something in the viewer's own space; all of this implies that he is getting ready to rise from his massive armchair.

The city of Bologna took an exceptionally progressive attitude toward its female citizens, symbolized by the fact that the University of Bologna accepted women students as early as the thirteenth century. This enlightened atmosphere seems to have encouraged Bolognese women to pursue careers in many fields, including the visual arts: there is documentary evidence of twenty-three female painters who were active there during the sixteenth and seventeenth centuries.

Lavinia Fontana was not merely active; she was unusually successful, becoming the first female painter from Bologna to achieve fame throughout Italy. She produced 135 documented paintings, more than 30 signed and dated examples of which are still known. And, perhaps most important, Fontana expanded the range of work made by women painters, receiving both private and public commissions for religious and mythological paintings in addition to portraits. She executed many complicated multifigure compositions and even painted large-scale male and female nudes.

Fontana was taught by her father, Prospero, a successful, cosmopolitan painter who had also worked in Florence and Rome. She grew up in an unusually stimulating environment, with access to important works by major painters, from Raphael to Parmigianino, and the chance to meet both Bolognese and foreign artists. Although historically important as a painter of religious works, Fontana achieved her first, and greatest, fame for her elegant portraits of Bolognese noblewomen.

7. Lucia Anguissola (c. 1540–1565) Pietro Maria, Doctor of Cremona, c. 1560 Oil on canvas, 37¹³/16 x 30 in. Museo del Prado, Madrid

Her style combines a careful attention to the details of clothing and jewelry with an insight into the sitter's personality. Fontana's subjects are doing something—whether petting a dog or turning the pages of a book—and they seem to be thinking about something as well. Plate 9 is a typical Fontana portrait. With one hand the woman holds an elaborately tasseled handkerchief, with the other she caresses her tiny lapdog. The minutiae of costume—the edgings of lace on her scalloped collar, the pearl drops suspended at her forehead and from her headpiece, the pattern on her bodice—all are rendered with astonishing precision. As in most of her pictures of women, Fontana limited the space by means of the chair back, the table, and the ubiquitous bit of drapery hanging to the sitter's right.¹¹

The popular portraitist received numerous proposals of marriage from noble suitors before accepting the offer of Gian Paolo Zappi, a wealthy painter who had studied with her father. As was customary, the couple continued to live with her father and, presumably, to help in his painting workshop. Fontana had eleven children, only three of whom outlived her. In what seems like a curious role reversal for an Italian couple of the 1500s, Zappi took over most of the household work and confined his own artistic activity to painting the backgrounds and frames for his wife's compositions. After her father's death in 1563, Fontana moved her family to Rome, where she became an official painter to the papal court of Clement VIII, producing many mythological and history paintings, and was elected to the Roman Academy. Her first Roman commission was an altarpiece, The Stoning of Saint Stebhen, for the basilica of San Paolo Fuori le Mura. (This enormous work, over twenty feet high and the object of some critical controversy, was destroyed in a fire in 1823. 12) At the height of her fame, Fontana was a wealthy and celebrated woman, who used the considerable proceeds from her work to amass an impressive collection of antiques. In 1611 a medal was struck in her honor (plate 8), showing both a formal profile and a view of the artist at her easel.

Although best known today for her beautifully simple still lifes, Fede Galizia achieved her initial fame as a portraitist. The daughter of Nunzio Galizia, a miniature painter and presumably her teacher, Fede was sufficiently well regarded as an artist to be mentioned by the writer Giovanni P. Lomazzo when she was only twelve years old. By her late teens she had received international notice for her portraits; records show that she also painted both miniatures and altarpieces. Pictures of inanimate objects, without any human figures, were rare in Italy before the seventeenth century. Those that did exist tended to be far more complex and lavish than Galizia's, so that writers compared her work instead with the dignified still lifes by the Spanish painter Francisco de Zurbarán. Only one still life by Galizia is signed and dated; based on that, some twenty other related examples have been assigned to her, all

Below
8. Portrait medal of Lavinia
Fontana, 1611
Bronze, diameter: 2¾ in.
Museo Communale di Imola,
Imola, Italy

Right
9. Lavinia Fontana (1552–1614)
Portrait of a Lady with a Lapdog, late 1590s
Oil on canvas, 44% x 37 in.
The Walters Art Gallery, Baltimore

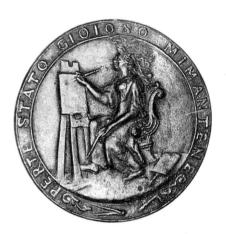

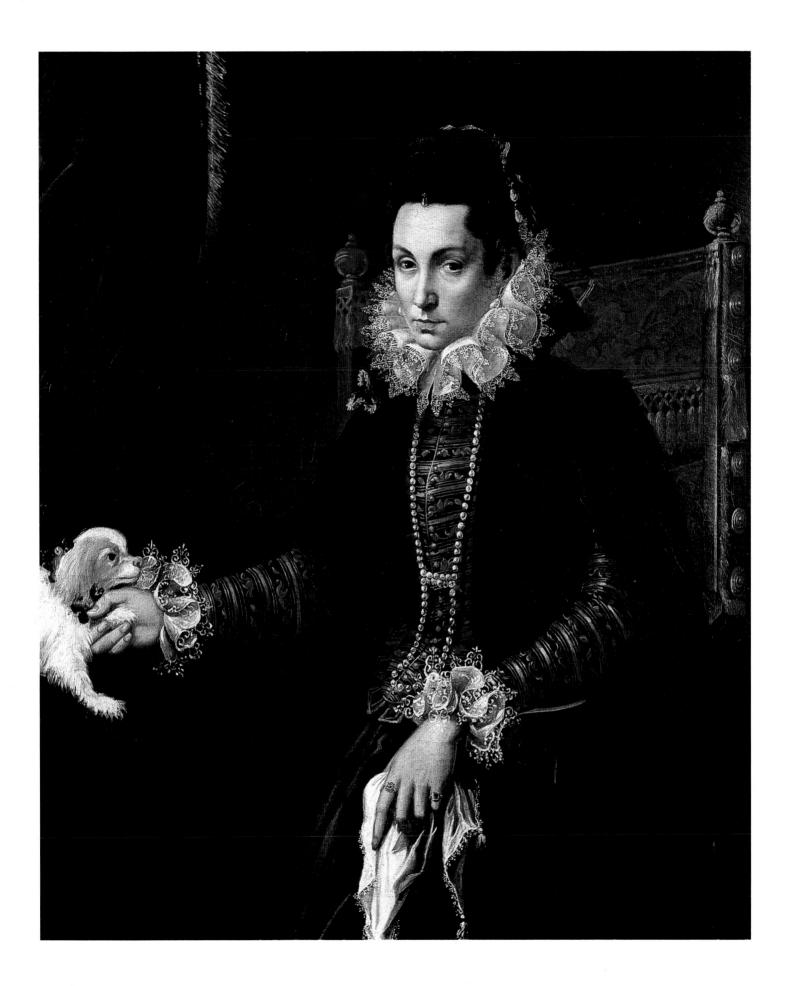

featuring a central container of fruit, with a few individual pieces scattered around the base. ¹³ In plate 10 the artist played the mysterious inky blackness of the background against the lovingly detailed sensuousness of her subjects—furry peaches, delicately curled blossoms, curvaceous vase. By concentrating on relatively few objects and having them fill virtually the entire picture space, Galizia enhanced their importance.

Unlike Fede Galizia, a pioneer in the new genre of still life, or international celebrities such as Sofonisba Anguissola and Lavinia Fontana, Barbara Longhi was a rather conservative painter whose surviving pictures are small-scale devotional images. The daughter of Luca Longhi, a Mannerist painter in Ravenna, Barbara finished her artistic training in the 1570s and produced a large number of simple compositions, notable for their subtle colors and human interaction. She painted several Madonna and Child pictures, emphasizing Mary's youth and her warm relationship with the infant (plate 11). Typically, these paintings utilize the device of a draped column on one side, with the other half of the painting opening up to reveal a distant landscape. Although a minor artist, about whom relatively little is known, Longhi was sufficiently important to be mentioned by Vasari. 14

10. Fede Galizia
(1578–1630)
Still Life with Peaches in a Porcelain Bowl, n.d.
Oil on panel,
11¾ x 15¾ in.
Silvano Lodi Collection,
Campione, Switzerland

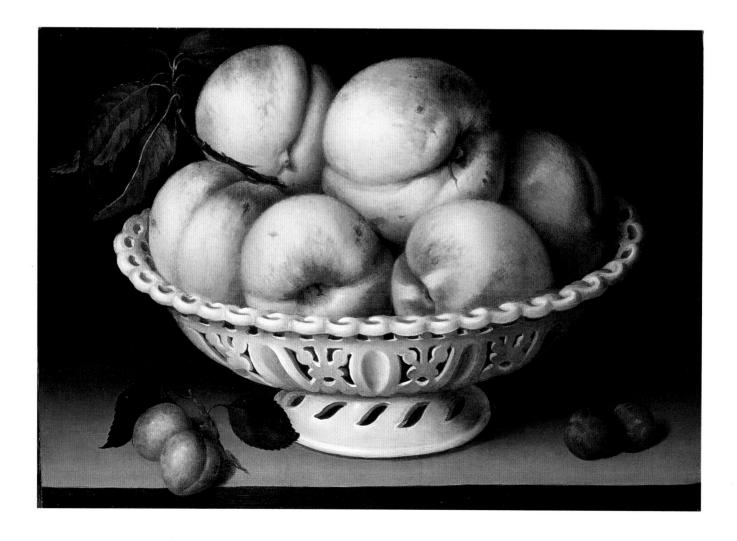

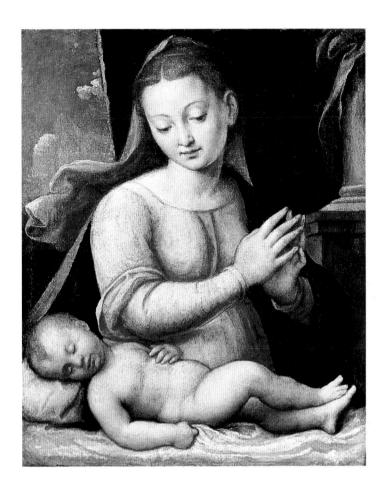

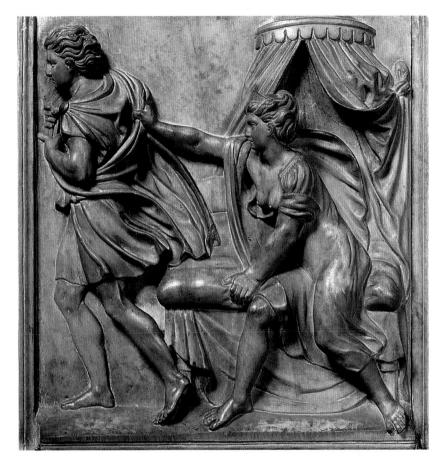

Above, left
11. Barbara Longhi (1552–1638)
Madonna and Child, n.d.
Oil on panel, 16% x 13½ in.
The Walters Art Gallery, Baltimore

Above, right
12. Properzia de' Rossi
(c. 1490–1530)

Joseph and Potiphar's Wife, c. 1520

Marble bas-relief, 19 ft. ¼ in. x
18 ft. ⅓ in.

Museo di San Petronio, Bologna

The only sculptors who have been noted thus far are the fabled figures Kora and Sabina von Steinbach. In contrast, Properzia de' Rossi was very real. Rossi, whose father was a notary rather than an artist, had the good fortune to be born in Bologna, where she studied drawing under Marcantonio Raimondi, a master best known today for his engravings of Raphael's paintings. In her youth Rossi was celebrated for her complex sculptures—an entire Crucifixion, for example—intricately carved in the unorthodox medium of apricot, peach, or cherry stones. These tiny curiosities attracted the attention of Vasari, who described them as "miraculous." But Rossi was no mere whittler of miniatures. In her thirties she began to make larger, more conventional sculptures, such as marble portrait busts, which established her credentials as a serious artist. She also received several public commissions, including an assignment to decorate the high altar of Santa Maria del Baraccano in Bologna.

Rossi's most impressive accomplishment was winning an important competition to produce some of the marble sculpture on the west façade of the Bolognese church of San Petronio. While it is not clear which sculptures are hers, records show that she was paid for at least three sibyls, two angels, and a pair of bas-relief panels, one of which is presumed to be *Joseph and Potiphar's Wife* (plate 12). This scene of

attempted seduction is quite complex, involving many levels of spatial illusion. Rossi achieved an impressive sense of swift movement, as the Egyptian officer's wife reaches out to grab Joseph's cloak; the artist also revealed a sophisticated ability to imply anatomy beneath the drapery.

A popular story, almost certainly apocryphal, has grown up around this relief. Vasari claimed it was an indiscreet self-portrait, based on the artist's unrequited love for Anton Galeazzo Malvasia, a young nobleman who rejected her and later married someone from a higher social class. True or not, this tale has become the basis for a romantic legend about Rossi, and the few facts available concerning the end of her life only add to the confusion. Apparently she was the victim of malicious gossip during her lifetime—several contemporary writers note that she was persecuted by a jealous male painter. And when she died, not yet forty, this noted artist, successful in her day and praised by later sculptors such as the Neoclassicist Antonio Canova, seems to have been completely without money, close relatives, or friends.

Considerably less is known about the sixteenth-century women artists working in Northern Europe than their Italian counterparts. However, some of the same general trends apply—most notably, a new emphasis on education for women, spurred by the Protestant Reformation. By far the most important female artists of the Northern Renaissance were two Flemish painters: Caterina van Hemessen and Levina Teerlinc.

Caterina van Hemessen's father, Jan Sanders van Hemessen, was a well-known Mannerist painter in Antwerp and presumably her teacher. Although she produced at least two religious paintings, Caterina was primarily a portraitist. One self-portrait and about a half-dozen other signed likenesses by her have been located; they tend to be small, quiet pictures of individuals placed against plain dark backgrounds that give no sense of location or extended space. Compared with a portrait by Lavinia Fontana (plate 9), van Hemessen's (plate 13) seems more stiff and old-fashioned. The Flemish example places less emphasis on the details of clothing, and the dog is treated more like a toy than a pet. There is a kind of quiet dignity to van Hemessen's sitters, whose eyes never meet the viewer's.

Van Hemessen was a highly successful painter. Her principal patron was Queen Mary of Hungary, Regent of the Low Countries, where she ruled on behalf of her brother, King Charles I of Spain. In 1554 van Hemessen married Christian de Morien, an organist at Antwerp Cathedral (a prestigious position in sixteenth-century Flanders). Two years later, when Queen Mary abdicated her regency and returned to Spain, she invited Caterina and her husband to join her. They did so and remained there until 1558, when the queen died, bequeathing the couple adequate funds to live out their lives in comfort back in Antwerp. Presumably Caterina produced paintings for the queen, but thus far no

13. Caterina van Hemessen (1527/8–c. 1566) Portrait of a Lady, 1551 Oil, on oak, 9 x 7 in. The National Gallery, London

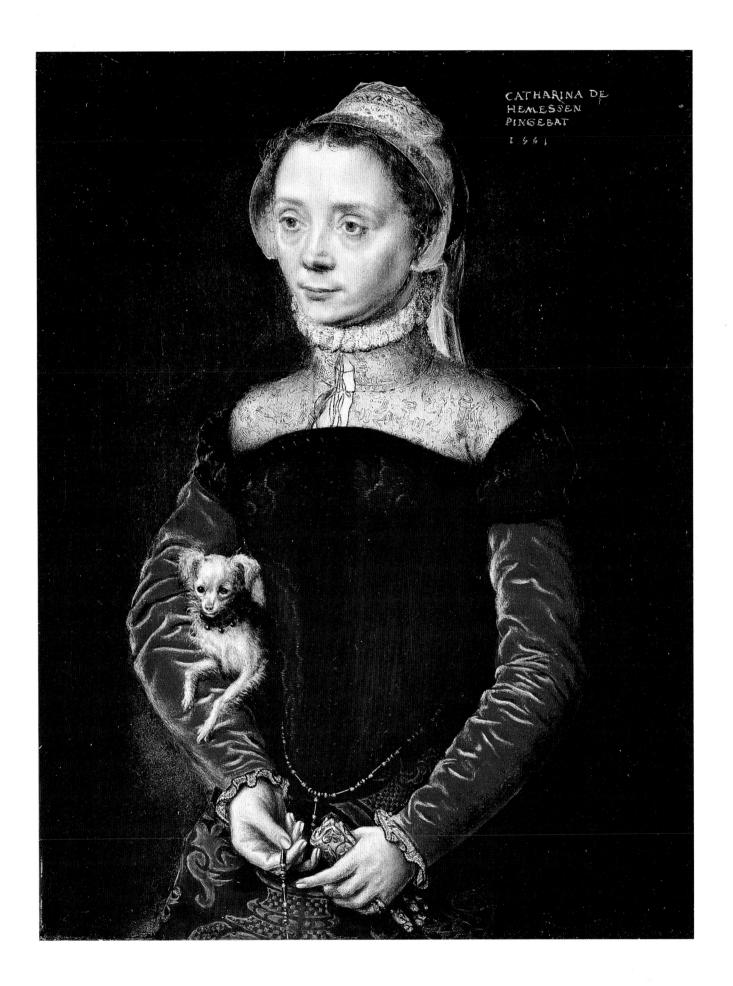

works by her have been dated after 1552. Because of this, many writers have assumed that van Hemessen's painting career ended with her marriage, as did often happen.

Miniatures—paintings of various subjects (primarily portraits) ranging in size from less than an inch to about fifteen inches high—were first produced in the sixteenth century. These tiny pictures were painted in watercolor, oil, or enamel on vellum or parchment and then pasted onto playing cards; later examples had wood, copper, slate, or ivory as a base. The vogue for miniatures, typically set into frames and boxes or worn as jewelry, grew quickly—especially in England, where many of the finest examples were made—reaching its peak in the early 1800s. Because of their diminutive size, miniatures have been considered the province of female artists, and a number of the most important miniaturists were, in fact, women. But many male painters also excelled at the art, which enjoyed a prestige equal to that accorded easel painting.

Due to the remarkable demand for miniatures in sixteenth-century England, a number of foreign painters were imported to serve the Tudor monarchs. One of these was the Flemish painter Levina Teerlinc, of Bruges. Teerlinc's family was active in the art world: her father, Simon Benninck, and grandfather were miniaturists, and one of her four younger sisters became an art dealer. Trained by her father, Teerlinc established herself as a successful miniature painter. Sometime before 1545 she married George Teerlinc, and soon after that the couple moved to England, where she served as court miniaturist to Henry VIII. An index of her success is the fact that she retained this position under three succeeding monarchs: Edward VI, Mary I, and Elizabeth I. Moreover, Teerlinc's annual stipend was greater than that assigned to Hans Holbein, the acknowledged "father" of miniature painting, who was also widely known for his larger-scale pictures.

Despite a comparative wealth of information about Teerlinc, no works signed by her are now known to exist. Attempts have been made to assign particular miniatures to her, with varying degrees of success, but scholarly knowledge about her oeuvre remains sadly incomplete. Writers even disagree about the kinds of subjects that Teerlinc painted, although it is known that she produced small-scale religious and other group scenes, as well as portraits. The example illustrated here (plate 14) is identified by the Victoria and Albert Museum as a portrait of Lady Catherine Grey, but the attribution of this work, like all the other pictures given to Teerlinc, remains tentative. ¹⁹ Certainly, the meticulous details in this painting—notably the elaborate lace ruff and the individual strands of curling hair—are the work of a skilled miniaturist and may reflect the artist's training in manuscript illumination. An interesting additional feature here is the sitter's meditative expression, with lips slightly pursed and blue eyes gazing into space.

SUMMARY

During the Renaissance both Italian and Northern European women made tremendous strides as professional artists. While still emphasizing portraits, they broadened their range to include religious and mythological subjects and to explore the newly established genre of still life. In addition to women painters, for the first time in many centuries there were also significant female sculptors, who participated in major public building projects. As education became more accessible, women artists achieved greater levels of skill and sophistication in their work, gaining international reputations and traveling to serve the rulers of many countries. These achievements were expanded still further by European women artists of the succeeding century.

14. Levina Teerlinc (c.1520–1576) Lady Catherine Grey, n.d. Watercolor with gouache and powdered gold on vellum, diameter: 1¹/₄ in. By courtesy of the Board of Trustees of the Victoria and Albert Museum, London

27

THE SEVENTEENTH CENTURY

Do not waste time. Do not get drunk or fight. Do not draw attention by living an immoral life. Painters belong in the environment of princes and learned people. . . . Thank God for your talent and do not be conceited. Do not fall in love too young and do not marry too soon. . . .—Carel Van Mander, Advice to Painters, Art Lovers, and Poets, and for People of All Ranks, 1604

he Baroque era was a time of tremendous change in the visual arts. During the 1600s European painters and sculptors experimented with a broader range of subjects than had been acceptable in previous periods, and they handled them in an energetic, often theatrical manner. The goal was not the idealized beauty of the Renaissance but a view of the world as it actually looked, with both the sensual and the unpleasant elements left intact. Many Baroque artists worked on a monumental scale; even art that is not especially large often gives an impression of grandeur. Religious and mythological pictures generally feature a strong contrast between light and dark, and compositions emphasize energy, not stasis. Even in relatively calm portraits, where nothing of great importance is going on, there is a new sense of excitement, with figures seemingly ready to speak or move. There is an observable difference in still lifes, too, which came into their own as a significant genre at this time. The meticulous attention to detail remains, but it is combined with more interest in the lushness of flowers, fruit, and luxurious objects and in their ability to convey complex layers of meaning.

The quintessential female painter of the Baroque era was Artemisia Gentileschi. Born in Rome, she is credited with having transmitted the Caravaggesque style to Florence, Genoa, and Naples. (The Caravaggesque style—characterized by theatrical depictions of the human form illuminated by a strong light against inky-dark backgrounds—is named after the Italian painter Michelangelo Merisi da Caravaggio.) Gentileschi was known in her day as a portraitist, but her reputation now rests on an impressive group of full-scale religious paintings that demonstrate a sophisticated understanding of anatomy and perspective and a highly personal flair for the dramatic.

Artemisia was the oldest child of Orazio Gentileschi, a highly respected follower of Caravaggio. As a young girl she was exposed to many of the major art historical monuments and had the further benefit of her father's teaching. It was common for young artists—especially women, who were denied access to more formal means of education—to be tutored at home. So when Orazio decided that his daughter needed

15. Rachel Ruysch Flower Still Life, after 1700 (detail) See plate 24 further instruction in drawing, it was perfectly natural for him to hire a colleague and friend, Agostino Tassi, who worked with Artemisia in the company of a female chaperone. But things somehow got out of hand, and in 1612 Orazio Gentileschi accused Tassi of raping his daughter. This resulted in a five-month-long trial, during which Artemisia was cross-examined under torture but refused to change her testimony.² Tassi pleaded innocent, spent eight months in jail, and was ultimately acquitted of the charge.

Possibly to escape the notoriety generated by this scandal, one month after the trial Artemisia married a Florentine, Pietro Antonio de Vincenzo Stiattesi, and moved to his hometown. The marriage was not successful, but the couple had a daughter, Palerma, who also became a painter. Meanwhile, Gentileschi achieved considerable success with her work in Florence, joining the Academy at age twenty-three. During the 1620s she worked in Genoa and Venice, where she continued to produce well-received pictures. By 1630 Gentileschi had settled in Naples; she remained there until her death, except for a brief stay in London between 1638 and 1640 or '41, where she helped her ailing father complete a major commission for Charles I.

Gentileschi's most intriguing works are her pictures of Old Testament heroines—Judith, Esther, Bathsheba, Susanna—whom she invested with a combination of vulnerability and strength. Although these are all standard Biblical subjects, Gentileschi took an unusual approach to the stories, stopping the action at a particularly dramatic point or revealing aspects of the main characters that were usually left unexplored. In *Susanna and the Elders*, for example, Susanna's fear is stressed as she cringes from the old men leering at her.³ Gentileschi's tour de force is undoubtedly a series of pictures representing Judith, who saved her besieged town from the Assyrian army by seducing its general, Holofernes, getting him drunk, and cutting off his head with his own sword. In the Biblical account, Judith and her maid then quietly recrossed enemy lines, carrying the general's head in a basket. They displayed their bloody prize the next day, causing the enemy to flee in terror.

The story of Judith has been treated by numerous Italian artists, but never so convincingly. Other versions of the scene typically show the moment after the sword has struck. Fede Galizia's Judith, for example, stands quietly, with a curiously blank expression on her face, holding the weapon limply in one hand, the severed head in the other, as her elderly maid warns her to hurry. In the late seventeenth century Elisabetta Sirani painted a slightly built Judith, whose flowing draperies seem impractical—and far too clean, under the circumstances. Her sweet face gazes away from Holofernes' head, which she grasps by the hair in both hands, as though she were doing a bit of washing and had just paused to listen to a bird singing in the distance. Even Caravaggio's

16. Artemisia Gentileschi (1593–1652/53) Judith Beheading Holofernes, n.d. Oil on canvas, dimensions unknown Galleria degli Uffizi, Florence

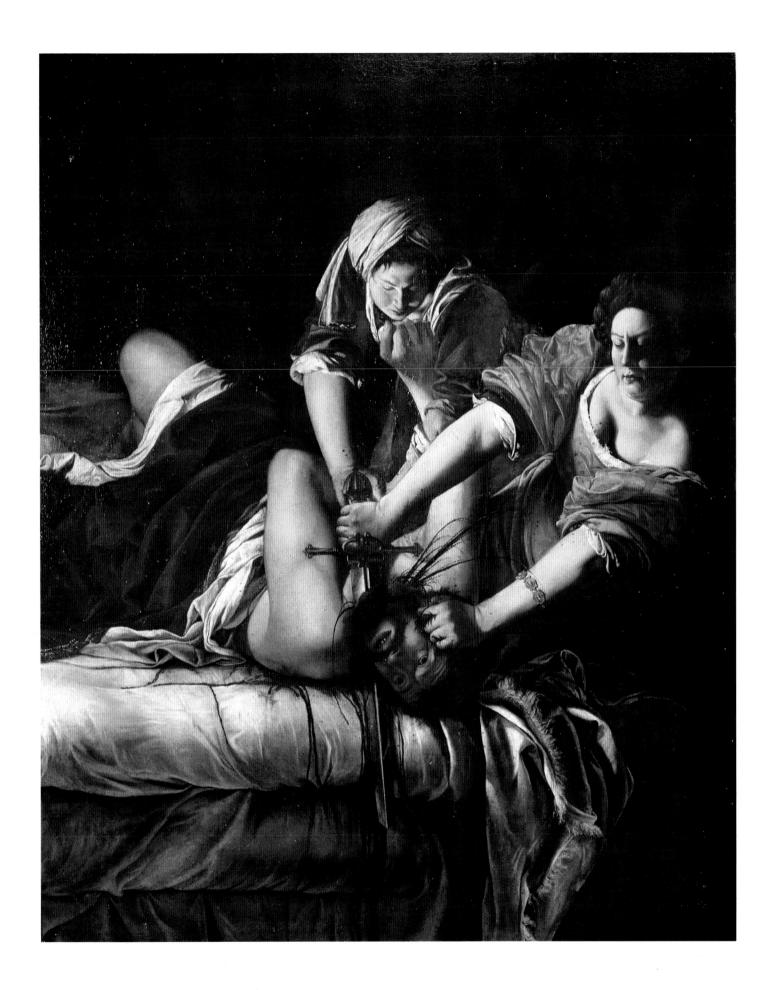

version of this scene, which shows Judith in the act of removing the general's head, is unconvincing because his heroine seems exceedingly weak and girlish.

Only Gentileschi's masterful Judith Beheading Holofernes (plate 16) tells a realistic story. In this large canvas, the nearly life-size Judith is depicted as a powerful, determined woman, amply endowed with the physical and emotional strength necessary to separate the head of a well-muscled general from his body. Judith is really working: the exertion shows in her locked elbows and furrowed brow. Holofernes who, after all, is supposed to be drunk but not unconscious—puts up a struggle, as demonstrated by the position of his legs and that desperately raised right arm. He fights so hard that the maid—no longer an elderly woman but a person roughly Judith's age—has to help keep him on the mattress. This is a dirty business, and Gentileschi shows it as such: blood spurts everywhere, dripping obscenely down the sheets, adding a further note of realism to the dramatically spotlit scene. Two other pictures of Judith by Gentileschi show the more traditional moment after the decapitation.⁶ But even these are unusually active scenes: the women pause as they prepare to flee Holofernes' tent with their gory prize stopping in mid-gesture, holding their breath, eves and ears scanning the darkness beyond their flickering candle for signs of soldiers.

By the time Gentileschi reached forty, her Caravaggesque style was out of fashion. In order to continue making a living, she was compelled to alter her approach, switching to calmer, more classical compositions. These late religious paintings, such as *David and Bathsheba* from c. 1640–45,⁷ are far less interesting than her earlier works.

Like Gentileschi, Elisabetta Sirani was the focus of a notorious trial, but Sirani's was posthumous. When she died suddenly at twenty-seven, after suffering severe stomach pains, the celebrated painter's father suspected foul play and accused a family servant of poisoning her mistress. After a lengthy trial the servant was acquitted, but sufficient doubts remained to justify an autopsy. No specific cause of death was determined, but eyewitnesses reported seeing numerous holes in Sirani's stomach. More recent opinions lean toward a diagnosis of bleeding ulcers, exacerbated by chronic overwork.

Although the circumstances surrounding Sirani's death remain unclear, her youth is well documented. Carlo Cesare Malvasia, an influential writer and art collector, was a close family friend who visited often, showering Sirani with praise in his history of Bolognese painters, *Felsina Pittrice*, published in 1678. She was born in Bologna, a city whose roster of successful female artists included Caterina dei Vigri, Lavinia Fontana, and Properzia de' Rossi. Her father, Giovanni Andrea Sirani, was a well-known painter working in the style of his master, Guido Reni. As a girl Elisabetta, the eldest of four children, studied singing, the harp, poetry writing, the Bible, and mythology. She also

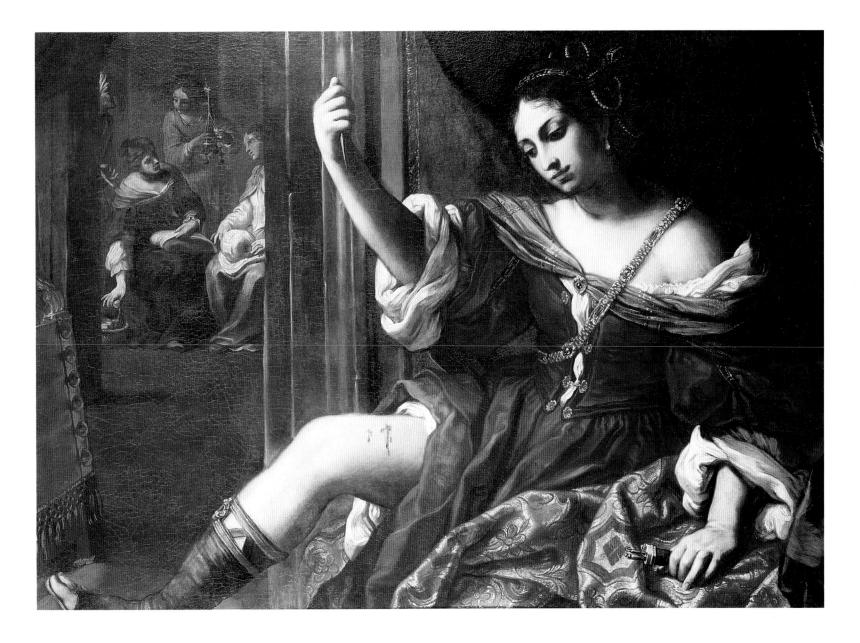

17. Elisabetta Sirani (1638–1665) Porcia Wounding Her Thigh, 1664 Oil on canvas, 39¾ x 54¾ in. Spencer A. Samuels & Company, New York

demonstrated great skill in drawing, but it took Malvasia's persuasive intervention to convince Elisabetta's father to take her on as a pupil. Her own meticulous records show that she was producing significant works by the age of seventeen; the list includes close to 190 examples made before her death ten years later.

Sirani painted a wide range of subjects—portraits, allegories, religious themes—and she painted them fast. So fast, in fact, that many people did not believe that she painted them all herself, and incredulous dignitaries came from all over Italy and beyond to watch her work. To refute charges that her father, and others, had helped with her work, on May 13, 1664, Sirani invited her accusers to her studio to watch her paint a portrait in one sitting.⁸ Her speed seems to have been developed under pressure from her father, who has been portrayed by several writers as an ill-tempered tyrant who took all her earnings and discour-

aged her from marrying. When a form of gout so crippled his hands that he could no longer paint, Elisabetta became the primary breadwinner for the family. Also important as a teacher, she set up a painting school for women and trained a number of notable pupils, including her two sisters Anna Maria and Barbara, who became professional artists. In addition to painting and teaching, Sirani was an accomplished etcher, although she seems to have given up this medium as her commissions for paintings increased.

Perhaps because of the speed at which she worked or because she may have collaborated with her students, Sirani's work varies in quality. But *Porcia Wounding Her Thigh* (plate 17) is interesting for several reasons. First of all, it is an unusual subject. Taken from Plutarch's *Life of Brutus*, the painting illustrates the moment when Brutus's wife raises a dagger to stab herself, thus demonstrating to her distraught husband, by her ability to withstand pain, that she can also keep a secret —in this case, the plot to assassinate Julius Caesar. In stylistic terms, this is one of Sirani's most impressive works. Porcia's calm, almost trancelike expression and the strong light on her face, leg, and upper torso dramatically contrast with the darkness that frames her body. A daringly cropped chair slides out of the picture at one end, and an open door reveals a view of men engaged in no doubt conspiratorial conversation at another end of the building.

Because the style in which she worked has long been out of fashion, Sirani has received little critical attention in the last century. But the ostentatiousness of her funeral indicates how highly she was esteemed by her contemporaries. Bologna's most prominent citizens eulogized her, and a local artist designed an enormous domed catafalque (plate 18), representing the Temple of Fame, which was dominated by a life-size statue of Sirani seated at her easel. In her brief twenty-seven years, Sirani became one of the select number of women artists who enjoyed international celebrity, along with Anguissola, Teerlinc, and Fontana.

Whereas Gentileschi and Sirani achieved fame as interpreters of religious and historical subjects, many of their contemporaries established major reputations for painting still lifes, which had become enormously popular in several parts of Western Europe beginning in the late sixteenth century. In Holland the demand for still lifes was so great in the seventeenth century that artists made a good living by specializing in narrow subcategories of this genre: breakfast pieces, flower pictures, and so on. Notable still lifes were also produced during this period by artists from Italy, Germany, and France. A remarkable number of successful Baroque still-life painters were women, presumably because still lifes are more dependent than the more prestigious genres on the artist's keen eye and strong technical skills, rather than on exposure to traditional academic education.

18. Catafalque design for Elisabetta Sirani, after 1665

Giovanna Garzoni also produced portraits and religious pictures, but it is for her meticulous studies of plants and animals, executed in watercolor on vellum, that she is remembered today. Information about her early life and artistic education is scarce and inconclusive, but records do indicate that she had painted a *Holy Family* by age sixteen. Garzoni never married; rather, she followed the lead of her male counterparts, traveling and working for powerful patrons in Venice, Naples, Florence, and Rome, where she had settled by 1654. Garzoni willed all her possessions and a considerable sum of money to the Academy of Saint Luke, of which she had been a member for several decades. In accordance with her wishes, the Academy erected a monument to her in the church of Santi Luca e Martina; it was completed nearly thirty years after her death.

her still lifes, is a deceptively simple composition, depicting in great

Garzoni's Plate of White Beans (plate 19), a typical example of

19. Giovanna Garzoni (1600–1670) Plate of White Beans, n.d. Tempera on parchment, 9¾ x 13½ in. Palazzo Pitti, Florence

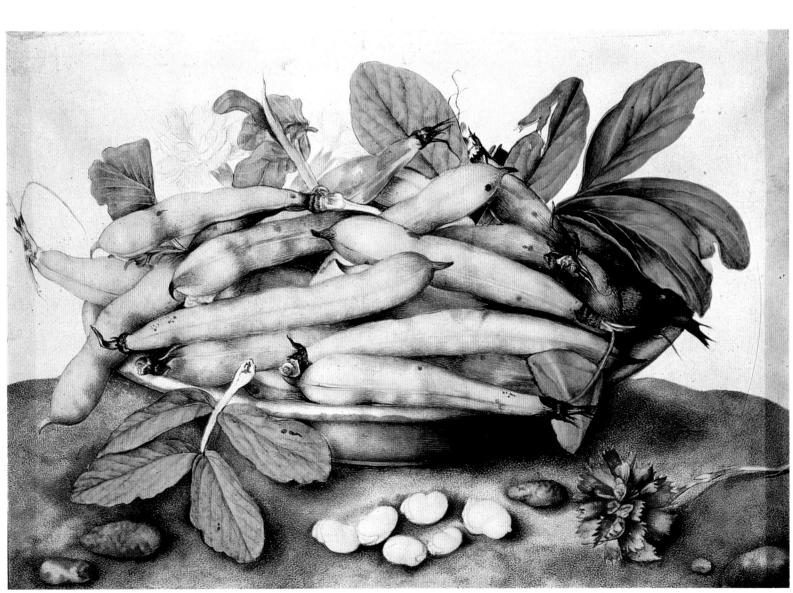

detail the damaged leaves, the ripe bean pods, and the irregularly colored rim of the shallow bowl in which they are displayed. Other works by Garzoni also reveal her technique of delicately stippling the ground plane, giving it a pleasantly grainy texture. ¹⁰ She frequently combined different sorts of fruits or vegetables within the same painting and, like her Dutch counterparts, often enlivened her pictures with the addition of living creatures.

A still-life painter who worked in watercolor on vellum but placed greater emphasis on the scientific aspects of her work was Maria Sibylla Merian. The daughter of the Swiss engraver and publisher Matthäus Merian the Elder, she was born in Frankfurt-am-Main and lived much of her adult life in Holland. Although he died when she was three, Merian's father had a lasting influence on her: the volume of scientific flower engravings that he had published six years before her birth inspired her to observe and record the world around her. Merian's stepfather, Jacob Marell, was a Flemish flower painter who helped with her artistic education. At age eighteen she married Johann Andreas Graff, one of Marell's students, who also specialized in flower still lifes. The couple had two daughters but were divorced some time during the 1690s.

20. Maria Sibylla Merian (1647–1717)
Watercolor from *Metamorphosis insectorum Surinamensium*, c. 1705
Watercolor on paper, dimensions unknown
Reproduced by courtesy of the Trustees of the British Museum, London

When she was only twenty-three, Merian published a threevolume set of her flower engravings, the first of which appeared in 1670. Her major contribution to entomology and botany came nine years later, with the publication of her second three-volume work. The Wonderful Transformation of Caterpillars and Their Singular Plant Nourishment. In an abrupt departure from the traditional method of drawing from preserved insect specimens, she carefully studied living examples of 186 kinds of European moths and butterflies, recording their appearance and activities at various stages in their life cycles. Merian's scrupulously accurate, painstakingly detailed illustrations provided a wealth of new information for the scientific community. Her work continued with a considerably more exotic project: the cataloging of indigenous insect, plant, and animal life in the Dutch colony of Suriname in South America. Funded by the city of Amsterdam, Merian worked in Suriname two years, assisted by her daughters; she returned to Holland because of ill health. The result of her research was Metamorphosis insectorum Surinamensium, published in 1705—an impressive volume with sixty large plates engraved from her watercolor paintings, complete with useful commentaries (plate 20). Like Albrecht Dürer and Leonardo da Vinci. Merian made important contributions to both art and science through her original observations about the natural world, conveyed in elegantly composed and beautifully detailed illustrations.

"The greatest still-life painter of the French seventeenth century," Louise Moillon, was selling her pictures by the age of ten. And this in a country where still life never enjoyed the widespread popularity that it had in the Netherlands. Louise was one of seven children born to the Parisian painter and picture dealer Nicolas Moillon. Since he died when she was nine, presumably her stepfather, François Garnier, also a painter and art dealer, contributed significantly to her education. The situation for female still-life painters in seventeenth-century France was rather odd. On the one hand, the Royal Academy of Painting and Sculpture, the arbiter of French artistic taste from its inception in 1648, had decreed that still life was an unimportant genre, ranked well below religious and history painting and even portraits in the hierarchy of artistic subjects. But, on the other hand, it was a field that was relatively accessible to women—indeed, of the few women artists elected to membership in the Academy during this century, four were still-life painters. 12

Most of Moillon's surviving works were painted before 1642. Since she married Etienne Girardot in 1640 and thereafter had at least three children, family life seems to have interrupted her career. However, Moillon started painting again in the 1670s or '80s, possibly because of financial need, which may have been related to the religious persecution she suffered as a French Protestant.

Plate 21 shows a typical example of Moillon's work, in which a few simple masses are carefully balanced against each other. The paint-

ing dates from 1630, by which time she was already established as a successful painter, specializing in still lifes of fruit. Here her skill is evident in the distinction of textures—woven basket, patterned bowls, and various types of berries. Like so many other still-life painters of this era, she delighted in showing off her technical expertise in passages such as the water droplets on the table and the individual highlights on the shiny berries. Also notable is the dark background, which focuses attention on the fruits themselves, giving the picture a quiet intensity. An ambitious artist, by age twenty Moillon was also creating large-scale pictures that combined figures with still-life elements. In one example, a wealthy housewife shops for vegetables while a cat sniffs curiously at the produce; another features a pickpocket liberating a shopper's purse. Such subjects were very rare outside Holland and establish Moillon's significance as a pioneer in the relatively new field of French still-life painting.

A different approach to still life characterizes the work of Clara Peeters, a Flemish painter about whose life little is known. ¹⁴ Scholars have established the place of Clara's birth (Antwerp) and her father's name (Jan Peeters), but not his profession or the source of his daughter's education. She must have received excellent training, however, since Peeters signed her first painting at age fourteen and by seventeen she had executed a group of four highly accomplished still lifes, now in the Prado. Peeters is known to have married a man named Hendrick Joossen when she was forty-five (a remarkably advanced age for a first marriage in that era) and to have specialized during the early part of her career in breakfast or banquet pieces—tabletop arrangements of luxurious objects and exotic, expensive food and drink (plate 22).

Many of Peeters's works have been identified, for she generally signed and often dated her pictures. Typical early examples feature dense combinations of many different kinds of objects—elaborately chased metal goblets, flowers, fruit, gold coins, rare seashells. She also painted pictures of fish and game. Like her Dutch peers, Peeters demonstrated marvelous technical control, distinguishing different textures and conveying a clear sense of the lusciousness, and solidity, of her subjects. Like many seventeenth-century still-life specialists, she often placed certain objects so that they extended over the table's edge, creating the illusion that they projected into the viewer's space. Another characteristic of Peeters's work is a multiplicity of reflections. In particular, she was fond of painting miniature self-portraits, reflected, often many times over, in the shiny curved surface of a wineglass or pewter pitcher. There is one further aspect of Peeters's art that should be noted —namely, its symbolic content. Many Flemish and Dutch Baroque still lifes include objects specifically chosen to remind viewers of the temporary nature of earthly existence. Some of these so-called *vanitas* paintings make overt references to human mortality through the inclusion of

21. Louise Moillon (1610–1696) Still Life with Cherries, Strawberries, and Gooseberries, 1630 Oil on panel, 125 x 191/8 in. The Norton Simon Foundation, Pasadena, California

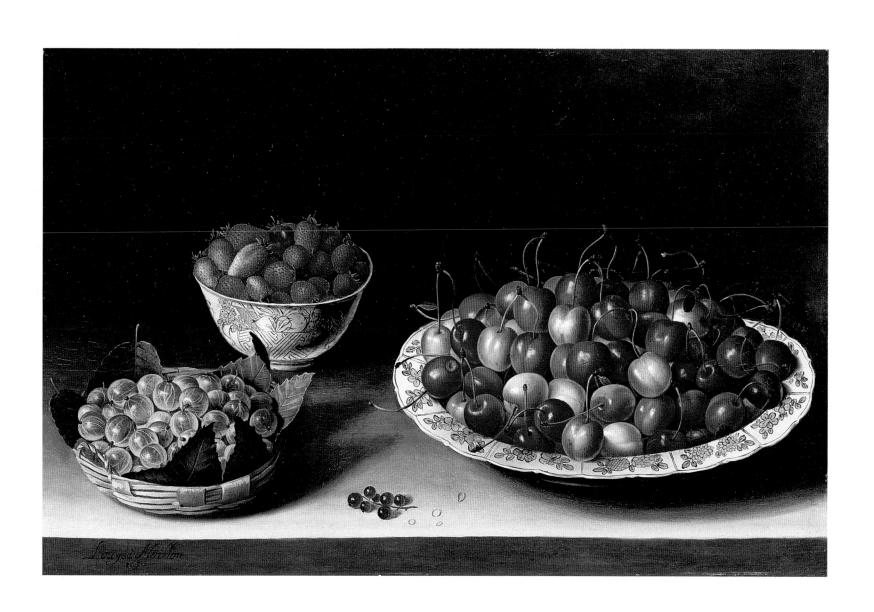

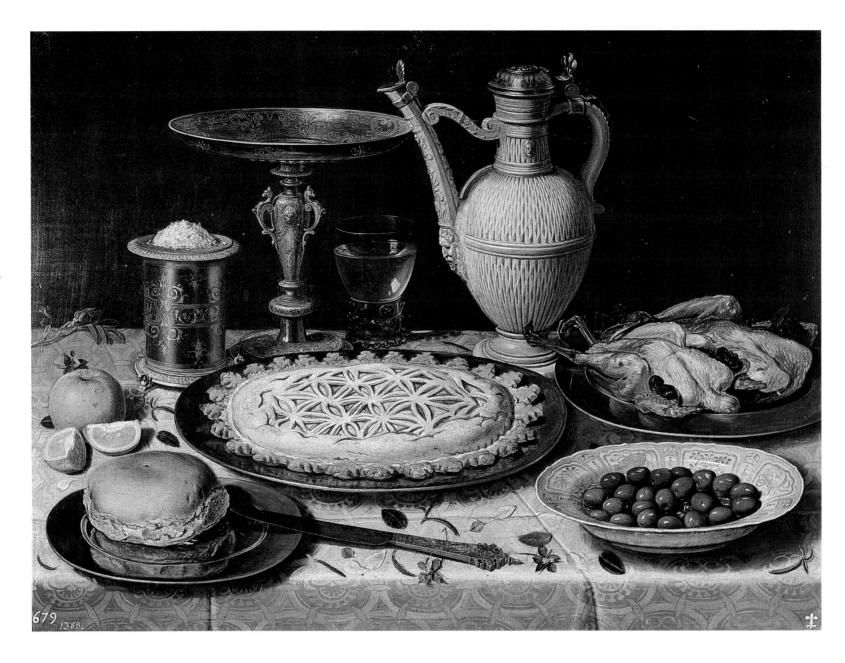

snuffed candles, hourglasses, or even skulls. Others are more subtle, relying on overturned goblets, worm-eaten flower petals, or peeled fruit to make the same point. What may seem like hidden symbolism to modern eyes would have been perfectly clear to seventeenth-century viewers. Such paintings appealed to the burgeoning middle class and its apparently insatiable appetite for secular art that was both beautiful and meaningful. Fafter 1620 Peeters switched from painting luxury items to plainer, more humble food and drink, such as bread, cheese, olives, pretzels, and beer. This change may have been intended to appeal to more modern tastes, since Peeters's earlier pictures had gone out of style in Flanders.

Rather than fastidiously rendered botanical illustrations or lavish arrangements of edibles, many Baroque still-life painters specialized

22. Clara Peeters (1594–after 1657) Still Life, n.d. Medium and dimensions unknown Museo del Prado, Madrid

23. Constantijn Netscher (1668–1723) Rachel Ruysch in Her Studio, c. 1710 Oil on canvas, 44¹⁵/16 x 35⁷/8 in. The North Carolina Museum of Art, Raleigh

in pictures of flowers. In fact, flower painting was the most highly paid form of still life in seventeenth-century Flanders and Holland, one that attracted many noted male and female artists. One of the most distinguished seventeenth-century Dutch flower painters was Rachel Ruysch (plate 23). Born in Amsterdam, she was the daughter of Anthony Frederick Ruysch, a professor of botany and anatomy and an amateur painter. Like so many other women artists, she began her career early, first as a fifteen-year-old apprentice to Willem van Aelst, a famous Dutch painter who specialized in flowers. Three years later Ruysch was producing independent, signed pictures; she also taught her sister, Anna Maria, to paint still-life subjects. In 1693 Ruysch married Juriaen Pool, a portrait painter with whom she had ten children. Despite her considerable domestic obligations, Ruysch continued to paint, producing more than one hundred signed works. She was court painter to the Elector Palatine, Johann Wilhelm von Pfalz, in Düsseldorf, from 1708 until his death in 1716. At that point Ruysch and her husband returned to Amsterdam, where she continued painting well into her eighties.

Presumably influenced by her father's professional interests, Ruysch brought a thorough knowledge of botany and zoology to her work. She painted tabletop views of vases crammed with flowers (plate 24) as well as outdoor scenes in which fruit coexists with snakes, lizards, and a host of menacing insects. Unlike Moillon's and Garzoni's tranquil still lifes, Ruysch's are anything but still. Even her indoor flower pictures have an unusual sense of vitality: the profuse plants flaunt many different colors, shapes, and sizes; their stems twist and curve energetically; and the compositions are open, with irregular contours, all contributing to the liveliness of her pictures. As in some of Peeters's works, and many by Maria van Oosterwyck, blossoms occasionally extend beyond the table's edge and Ruysch would sometimes "sign" her works with reflected self-portraits.

Approximately twenty-four pictures, mostly flower pieces, are known today by the Dutch still-life specialist Maria van Oosterwyck. Although her paintings (plate 25) are less lively than Ruysch's, Oosterwyck's include many of the same elements—the vase of exotic flowers on a marble tabletop, insects, reflected images. As compared to the Ruysch painting illustrated here, Oosterwyck's includes fewer and larger shapes, concentrating on a pair of aggressively striped tulips that are visually connected to the green-and-white-striped grasses dangling over the table's edge. These forms and the large masses of light-hued flowers in the center of the picture contrast quite effectively with the darker foliage in the background and the tiny lilies of the valley.

Although modern scholars doubt the veracity of much of the information available on Oosterwyck's early life, it is certain, at least, that she was born near Delft and that her father was a Dutch Reformed minister. She is thought to have studied with Jan Davidsz. de Heem, a

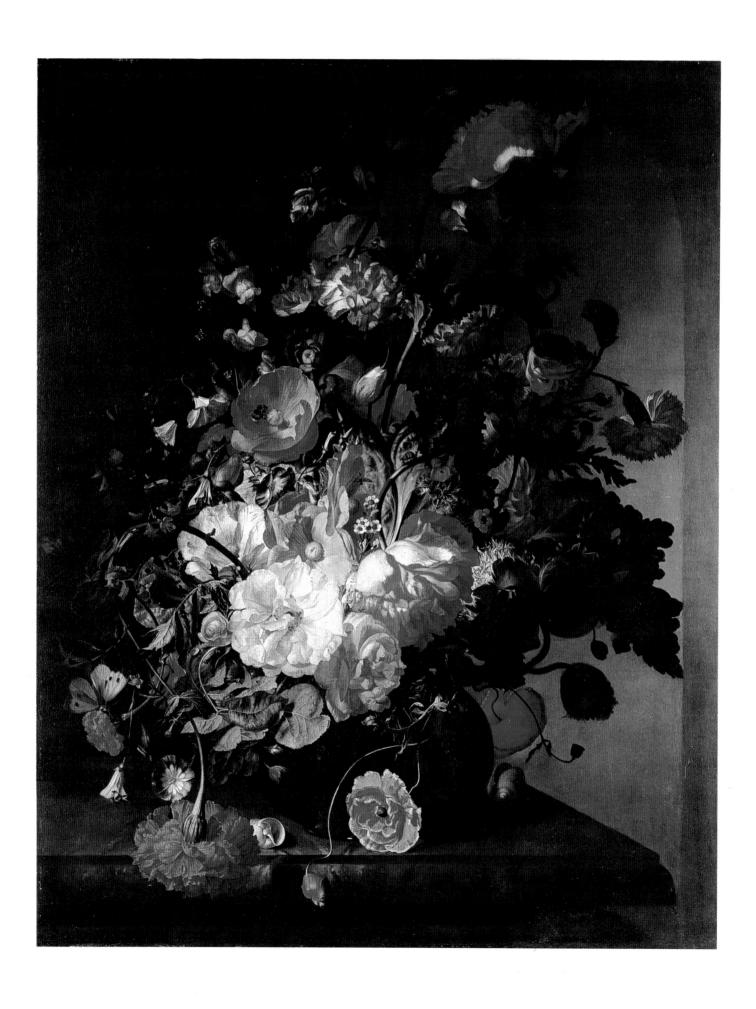

Left
24. Rachel Ruysch (1664–1750)
Flower Still Life, after 1700
Oil on canvas, 29¾ x 23¾ in.
The Toledo Museum of Art,
Toledo, Ohio; Gift of Edward
Drummond Libbey

Right
25. Maria van Oosterwyck
(1630–1693)
Vase of Tulips, Roses, and
Other Flowers with Insects, 1669
Oil on panel, 185/8 x 151/8 in.
Mrs. L. W. Scott Alter

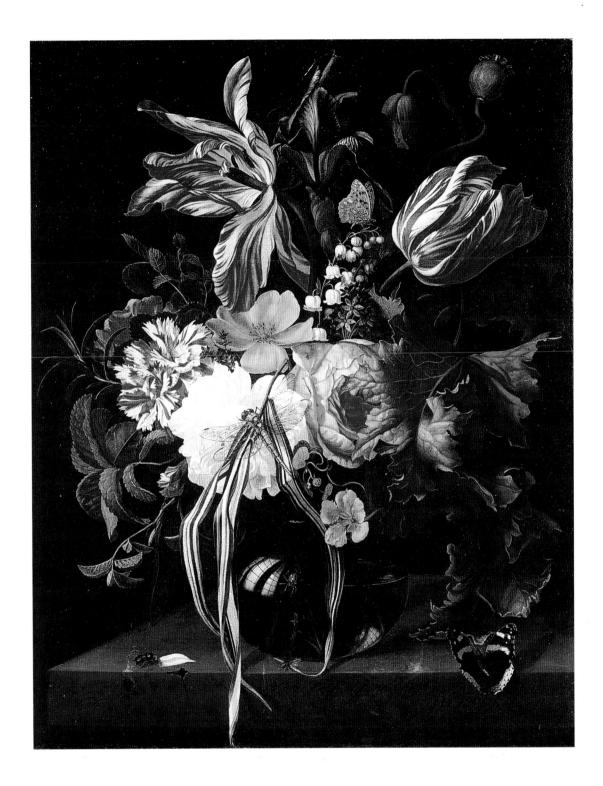

noted still-life painter. Another, less reliable story reports that she was courted by Willem van Aelst, who taught Rachel Ruysch. Oosterwyck is said to have told van Aelst that if he would paint ten hours a day for one year, she would consider his proposal. He did not, and she remained single, ¹⁶ eventually attracting as patrons such international luminaries as Louis XIV, William III of England, the king of Poland, and Leopold I, ruler of the Holy Roman Empire.

Obviously, not all seventeenth-century Dutch paintings were still lifes. The Dutch artist Judith Leyster, for example, was extremely successful in her day as a portrait and genre specialist. But her reputation faded soon after her death, until 1893, when the Dutch art historian C. Hofstede de Groot published an article about her work, identifying her monogram—the letter "J" combined with a star (a play on her last name)—and reviving interest in her paintings. Theyster was the child of a Haarlem brewer. Little is known about her early training, but she was well enough regarded by the age of seventeen to be cited as a local artist in a book about that city. While still in her early twenties, Leyster became the only female member of the Haarlem painters' guild, and two years later she had three pupils of her own, all male. Leyster painted considerably less after her marriage in 1636 to Jan Miense Molenaer, a genre specialist, with whom she had at least five children. 18

Although her work has become closely identified with that of Hals, the precise nature of their relationship remains unclear. Certainly Levster knew Hals by the early 1630s, and some scholars believe that she studied with him. 19 Whatever relationship they had must have been severely strained when, in 1635, she sued Hals—successfully—for breach of ethics, when he took on one of her former students as a painting apprentice. Art historians have often commented on the similarity of Leyster's art to Hals's. Both artists are known for figure studies painted with rather loose brushstrokes and a strong sense of vitality. But, as more paintings by Levster have been identified, writers have begun to note differences between the two artists' works. For example, Harris points out that Levster's brushwork is generally more restrained; that her compositions, while outwardly simple, are more sophisticated in a formal sense; and that she was more versatile in terms of subject matter.²⁰ Clearly, Leyster was strongly influenced by Hals, especially in her tavern scenes. But her paintings also reveal a considerable influence from the so-called Utrecht Caravaggisti (a group of Dutch painters who had spent time in Italy and adopted some of Caravaggio's stylistic traits), whom Levster presumably encountered while living in nearby Vreeland. Caravaggesque aspects of Leyster's work include her tendency to focus on a few large-scale figures (plate 26) rather than a group of small ones and, most obviously, her interest in dramatically lit scenes featuring a strong contrast between rich areas of darkness and intense highlights thrown by strategically placed candles. Levster is also significant for her unor-

26. Judith Leyster (1609–1660) The Flute Player, n.d. Oil on canvas, 28½ x 24¼ in. Nationalmuseum, Stockholm

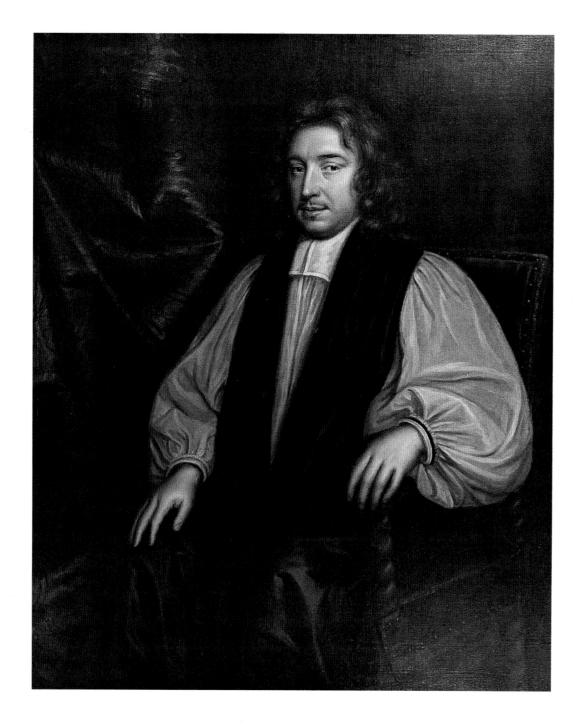

27. Mary Beale (1632–1697) John Wilkins DD, c. 1670 Oil on canvas, 49 x 39½ in. Bodleian Library, Oxford, England

thodox interpretations of certain popular subjects. Especially intriguing is her painting *The Proposition*. ²¹ Typical Dutch and Flemish treatments of this theme feature seductively clad women who are clearly enjoying their encounters with men, while Leyster painted a modestly attired woman, busily sewing, who obviously disdains the coins she is being offered.

Surveys of Western art from the fourteenth through the seventeenth century tend to focus first on Italy and then on Holland. Although this long-standing convention has reinforced the well-deserved reputations of such artists as Michelangelo and Rembrandt, it has

slighted the accomplishments of artists from other countries who produced significant bodies of work during those four hundred years. This problem is particularly acute in terms of English art, which was dominated by portraiture, considered a minor form, until the eighteenth century. If male artists from England have been neglected by art history, their female counterparts have fared worse, since so many of their works have been attributed to other people.

A case in point is that of Mary Beale, a prominent portraitist whose works have often been confused with those of Sir Peter Lely and other noted painters. The daughter of a clergyman who was also an amateur artist, Beale is presumed to have studied with Robert Walker, official painter to Thomas Cromwell, and Thomas Flatman, a lawyer, poet, and miniaturist. Although she was not his pupil, Beale was nevertheless helped by Lely, who invited her to copy works from his personal art collection, one of the largest in London at that time. After Lely died in 1680, there was a demand for copies of his work, which Beale was generally commissioned to make. Ironically, the accuracy of these copies has caused much of the confusion surrounding her own work. Beale's portrait of John Wilkins (plate 27) illustrates her standard formula: half-length, seated figures set against dark backgrounds, their eyes fixed on the viewer. Wilkins was an important figure at both Oxford and Cambridge universities and became Bishop of Chester in 1668.²³

While marriage has called a halt to the careers of many women artists, Beale seems to have thrived on a combination of roles. In fact, it was only after her marriage to Charles Beale that she began her professional apprenticeship, continuing to paint while their two sons were young. By 1670 she was established as an independent artist, working in pastels, watercolor, and oils, and especially popular for her pictures of children. Beale's spouse managed their household and the mechanics of her career, priming her canvases, mixing her colors, and eventually becoming an art dealer. Some of his notebooks still survive and meticulously record the daily activities of his prolific wife: In 1677, for example, she completed eighty-three commissions. Her sons also helped with the work; Mary taught one of them, also named Charles, to paint portraits, which he went on to do as a profession. In addition to her son, Beale took on other pupils, at least one of whom, Sarah Curties, became a successful portraitist.²⁴

Portrait miniatures enjoyed a tremendous vogue in England, where they had become well established by the seventeenth century. One of the best-known miniaturists from this period was Susan Penelope Rosse, whose father, Richard Gibson, was a miniaturist and her first teacher. ²⁵ As a young artist she also copied the miniatures of Samuel Cooper, who, with his brother Alexander, was responsible for developing new techniques and styles in miniature painting. ²⁶ Susan married a jeweler named Michael Rosse, but neither the year of her marriage nor

any other information concerning her family life is known. Her portraits tend to be very small, even for miniatures—many are just one inch high. Rosse painted primarily female subjects, including two mistresses of Charles II, many of which are now in the Victoria and Albert Museum. Her portrait of an unknown boy (plate 28) is typical of many miniatures from this time in its oval shape, bust length, and background. Its scale (1½ by ½ inches) demonstrates Rosse's remarkable technical control.

Miniatures were also popular outside England. For example, the Italian artist Teresa del Pò produced a number of fine religious and mythological scenes, such as Apollo and Daphne (plate 1). Born in Rome, del Pò came from an artistic family—she studied with her father. Pietro del Pò, who taught her to paint and to make copper engravings: she was also a student of Domenichino's. Both Teresa's brothers, Andrea and Giacomo, also became artists, as did her daughter, Vittoria, whom she taught to paint. In 1675 Teresa was elected a member of the Academy of Saint Luke in Rome; her mature work was produced there and in Naples, where she spent the last part of her life. Apollo and Daphne demonstrates del Pò's skill at conveying movement—seen especially in the figures' streaming hair and agitated drapery—and great detail, as in the foreground flowers and the individual feathers of the cherubs' wings. Like the great Italian Baroque sculptor Gianlorenzo Bernini, she chose the most dramatic moment in Ovid's tale, when Daphne's metamorphosis begins—her fingers sprouting delicate branches and her right foot taking root. But, unlike her countryman, Teresa del Pò illustrated the story in delicate pastel colors, under tranquil, even light, and with a playfully erotic quality that is clearly Rococo rather than Baroque.

Two women artists from Spain—one a painter, the other a sculptor—achieved great success during the seventeenth century. 27 Josefa de Ayala was born in Seville, the daughter of a Portuguese portrait painter named Balthasar Gomes Figueira. 28 There is no record of her training, but she was apparently an independent painter by the time she moved with her family to Portugal. Avala painted a broad range of subjects: portraits, still lifes, allegories, and religious pictures, including an important altarpiece for the church of Santa Maria in Obidos. She also made etchings. Ayala's still lifes have a Northern European quality; the one illustrated by Greer is a sumptuous and precisely detailed array of desserts, flowers, and expensive containers. Her religious works include an intriguing treatment of the popular subject The Mystical Marriage of Saint Catherine (plate 29). In addition to such standard elements as attendant angels and the wheel (a reference to the method of Catherine's martyrdom), this version has several unusual touches that add a sense of everyday reality to the scene—like the domestic still life at the left and the open window on the right. A successful artist in Portugal, Avala was elected a member of the Lisbon Academy.

Above
28. Susan Penelope Rosse
(c. 1652–1700)
Unknown Boy (William Wentworth),
c. 1680
Vellum on card, 11/8 x 7/8 in.
Reproduced by permission of the
Syndics of the Fitzwilliam Museum,
Cambridge, England

Right
29. Josefa de Ayala (1630–1684)
The Mystical Marriage of Saint
Catherine, 1647
Oil on copper, 107/8 x 143/4 in.
Museu Nacional de Arte Antiga,
Lisboa

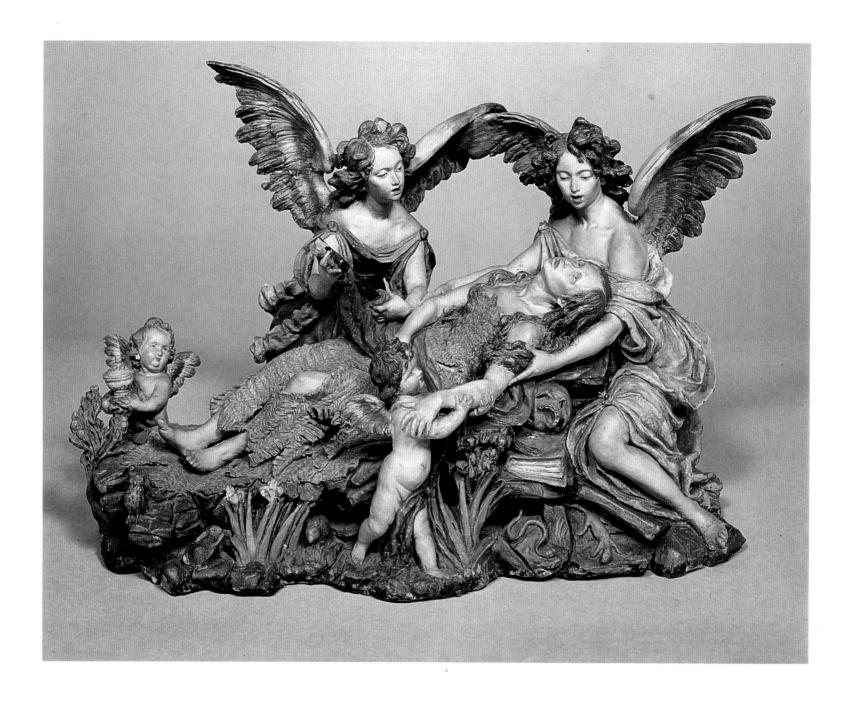

The first woman sculptor recorded in Spain is Luisa Ignacia Roldán. "La Roldana," as she was popularly known, also came from Seville. Her father, Pedro Roldán, established a family workshop, where she was trained; her older sister Maria and two brothers helped produce the sculptures, while her sister Francisca painted them.²⁹ This workshop soon began to revolve around Luisa's numerous commissions for religious sculptures of polychromed wood or—her specialty—terra-cotta. She was married at age fifteen to Luis Antonio de los Arcos, a sculptor whose only known work is what he did in collaboration with his wife. By the early 1690s Luisa and her husband were in Madrid, where she was named Sculptor of the Chamber to King Charles II. Beatrice Gilman

30. Luisa Ignacia Roldán (1656–1704) The Death of Saint Mary Magdalene, n.d. Polychrome terra-cotta, 12¹/₄ x 17³/₄ in. The Hispanic Society of America, New York Proske describes in heartrending detail the difficulties that Roldán, her husband, and their two small children suffered during the next few years because of the country's severe economic crisis, which affected the food supply even at Charles's court. ³⁰ Nevertheless, Roldán produced a considerable amount of sculpture, including the carved wooden statues *Saint Michael* and *Christ Bearing the Cross*, both over life size. Roldán retained her position under Charles's successor, Philip V, and continued making wooden freestanding and relief sculptures as well as the work for which she became best known, small polychrome terra-cotta groups. Such sculptures were virtually unknown before this time. More typically, individual clay figures were modeled for temporary groupings on an altar or to be carried during a procession. La Roldana's groups were kept permanently on view, often in glass cases, along with other church treasures.

Like Ayala's religious subjects, Roldán's group sculptures have the intimacy of genre scenes; she added to their charm by including numerous details. For example, in *The Death of Saint Mary Magdalene* (plate 30), besides the saint herself, two large angels, and a pair of cherubs, there are the standard still-life elements that identify the subject—Mary's scourge, a skull, and a book—plus a lizard, a snake, an owl, two rabbits nibbling on grass, and some flowers. The colors are bright, and a great deal of gold was used, creating an effect that may seem odd to viewers accustomed to the monochromatic sculptures of Italy but that is very much in keeping with the Spanish love of polychromy. Other subjects treated by Roldán include *The Annunciation*, *The Mystical Marriage of Saint Catherine*, and *The Education of the Virgin*.³¹

During the seventeenth century the number of successful women artists increased significantly, as did the number of options open to them. No longer confined primarily to portraiture, Baroque women artists excelled in such diverse fields as genre painting, religious sculpture, and the newly popular still life. Like their male contemporaries, many seventeenth-century women artists were united by their interest in bringing even religious and historical subject matter down to earth—by emphasizing domestic details with which viewers could easily identify—and in attracting the observer's attention through such devices as Gentileschi's aggressive theatricality and Peeters's virtuosic *trompe-l'oeil* illusionism. The succeeding century marked a significant change in European politics, religion, and aesthetics. In this changing climate several female artists rose to unprecedented levels of prominence, celebrated for works that were quieter and considerably more sentimental than those created by their Baroque predecessors.

THE EIGHTEENTH CENTURY

Up to now we only expected amusement and neatness from their brushes; they [women artists] show today vigor and nobility. They are finally the worthy rivals of our sex; and men, who had previously assumed their own talents to be superior in all respects, can from now on worry abut real competition.

—Picturesque Lottery for the Salon of 1783

was inaccurately named. In France, which had come to dominate European art, as Italy and Holland had done in earlier centuries, this was a particularly complex and contradictory time, characterized by tremendous intellectual advances on the one hand and political turmoil on the other. Private salons, hosted by wealthy and powerful women, reached the height of their influence, and voices were raised in favor of women's rights. However, by the end of the eighteenth century little progress had been made in the way most women lived. In fact, the establishment of the Napoleonic code of law, the popularity of Jean-Jacques Rousseau's ideas about the importance of the family, and the increasing power of the Academy all combined to place most women artists in a position that was in many ways inferior to the one they had held before.

Education was still beyond the reach of all but the upper classes, and the European art academies, which largely determined whose careers would prosper, enacted policies that severely restricted the activities of women. In 1770, for example, the French Royal Academy of Painting and Sculpture (founded in 1648) decreed that no more than four women could be members at any one time. (Previously, a small number of female members had been elected but were denied many of the privileges enjoyed by male Academicians.) The situation was even worse in England, where two of the founding members of the British Royal Academy (established in 1768) were women: no other female members were elected until the twentieth century. During the late eighteenth century there was a marked increase in the number of both French and English women studying drawing, but most of these were wealthy amateurs interested in art as a womanly accomplishment. Ironically, the widespread awareness of such dilettantes made it even harder for professional women artists to establish their credibility as serious painters and sculptors. Nevertheless, those who were able to do so found themselves somewhat less limited than their predecessors to traditionally female subjects, for the 1700s saw a significant increase in genre, mythological, and history subjects created by women.

31. Angelica Kauffmann Virgil Writing His Own Epitaph at Brundisium, 1785 (detail) See plate 33

During the eighteenth century three women painters emerged who earned unprecedented praise, international fame, and financial success. Rosalba Carriera, Angelica Kauffmann, and Elisabeth Vigée-Lebrun were from different countries and diverse backgrounds. But they shared several important qualities: All began their careers making portraits; all were exceptionally accomplished musicians; all exerted a major influence on younger artists; and all lived relatively long lives—Kauffmann died at sixty-six, and both Carriera and Vigée-Lebrun lived into their eighties.

Rosalba Carriera is of particular art historical significance because she popularized a new type of painting: the pastel portrait. Carriera was born in Venice, which remained her favorite city despite occasional sojourns elsewhere. Her father was a public official whose limited salary was augmented by the money her mother earned by making lace. Possibly influenced by her grandfather, who was a painter, Rosalba demonstrated a youthful interest in art. She designed lace patterns for her mother and later painted miniature portraits on the ivory lids of snuffboxes. There is some question about her early training, but Carriera was making and selling miniatures by 1700, and pastel portraits three years later. She also taught painting techniques to her two younger sisters—Angela, who married a painter, and Giovanna, who became Rosalba's assistant.

While black, white, and red chalk had long been used for sketching, it was only in the late fifteenth century that pastels—crayonlike sticks of compressed chalk in many different colors—became available to artists. Initially, pastels were used for making copies of oil paintings. But by the late 1600s pastels were beginning to gain wider recognition in their own right. Artists enjoyed the speed with which they could work using pastels and the variety of effects available, from crisp lines to loose patches of color rubbed softly into one another. Pastels were the ideal medium for the Rococo-style portraits that Carriera created in large numbers for distinguished patrons in several countries. Moreover, she inspired other men and women to work with pastels most notably, Maurice Quentin de la Tour, the acknowledged eighteenth-century master of the medium. Although she did produce allegories and mythological pictures, Carriera was known primarily for her ability to flatter sitters while retaining a sense of their individuality. In the early self-portrait illustrated here (plate 32), the artist set herself against a plain background, wielding the tools of her trade as she finished a portrait of her sister Giovanna. While Carriera's later works are far more impressionistic, this one, too, exhibits an appealing painterly quality, especially notable in the lace details of her dress.

Carriera was well regarded in Italy: she was elected to membership in the academies of Saint Luke in Rome, Bologna, and Florence, and the Grand Duke Cosimo III de' Medici invited her to add her self-

32. Rosalba Carriera (1675–1757) Self-Portrait Holding Portrait of Her Sister, 1715 Pastel on paper, dimensions unknown Galleria degli Uffizi, Florence

portrait to his collection. Her reception in France was even more of a triumph. After her father's death in 1719, Carriera accepted the invitation of Pierre Crozat, a French financier and art collector, to visit him in Paris. Along with her mother, two sisters, and a brother-in-law, Carriera arrived in Paris in the spring of 1720, where one of her first sitters was the boy king Louis XV. Given that introduction, Carriera found herself besieged by noble patrons. She was elected to the French Academy—despite the 1706 rule forbidding the admission of any more women—and scored a series of major social victories, aided by her considerable skill on the violin.

In 1721 Carriera returned to Venice, where she continued to paint a remarkable number of miniatures and pastel portraits to meet the great demand for her work. Her speed was increased by the fact that she worked on a fairly small scale and that Giovanna often filled in the backgrounds and draperies of her pictures. Giovanna's death from tuberculosis in 1737 sent Carriera into a serious depression, from which she recovered only to be plagued by deteriorating vision during the late 1740s. Cataract surgery provided only temporary relief, and Carriera spent her last decade totally blind.⁴

Like so many female artists, Angelica Kauffmann was a child prodigy, producing her first commissioned portrait before she had reached her teens. 5 She was only sixteen when her mother died, and her father, the painter Joseph Johann Kauffmann, decided to leave Switzerland to search for a broader range of patrons, taking his only child along. As the pair traveled through Austria and Italy, Angelica assisted her father with his religious commissions and received numerous portrait assignments of her own. Contemporary accounts describe Kauffmann as an exceptionally accomplished, attractive young woman. Proficient in several languages, she was also a gifted singer and played several musical instruments. While Kauffmann's initial training came from her father, she was also influenced by the distinguished Neoclassical artists and theorists she met on her travels; these included the American painter Benjamin West and the writer J. J. Winckelmann.

The most remarkable aspect of Kauffmann's career is that she painted works based on ancient and modern history—especially after 1766, when she arrived in London.⁶ Although she produced a significant number of portraits and allegories, she excelled at history painting, then considered the most prestigious artistic category and one in which women had rarely succeeded. One measure of Kauffmann's success is the fact that she, along with the British flower painter Mary Moser, was one of two female founding members of the British Royal Academy.⁷ Moreover, she made sufficient money from her paintings during her first year in London to purchase her own home.⁸ Virgil Writing His Own Epitaph at Brundisium (plate 33) is a typical example of Kauffmann's mature work, featuring meticulous attention to details—of the carved

33. Angelica Kauffmann (1741–1807) Virgil Writing His Own Epitaph at Brundisium, 1785 Oil on canvas, 40 x 50 in. Peter Walch

table legs, the individual leaves in the laurel wreaths, and the lyre—and a dignified, yet wistful mood, as two other male poets and the Muse grieve at the approaching death of the *Aeneid*'s author.

Stories about Kauffmann's personal life seem to be as enduring as her impressive professional reputation. As a prominent and lovely young woman, she was the subject of gossip wherever she went. In England there were rumors about her friendship with Sir Joshua Revnolds; her rejected suitors supposedly included the painters Henry Fuseli and Nathaniel Dance; and the French Revolutionary martyr Jean-Paul Marat boasted that he had seduced her. But the facts of her life are sadder than the rumors. In 1767 Kauffmann secretly married a handsome Swedish nobleman, the Count de Horn, who turned out to be a non-Swedish commoner named Brandt and who already had a wife. The public humiliation she suffered when Brandt's true identity became known was compounded by his trying to kidnap her and then demanding (and receiving) money from her father. Since the marriage was never annulled, the Catholic Kauffmann could not remarry until Brandt died in 1780. Soon thereafter she married a successful painter, Antonio Zucchi. The couple moved to Venice, and then Rome, where he managed her career.

The third of the principal women artist celebrities of the 1700s, Marie-Louise-Elisabeth Vigée-Lebrun, was the quintessential eighteenth-century court painter—an unusually attractive, charming, selfconfident woman with the ability to present her sitters to their best advantage. Like her contemporary and rival, Jacques-Louis David, she. managed to keep both her head and her professional reputation during a period of political upheaval, achieving fame in her native France as well as in Italy, Austria, and Russia. Vigée-Lebrun's Memoirs, first published in 1835, provide a sparkling portrait of international society through her chatty descriptions of the dignitaries she met, her reminiscences of friends killed during the Revolution, and her lively gossip about assorted romantic liaisons, social gaffes, and fashion trends. As Joseph Baillio has pointed out, these memoirs have given later generations the impression that she was a shallow person, concerned more with society than her art. 10 On the contrary, she was profoundly serious about her painting, to which she seems to have applied herself with almost single-minded devotion from an early age.

Vigée-Lebrun was born in Paris to an artist-father who made pastel portraits and taught at the Academy of Saint Luke, the only alternative to the Royal Academy for young artists—especially women —who were unable to enter the Ecole des Beaux-Arts. While at a local convent school, Vigée-Lebrun spent much of her time drawing in the margins of her books. After studying briefly with her father (who died when she was twelve) and several of his colleagues, Vigée-Lebrun established herself as a professional portraitist. By the age of fifteen she was

earning enough money from her art to support herself, her widowed mother, and her younger brother, and her portrait style became more and more popular. But control of her craft did not yield control of her finances: her fees were taken from her first by her stepfather, a goldsmith who appears to have been thoroughly disagreeable, and later by the painter and art dealer Jean-Baptiste-Pierre Lebrun, whom she married in 1776. Her husband has frequently been portrayed as an exploitative, irresponsible gambler. In fact, Lebrun was also a highly successful, well-connected member of the art and business worlds who exposed his wife to important works of art and prominent people she would not otherwise have encountered.¹¹

When she was twenty-four, Vigée-Lebrun painted the first of what was to be a series of portraits of Marie Antoinette, with whom the artist developed a close relationship. One of the most instructive of these royal portraits shows the queen standing, three-quarter-length, wearing an elaborately plumed and beribboned hat and holding a single, patently artificial rose. Her powdered hair, fussy gown, pastel colors, and sweet, rather vacant expression all mark this as a typical Rococo portrait. Eighteenth-century French art abounds with related examples by various artists, and it is interesting that this type remained the same whether the painter was a man or a woman and whether the subject was a wealthy socialite or the queen of France. In many of her later portraits, Vigée-Lebrun focused on much simpler settings and costumes; the spare white gowns and antique-inspired coiffures she employed helped start a vogue for Neoclassical clothing and décor.

Vigée-Lebrun's closeness with the queen conferred certain obvious advantages; it even facilitated her acceptance into the Royal Academy, from which she was technically barred because of her husband's profession. However, this closeness made it far too dangerous for Vigée-Lebrun to remain in France once the Revolution began. The artist and her only child, nine-year-old Julie, made a dramatic escape from Paris the night Marie Antoinette and Louis XVI were arrested. Thus began twelve years of exile (four years in Italy, two in Austria, six in Russia) during which she captivated the local nobility and produced numerous portraits that ultimately gained her admission into several academies and enabled her to amass a considerable fortune. In 1802 Vigée-Lebrun returned to Paris, where her wealth allowed her to live the rest of her eighty-seven years in comfort, conducting fashionable salons and publishing her memoirs.

The reasons for Vigée-Lebrun's popularity can easily be deduced from almost any example of her work. For instance, her Self-Portrait with Her Daughter in the Louvre (plate 34) is thoroughly charming, if rather saccharine for modern tastes. By all accounts an unusually attractive woman, the artist flattered herself here by emphasizing her youthful complexion and her close bond with Julie. Their

34. Marie-Louise-Elisabeth Vigée-Lebrun (1755–1842) Self-Portrait with Her Daughter, n.d. Oil on wood, 511/8 x 37 in. Musée du Louvre, Paris

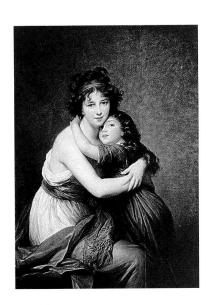

curly hair, sparkling eyes, and moist, slightly parted lips are quite appealing; and the plain, monochromatic background further focuses attention on the two figures, whose clothing is based on antique prototypes. The portrait of *Countess Golovin* (plate 35) illustrates the more dramatic side of Vigée-Lebrun's work. The Russian aristocrat is not a classic beauty—her nose is rather large and her eyes far apart—but the artist emphasizes romantic elements such as the wind-blown hair, the diagonal shaft of light, and the way the countess clutches one end of her embroidered cloak to underscore the attractive, even erotic, quality of the sitter.

One recent writer has characterized Vigée-Lebrun's art as "a conscious anachronism, typifying the final attempt by Ancien Régime society to shut its eyes to unwelcome realities, and to take refuge in a world of make-believe and fancy dress." In large measure, this is true; it is one reason that Vigée-Lebrun got along so well with Marie Antoinette. However, Vigée-Lebrun produced more than mere escapist fare—her best portraits are vibrant evocations of individual personalities and vividly preserve a way of life that was fading even as she painted it.

Over the past century and a half, Vigée-Lebrun's reputation has eclipsed that of her contemporary, Adélaïde Labille-Guiard. The two women—both successful French portraitists, who shared some of the same patrons and were admitted to the Academy on the same day in May 1783—were often spoken of as rivals in their own time, although Danielle Rice has suggested that this rivalry was largely the invention of male artists and critics who felt threatened by their female competitors. Labille-Guiard was the youngest child of a Parisian haberdasher; her first teacher was the miniaturist François-Elie Vincent, and she studied pastel technique with Maurice Quentin de la Tour. (Three years before her death Labille-Guiard married François-André Vincent, her teacher's son and a painter in his own right. Unlike Vigée-Lebrun, who taught only briefly out of financial need shortly after her marriage, Labille-Guiard enjoyed teaching and had several distinguished pupils. She was also an active promoter of rights for women artists.

More sympathetic than Vigée-Lebrun to certain aspects of the Revolution, Labille-Guiard painted several portraits of members of the court who were highly critical of Marie Antoinette. But as Peintre des Mesdames, Labille-Guiard was also the official painter to Louis XVI's great-aunts, the princesses Adélaïde and Victoire. In 1787 they commissioned a portrait of their sister, Louise-Elisabeth of France, the former Duchess of Parma, who had died of smallpox at age thirty-two, nearly thirty years earlier (plate 36). Completed in 1788, the picture idealizes its subject, who stands on her terrace in a relaxed, graceful pose, dressed in the low-cut and elaborately decorated costume popular in late eighteenth-century France. The jaunty plumes of her hat have a visual parallel in the blue-and-vellow parrot perched on the balustrade, but the

35. Marie-Louise-Elisabeth Vigée-Lebrun (1755–1842) Countess Golovin, 1797–1800 Oil on canvas, 32½ x 26½ in. The Barber Institute of Fine Arts, The University of Birmingham, England

36. Adélaïde Labille-Guiard (1749–1803) Louise-Elisabeth of France, 1788 Oil on canvas, 107 x 63 in. Musée du Louvre, Paris

37. Marie-Guillemine Benoist (1768–1826) Portrait of a Negress, 1800 Oil on canvas, 31% x 25% in. Musée du Louvre, Paris

overall effect of the painting is sad, the duchess's early demise implied by the emphasis on shadows (on the upper part of her face and on the wall to her right), plus the melancholy gaze of her young son.

A very different mood is conveyed by Marie-Guillemine Benoist's powerful likeness of a stunning black woman dressed in white gown and turban (plate 37), which established the artist's reputation when it was exhibited in 1800; the painting was later acquired by Louis XVIII. 17 The child of a government official, Benoist began studying with Vigée-Lebrun in 1791, and her earliest works were pastel portraits that demonstrated her teacher's influence. But the style seen in the 1800 portrait is more closely related to Benoist's second master, the great Neoclassical

painter Jacques-Louis David, whose pupil she had become while Vigée-Lebrun's studio was being renovated. Under the influence of David, Benoist started producing more ambitious works; in the Salon of 1791 she showed two history paintings and for some time continued to paint both histories and dignified portraits such as the one illustrated here, which may have been inspired by a 1794 decree abolishing slavery. Napoleon commissioned Benoist to paint portraits of himself and his family; she received an annual stipend from the government and in 1804 won a gold medal. In the early 1800s Benoist switched to the sentimental scenes of family life that were becoming more popular with middle-class patrons. At the height of her fame she was forced to stop participating in public exhibitions—which effectively ended her career—when her husband, Pierre-Vincent Benoist, was appointed to a high position in the Restoration government.

During the eighteenth century, in addition to portrait miniatures and pastel and oil portraits, three-dimensional portraits became very popular. The English artist Anne Seymour Damer was one of the best-known portrait sculptors of her day, producing bust and full-length works in bronze, marble, and terra-cotta, commissioned by such important patrons as Napoleon and King George III. A well-educated child from a wealthy family, Damer was supposedly goaded into her artistic career by the Scottish philosopher David Hume, who pointed out some plaster figures modeled by a beggar and challenged her to do as well.¹⁹ According to the story, Damer was thus inspired to work in wax and then in marble, going on to study anatomy, modeling, and carving with a succession of male sculptors. At age nineteen she married John Damer, a compulsive gambler and drinker who committed suicide in a London tavern nine years later. During the marriage she had produced little art, but after her husband's death Damer traveled throughout Europe, continuing her studies. Damer produced numerous animal subjects—charming, lifelike works including a marble sculpture of two dogs that her cousin Horace Walpole thought compared favorably with the work of Bernini. 20 At the same time, Damer sculpted widely admired allegorical figures and Neoclassical portrait busts in both marble and bronze (plate 38). Little is known today about the private life of this artist because she specified in her will that all her correspondence be burned. An acknowledged eccentric, Damer further directed that she be buried with her mallet, chisel, apron, and the ashes of her favorite pet dog.

While portraits remained extremely popular in eighteenth-century France and England, at the same time the vogue for genre paintings increased enormously. Some of these were quite sentimental bourgeois scenes but others—notably the works of Françoise Duparc—are relatively straightforward depictions of a group that had traditionally been left out of French art: the working class.

38. Anne Seymour Damer (1748–1828)
Sir Joseph Banks, 1813
Bronze, dimensions unknown
Reproduced by courtesy of the
Trustees of the British Museum,
London

Françoise Duparc was born in Spain to a French father and a Spanish mother. Antoine Duparc was a sculptor from Marseilles, where the family moved when Françoise was four. Although little is certain about Duparc's early education, presumably she was first taught by her father; and there is some evidence that she may have trained briefly with the painter Jean-Baptiste van Loo. Duparc's sister, Josephe-Antonia, also became a professional artist. As an adult, Duparc lived in Paris and London, producing and exhibiting figure paintings, religious subjects, and portraits, but by 1771 she was back in Marseilles, where she became a member of the local Academy. Unlike most French genre pictures of the time, Duparc's neither entertain nor moralize. Instead, influenced by seventeenth-century Dutch genre painting, she portrayed with great dignity the everyday tasks of working-class people—knitting (plate 39), carrying bundles, selling tea. The quiet warmth of her paintings has been compared with the mood created by Jean-Baptiste-Siméon Chardin. 21 Certainly, Duparc's subjects are worlds apart from Vigée-Lebrun's aristocrats.

After the French Revolution there was an upsurge of interest in sentimental domestic paintings. This was due in large measure to the popularity of Jean-Jacques Rousseau's radical notion that middle-class mothers should devote themselves to their children, breast-feeding and educating them themselves rather than relying on wet nurses and other servants, and generally focusing their energies on home and family life. As a result, members of the bourgeoisie became eager to acquire pictures that demonstrated the joys of motherhood and other domestic subjects. Well-known painters of such scenes included Jean-Honoré Fragonard and his sister-in-law and protégé, Marguerite Gérard.

Originally from Grasse, where her father was a perfume distiller, Gérard moved to Paris as a teenager, where she lived with her older sister, Marie-Anne, who was Fragonard's wife.²² Gérard studied with her celebrated relative, making engravings based on his pictures, and she was soon helping him to paint—to what degree is not known. Although she could not join the French Royal Academy (since all four of the places reserved for women artists were already occupied), by the late 1780s Gérard had become quite well known. Her reputation continued to rise in post–Revolutionary France, where she participated in the annual Salon exhibitions through 1824 and earned several medals. By then, in a reversal of her youthful experience, other artists were making engravings of her pictures. In 1805 Napoleon purchased one of her works, a contemporary history painting. Like Mary Cassatt, Gérard is best known today for her sentimental domestic subjects idealizing quiet interaction between young mothers and their children. Gérard's Motherhood (plate 40) is a good illustration of Rousseau's ideal, with an attractive young woman caressing her young child. It is also a typical example of the artist's later style. Whereas Duparc's genre pictures concentrate

39. Françoise Duparc (1726–1778) Woman Knitting, n.d. Oil on canvas, 30% x 25 in. Musée des Beaux-Arts, Marseilles

on a single individual, viewed half-length, in an indeterminate space, Gérard's treat full-length figures, often in groups, placed within detailed settings and imbued with a sense of melodrama.

The highly theatrical genre paintings by Constance Mayer are closer to Gérard's, although they create their own distinctive mood of reverie. Born and raised in Paris, Mayer was trained by J. B. Suvée and later by Jean-Baptiste Greuze, the eighteenth-century French master of sentimental domestic scenes.²³ In addition to genre subjects, Mayer also painted allegories and portraits. Her early work was clearly influenced by Greuze, but her art changed when she met Pierre-Paul Prud'hon in 1802. Although her later pictures remain melodramatic, they are less overtly theatrical and often have allegorical themes. After 1810 Mayer and Prud'hon lived in neighboring apartments at the Sorbonne, ate their

Below

41. Constance Mayer (1775/78–1821)

The Unhappy Mother, n.d.
Oil on canvas, 75% x 56½ in.
Musée du Louvre, Paris

Right 42. Constance Mayer (1775/78–1821) The Happy Mother, n.d. Oil on canvas, 76% x 57¾ in. Musée du Louvre, Paris

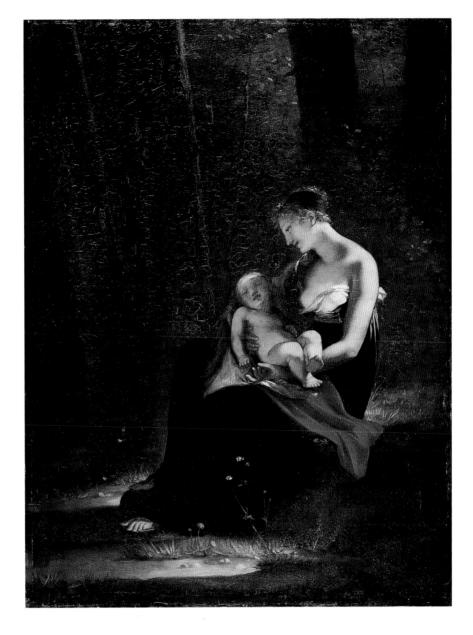

meals together, and collaborated on paintings, which he generally signed. Since many of the works that do bear Mayer's name were painted from Prud'hon's designs, attributions to her are problematic. *The Happy Mother* (plate 42), exhibited in the Salon of 1810, is a sentimental, somewhat erotic scene of a young woman with a classical profile gazing, enraptured, at her sleeping infant, who presumably has just finished nursing. Its companion piece, *The Unhappy Mother* (plate 41), shown the same year, is more overt in its depiction of grief.

On May 27, 1821, Mayer slashed her throat with Prud'hon's razor while he worked in his studio next door. The motivation behind her suicide has long been debated. Beginning in 1818 she suffered periodic bouts of depression, which some scholars believe were caused by the actual or threatened removal from her life of various male mentors.

43. Anne Vallayer-Coster (1744–1818)
Still-life with Round Bottle, 1770
Oil on canvas, 10½ x 12½ in.
Gemäldegalerie, Staatliche Museen
Preussischer Kulturbesitz, Berlin

Her first painting teacher was imprisoned during the Reign of Terror; her second, Greuze, had died in 1805, followed by the death of her beloved father five years later. Prud'hon, who was married and the father of five children, told Mayer that even if his wife died, he would never remarry. Horeover, his children, whom Mayer cared for during Mme. Prud'hon's absence, were unpleasant to her; and her work had been badly received at recent exhibitions. Given all this, Mayer's depression is understandable. On returning from vacation she and Prud'hon were told that all artists had to relinquish their Sorbonne apartments. Although Prud'hon insisted that they could continue to live as they had done, apparently Mayer could not bear to face the future. She left behind at least one pupil, Sophie Duprat, and a number of unfinished pictures, which the grief-stricken Prud'hon completed before his death two years later.

The status of still-life painting in France improved significantly from the seventeenth to the late eighteenth century, largely due to the widely admired works of Chardin. This change in aesthetic climate presumably encouraged the unanimous election of an exceptional twenty-six-year-old still-life artist, Anne Vallayer-Coster, to the French Academy in 1770. Vallayer-Coster's father was a goldsmith who worked for the Gobelin tapestry factory; when Anne was ten, her father opened his own shop in Paris, which her mother ran after his death. There are no records of Vallayer-Coster's early training, but she was painting independent works before she was twenty. Her reputation for still lifes increased steadily after she joined the Academy (Denis Diderot, in particular, admired her work), though reviews of the few portraits she attempted were tepid, or worse. Her still-life subjects were unusually varied: flowers, game, musical instruments, and arrangements of food and table settings ranging from humble meals of bread, wine, and cheese (plate 43) to opulent spreads featuring elegant vases and exotic comestibles such as lobster.25 With the help of her patron, Marie Antoinette, Vallayer-Coster was assigned an apartment at the Louvre in 1781. Despite her royal connections, the painter survived the Revolution, perhaps because of the political neutrality of her subjects. 26

During the eighteenth century women artists invented entirely new genres such as the pastel portrait, stimulated interest in still lifes outside the Low Countries, and helped popularize the Rococo style of painting. Moreover, the trio of female artists who achieved international celebrity paved the way for the remarkable variety of women painters and sculptors who established successful careers in the 1800s.

THE NINETEENTH CENTURY

I honor every woman who has strength enough to step out of the beaten path when she feels that her walk lies in another, strength enough to stand up and be laughed at, if necessary. . . . But in a few years it will not be thought strange that women should be preachers and sculptors, and every one who comes after us will have to bear fewer and fewer blows. —Harriet Hosmer, Daughters of America, 1883

he nineteenth century marks the emergence of far greater numbers of women artists than ever before, working in a wider range of both subjects and styles. Genre pieces increased tremendously in popularity, especially in Victorian England, where the field was well represented by women. Meanwhile, many women artists—a much larger proportion of whom were sculptors than in earlier eras—continued making their living from portraits and still lifes. When the radical style known as Impressionism developed in the 1870s, several of its leading practitioners were female. Women also achieved success in a number of esoteric specialties, notably animal images and battle scenes. At the same time that more opportunities were becoming available to women artists, the pressure to live traditional, domestic lives remained strong. Moreover, their careers were still hampered by lack of access to first-rate education, especially study of the nude model—the cornerstone of Western art training.1 This restrictive attitude toward women art students is illustrated by The Studio of Abel Pujol in 1822, painted by his pupil—and wife—Adrienne-Marie-Louise Grandpierre-Deverzy (plate 45). In this picture the master, Pujol, gives criticism to a student as others continue working from the elegantly dressed female model. The only chance these artists would have been given to learn anatomy would have been to draw the plaster casts of antique sculptures arranged on the shelf at left—just one of which is a nude male torso, modestly turned toward the wall.2

Despite such impediments, women artists continued to grow in both number and stature throughout the 1800s. The situation was particularly intriguing in nineteenth-century England, which underwent a period of tremendous artistic activity during Victoria's reign. The enthusiastic patronage of the queen helped raise the status of English artists, which was further elevated by the great International Exhibitions of 1851 and 1862. Although English painting remained largely self-contained, several elements of it served as inspiration for the great nineteenth-century French painters; Théodore Géricault, Eugène Delacroix, and the Impressionists were all strongly influenced by the paintings of Edwin

44. Eva Gonzalès *The Italian Music Hall Box*, n.d. (detail) See plate 68

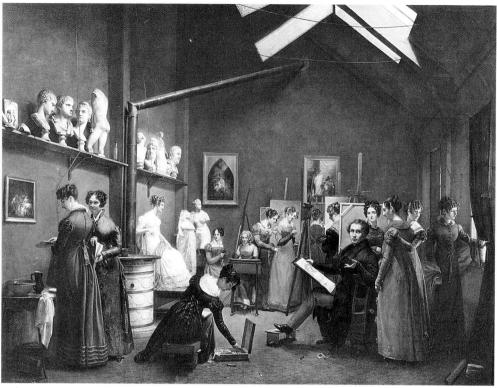

Landseer, John Constable, and Joseph Mallord William Turner. At the same time, English women artists had to contend with some significant obstacles to their careers. For example, although two female painters had helped found the British Royal Academy, women were not eligible to become Academy members during the nineteenth century. Nevertheless, female artists proliferated in that country, as reflected by a picture published in the *Illustrated London News* of November 21, 1885, showing a half-dozen earnest painters busily copying works at the National Gallery (plate 46). In fact, record numbers of nineteenth-century Englishwomen participated in public exhibitions, including those sponsored by the Academy. The most characteristically "Victorian" of their pictures were genre scenes dealing with the same kinds of sentimental subjects—young couples flirting, children playing, ladies having tea, families enjoying outings—with which numerous male Victorian paint-

orous fashion and genteel conversation.

Rolinda's father, James Sharples, was an itinerant portrait painter and inventor whose work took the family away from their native England to live first in Philadelphia and then New York City. Ellen Sharples, Rolinda's mother, had been James's pupil; she assisted her

ers achieved great success. A typical example is Rolinda Sharples's Cloakroom of the Clifton Assembly Rooms (plate 47). Like a Jane Austen novel, this painting is warm and animated, filled with amusing interactions among the various characters and emphasizing the pleasurable aspects of early nineteenth-century English society—a world of glam-

Left
45. Adrienne-Marie-Louise
Grandpierre-Deverzy
(1798–active to 1855)
The Studio of Abel Pujol in 1822
1822
Oil on canvas, 37 k x 50 4 in.
Musée Marmottan, Paris

Below 46. Lady students at the National Gallery, from the Illustrated London News, November 21, 1885

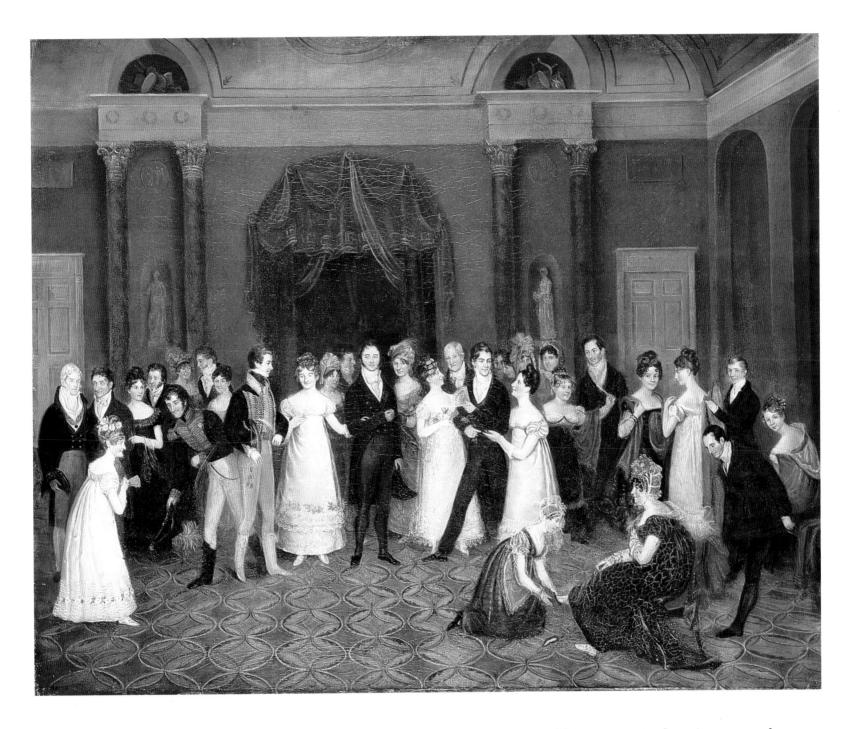

47. Rolinda Sharples (1794–1838) Cloakroom of the Clifton Assembly Rooms, 1817–18 Oil on canvas, 28% x 34¾ in. City of Bristol Museum and Art Gallery, England

husband with his art, making copies of his most popular pictures and executing commissions of her own. When Mr. Sharples died in 1811, Ellen, Rolinda, and James, Jr., returned permanently to England, where all three became established as painters and Mrs. Sharples founded the Bristol Fine Arts Academy. Encouraged by her mother, Rolinda had produced her first commissioned painting at age thirteen. As an adult, she expanded her repertoire to include history and genre subjects as well as watercolor, pastel, and oil portraits. Rolinda exhibited her work at the Royal Academy and in 1827 was made an honorary member of the Society of British Artists.³

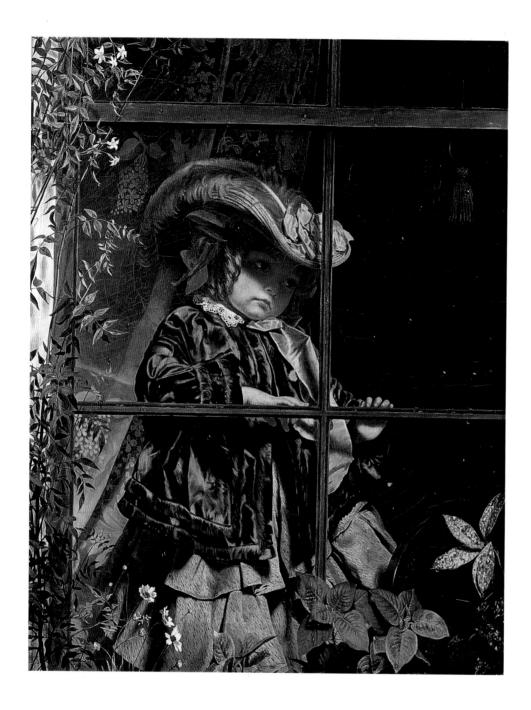

48. Sophie Anderson (1823–1898) No Walk Today, n.d. Oil on canvas, 19¾ x 15¾ in. Private collection

The amusingly melodramatic side of Victorian genre painting is exemplified by Sophie Anderson's No Walk Today (plate 48), in which the close-up of the child's woebegone face exaggerates the seriousness of this small domestic tragedy. The subject gave the artist a chance to show off her technical skill by lovingly portraying the details of costume and foliage. Although she regularly exhibited other genre paintings as well as religious works and scenes from ancient history in the Royal Academy's shows from 1855 through 1896, little is known about Anderson today. Like that of a surprisingly large number of her contemporaries, both male and female, her current reputation rests almost entirely on a single painting.⁴

Addressing a far more serious topic is the genre painting Nameless and Friendless (plate 49), by Emily Mary Osborn. The first child of an Essex clergyman, Osborn moved to London with her family in 1848. There she began to study art and by age seventeen was exhibiting at the Royal Academy, which she continued to do, with considerable success. for the next thirty years. Although she made a great deal of money from her portraits⁵ and occasionally depicted literary subjects, Osborn was primarily a genre painter. She won several medals for her genre pictures, at least two of which were purchased by Queen Victoria. Nameless and Friendless, Osborn's best-known work, makes a strong statement about the perils of being poor—particularly a poor woman. In her analysis of this work, Linda Nochlin points out that the heroine's clothing identifies her as an unmarried orphan, dependent for her income on the opinion of the prosperous art dealer at right, who is studying her painting.⁶ Nochlin notes how certain details in the picture underscore the pathos of the story it tells: The day is dark and rainy; the woman, nervously twisting a string in her hands, is not considered important enough to be

49. Emily Mary Osborn (1834-?) Nameless and Friendless, 1857 Oil on canvas, 34 x 44 in. Private collection

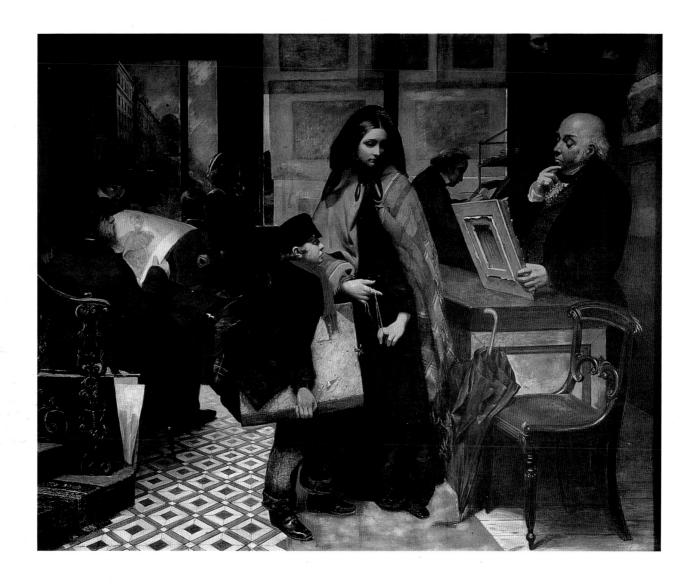

invited to sit in the empty chair beside the dealer; moreover, she must endure the curious glances of the two well-dressed male customers ogling a print of a scantily clad dancing girl.

While women artists were recorded in the New World before the nineteenth century, most of them were folk artists whose works remain largely anonymous. Many of the others—such as English-born Henrietta Johnston, who produced rather primitive pastel portraits, and Patience Lovell Wright,⁷ a sculptor of portraits in wax—had only limited training. Little is known about these pioneers, and little of their art survives.⁸

It was during the nineteenth century that American women artists came into their own as successful professional painters and sculptors of various subjects in diverse styles. One of the closest American parallels to Victorian genre painting is the art of Lilly Martin Spencer. Born in England of French parents who emigrated to the United States in 1830, Spencer was raised in a politically progressive household that supported abolition and women's suffrage. 9 As a teenager, Lilly executed her first important project—painting portraits of her parents and two brothers on the walls of their farmhouse in Marietta, Ohio. This unusual form of decoration attracted considerable attention, including the interest of the art patron Nicholas Longworth, who offered to send Lilly either to the East or to Europe for further training. She refused his offer, remaining largely self-taught. ¹⁰ In 1841 Lilly moved to Cincinnati, a cosmopolitan city where she participated in numerous exhibitions and studied briefly with a local portraitist. Three years later she married the English painter Benjamin Rush Spencer, who devoted himself to managing her career and taking care of their seven surviving children.

Although she never made much money and was always struggling to keep the family going, Spencer became an extremely popular painter, producing still lifes, allegories, and literary pictures, and achieving particular success with her humorous domestic subjects. Beginning in the 1850s she specialized in scenes based on a housewife's daily routine—cooking, doing laundry, playing with the children. Many of these subjects—women wiping their eyes as they peel onions or gleefully extending their flour-covered hands in greeting—convey the broad humor characteristic of much contemporary English painting. In the late 1860s Spencer was commissioned by Richard B. Connally, comptroller general of New York, to paint four full-length portraits of his family members. We Both Must Fade (plate 50) is the only one of these pictures still extant, though all of them were exhibited in the Women's Pavilion at the Philadelphia Centennial Exposition of 1876. Based on the vanitas pictures of seventeenth-century Holland, in which luxurious still-life objects are juxtaposed with reminders of mortality, this picture makes a statement about the transience of youth, beauty, and life by juxtaposing a lavishly dressed young woman with a timepiece and a wilting flower.

50. Lilly Martin Spencer (1822–1902)
We Both Must Fade (Mrs. Fithian), 1869
Oil on canvas, 71 % x 53 ¼ in.
National Museum of American
Art, Smithsonian Institution,
Washington, D.C.;
Museum Purchase

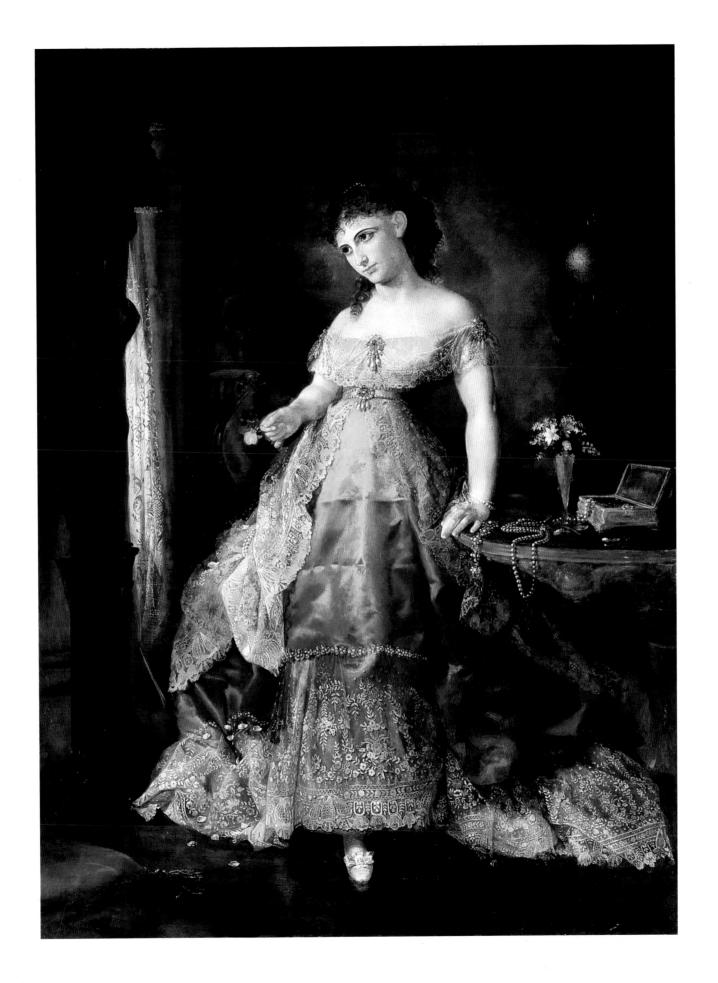

In addition to genre scenes, nineteenth-century American women artists excelled at painting still lifes. One such specialist was Margaretta Angelica Peale, who was a founding member of the Pennsylvania Academy of the Fine Arts and part of the dynasty of American artists established in Philadelphia by her uncle, Charles Willson Peale, the eighteenth-century painter, naturalist, and entrepreneur. Many of his seventeen children, named after distinguished European artists (including Angelica Kauffmann, Sofonisba Anguissola, and Rosalba Carriera), themselves became painters. His brother James had five surviving daughters, four of whom painted, despite their more commonplace names (Maria, Anna Claypoole, Margaretta Angelica, and Sarah Miriam). All of her sisters painted still lifes, but only Margaretta Angelica specialized in them (plate 51).

Margaretta Angelica's youngest sister, Sarah Miriam, was the most successful female painter in the Peale family, producing still lifes and full-size portraits. In 1825 she moved from Philadelphia to Baltimore and became that city's leading portraitist. Her distinguished sitters included Daniel Webster, the Marquis de Lafayette (to whom she wrote to secure a commission when she discovered he was planning to visit the United States), and many other dignitaries. Her portrait of the long-time senator from Missouri Thomas Hart Benton is typical of the work she produced during the early 1840s. ¹¹ At age forty-six Peale settled in Saint Louis, where her portraits were equally successful.

Relow

51. Margaretta Angelica Peale (1795–1882)
Still Life with Watermelon and Peaches, 1828
Oil on canvas, 13 x 19½ in.
Smith College Museum of Art,
Northampton, Massachusetts;
Purchased with funds given anonymously by a member of the class of 1952

Right
52. Sarah Miriam Peale
(1800–1885)
Senator Thomas Hart Benton, 1842
Oil on canvas, 30 x 25 in.
Missouri Historical Society,
Saint Louis

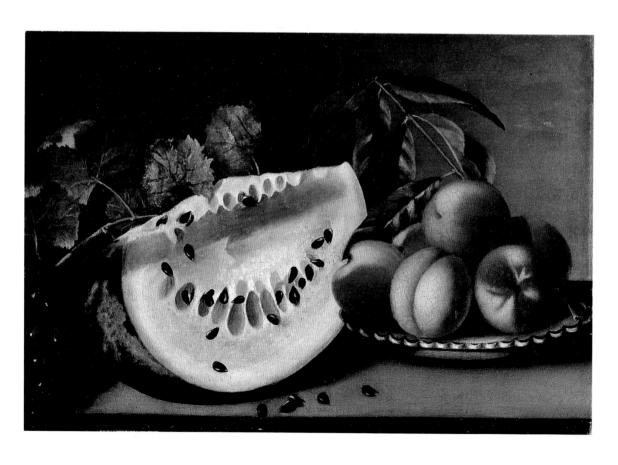

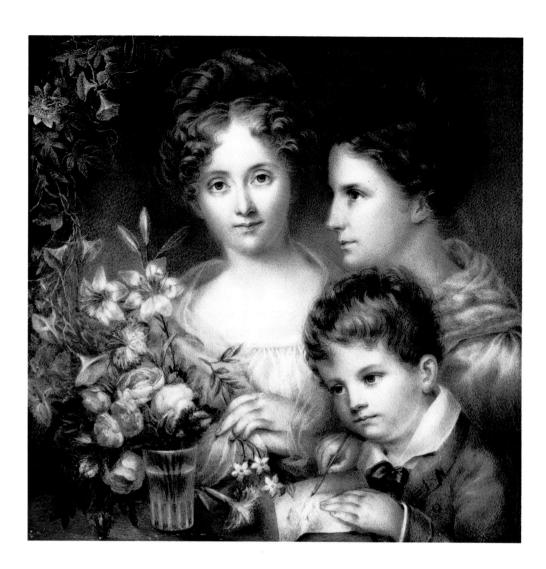

53. Ann Hall (1792–1863) Ann Hall, Mrs. Henry Ward, and Henry Hall Ward, 1828 Miniature on ivory, 4 x 4 in. The New-York Historical Society

Ann Hall was greatly admired for her delicately painted group miniatures, which often combined several kinds of subject matter. For example, the picture illustrated here (plate 53) includes a self-portrait plus likenesses of the artist's sister and young nephew, as well as flowers—one of her favorite subjects from early childhood. Born in Connecticut, Hall studied oil painting briefly but decided to devote herself to miniatures. Her works sold extremely well and were favorably compared with portraits by Joshua Reynolds and Thomas Lawrence. In 1827 she became the first woman admitted to the National Academy of Design.

A particularly sumptuous European setting is depicted by the French painter Marie-Eléonore Godefroid in *The Sons of Marshal Ney* (plate 54). She literally grew up in the Louvre, where her father, the painter François-Ferdinand-Joseph Godefroid, had an apartment, and she first made a living by teaching drawing at an exclusive boarding school for girls. Beginning in 1805, however, Godefroid worked in the studio of Baron François Gérard, assisting with his Romantic history, religious, allegorical, and portrait paintings and developing her own

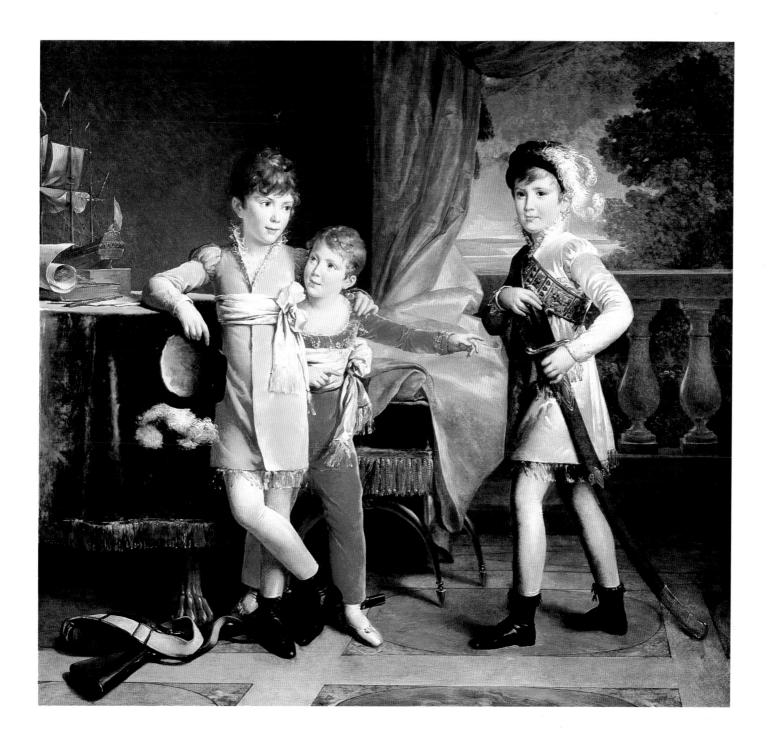

54. Marie-Eléonore Godefroid (1778–1849)

The Sons of Marshal Ney, 1810
Oil on canvas, 63¾ x 70⅓ in.
Gemäldegalerie,
Staatliche Museen
Preussischer Kulturbesitz,
Berlin

highly successful career as a portraitist. Godefroid specialized in pictures of socially prominent women and their children. In the example shown here, the boys' lavish clothing—plumed hats, fringed tunics, and the rest—fits in with the well-appointed interior. The artist has created additional visual interest by framing two of the children's heads against a plain dark wall, while the third is placed before a distant landscape view. The objects in the painting—a model ship, a rifle, and an elaborately decorated sword—presumably refer to the occupation of their father, a celebrated military leader. 12

"The number of women who have acquired celebrity in the art of painting is large; but half a score would probably include all the names of those who have achieved greatness in sculpture. . . . The palette, the pencil, and colors fall naturally to their hands; but mallets and chisels are weighty and painful implements, and masses of wet clay, blocks of marble, and castings of bronze are rude and intractable materials for feminine labors." ¹³

The tremendous increase in the number of professional women painters during the nineteenth century has already been noted. Even more remarkable is the emergence of a great many significant female sculptors within the same period. Of course, women sculptors had existed well before the nineteenth century. We have seen works by the sixteenth-century sculptor Properzia de' Rossi, by her seventeenthcentury counterpart Luisa Roldán, and by Anne Seymour Damer in the eighteenth century. But generally speaking, women were less inclined to pursue careers in sculpture than in painting because of a whole host of difficulties, not the least of which was the prevailing attitude that sculpture was an unsuitable occupation for a woman, as expressed in the comment by the Reverend R. B. Thurston quoted above. Moreover, the study of anatomy—particularly the nude model, which was still largely inaccessible to women—was essential for nineteenth-century sculptors, whose subjects almost invariably centered on the human figure. Sculpture is a more expensive undertaking than painting, too, which increased men's hesitation to entrust major commissions to women. And the mechanics of producing large-scale sculpture, requiring sizable workshops with numerous assistants and specialized equipment, also made such commissions difficult for female artists to obtain. In view of these limitations, the proliferation of nineteenth-century women sculptors is even more impressive, for French, American, and German women, among others, began producing not merely portrait busts but also tomb and fountain sculptures, multifigure historical scenes, and many other subjects.

At the height of the international vogue for Neoclassical art, there appeared in Rome a group of American expatriate sculptors, all women, that Henry James labeled "the white, marmorean flock," referring to the marble that was their preferred medium. One of the youngest members of this group was a highly successful sculptor who first encountered sculpture in her mid-thirties, having initially been a poet. Anne Whitney was born in Watertown, Massachusetts, to a wealthy family; she studied sculpture in New York and Philadelphia. Her liberal politics are apparent from her subjects, including portraits of the abolitionist leader William Lloyd Garrison and the suffragist Lucy Stone. After spending time in Rome, Whitney returned to the United States in 1871, where she continued working. Her last major piece was a heroic bronze statue of the abolitionist senator Charles Sumner (plate 55), in Harvard

Bronze, dimensions unknown Harvard Square, Cambridge, Massachusetts

Far right
56. Harriet Hosmer (1830–1908)

Zenobia in Chains, 1859

55. Anne Whitney (1821–1915)

Charles Sumner, n.d.

Right

Marble, height: 49 in.
Wadsworth Atheneum, Hartford,
Connecticut; Gift of

Mrs. Josephine M. L. Dodge

Square. Whitney completed *Sumner* independently, twenty-seven years after she had won the competition for that commission and then lost it when the Boston Art Committee discovered that she was a woman.

Another Watertown native, Harriet Hosmer, was a particularly interesting member of the American expatriate group. Because her mother and siblings had all died of tuberculosis, her father, a physician, raised her to be physically active, in the hope that she would escape a similar fate. She grew up healthy but decidedly unconventional, determined to become a sculptor. After attending a liberal private school in Lenox, Massachusetts, Hosmer was helped by Dr. Wayman Crow to enroll in the Medical School of Saint Louis, where she studied anatomy. In 1852, accompanied by her father, Hosmer went to Rome, where she trained with an English sculptor, John Gibson, and established herself as a major Neoclassical artist. Hosmer's most popular work

was *Puck* (1856), a charming image of a mischievous winged child seated on a toadstool and playing with beetles and lizards. The Prince of Wales purchased *Puck*, and Hosmer sold thirty more reproductions of the statue, amassing a tidy sum. But her most important sculpture was *Zenobia in Chains* (plate 56), based on the story of an ancient queen of Palmyra who was captured by enemy forces. This large-scale marble figure has the blank eyes, regular features, and dignified bearing of an ancient Greek statue, and the details of her sandals, crown, and chains are skillfully rendered.

By the time Emma Stebbins joined the group of expatriate sculptors she had already established a successful career working in oils, watercolor, and pastel and had even been elected an Associate of the National Academy of Design. When she went to Rome in 1857, the New York–born artist followed Hosmer's lead in studying with John Gibson. Stebbins also met Charlotte Cushman, an American actress and singer who had established a successful international career and who was largely responsible for inspiring the expatriate women sculptors to make their headquarters in Rome. The two women became close friends, and when Cushman died, Stebbins compiled her letters and biography, publishing them in 1878. Stebbins made marble and bronze portrait busts and full-length figures. Her most celebrated work is the large Neoclassical fountain sculpture *Angel of the Waters* (plate 58), in New York's Central Park.

Most remarkable of all the expatriate sculptors was Edmonia Lewis (plate 57). ¹⁶ Born near Albany, New York, to a Chippewa Indian mother and a black father, Lewis had to deal with racial prejudice in addition to all the other problems facing any nineteenth-century American woman without financial resources who wanted to be a professional sculptor. Orphaned as a child, Lewis was raised by two Indian aunts. Her brother, a successful gold miner in California, financed her early education, and in 1859 she entered Oberlin College in Ohio, the first American institution of higher learning to admit women of all races. ¹⁷ Her Oberlin experience ended tragically, however, when she was accused in 1862 of poisoning two of her white schoolmates. Although they recovered, and she was acquitted, Lewis was badly beaten by an angry mob before her trial.

Lewis moved to Boston, where William Lloyd Garrison arranged for her to study sculpture. Her portrait bust of Robert Gould Shaw, leader of a black Civil War regiment, was extremely popular, and the money she made by selling copies of it enabled Lewis to go to Rome in 1865. There she met Hosmer, and through her became a student of John Gibson. Soon Lewis attracted a number of patrons. She carved many portrait busts and playful cupids, plus statues of Hagar, Hygeia, a Madonna and Child, and several works relating to her dual heritage—such as *Forever Free*, a celebration of the end of slavery, and *The Old*

57. Edmonia Lewis, Chicago, 1870

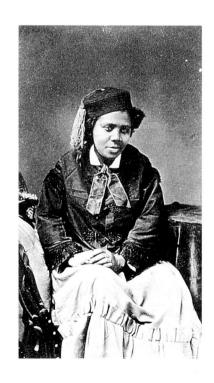

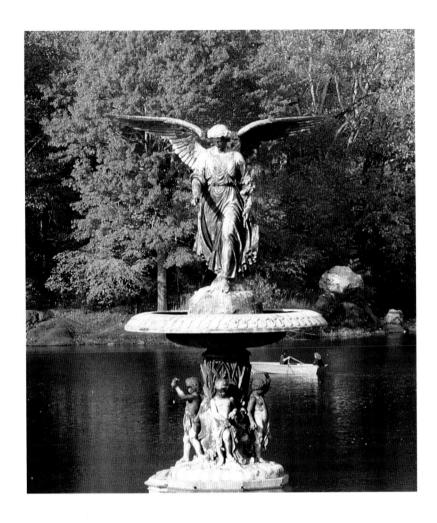

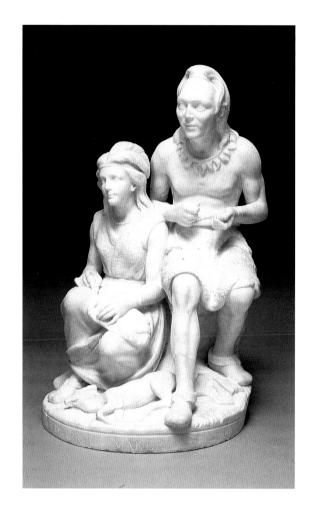

Above, left 58. Emma Stebbins (1815–1882) Angel of the Waters, constructed 1868, unveiled 1873 Bronze, height of angel: 8 ft. Central Park, New York

Above, right
59. Edmonia Lewis
(1845–after 1911)
The Old Indian Arrowmaker
and His Daughter, c. 1872
Marble, 21½ x 13½ x 13½ in.
National Museum of American
Art, Smithsonian Institution,
Washington, D.C.; Transfer from
National Museum of African Art,
Gift of Norman Robbins

Indian Arrowmaker and His Daughter (plate 59). Lewis's best-known work in her lifetime was the Death of Cleopatra, a twelve-foot-tall sculpture weighing two tons that took four years to execute. Exhibited at the 1876 Centennial, Cleopatra was called "the grandest statue in the exposition." Today it is one of her many lost works. Little is known of Lewis after 1885, though records indicate that she was still alive in 1911.

Vinnie Ream Hoxie was the first woman to receive a United States government commission for sculpture, at the tender age of fifteen. ¹⁹ Her full-length statue of Abraham Lincoln (plate 60), unveiled in 1871, still stands in the Capitol Rotunda. Hoxie was born in Madison, Wisconsin, but soon moved with her family to Washington, D.C. She studied sculpture there and later in Paris, becoming a successful portraitist whose sitters ranged from Franz Liszt and Gustave Doré to Ulysses S. Grant and Horace Greeley. In addition, Hoxie produced many Neoclassical history subjects and allegories. But her most impressive works are monumental public commissions, including *Abraham Lincoln* (based on a bust she had modeled from life shortly before the president's assassination) and several other heroic statues located in Washington, D.C., Oklahoma, and elsewhere. In 1878 she married Richard Hoxie, a prominent military figure. As her family and social obligations increased,

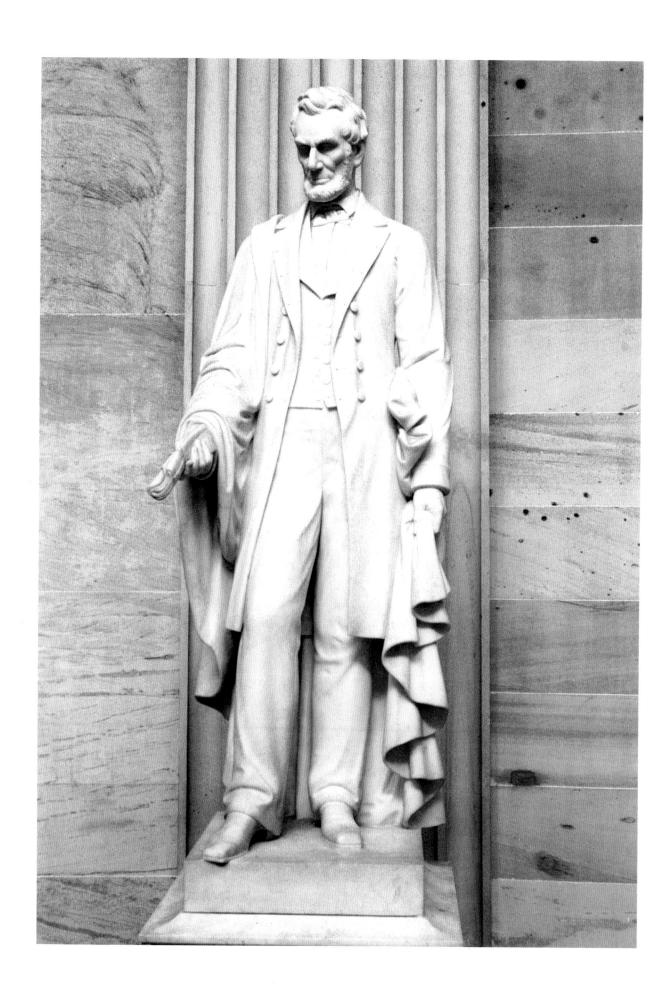

Below 61. Elisabet Ney, 1860

Right
62. Elisabet Ney (1833–1907)
Arthur Schopenhauer, 1859
Marble, 19½ x 18½ x 11 in.
Elisabet Ney Museum,
Austin, Texas

her artistic output diminished, and Hoxie soon gave up sculpture except for two projects at the very end of her life.

One of the best-known early nineteenth-century women sculptors outside this group of Americans was the German Elisabet Ney (plate 61). A distant relative of Marshal Ney, Elisabet was celebrated for her portrait busts, including likenesses of King George V, Otto von Bismarck, Giuseppe Garibaldi, and the philosopher Arthur Schopenhauer (plate 62).²⁰ Her first teacher was her father, a sculptor of religious subiects in Westphalia. At nineteen she entered the Academy of Fine Arts in Munich, and two years later studied with Christian Rauch, a leading German sculptor. Although well established as an independent artist by the late 1850s, Nev had to overcome considerable reluctance on Schopenhauer's part to convince him to pose. While not flattering, her bust presents an intellectually lively, intense, even intimidating, older man.²¹ In 1863 Nev married Edmund Montgomery, a Scottish scientist and writer, with whom she lived first in Germany, then in the United States in Georgia, and finally in Austin, Texas, where Ney continued producing portraits of important leaders and where the Nev Museum is now located.

Of the numerous women who developed successful careers portraying animals during the nineteenth century, Rosa Bonheur was probably the best known; she was the first woman artist to receive the cross of the Legion of Honor, presented to her by the empress Eugénie in 1865. It was almost inevitable that Bonheur would become an artist: her mother had studied with Rosa's father, Raymond Bonheur, a landscape painter in Bordeaux, and all three of her younger siblings also became artists specializing in animal subjects.²² Trained principally by her father, Bonheur was interested in painting and sculpting animals from an early age. When her parents moved to Paris in 1820, she began spending hours sketching in the Bois de Boulogne. Bonheur's personal appearance and mannerisms have received much comment; going against the prevailing norms for women, she cropped her hair short, wore "men's clothing" (that is, trousers, for which she needed police permits that had to be renewed every six months), smoked cigarettes. and rode horses astride rather than sidesaddle. She never married, living successively with two female companions, both painters: Nathalie Micas and, after her death in 1889, Anna Klumpke, an American who became Bonheur's sole heir.

Concerned about anatomical accuracy in her art, Bonheur visited slaughterhouses, dissected animal parts obtained from butcher shops, and attended horse fairs and cattle markets—another reason for her choice of attire. Her first Salon entries, of animals at work, were well received. In particular, *Ploughing in Nivernais*, a government commission exhibited in the 1849 Salon, attracted praise.²³ But her masterpiece is certainly The Horse Fair (plate 63), an enormous canvas that was the hit of the 1853 Salon. Set at a horse market that Bonheur had begun visiting two years earlier, The Horse Fair emphasizes motion, calling to mind the procession on the Parthenon frieze and Géricault's Romantic pictures of horses. Delacroix admired this painting, as did Emperor Napoleon III. Lithographs of it made Bonheur famous throughout France, England, and the United States, where she was called "the world's greatest animal painter." When the painting went on tour in England, Queen Victoria had it brought to Windsor Castle for a private viewing, attracting even more attention to the work. Bonheur herself took a highly successful trip through England, where she was hailed as "the French Landseer," after the noted English animal painter.²⁴

Back in France, in 1860 Bonheur purchased the Château de By, near the edge of Fontainebleau Forest, where she lived out her days with a menagerie of exotic creatures, including lions, gazelles, Icelandic ponies, yaks, and the more usual European farm animals (plate 64). Although her status declined in France toward the end of the century as fashions in painting changed, Bonheur continued to receive many awards: medals were struck and songs were written in her honor, and Buffalo Bill, touring France with his well-publicized Wild West troupe,

Above
63. Rosa Bonheur (1822–1899)
The Horse Fair, 1853–55
Oil on canvas,
8 ft. 1/4 in. x 16 ft. 1 in.
The Metropolitan Museum of Art,
New York; Gift of Cornelius
Vanderbilt

Right 64. Rosa Bonheur with Fathma (her pet lioness) at Château de By, France, c. 1885

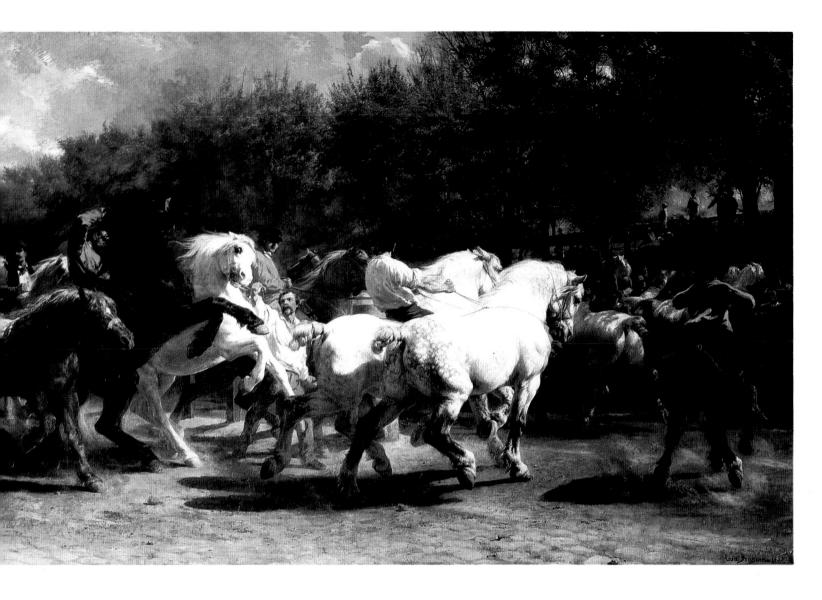

came to visit, presenting her with two mustangs from his Wyoming cattle ranch, a gift she particularly valued.

A specialty even more unusual for a woman artist than animal subjects was the battle scenes painted with phenomenal success by Elizabeth Thompson, later known as Lady Butler. Born in Switzerland to British parents, she spent her early years traveling with her family and studying art in Italy and later England. Butler's mother was a noted pianist and watercolor painter, her father a wealthy connoisseur who encouraged his two daughters to develop their own careers.²⁵

In 1874, the second year she exhibited at the Royal Academy, Butler caused a sensation with her most famous work, *Calling the Roll after an Engagement*, *Crimea* (plate 65). This monumental painting, with its simple spatial planes and myriad figures, was praised for its ambition, energy, and accuracy of detail, as were all of Butler's many military subjects. To guarantee the veracity of her paintings, Butler typically had authentic uniforms re-created and worn by specially hired

platoons of soldiers who assembled and fired their cannons on cue; once she even purchased a field of rye and had it trampled by horses to simulate the effect of a particular skirmish. ²⁶ Butler may also have used photographs as a tool for her art, and many writers have compared her elaborate preparations to those of a motion-picture director. The Royal

65. Lady Elizabeth Butler (1850–1933)
Calling the Roll after an Engagement, Crimea, 1874
Oil on canvas, 36 x 72 in.
Copyright reserved to
Her Majesty Queen Elizabeth II

Academy's hanging committee was so impressed by Calling the Roll that they put it in the place of honor, where its lifelike qualities supposedly brought tears to many viewers' eyes. Queen Victoria, again, arranged a private viewing of the picture, this time at Buckingham Palace, and when the exhibition opened to the public, extra policemen had to be

hired to control the crowds. Having wisely kept the copyright of the painting, Butler acquired both widespread fame and considerable wealth from the sale of the rights to engrave it.

One of the most revolutionary movements in nineteenth-century painting was Impressionism, which challenged traditional French academic ideas about art with a new way of seeing and depicting the world. Two members of the core group of Impressionist painters, Berthe Morisot and Mary Cassatt, were women. And a third woman, Eva Gonzalès, was closely allied to Edouard Manet, an important precursor of Impressionism.

Gonzalès grew up in an environment that valued the arts; her father, Emmanuel Gonzalès, a Frenchman of Spanish extraction, was a well-known novelist, and her mother, an accomplished musician. At age sixteen Gonzalès started studying with the fashionable academic painter Charles Chaplin, who also briefly taught Cassatt. But the strongest influence on her work clearly came from Manet, whom she met in 1869 and whose student, model (plate 66), and friend she quickly became. Gonzalès first exhibited at the Salon in 1870 and continued to do so thereafter; her works received generally good reviews, and her reputation extended beyond France to England and Belgium. Four years after her marriage to Henri Guérard, an engraver, Gonzalès had a son. She died suddenly that same year, only thirty-four years old.

Although many of Gonzalès's subjects, such as theatergoers and young women relaxing outdoors, were also favored by the Impressionists, her style was not Impressionist. Rather, her pictures resemble Manet's early "Spanish" paintings, featuring a dark, restricted palette; strong contrasts of light and dark; a creamy quality to the pigment; solid, clearly defined forms; and a hint of mystery tingeing the relationships among many of her figures (plate 68).

In contrast, the French Impressionist painter Berthe Morisot used much lighter colors and loose, undisguised brushstrokes (plate 69). Whereas Gonzalès basically followed the lead of her mentor, Manet, Morisot was in the forefront of the Impressionists' fight to change the very nature of painting. Although Gonzalès and Manet made their mark through the annual Salons, after her first ten years of showing there Morisot vowed never again to participate in those conservative exhibitions. Morisot, too, was a close friend of Manet, whom she met in 1868. He used her as a model on several occasions, and in 1874 she married his younger brother, Eugène.²⁷

Morisot came from a well-to-do, artistically inclined French family that moved to Paris when she was seven. ²⁸ She was the youngest of three daughters, another of whom, Edma, also studied art from child-hood (plate 67). The two sisters worked with several conservative painters but were particularly inspired by Jean-Baptiste-Camille Corot, whom they met in 1861. He encouraged them to paint landscapes outdoors

Below 66. Edouard Manet (1832–1883) Eva Gonzalès, 1870 Oil on canvas, 75½ x 52½ in. The National Gallery, London

Bottom 67. Edma Morisot (1839–1921) Berthe Morisot Painting, 1863 Oil on canvas, 39% x 27¹⁵/16 in. Yves Rouart

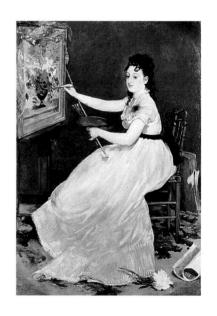

68. Eva Gonzalès (1849–1883) The Italian Music Hall Box, n.d. Oil on canvas, 38½ x 51 in. Musée du Louvre, Paris

Left
69. Berthe Morisot
(1841–1895)
Young Girl by
the Window, 1878
Oil on canvas,
29¹⁵/16 x 24 in.
Musée Fabre,
Montpellier, France

Right
70. Mary Cassatt
(1844–1926)
Lydia in a Loge,
Wearing a Pearl
Necklace, 1879
Oil on canvas,
31½ x 23 in.
Philadelphia Museum
of Art; Bequest
of Charlotte
Dorrance Wright

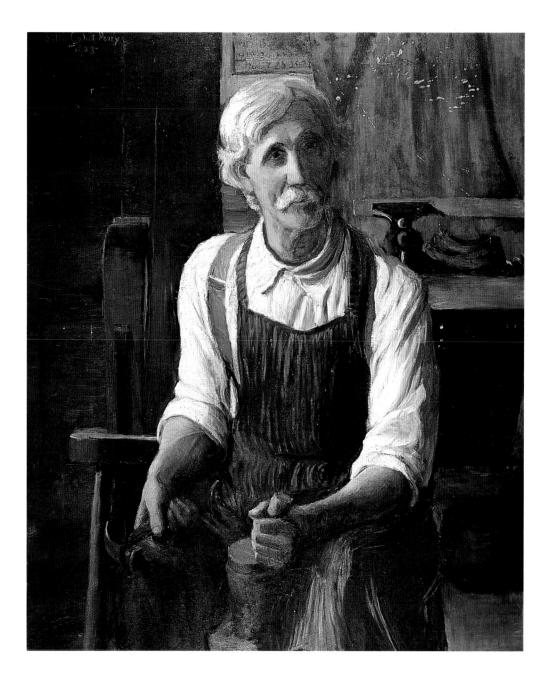

father's profitable business as a Louisiana coal merchant was ruined. Her mother's death in 1865 was followed six years later by the death of her father. Turner, then barely into her teens, was raised by an uncle in New Orleans, where she first became interested in art. After teaching at a girls' school in Dallas, Turner moved to New York, where she studied for four years at the Art Students League; she also took classes at Cooper Union and Columbia University. From 1902 to 1919 she taught art at the local YWCA, while producing and exhibiting her own paintings. In 1921 Turner became the third woman to be elected to full Academician status by the National Academy of Design.

Turner's early works were portrait miniatures, but beginning in 1910 she concentrated on full-size oils, generally featuring individual

painting, and the reflective surface of a mirror behind her is emphasized. Also typically Impressionist is the looseness of the strokes used to sketch in Lydia's gown and the members of the audience seated behind her.

Cassatt, who remained single, used many of her relatives and their young children as models. Although she has become famous as the painter par excellence of mother-and-child scenes, which she painted with remarkably fresh tenderness, Cassatt's range extends well beyond this one subject. She also produced many portraits and genre scenes, a large mural for the 1893 World's Columbian Exposition in Chicago, and several exquisite series of color etchings—of women dressing, arranging their hair, writing letters—that clearly show the influence of Japanese woodblock prints, which had become a major source of inspiration for both French and American artists. Like her friend Degas, Cassatt suffered from a serious deterioration of her eyesight in later years and was forced to stop painting in 1914; she died of diabetes twelve years later. Although the American art world was slow to appreciate Cassatt, she was made a chevalier of the Legion of Honor by the French government in 1904, an impressive honor, especially for a foreigner.

Impressionism also had a strong impact on the work of several other late nineteenth-century American women artists, including Lilla Cabot Perry, who painted landscapes, figures, and other subjects. Born to a prominent Boston family, she was well educated and familiar with many aspects of the arts. In 1874 she married Thomas Sergeant Perry, a professor of eighteenth-century English literature; they later spent several years in Japan, where he taught at Tokyo's Keiogijiku College. Perry studied painting in Boston and Paris, but the greatest influence on her work came from the Impressionist Claude Monet, whom she met in 1889. For ten summers the Perrys lived in a house next door to Monet's at Giverny. The French master did not take pupils, but he sometimes gave her advice, which formed the basis for Reminiscences, a book she published in 1927; she also published four volumes of poetry. Some of Perry's landscapes, notably her Haystacks, Giverny, make clear references to Monet's late series in both their subjects and their dematerialized, color-infused style.30 But other pictures, like the one illustrated here (plate 72), are much more solid and detailed. Even the latter, however, retain the informal, candid composition and light-filled atmosphere characteristic of French Impressionism. Like Cassatt, Perry was an influential promoter of Impressionism in the United States.

The theme of women reading in well-appointed domestic interiors can be traced back at least as far as Jan Vermeer, but it was particularly popular during the nineteenth century.³¹ Helen M. Turner explored this subject in *Morning News* (plate 74), using the bright colors and loose, painterly brushstrokes she adopted from the Impressionists. Turner's early years were tragically affected by the Civil War: her eldest brother was killed, several of the family's houses were burned, and her

rather than following the accepted academic practice of finishing such pictures inside the studio. When Edma married a naval officer in 1869, she stopped painting. But Berthe continued, participating in all but one of the Impressionist group shows,²⁹ despite receiving the same, generally negative critical responses as her Impressionist colleagues and despite her lack of commercial success. Her unwavering dedication to Impressionism eventually stimulated Manet's interest in the style, which became evident in his late work. Morisot produced Impressionist still lifes, landscapes, and scenes of women in various settings—standing by a dining-room table, peering into a baby's cradle, looking out a window. All are characterized by a lively sense of spontaneity in both pose and brushwork.

Like Gonzalès and Morisot, Mary Cassatt came from an uppermiddle-class family, but her background differed from theirs in two significant respects: her parents were not especially interested in the arts, and she was American. Born in Pittsburgh, Cassatt was enthusiastic about painting from an early age. She became familiar with Europe quite young as a result of the family trips around the Continent that were de rigueur for Americans of a certain social standing. When she decided, against her parents' wishes, to pursue a career in art, Cassatt first spent four years studying at the Pennsylvania Academy of the Fine Arts. Then, like most American artists of the day, she went for further training to Paris, considered the principal center of the international art world. Unlike most of her compatriots, however, Cassatt settled in Paris for most of her long life.

By the early 1870s Cassatt was exhibiting at the National Academy of Design in New York and at the annual Paris Salon. Influenced by Manet and rather dark, her work from this period resembles that of Gonzalès. But Cassatt soon became intrigued by the French Impressionists, and when Edgar Degas invited her to join their group exhibition for 1879, she did so eagerly. Cassatt participated in four of the five remaining Impressionist group shows and encouraged her wealthy American friends to purchase Impressionist paintings (collections that she helped to shape later formed the cores of many of the great museum holdings of Impressionist pictures in this country).

Despite his notoriously cranky temperament, Degas and Cassatt became close friends. He painted her portrait (plate 71), and her work was clearly influenced by his, in terms of subject and composition. For example, *Lydia in a Loge*, *Wearing a Pearl Necklace* (plate 70) depicts an evening at the theater, one of Degas's favorite themes. Here Cassatt's elder sister—who, along with their parents, had come to live with her in Paris—is shown in an informal pose, twisting to one side as she looks toward the stage, colored light playing on her bare shoulders and bright hair. The typical Impressionist "snapshot" composition is in evidence here: one of Lydia's arms is casually cut off by the edge of the

71. Edgar Degas (1834–1917)

Mary Cassatt, c. 1880–84
Oil on canvas, 28½ x 23½ in.

National Portrait Gallery,

Smithsonian Institution,

Washington, D.C.; Gift of the

Morris and G. Cafritz Foundation
and the Regents' Major

Acquisitions Fund

Left
72. Lilla Cabot Perry (1848–1933)
The Old Cobbler, n.d.
Oil on canvas, 33¼ x 39¾ in.
The National Museum of Women in the Arts, Washington, D.C.;
Gift of Elizabeth S. Lyon

Below

73. Helen Turner in front of "Takusan," her Cragsmoor home, c. 1912

Right

74. Helen M. Turner (1858–1958) Morning News, 1915 Oil on canvas, 16 x 14 in. Jersey City Museum, Jersey City, New Jersey

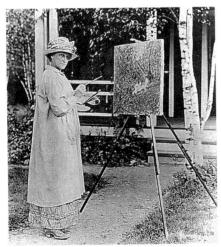

female figures, often in lush, flower-filled outdoor settings. Never married, she lived with one of her sisters, who managed the household. Starting in 1906 Turner spent summers at Cragsmoor (plate 73), an art colony in the mountains of upstate New York. She built a summer home there in 1910 and used it every year until ill health forced her to sell it in 1941. Turner spent her last thirty years back in New Orleans, where she died at the age of ninety-nine.

Portraiture, the art form to which most women had been restricted in earlier times, remained the choice of many late nineteenth-century painters and sculptors, since the market for likenesses was still strong. The American painter Cecilia Beaux (plate 75) specialized in figure studies, generally using her family and friends as models. Some

of her best-known works, such as *The Man with a Cat* and *A New England Woman*, ³² feature sun-drenched rooms; these studies in light explore the many shades of white in her sitters' clothing and the way those whites are affected by reflected colors. Clearly, such pictures owe much to the stylistic experimentation of the Impressionists. *After the Meeting* (plate 76) shows another side of Beaux's art. Here the artist's friend Dorothy Gilder gestures animatedly, her gloved hands making a stark contrast against the dark wall and floral-patterned chair. The lightness of her face and the darkness of her hair form a dramatic series of abstract shapes, further accented by the emphatic stripes of her dress. The painting reveals a complicated series of spatial planes and has the lively, intimate quality of a candid photograph that catches the subject in mid-action.

Born in Philadelphia, Beaux was raised by her grandmother and aunts after her mother's early death.³³ Encouraged to pursue her interest in art, Beaux studied with several local painters and participated in her first group exhibitions during the late 1870s. Her pictures won awards and enthusiastic reviews from the start. After several years spent working in Europe she began teaching at the Pennsylvania Academy of the Fine Arts in 1895. Soon thereafter she settled in New York, where she became a popular portraitist whose sitters included many prominent political and artistic figures. She traveled widely, lectured often, and published her autobiography, *Background with Figures*, in 1930.

Whereas Beaux's art received widespread recognition during her lifetime, the award-winning portraits by Susan Macdowell Eakins were first exhibited in a solo show thirty-five years after her death.³⁴ Of the eight children of William H. Macdowell, a Philadelphia engraver, both Susan and her sister Elizabeth became interested in art early in life. Their parents encouraged this, providing the girls with a studio of their own. At age twenty-five Susan entered the Pennsylvania Academy of the Fine Arts, where she studied for six years with Christian Schussele, a history painter, and Thomas Eakins, whom she married in 1884. Although her output decreased during the marriage, Susan Eakins never stopped painting; she continued another twenty years after her husband's death in 1916.

Many writers have commented on the similarity of Thomas's and Susan's styles, and her works do display the same sense of contemplative quiet, the same rich, dark backgrounds, the same eloquent but never fussy details, and the same interest in individual personalities that are so characteristic of Thomas Eakins's art. *Two Sisters* (plate 77) is a picture of some of Susan's family members, her favorite models. Here her sister Dolly (also called Mary) sits on the left with an open book in her lap, while Elizabeth sews. The subtle interaction between the two women, the strong highlighting of their faces and hands, and the man-

Above 75. Cecilia Beaux seated next to her painting Les Derniers Jours d'Enfance, 1883–84

Right 76. Cecilia Beaux (1855–1942) After the Meeting, 1914 Oil on canvas, 40¹⁵/16 x 281/8 in. The Toledo Museum of Art, Toledo, Ohio; Gift of Florence Scott Libbey

105

Left
77. Susan Macdowell Eakins
(1851–1938)
Two Sisters, 1879
Oil on canvas, 57½ x 45¾ in.
Peggy Macdowell Thomas

Right
78. Claude Raguet Hirst
(1885–1942)
Still Life, c. 1890
Watercolor on paper, 10 x 14½ in.
Butler Institute of American Art,
Youngstown, Ohio

ner in which Eakins has captured a split second of time reflect her interest in both old master paintings and contemporary photography.

Early nineteenth-century still-life painting, as exemplified by the works of Margaretta Angelica Peale, emphasized decorative arrangements of one kind of object, typically fruit or flowers, in a simple container. A different approach to still life was taken later in the century by Claude Raguet Hirst.³⁵ Born in Cincinnati, Hirst spent most of her life in New York, where she began exhibiting fruit and flower paintings at the National Academy of Design in 1884. A few years later she changed her subject matter to tabletop groupings of old books and pipes and other smoking materials, painted in the popular trompe-l'oeil manner that makes every rip in a leather binding, every bit of fallen ash, every nick in the wooden table, seem remarkably real (plate 78). This change in Hirst's art is attributed to the influence of the noted American painter William Michael Harnett, who moved into a studio two doors from Hirst's at about this time. Hirst's works differ from Harnett's, however, both in their relatively small scale and in their technique: watercolor on paper. Although her paintings have sometimes been confused with his. Hirst's career was far less successful than Harnett's, and she died in extreme poverty.

Two women artists active during the latter part of the 1800s shared both a gift for creating intense, appealing likenesses and tragic personal lives—one spent many years in ill health, dying while still in her twenties; the other lived for nearly thirty years in a mental institu-

79. Marie Bashkirtseff (1859–1884) A Meeting, n.d. Oil on canvas, 74¹⁵/₁₆ x 68¹⁵/₁₆ in. Musée d'Orsay, Paris

tion. Although the Russian-born painter Marie Bashkirtseff lived to be only twenty-five, she is widely known through the posthumous publication of parts of her *Journal*, which provides a vivid impression of what it was like to be a woman art student in nineteenth-century Paris. ³⁶ When her parents separated, Bashkirtseff moved with her mother and several other family members to France, where she studied and painted until her death from tuberculosis. The painstaking details and sentimental mood of Bashkirtseff's genre scene, A *Meeting* (plate 79), reflect the influence of Jules Bastien-Lepage, with whom she had studied. Exhibited at the 1884 Salon, this painting was purchased by the French government.

The story of Camille Claudel is tragically reminiscent of Constance Mayer's. Both women's professional and emotional lives were inextricably entwined with those of famous male artists, and both suf-

fered as a result. Claudel was the child of a wealthy civil servant in northeastern France. Her brother Paul, to whom she was quite close, became a well-known poet and playwright and later a high-level diplomat; but there was constant friction among the family members and, in particular, a great deal of ill feeling toward Camille from her mother and her younger sister Louise.³⁷

Encouraged by her father, Camille began studying art and produced busts of Bismarck and Napoleon while still in her teens. The family moved to Paris in 1881, and her art continued to improve. One day the famous sculptor Auguste Rodin came to give critiques at the

80. Camille Claudel (1864–1943) Auguste Rodin, 1892 Bronze, 16 x 10 x 11½ in. Musée de Petit Palais, Paris

studio where Camille was studying; thus began a fifteen-year relationship, in which she served as his pupil, model, lover, and artistic collaborator, incurring the wrath both of Camille's mother and of Rose Beuret, Rodin's longtime companion. Eventually this relationship ended, and for a variety of reasons Camille developed a persecution mania that lasted the rest of her life. She was institutionalized by her family in 1913 and spent the next twenty-nine years in a series of asylums.³⁸ Both the subjects and the style of Claudel's work are very close to those of Rodin. Her portrait bust of the artist (plate 80) has the same rough, expressive surface and emphasis on emotion that are associated with her teacher's work. In addition to busts, genre scenes, and allegorical sculptures, Claudel also produced large-scale mythological subjects (plate 81).

Two American sculptors—Gertrude Vanderbilt Whitney and Malyina Hoffman—were also affected by Rodin but in a more positive fashion, as his pupils. Both produced major sculptural projects, in styles quite different from that of the French master. Although their careers developed in the twentieth century, these artists—and a third, Anna Hvatt Huntington—produced work tied more closely to nineteenth-century portraiture and the French animalier tradition than to the experimental nature of most early twentieth-century art. Born to a prominent New York family, Whitney studied sculpture privately and at the Art Students League; she also trained briefly with several artists in Paris, including Rodin. 39 Whitney drew on her experiences at the hospital that she set up in France during World War I to create several war monuments (plate 82); she also produced an equestrian statue of Buffalo Bill Cody, a good many architectural sculptures, and several prize-winning fountains. Her Titanic Memorial in Washington, D.C. (plate 83), was commissioned in 1914. This granite figure of a partially draped man with dramatically outstretched arms is eighteen feet tall. Active and talented in many fields, Whitney also had a novel published and established the Whitney Studio, which became the Whitney Museum of American Art.

A determined, energetic young woman, Malvina Hoffman studied both painting and sculpture in New York and in Paris, where she managed to persuade the reluctant Rodin to take her on as a pupil. In the end, he gave weekly critiques of her sculpture over a period of four years; he also encouraged her to study anatomy by taking classes in dissection at a medical college. By 1914 Hoffman had become friendly with many of the most exciting visual and performing artists in Europe and America, whom she portrayed in portrait busts. She was especially intrigued with dance and with the idea of sculpting dancers in motion. Beginning in the 1910s, Hoffman sculpted many images based on her good friend the Russian ballerina Anna Pavlova. 40

In 1929 Hoffman received her largest commission: to sculpt over one hundred life-size figures representing the racial types of man-

Below 81. Camille Claudel in her studio with a large plaster of *Perseus*. 1000

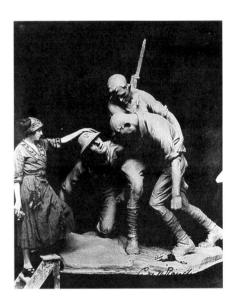

Above 82. Gertrude Vanderbilt Whitney at Washington Heights War Memorial, 1921–22

Right
83. Gertrude Vanderbilt Whitney
(1875–1942)
Titanic Memorial, 1914
Granite, height: 18 ft.
Washington Channel Park,
Washington, D.C.

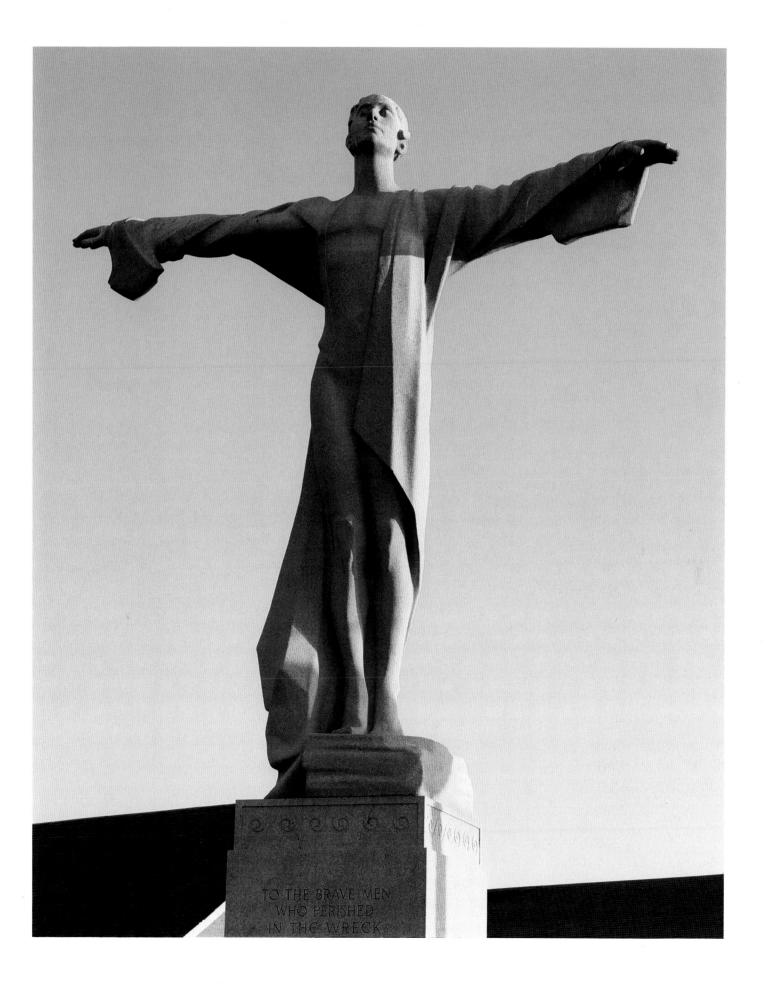

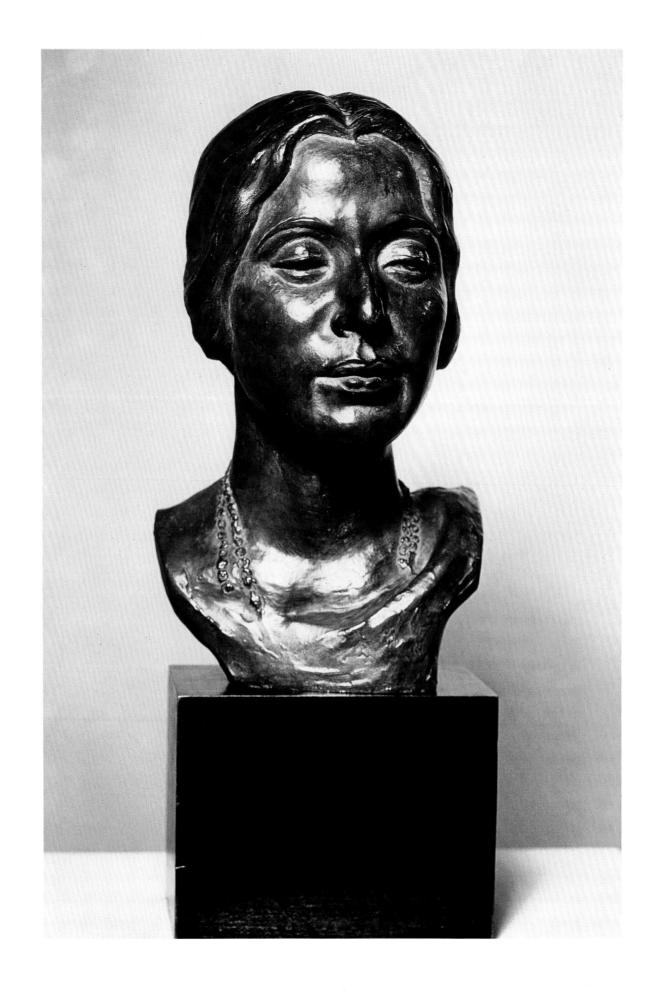

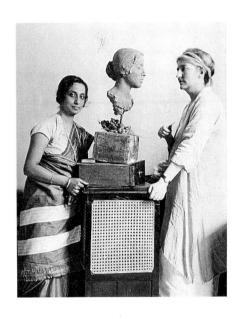

Left 84. Malvina Hoffman (1887–1966) Bengali Woman, 1933 Bronze, height: 13½ in. Field Museum of Natural History, Chicago, and the sculptor

Above 85. Malvina Hoffman with Kamalia Chatterji, the model for Bengali Woman, 1933 kind for the Field Museum of Natural History in Chicago (see plates 84, 85). Museum officials had originally intended to divide this massive task among five sculptors, but again Hoffman's tenaciousness prevailed—she convinced them to give the entire job to her and even to finance the casting of all 105 statues in bronze, rather than keeping them in plaster, as originally planned. To prepare for this project, she and her husband, the musician Samuel Grimson, traveled around the world for two years. Hoffman's autobiography, *Heads and Tales*, describes in vivid detail the fascinating experiences they had during the course of this voyage.⁴¹

Like Rosa Bonheur, Anna Hvatt Huntington was known for animal subjects, but in three dimensions. Born in Cambridge, Massachusetts, she spent her early summers on a Maryland farm, where she became fascinated by animals. Following in the footsteps of her older sister, at age nineteen Huntington began to sculpt, studying in Boston and New York. Her most famous works are anatomically precise bronze statues of prowling jaguars, colossal lions, and massive bulls, modeled after lengthy and meticulous observation and numerous preparatory studies. Huntington also produced a number of powerful equestrian statues of historical, literary, and mythological figures. These include her famous Joan of Arc, located in New York's Riverside Park (with replicas in Massachusetts, California, and France), for which the French government made her a chevalier of the Legion of Honor; plus images of the nineteenth-century Cuban leader José Martí and the eleventh-century Spanish military hero El Cid. While the human subjects are impressive, it is the horses that animate Huntington's equestrian monuments—her steeds are always prancing or rearing, their nostrils flaring, manes tousled, tails arching in the air (plate 2).

Huntington had her first solo show, of forty animal sculptures, at age twenty-four; four years later, a work on which she collaborated with another American sculptor, Abastenia St. Leger Eberle (see chapter 5), was exhibited at the 1904 Saint Louis Exposition. She spent time working in both Italy and France and won numerous honors, including election to the status of Academician at the National Academy of Design in 1922. The next year she married a poet and philanthropist, Archer M. Huntington, with whom she founded Brookgreen Gardens, near Charleston, South Carolina—a nature retreat and a place to display her own works and those by other sculptors. 42

During the nineteenth century women artists became more visible than before, due to their increasing number and the quantity of important public commissions they were awarded. By the end of the century women had finally gained a significant degree of access to serious art training, including the study of the nude. This important gain helped pave the way for the profusion of women artists who matured during the following century.

THE EARLY TWENTIETH CENTURY

I said to myself [in the fall of 1915], "I have things in my head that are not like what anyone has taught me—so natural to my way of being and thinking that it hasn't occurred to me to put them down." I decided to start anew—to strip away what I had been taught—to accept as true my own thinking.—Georgia O'Keeffe, Georgia O'Keeffe, 1976

he twentieth century began with a veritable explosion of scientific and technological discoveries. During its first decade alone, the telegraph was invented, airplanes made their first successful flights, Henry Ford started mass-producing automobiles, and Albert Einstein formulated his theory of relativity. The world had changed and could now be seen from high above—the Eiffel Tower, a skyscraper, a plane —or rushing past the windows of a car or train. This climate of new inventions and ideas led to an unprecedented questioning of traditional beliefs and values regarding all aspects of life, a process that was heightened immeasurably by the trauma of World War I. As the old philosophical and scientific bases for understanding the world changed, art changed too. Myriad new developments—the modern "isms" of Fauve, Expressionist, Cubist, Dada, and Surrealist painting and sculpture—followed one another with remarkable speed. These radical styles reflected the new freedom of artists who were no longer dependent on church or government patronage, who had new materials and techniques—from plastics to welding—at their disposal, and who, in the early years of the century, made what may be the ultimate leap, to creating art that had no subject, in the traditional sense, but that was made up entirely of abstract arrangements of color and form.

Women artists were actively involved in these radical new approaches to art. Moreover, although many of the leading painters and sculptors continued to come from France, which still dominated Western art during the first half of the century, a significant number of important women artists emerged from countries not previously represented here, including Russia, Sweden, Canada, and Portugal. Significant numbers of women artists—especially those who could afford to spend time in Paris—at last were allowed to study along with men, to draw from the nude model, and to compete for major prizes. Societal pressures for women to lead conventional, home-centered lives still had an impact, but more and more women were able to overcome these various obstacles to establish careers as professional artists. However, considerable resistance to women artists remained, especially in the United States, where several organizations were formed to combat it.²

86. Natalya Goncharova *Linen*, 1912 (detail) See plate 97 The first two revolutionary movements in twentieth-century art, Fauvism and Expressionism, originated in France and Germany, respectively. The former is characterized by its sensual, joyous mood and the latter by its emphasis on darker emotions. Despite their obvious differences, these styles share a number of important elements. Both have their roots in the experiments of the Post-Impressionist painters (particularly Georges Seurat, Paul Gauguin, Vincent van Gogh, and Paul Cézanne); both are based on things seen in the real world that have been stylized through the use of heavy outlines, flattened forms, intense colors, and relatively thick paint. And both affected the work of innumerable artists who were not, strictly speaking, members of the groups.

A fascinating artist whose work reflects these trends was Suzanne Valadon. Pablo Picasso, Georges Braque, and André Derain, as well as many other notables from the Parisian art community, all attended Valadon's funeral—an impressive turnout for the illegitimate child of a French laundress. She had grown up quickly in the bohemian quarter of Montmartre, supporting herself from age nine through a series of odd jobs. She was a circus acrobat until a fall from a trapeze at age sixteen convinced her to seek safer work as an artist's model, sitting for many noted painters, including Pierre Puvis de Chavannes, Pierre-Auguste Renoir, and Henri de Toulouse-Lautrec.

Determining that she preferred life on the other side of the easel, Valadon observed her employers carefully and began to make her own paintings. Encouraged by Toulouse-Lautrec and Edgar Degas, she produced landscapes, still lifes, and portraits, plus her specialty, female nudes. These powerful, brightly colored pictures made clear references to Post-Impressionist and Fauve art. Valadon's first one-person exhibition (held at the Berthe Weill gallery in 1915) was a critical and commercial success, as were her subsequent showings; but the details of her colorful personal life have received more attention than her paintings. Valadon had notorious affairs with the painter Puvis de Chavannes and the composer Erik Satie; she lived fourteen years with a wealthy banker. Paul Moussis, before leaving him for André Utter, a painter twenty-one years her junior. Utter and Valadon married, and the couple gave several joint exhibitions with Maurice Utrillo, Valadon's son; Utter also posed for several of Valadon's works, including Adam and Eve (plate 87). There is an assertive sexuality in many of Valadon's figures; the nudes are unashamedly naked, despite occasional coy devices such as the foliage decorating Adam's groin, and she painted bodies that have obvious substance. Valadon's use of color is also noteworthy: in particular, her self-portraits feature shocking juxtapositions of vibrant hues that strengthen the emotional impact of these unflattering, and unforgettable, images.

Although she died just as the Fauves and Expressionists were beginning to make an impact on the art world, Paula Modersohn-Becker

87. Suzanne Valadon (1865–1938) Adam and Eve, 1909 Oil on canvas, 63¾ x 51% in. Musée National d'Art Moderne, Centre Georges Pompidou, Paris

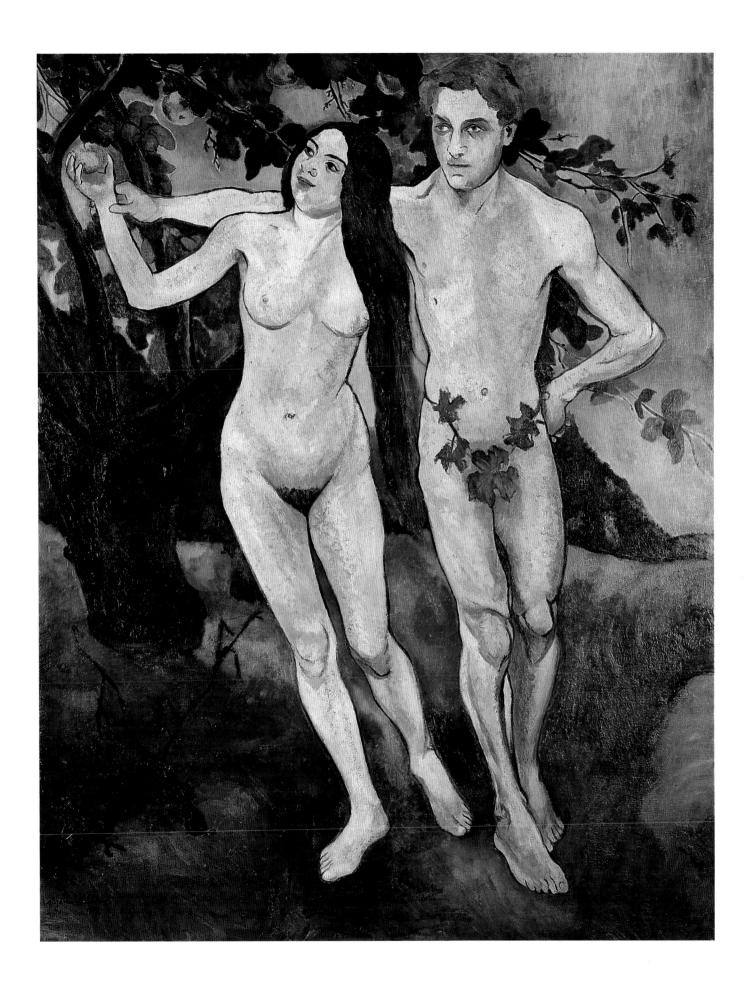

Left
88. Paula Modersohn-Becker
(1876–1907)
Still Life with Blue and White
Porcelain, 1900
Oil on board, 195% x 227% in.
Niedersächsisches Landesmuseum,
Hannover

Right
89. Gabriele Münter (1877–1962)
Black Mask with Rose, 1912
Oil on canvas, 221/4 x 193/8 in.
Leonard Hutton Galleries,
New York

shared their pioneering spirit. Best known for her affecting, often lyrical self-portraits and studies of elderly peasant women, Modersohn-Becker also produced intriguing landscapes and still lifes. An especially successful example of the latter is her *Still Life with Blue and White Porcelain* (plate 88). Here the artist focused on a single corner of the table, using cast shadows as strong design elements and—in the manner of Matisse, whose work she had presumably seen on one of her four trips to Paris between 1900 and 1907—emphasizing the flat, abstract qualities of the bold wallpaper design.

Modersohn-Becker was born in Dresden; her early art studies took place in Bremen, where the family moved in 1888, and in London. After completing a teacher's training program (to mollify her parents regarding her future livelihood), Modersohn-Becker went to Berlin for further art study. In 1898 she settled in an artists' colony at Worpswede, Germany; three years later she married one of the artists there, Otto Modersohn. Modersohn-Becker died at age thirty-one, just three weeks after her daughter was born, having produced more than four hundred paintings and many etchings and drawings.

Because the official art academies in both Munich and Düsseldorf were closed to women, the German painter Gabriele Münter studied elsewhere, including the Phalanx School, an avant-garde institution

founded by the Russian artist Wassily Kandinsky. There Münter was introduced to Post-Impressionism and to the technique of combining marks made with a palette knife and a brush. The vivid colors and bold outlines common in her work are partly derived from the paintings of Gauguin and the Fauves, whom she admired; Münter was also strongly influenced by her collection of Bavarian folk art objects, particularly paintings on glass. Kandinsky's professional relationship with Münter developed into a personal one, and the two lived together for more than a decade. She was one of the first artists to exhibit with Kandinsky's German Expressionist group known as the Blue Rider. After Münter separated from him, her painting underwent a fallow period during the

Left 90. Emily Carr (1871–1945) Forest, British Columbia, 1932 Oil on canvas, 51 x 34 in. Vancouver Art Gallery

Below

91. Emily Carr on horseback in the Cariboo, Canada, 1904

Right

92. Marguerite Thompson Zorach (1887–1968)

Man among the Redwoods, 1912

Oil on canvas, 25¾ x 20¼ in.

Private collection, Hockessin,

Delaware

1920s, and when the Nazis came to power her work—like that of her modernist contemporaries—was condemned as "degenerate." But Münter survived, living to the age of eighty-five. Her paintings include many powerful landscapes and figure studies as well as striking still lifes, such as the one reproduced here (plate 89).

A highly personal, almost mystical response to nature characterizes the dark, haunting landscapes of Emily Carr (plate 91). At age eighteen Carr left her native British Columbia to study art in San Francisco. She stayed there five years and later trained in London, at the Westminster School of Art. In 1905 Carr established herself as an artist-teacher in Vancouver. However, that city's art scene was severely lim-

ited, so she found herself spending more and more time observing, and then painting, aspects of Canadian Indian culture. Dissatisfied with her technical skills, Carr studied painting for two years in Paris, where despite recurring bouts of severe anemia, which continued to plague her for many years—she produced brightly colored paintings, some of which were accepted into the Salon d'Automne. Back in Canada, Carr's Fauvist landscapes briefly attracted some attention; ironically, her Canadian subjects were considered less interesting. Her struggles to establish a serious reputation foundered until 1921, when a major exhibition of West Coast Canadian art featured twenty-six of her Indian paintings. Inspired by the success of this show, and by her trip to Ottawa to view it at the National Gallery of Canada, Carr began painting dramatic, stylized landscapes (plate 90). In the late 1930s she had three solo exhibitions in Toronto and achieved her first significant public recognition. A series of heart attacks made painting difficult for her and turned Carr toward a second career, as a writer—during her last years she published several autobiographical books that still remain popular in Canada.

Vibrantly colored, energetic landscapes clearly inspired by the work of the Fauves exemplify the art of Marguerite Thompson Zorach (plate 92). Like Emily Carr, she was a pioneer who introduced French modernism to her own country. After a comfortable childhood spent in central California, she accepted the invitation of a wealthy aunt to study art in Paris, where Marguerite lived for several years beginning in 1908, getting to know Picasso, Gertrude Stein, and many other members of the avant-garde. In 1911, in an attempt to halt her romance with William Zorach, a young American sculptor of modest background whom she had met at a progressive Parisian art school, Marguerite's aunt took her on a lengthy trip through Egypt, Palestine, India, and Japan, ending up back in California. Although the romance remained undiminished. Marguerite had a rare opportunity to observe the grace and economy of Oriental art, which influenced much of her work, notably a series of ink landscape drawings she executed on a camping trip in 1912. In that same year, after having her first solo exhibition, in Los Angeles, the artist married Zorach and moved with him to New York. Although she continued painting the rest of her life, after her marriage and the birth of two children Marguerite became better known for her work in other media, primarily innovative embroidered tapestries that combined stylized figures and landscape elements. She also produced many of the preliminary drawings for her husband's sculptures.

Paris was a source of inspiration for many other American women artists, including Boston-born Lois Mailou Jones (plate 93). Jones began studying art at age fourteen, encouraged by her energetic and ambitious parents: her father, a building supervisor, earned a law degree when he was forty, and her mother ran a beauty shop and made hats. In 1923 Jones started attending the Boston Museum School full

93. Lois Mailou Jones in her Paris studio, 1937–38

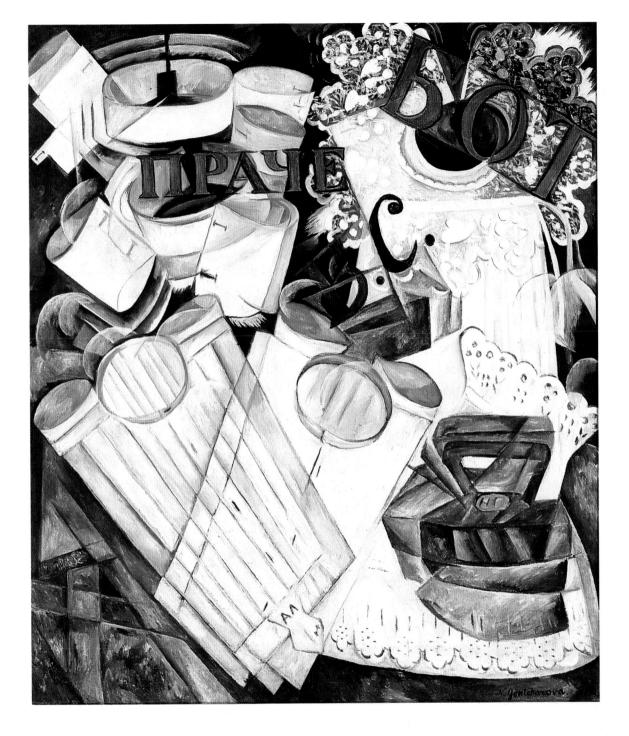

97. Natalya Goncharova (1881–1962) Linen, 1912 Oil on canvas, 37% x 33 in. Tate Gallery, London

most innovative work dates from 1912–14, when she and Larionov were developing Rayonism, a Cubist-based optical system that emphasized the rays of light emanating from, and reflected by, various objects. Many of Goncharova's Rayonist pictures appear totally abstract; others, such as *Linen* (plate 97), involve highly stylized but still recognizable subjects. In the later 1910s Goncharova was commissioned by Serge Diaghilev to design the first of many of her costumes and sets for his Ballets Russes; she settled in Paris in 1917 and there continued producing theatrical designs and abstract paintings.⁶

96. Natalya Goncharova with Léonide Massine, Mikhail Larionov, Igor Stravinsky, and Léon Bakst at Ouchy, France, 1915

was born in Russia and grew up in her uncle's Saint Petersburg home. She began studying art in Germany at age eighteen, then moved to Paris in 1905, where she soon met most of the avant-garde artists, including Picasso, Braque, and André Derain. In 1910 she married the painter Robert Delaunay, and the following year they had a son. An example of Sonia's Orphist art is *Electric Prisms* (plate 95), a complex arrangement of brightly colored interlacing arcs that suggests the intensity of artificial light. Delaunay exhibited this painting at the 1914 Salon des Indépendants, an alternative to the conservative official Salon. In addition to her paintings, which she continued to produce throughout her life, Delaunay also worked in many other media, designing innovative "simultaneous" fabrics based on the same aesthetic principles as her oils, plus theatrical costumes and book bindings. A number of other women artists—including Sophie Taeuber-Arp, Alexandra Exter, and Natalya Goncharova also explored a variety of media, from fashion to industrial design, in addition to painting.

Although France was the focal point of most early twentiethcentury avant-garde activity in the visual arts, Russia also produced major modernist pioneers. Ironically, even though the Soviet government sanctioned only Social Realism, the most radical art of the early twentieth century including some of the first totally nonrepresentational paintings—came from Russia.⁵ The history of twentieth-century Russian art is closely tied to political events. During the first decade and a half there was a great deal of interaction among Russian and Western European artists; before World War I many Russian artists spent time in Germany and France and were well aware of the latest developments in Western European avantgarde art. With the war came renewed cultural isolationism, but the most significant change in Russian art, and the rest of Russian life, began in 1917 with the Russian Revolution. In the early 1920s the newly formed Soviet government decreed that the purpose of all art was to serve the state; those who disagreed, preferring to experiment with abstraction, had to change their styles or leave. Many left, and Russia's loss was a boon for the Western world, as distinguished painters and sculptors—including Kandinsky, Alexander Archipenko, Marc Chagall, Naum Gabo, Antoine Pevsner, and Natalya Goncharova (plate 96)—fled to Europe and the United States.

Goncharova came from a distinguished family in central Russia. After completing secondary school, she entered the Moscow School of Painting, Sculpture, and Architecture, where she studied sculpture with a former pupil of Rodin. Her sculpture won awards, but after 1900 she switched to painting and—along with a fellow student, Mikhail Larionov—began experimenting with abstraction. Goncharova's early pictures reflect French Impressionist and Post-Impressionist ideas; by 1906 she and several other Russian Neo-Primitive painters were producing work based on the colors and shapes of Russian folk art. Some of her

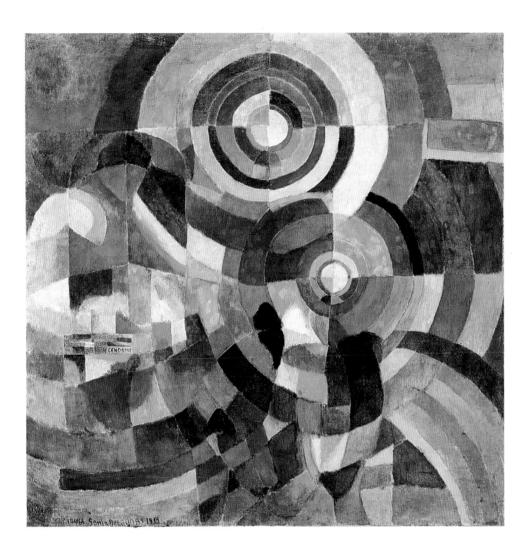

95. Sonia Terk Delaunay (1885–1979) Electric Prisms, 1914 Oil on canvas, 93¾ x 98¾ in. Musée National d'Art Moderne, Centre Georges Pompidou, Paris

American history. Her later work contains elements from her life in Haiti with her husband, the painter Louis Verniaud Pierre-Noël, whom she married in 1953. She has also taken motifs from her many travels throughout the world, most notably in Africa, where she presented a series of lectures sponsored by the United States Information Service and collected slides and information on contemporary African art for an international archive of black artists at Howard University.

In addition to Fauvism and Expressionism, one of the most important modernist styles to develop in the first decade of the twentieth century was Cubism. Invented jointly by Pablo Picasso and Georges Braque, Cubism challenged some of the most fundamental tenets of Western art: its fractured, incoherent spaces and distorted, often illegible subject matter represented a wholly new approach to painting. While Cubism as a historical phenomenon was relatively short-lived, its influence was tremendous, engendering offshoots in many other countries, from English Vorticism to Italian Futurism and Russian Rayonism. Another of these offshoots became known as Orphism, or Orphic Cubism, developed around 1911 by Sonia Terk Delaunay and her husband. Sonia

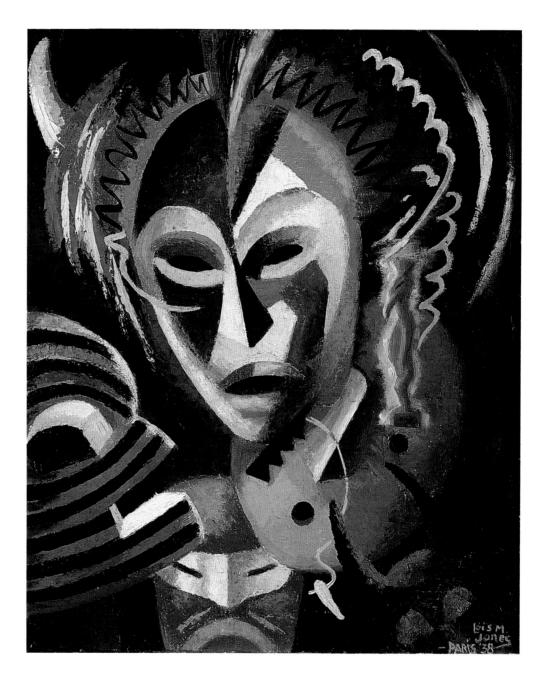

94. Lois Mailou Jones (1905–1998) Les Fétiches, 1938 Oil on canvas, 25½ x 21 in. Collection of the artist

time; later she supported herself as a free-lance illustrator and textile designer while continuing her studies in Washington, D.C., and New York. She became a teacher at Howard University in 1930, remaining on staff until she retired forty-seven years later.

From girlhood Jones had wanted to study art in Europe; she won a fellowship to the Académie Julien in Paris in 1937 and was inspired both by the city's exciting artistic atmosphere and by the fact that as a black woman painter she encountered considerably less prejudice there than she had at home. In France, Jones started painting colorful Fauvist landscapes; she also produced Cubist-influenced abstractions that show the influence of African tribal sculpture (plate 94). On her return to the United States, Jones painted a number of subjects from recent black

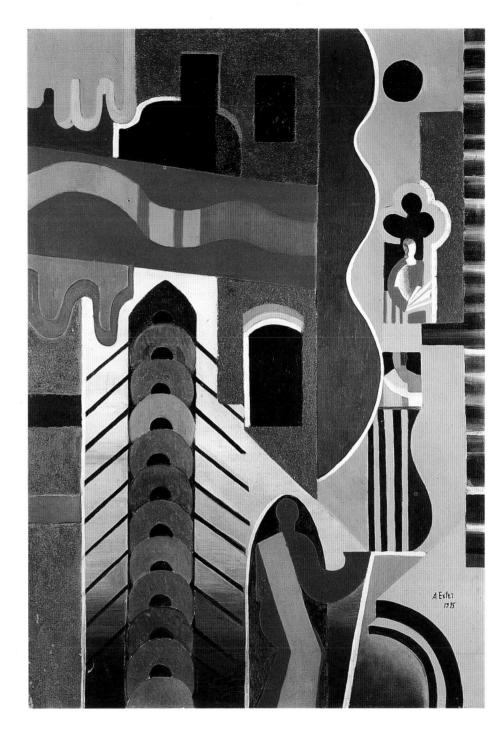

98. Alexandra Exter (1882–1949) The Boat and the Town, 1925 Oil on canvas, 42 x 29 in. Leonard Hutton Galleries, New York

Another early Russian abstractionist was Alexandra Exter. Born in Kiev, where she first studied art, Exter married a wealthy lawyer and lived in Paris from 1908 to 1914, getting to know Western European avant-garde artists and absorbing the influence of Cubism, which she transplanted to Russia at the start of World War I (plate 98). Back in Moscow, Exter produced increasingly abstract paintings, book illustrations, collages, and sculptures. Like Goncharova, she also designed costumes, lighting, and sets for experimental theater productions. As the political climate in post-Revolutionary Russia changed, Exter joined the

stream of artist-exiles, living in Paris from 1924 until her death. There she continued to make theatrical designs, avant-garde furniture, and a series of remarkable marionettes, as well as to teach art and work with experimental films.⁷

During the early twentieth century, abstraction was less common—and far less welcome—in the United States than in Western Europe or Russia. Nevertheless, there was a core of radical American artists who devoted themselves to exploring the potentials of modernism. Chief among them was Georgia O'Keeffe (plate 99), the most famous woman artist of our time, who is best known for her dramatic paintings of gigantic flowers and sun-bleached desert bones.

A native of Wisconsin, O'Keeffe studied there, in Virginia, at the Art Institute of Chicago, and New York's Art Students League, and then earned her living as a public-school art teacher in Virginia and Texas. In 1915, at the age of twenty-eight, O'Keeffe arranged around her room all the art that she had produced so far, to evaluate it. Condemning each work as derivative, she destroyed them all, embarking on an entirely new series that she hoped would reflect only herself. The next year O'Keeffe sent some of her new work—remarkably spare, totally abstract charcoal drawings—to Anita Pollitzer, a friend living in New York, with instructions not to show them to anyone else. Too impressed with the new work to keep it to herself, Pollitzer took the drawings to Alfred Stieglitz, the noted photographer, editor, dealer, and one of America's foremost promoters of modernist art. Stieglitz was also impressed; he became O'Keeffe's dealer, and later her husband. With Stieglitz's support and the help of positive reviews and significant sales, O'Keeffe was able to devote herself to painting: New York City scenes at night, at a time when the skyscrapers were still brand-new; rural landscapes seen during summers at Lake George in upstate New York; and. finally, the blossoms and bones for which she became famous. All were produced with the flat colors, eccentric compositions, and almost Oriental sense of simplicity that she credited to her early studies with Arthur Wesley Dow, a Columbia University art educator who, O'Keeffe said, taught her "to fill a space in a beautiful way."

By 1916—only a few years after the first major Russian experiments—O'Keeffe was producing totally abstract drawings and water-colors, many based on a series of simple lines and curved shapes. But she is known to far more viewers for her close-ups of flowers: red poppies, black irises, green orchids, pink-spotted lilies. Many theories have been advanced about the underlying meanings of these pictures. Much has been made of the "female" qualities of her blossoms, specifically their presumed vaginal imagery, and several writers have traced the scale of these pictures either to the criticism that O'Keeffe received as a Wisconsin schoolgirl for drawing too small or to the influence of photographic enlargements. O'Keeffe, however, always denied that there was

Above 99. Georgia O'Keeffe, 1953

Right 100. Georgia O'Keeffe (1887–1986) Music: Pink and Blue, 1919 Oil on canvas, 48 x 30 in. Mr. and Mrs. Barney A. Ebsworth

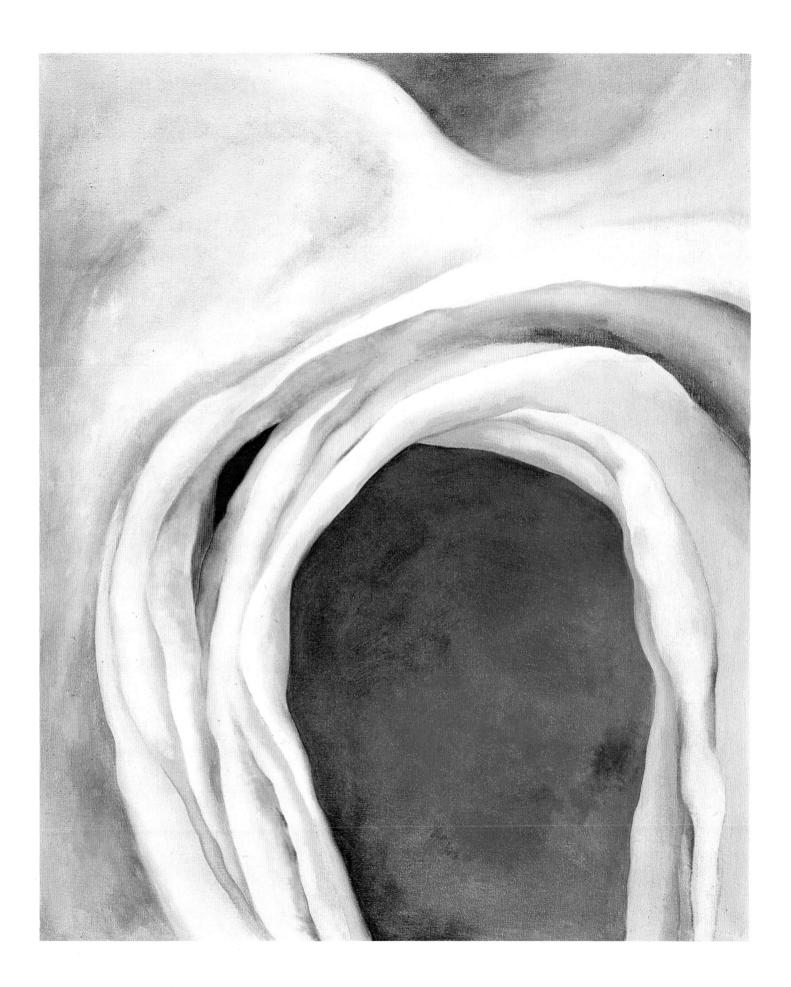

any symbolism, sexual or otherwise, in her flower paintings. She claimed that their size was inspired by the skyscrapers being built all over New York and that what really interested her in a subject was not the flower, or the skull, or the mountain, but the colors and shapes she saw as she looked at them. This essentially abstract orientation is clearest in O'Keeffe's series—where she began by painting a fairly realistic version of, say, a Jack-in-the-pulpit flower, progressively simplifying and stylizing it to the point where, in the final painting of the series, the original subject is unrecognizable. She followed the same procedure in many of her other series, transforming a pelvic bone into an abstract pattern of hollows and curves, or associating visual with aural stimuli—as in her many paintings representing music (plate 100).

Over the years O'Keeffe won countless honors and awards and had several major one-person exhibitions at Stieglitz's galleries and later at the Art Institute of Chicago, the Museum of Modern Art, the Whitney Museum of American Art, and many other institutions. Her remarkable longevity was matched by her astonishing physical energy. Despite deteriorating eyesight she continued to paint, and eventually to work with clay, virtually her entire life. A documentary film made to celebrate O'Keeffe's ninetieth birthday shows her climbing briskly through the New Mexico desert, where she moved soon after Stieglitz's death in 1946, while her young companion struggles to keep up.¹⁰

Unlike Georgia O'Keeffe, who maintained that her art was based almost entirely on aesthetic considerations, Hilma af Klint regarded her own abstract paintings as a form of spiritual expression (plate 101). An intriguing artist, little known outside her native Sweden, af Klint became interested in mathematics, botany, and art as a child. In 1882 she entered the Royal Academy in Stockholm, where she was a highly successful student; five years later she established a career as a portraitist and landscape painter. At the same time, af Klint's interest in spiritualism was growing; she served as the medium for a group of women who met for weekly séances and also began to experiment with automatic drawing. By 1906 she had given up traditional painting to make the *Drawings for the Temple*, a series of images she said were dictated to her by her "spiritual guides." In subsequent years af Klint explored various other approaches to art, particularly after her mother's death in 1920 freed the artist to travel outside Sweden.

Af Klint regarded the struggle for unity between dualities—for example, the male and female elements in human existence—as the principal theme of her work. Her art has not been studied widely, as she did not exhibit her occult paintings during her lifetime and specified in her will that they should not be made public until twenty years after her death. Their simple geometric forms and symmetrical compositions link af Klint's pictures visually to the work of many other twentieth-century modernists.

101. Hilma af Klint (1862–1944)

Untitled #1

(from Altar Paintings series), 1915

Oil and gold on canvas, 72% x 59% in.

Private collection

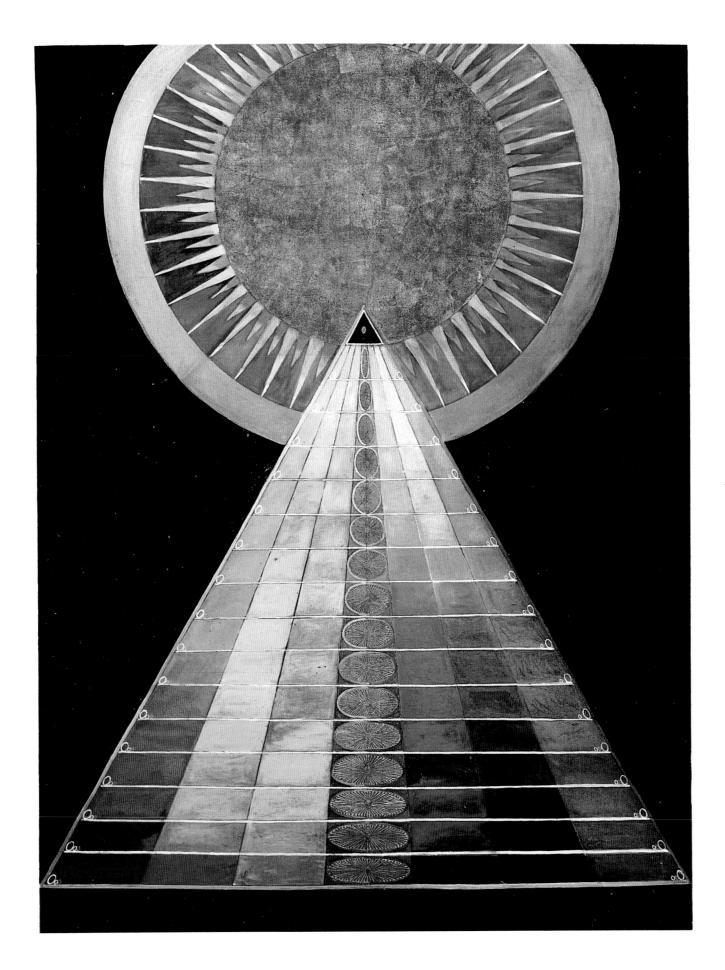

102. Irene Rice Pereira (1907–1971) *Untitled*, 1951
Oil on board, 40 x 24 in.
The Solomon R. Guggenheim
Museum, New York;
Gift of Mr. Jerome B. Lurie

The spiritual element in her paintings was also critically important to Irene Rice Pereira. The author of ten books of poetry and metaphysical essays, this American artist was named Poet Laureate by the government of the Philippines and awarded an honorary doctorate by the Free University of Asia in Karachi, Pakistan. Pereira was raised in Massachusetts, where, at age fifteen, she began supporting her widowed mother and three siblings by working in an accountant's office. Local night classes in art led her to study at the Art Students League in New York. After extensive travel in Europe and Africa, Pereira returned to New York and began making paintings that combined stylized human

into her eighties, Nevelson remained an active and prominent figure on the New York art scene.

Born in Russia, by 1905 she had moved with her family to Rockland, Maine; three years later she declared her intention of becoming a professional sculptor. After marrying Charles Nevelson and settling with him in New York, Louise studied dance, drama, and singing. Six years later she enrolled at the Art Students League; after separating from her husband she also studied in Europe and Mexico and was an assistant to the muralist Diego Rivera in 1933 while he was working in New York on his controversial painting for Rockefeller Center.

During the 1930s and early '40s Nevelson exhibited mostly small wood, stone, and terra-cotta sculptures, basically Cubist in style. But it was the approach that she developed in the mid-1950s that made her reputation. From old milk crates and other bits of scrap wood, Nevelson assembled a sculptural "wall," Moon Garden Plus One, first exhibited in 1958. Western artists had been combining discarded materials since at least the beginning of the century, but Nevelson was the first to build large-scale environments out of such detritus. Her most characteristic works since that time have been wooden wall-sculptures that are assembled from both found and specially constructed elements and then painted flat black or white or gold, creating a physical, emotional, and visual space inside which viewers can wander (plate 107). From the mid-1060s Nevelson also experimented with making sculptures out of clear Plexiglas, aluminum, Formica, and Cor-ten steel. During her last decades Nevelson received numerous awards and was the subject of several major retrospectives. In addition, she achieved the dubious distinction of having the forms she had developed imitated by many other artists and designers.

Curving abstract shapes that suggest a human figure or a landscape were the specialty of the English sculptor Barbara Hepworth. Her earliest memories involved the contours of the hilly land in Yorkshire, where she was raised, and these recur throughout her mature work. In 1018, on scholarship at the Leeds School of Art, Hepworth met another English sculptor, Henry Moore, with whose work hers has often been compared. At sixteen she entered London's Royal College of Art, graduating with a grant for two years of travel in Italy. There Hepworth learned to carve; she also married a sculptor, John Skeaping, with whom she had a son. While her work continued to develop—simple, abstract carvings of wood and stone always based, like Moore's or Alexander Calder's, on living forms—her marriage deteriorated. In 1931 she married the painter Ben Nicholson; three years later she gave birth to triplets, straining the family's modest income but not diminishing her sculptural output. Hepworth's later work became increasingly simple and eloquent. Sometimes paint, string, or wire was added to her wooden forms; she also continued to work in stone on a massive scale.

107. Louise Nevelson (1899–1988) *Mirror Shadow II*, 1985
Painted wood, 115 x 141 x 21 in.
Private collection

106. Sophie Taeuber-Arp (1889–1943)
Rectangular Relief with Cutout Circles, Painted and Cutout Squares, Rising Cubes and Cylinders, 1938
Oil on wood, 21¾ x 25¾ x 8¾ in. Kunstmuseum, Bern, Switzerland

in Paris. Her pictures, in both watercolor and oil, feature simple, repeated shapes, mostly rectangles and circles, laid against a monochromatic ground. The same elements characterize her relief sculptures, which she began producing in 1931 (plate 106). These sophisticated compositions feature brightly colored geometric shapes and irregular edges that look as though bites have been taken out of them. Here the shapes formed by the empty spaces are just as important to the overall design as the solid areas of the sculpture.

Few visual artists have faces that are familiar to any but their most ardent fans. Nevertheless, two women artists—O'Keeffe and Louise Nevelson—became almost as recognizable as their work. Both of their faces were unusually striking, accentuated by highly personal modes of dress, and like great character actors both artists became even more fascinating as they aged. The proud figure of Georgia O'Keeffe, isolated in the stark New Mexico desert, was immortalized by countless photographers over the years. Louise Nevelson, an imposing woman who was always most at home in the urban energy of New York, developed an equally impressive persona, based on her highly theatrical ensembles—long black gowns accented by elaborate jewelry and colorful head scarves—and her notoriously long false eyelashes (plate 105). Well

and with whom she exhibited regularly. Vieira da Silva had one-person shows in many countries; during the 1969–70 season, for example, she had five different retrospectives, at museums in Paris, Rotterdam, Oslo, Basel, and Lisbon. In addition to her oil and tempera paintings, Vieira da Silva produced many prints, as well as designs for tapestries, ceramic decorations, and stained-glass windows.

Major stylistic changes typically show up much later in sculpture, a more unwieldy and expensive art, than in painting. But a number of pioneering women sculptors did emerge in the first decades of the 1900s. These artists—from Switzerland, England, France, and the United States—were interested in many of the same aesthetic issues as their counterparts working in two dimensions, most notably abstraction, from stylized to entirely nonrepresentational images. Moreover, many of these early twentieth-century sculptors shared an interest in asymmetry, color, and the importance of space within their compositions.

Like many of her Russian-born contemporaries, the Swiss artist Sophie Taeuber-Arp (plate 104) worked in many media. Trained in the decorative arts, she created theatrical sets, marionettes, stained glass, embroideries, collages, and furniture designs; she even founded a magazine. In 1921 she married the Alsatian artist Jean Arp, with whom she often collaborated; they had met in 1915 when both were involved in the Dada activities at Zurich's Café Voltaire. In addition, Taeuber-Arp was a serious abstract painter, belonging to several avant-garde artists' groups

Far left 104. Sophie Taeuber-Arp, Munich, c. 1913

Left 105. Louise Nevelson, 1976

103. Maria Elena Vieira da Silva (1908–1992) Stones, 1950 Oil on canvas, 19¾ x 25½ in. The Phillips Collection, Washington, D.C.

figures with machine imagery. By 1937 she was working with pure abstraction; two years later she began experimenting with unconventional materials—parchment, plastic, and glass. Pereira's most typical works (plate 102) are geometric abstractions with a relatively limited range of colors. Often they imply many layers of space and diverse sources of light, and they are related to the spiritual concerns expressed in her extensive writings.¹²

Although her paintings lack specifically spiritual content, the gridlike compositions and restricted palette of the Portuguese artist Maria Elena Vieira da Silva are similar to Pereira's work. Vieira da Silva's family supported her decision to make a career in art, and in 1928 she left her native Lisbon to study sculpture in Paris. The following year she decided to concentrate instead on painting and went on to work with the Fauve artist Othon Friesz and the Cubist painter Fernand Léger. In the 1930s Vieira da Silva began producing her characteristic works: large, heavily impastoed canvases overlaid with a complex arrangement of small rectangles (plate 103). These pictures, often based on the rectilinear patterns of the urban landscape (bridges, trains, and the like), are painted directly onto the canvas, with no preparatory sketches. Although they remain essentially abstract, these paintings suggest many layers of space.

For almost sixty years Vieira da Silva lived in Paris with her husband, the Hungarian painter Arpad Szenes, whom she married in 1930,

y H H i

Left 108. Barbara Hepworth (1903–1975) Single Form (Memorial to Dag Hammarskjöld), 1962–63 Bronze, height: 21 ft. United Nations Plaza, New York

Right 109. Germaine Richier (1904–1959) The Batman, 1956 Bronze, height: 34 in. Wadsworth Atheneum, Hartford, Connecticut; Gift of Mrs. Frederick W. Hilles

Hepworth's most famous sculpture is *Single Form* (Memorial to Dag Hammarskjöld) at United Nations Plaza in New York (plate 108). Commissioned by Hammarskjöld, then the secretary general of the United Nations, the sculpture was dedicated to him after his death in 1961. The tall, slender, curving form, with its tactile surface and pierced upper section, is tremendously moving. Hepworth was created Dame Commander of the Order of the British Empire in 1965; she died ten years later in a fire that swept her studio.

The natural processes of birth and decay always fascinated the French sculptor Germaine Richier. Raised on a farm in southern France, as a young girl she became intrigued by the metamorphosis of insects from one shape to another; this concern resurfaced in her mature work as an artist. Despite opposition from her parents, Richier entered the Montpellier Ecole des Beaux-Arts in 1922 and three years later began studying with her most important teacher—Antoine Bourdelle, a former pupil of Rodin. 15 During the 1930s Richier's bronze busts and figural sculptures began to win awards, but after living in Zurich throughout World War II, she returned to France and started making the sculptures for which she is now best known; spectral, corroded-looking human forms that seem on the verge of transforming themselves into other creatures (plate 109). Regarded by many writers as illustrations of postwar angst, these works have been compared with the attenuated bronze figures of Alberto Giacometti. In the 1950s Richier began experimenting with different materials, adding paint and broken glass to some of her sculptures and collaborating for a time with the German artist Hans Hartung and with Maria Elena Vieira da Silva. Richier died of cancer at age fifty-four.

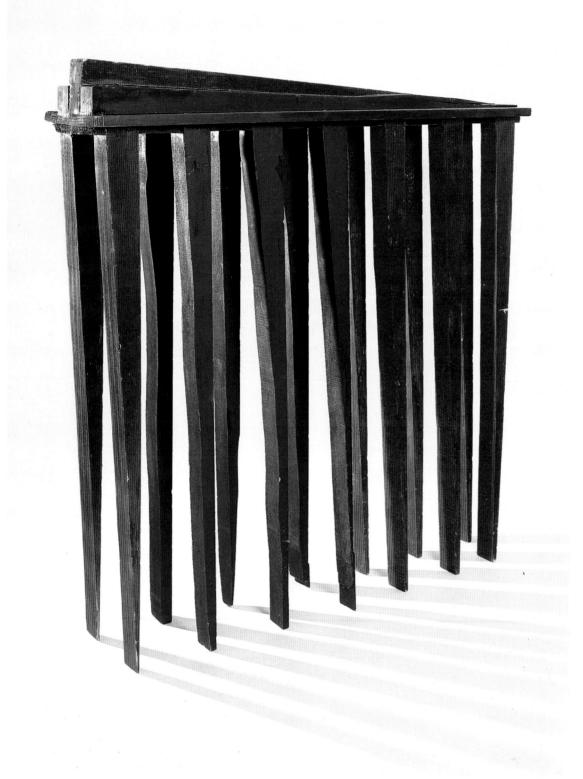

Left
110. Louise Bourgeois (b. 1911)
The Blind Leading the Blind,
c. 1947–49
Painted wood, 671/8 x 641/8 x 161/4 in.
Robert Miller Gallery, New York

Top
111. Louise Bourgeois, 1986

Above
112. Käthe Kollwitz (1867–1945)
Self-Portrait at Table by Lamplight,
1893
Etching and aquatint, 7 x 5 in.
National Gallery of Art,
Washington, D.C.;
Rosenwald Collection

The sculpture of Louise Bourgeois (plate 111) combines the abstract organic quality of Hepworth's art with the emotional subtext of Richier's. Bourgeois was born in Paris to a family of tapestry weavers, and as a child she learned to restore tapestries, acquiring both a sense of craft and an appreciation for aesthetics. She also exhibited an unusual gift for mathematics, in which she specialized at school. It was not until the age of twenty-five that Bourgeois began to study art, spending two years at the Ecole des Beaux-Arts, and also in the atelier of Fernand Léger, learning to paint. In 1938 Bourgeois married the American art historian Robert Goldwater and moved with him to New York, where she developed a career as an abstract painter and printmaker. Switching to sculpture in the late 1940s, Bourgeois had her first one-woman show at the Peridot Gallery in 1949. There she exhibited one of her signature works, The Blind Leading the Blind (plate 110), seven pairs of painted wooden posts connected by a horizontal lintel. This sculpture has been interpreted both as a symbol for Bourgeois's family in France, whom she missed, and as a commentary on the repressive atmosphere of the McCarthy era. 16 On a formal level, the concept of abstract, discrete forms with a human scale was fairly radical for its time, foreshadowing Bourgeois's own plaster-and-latex "lair" pieces of the 1960s and '70s and the environmental sculpture of Louise Nevelson. Bourgeois has also worked in metal and carved stone, creating massed, rounded forms based on architectural structures or human body parts and suggesting everything from solar energy to political demonstrations.

While the most radical early twentieth-century painters and sculptors were experimenting with varying degrees of abstraction, another equally significant group of artists was taking a second look at figuration—that is, art that features the human figure—giving it an entirely new cast through a series of unique, highly personal interpretations. Sociopolitical commentary and a strong sense of empathy lie at the core of the figurative art produced by Käthe Kollwitz (plate 112). She was born into a large, politically progressive family in Königsberg, an industrial center in East Prussia. By age fourteen she was taking drawing lessons, studying privately since the Königsberg Academy of Art did not admit female students. Four years later Kollwitz was studying art at the Women's School of the Berlin Academy; she also studied in Munich. In 1801 she married Karl Kollwitz, a physician to whom she had been engaged for seven years; in 1896 the first of their two sons was born. For the next fifty years the couple lived in the same modest Berlin apartment building, where she drew her husband's working-class patients as they sat in the waiting room.

A masterful draftsman, printmaker, and sculptor, Kollwitz produced powerful treatments of such universal subjects as poverty and sorrow. Her incomparably moving images of mothers grieving for their dead children are based, in part, on longstanding German artistic tradi-

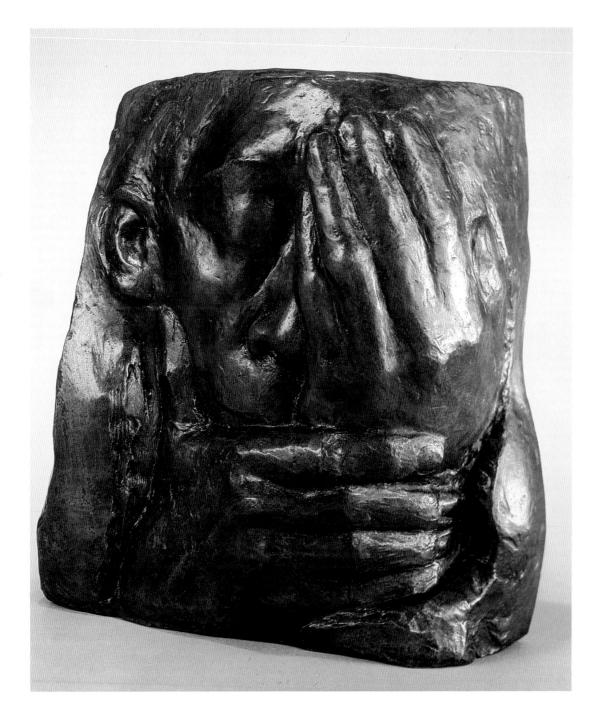

113. Käthe Kollwitz (1867–1945) Lamentation: In Memory of Ernst Barlach, 1938 Bronze, height: 10 ft. 1/4 in. Hirshhorn Museum and Sculpture Garden, Smithsonian Institution, Washington, D.C.; Gift of Joseph H. Hirshhorn, 1966

tion. But they also came from her own experience: her eldest son was killed in the first weeks of World War I, and a grandson was killed in World War II. In 1900 the King of Saxony had awarded Kollwitz a gold medal for *The Weaver's Uprising*, a cycle of prints depicting an 1844 workers' rebellion, but that official recognition, which continued through the 1920s, was of no help when the Nazis came to power. Her husband was prevented from practicing medicine, and the Gestapo harassed Käthe, banning her from public exhibitions because of the overtly leftist political content of her work. Karl died in 1940, and three years

141

later their home was destroyed by a bomb. In her sculptures, as well as her prints and drawings, Kollwitz eloquently communicated the extraordinary compassion of her response to such tragedies (plate 113).

Both Käthe Kollwitz and Florine Stettheimer made pointed

commentaries through their art. But whereas Kollwitz employed a few large forms, restricted colors, simple backgrounds, and highly expressive faces and gestures to make points about the political and economic realities of ordinary German citizens, Stettheimer crowded her canvases with myriad small figures, bright colors, detailed settings, and innumerable incidents to poke fun at New York's high society. Although her pictures are often labeled "fantasies," in fact Stettheimer's flat figures, intense colors, and inconsistent perspective are the intentionally primitive, often sharply satirical statements of a witty and sophisticated, albeit eccentric, New York painter. Trained at the Art Students League and briefly in Berlin, Stettheimer ran a celebrated salon, along with her wealthy mother and two unmarried sisters, who also had unusual talents: Ettie earned a Ph.D. degree in philosophy and published two novels, and Carrie spent twenty-five years creating an elaborate dollhouse with its own miniature art gallery, complete with tiny pictures executed by noted modernist painters. 17

After receiving negative reviews for her first solo show (at the Knoedler Gallery in 1916), Stettheimer exhibited her art almost exclusively at private showings in her own apartment. Stettheimer's paintings both celebrate and mock the elite of Manhattan: her subjects include the ostentatious marriage of two wealthy Manhattanites, featuring diamonds from Tiffany's suspended on a banner in the sky and a Rolls-Royce with a dollar sign on its grille; a view of Wall Street with a pediment labeled "Stock Exchange" dominating the center of the canvas like a Greek temple; and a composite portrait of the New York art world that makes pointed references to the politically motivated policies of both large museums and individual dealers. In her Spring Sale at Bendel's (plate 114), a horde of well-dressed women frantically vie with one another for bargains, admiring themselves as they try on a series of ludicrous costumes. Stettheimer's greatest critical triumph came in 1934, when she created the costumes and sets—made of cellophane, seashells, and lace—for Four Saints in Three Acts, an opera by Gertrude Stein and Virgil Thomson. A book of Stettheimer's poetry, Crystal Flowers, was published in 1949.18

In contrast to the lively, almost manic atmosphere of Stettheimer's paintings, the art of Gwen John depicts a quiet world of solitude. John's pictures reveal the artist's great sensitivity to nuances of color and to the personality of her subject, whether a room, a woman, or a cat. The example illustrated here (plate 115) shows John's delicate use of pigment and her ability to produce a haunting image based on a rather ordinary scene, concentrating the viewer's attention on such telling de-

Page 142 114. Florine Stettheimer (1871–1944) Spring Sale at Bendel's, 1921 Oil on canvas, 50 x 40 in. Philadelphia Museum of Art; Given by Miss Ettie Stettheimer

Page 143
115. Gwen John (1876–1935)
A Corner of the Artist's Room in Paris, c. 1907–9
Oil on canvas, 12¾ x 10¾ in.
Sheffield City Art Galleries,
England

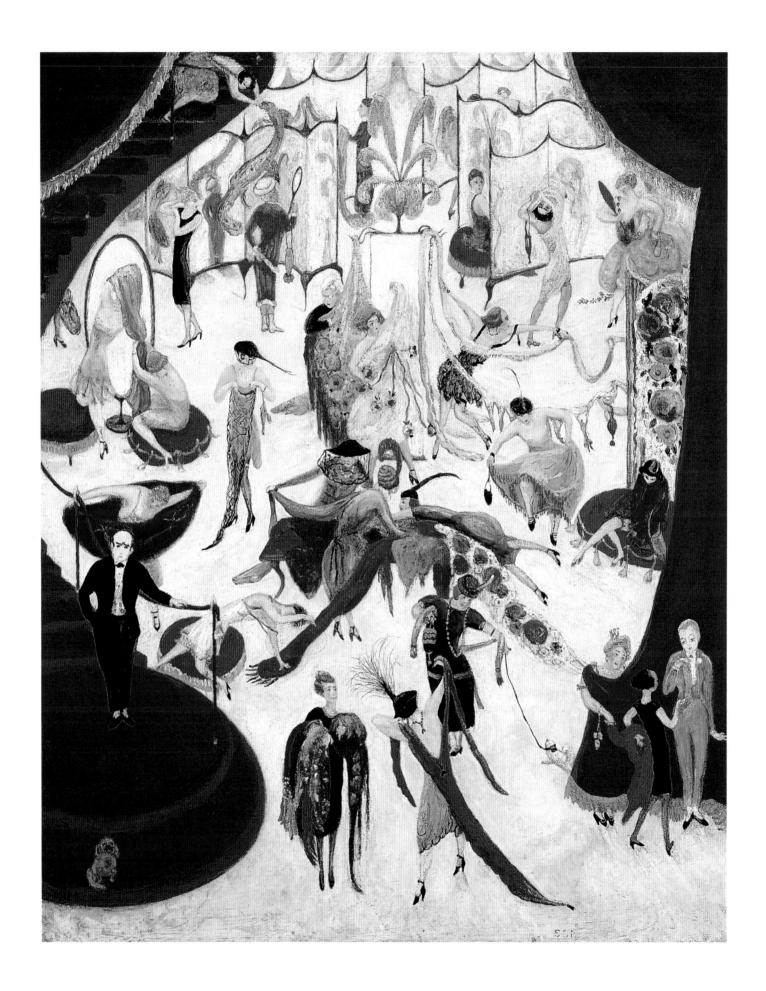

Left 116. Vanessa Bell (1879–1961) Lytton Strachey, 1912 Oil on board, 14 x 10 in. Anthony d'Offay Ltd., London

Right, top 117. Duncan Grant (1885–1978) Vanessa Bell, c. 1918 Oil on canvas, 37 x 23% in. National Portrait Gallery, London

Right, bottom
118. Romaine Brooks (1874–1970)
Self-Portrait, 1923
Oil on canvas, 46½ x 26½ in.
National Museum of American Art,
Smithsonian Institution,
Washington, D.C.; Gift of the artist

tails as the peeling paint beneath the small table and the pattern of light falling through the windows onto the dull-brown hexagonal floor tiles.

Born in Wales, John was eighteen months older than her flamboyant brother Augustus, a successful portrait painter and Royal Academician who became a professor at the University of Liverpool and a trustee of the Tate Gallery. Their mother died when Gwen was seven; thereafter, the children were raised by their father and two aunts. Even as youngsters, Gwen and Augustus were painting, mostly portraits of neighborhood children. In 1895 Gwen started studying at the Slade School of Art in London, where she learned an Impressionist style. She traveled to Paris for further training at the school run by James McNeill Whistler, and in 1903 she settled in Paris, where she remained the rest of her life.

A shy, introspective woman, John seldom exhibited her works and hated to sell them. However, she did attract the attention of the American collector John Quinn, who became her chief patron, providing her with a modest stipend in exchange for her pictures. In 1906 John met Rodin, whose model and lover she became; she also got to know his secretary, the German poet Rainer Maria Rilke, with whom she corresponded for many years thereafter. After a period of intense introspection John converted to Catholicism in 1913; religion continued to play an important role in her life, and she painted portraits of many of the residents of a nearby convent. Remaining single, John spent her last decades living alone, in near-isolation in a dilapidated building, surrounded by her beloved cats. ¹⁹

Although John spent virtually her entire adult life in Paris, French modernism was never important for her work. Conversely, John's contemporary, Vanessa Bell (plate 117), remained in England and was greatly inspired by the French artistic experiments of the late nineteenth and early twentieth centuries. The fashionable Bloomsbury circle, an influential group of English writers, artists, and intellectuals, more or less revolved around a single family: the Stephens. One daughter of Sir Leslie Stephen was the novelist Virginia Woolf; her older sister was Vanessa Bell, one of the most innovative British painters of the century. After studying at the Royal Academy and traveling through Italy, in 1907 Vanessa married Clive Bell, a noted art historian. She was close to the most important members of the British art world—including Roger Fry, who organized controversial exhibitions of European modernism, and Duncan Grant, a well-known painter who was her companion for over fifty years. A work such as Bell's portrait of the writer Lytton Strachey—a cousin of Grant's (plate 116)—would have seemed particularly radical in England, since by 1912 Fauve-style exaggeration of colors and loose, painterly outlines were still upsetting viewers even in less conservative France. One of the first British artists to make totally abstract pictures, Bell also produced innovative designs for textiles, mosaics, pottery, and book illustrations.

Like Bell, the American painter Romaine Brooks (plate 118) came from a privileged background, but the resemblance ends there. Brooks had an extraordinarily unpleasant childhood and an unusually peripatetic adult life. She was born in Rome to a rich, unbalanced mother whose husband had deserted her and who forced her young daughter to care for her older brother, who was mentally unstable as a child and became dangerously paranoid as he reached adolescence. At the age of six or seven Romaine was abandoned by her mother and

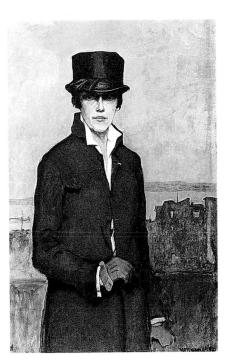

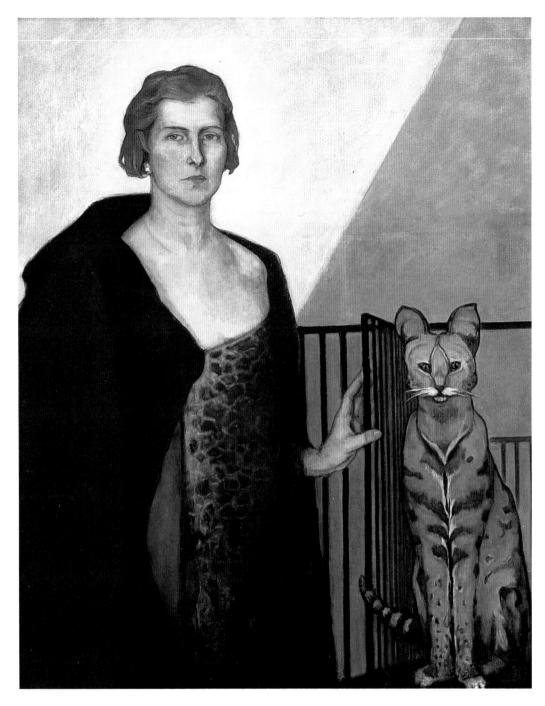

119. Romaine Brooks (1874–1970) *Emile d'Erlanger, La Baronne,* c. 1924 Oil on canvas, 41% x 34 in. National Museum of American Art, Smithsonian Institution, Washington, D.C.; Gift of the artist

taken to her grandfather, who sent her away to schools in New Jersey, Italy, Switzerland, and France. Brooks went to Rome in 1896 to study art, but soon moved to Capri. After both her mother and brother died in 1902, Brooks inherited a fortune, married John Ellingham Brooks for form's sake, and then lived openly as a lesbian, first in London and then Paris, with her companion of forty years, the American poet Natalie Barney. Brooks is best known for the haunting portraits she made of her friends (plate 119). Her palette—predominantly black, white, and gray —shows the influence of her favorite artist, Whistler. Many of her works are now at the National Museum of American Art in Washington, D.C.

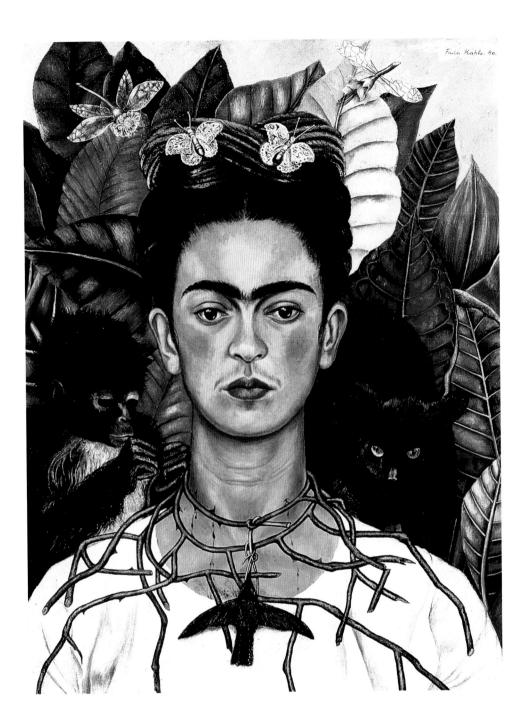

120. Frida Kahlo (1910–1954) Self-Portrait, 1940 Oil on canvas, 24½ x 18¾ in. Harry Ransom Humanities Research Center Art Collection, The University at Austin, Texas

Brooks's life and work were undoubtedly shaped by the emotional scars she suffered during her youth. In the case of Frida Kahlo, it was ongoing physical trauma that determined much of the path she would follow. Kahlo nearly lost her life at age fifteen in a terrible street-car accident that crushed her pelvis and spine. Although she survived another twenty-nine years, Kahlo lived in nearly constant pain, despite undergoing thirty-five operations. This physical reality, which also prevented her from having the children she desperately desired, became the theme for much of Kahlo's art. Many of her self-portraits make disturbingly direct references to the heavy braces she had to wear and

to her several miscarriages. Others (see plate 120) are more subtle, combining lush, fantastic imagery—fleshy green leaves, lace-winged insects, and a friendly monkey—with the blood slowly dripping from the thorns around Kahlo's neck. Here, she combined elements from Mexican folk art and traditional Christian symbolism to make her own very personal style. Born in Coyoacán, a suburb of Mexico City, Kahlo developed a crush on the much older painter Diego Rivera, whom she swore she would marry. She eventually did so, twice, and their stormy relationship became as famous as their work. Rivera was considered one of the "great four" of modern Mexican art (along with José Orozco, Rufino Tamayo, and David Siqueiros); his work also influenced American painters, primarily through the murals he executed in New York during the early 1930s. Kahlo's art has been honored by the Mexican government, which has turned her birthplace into the Frida Kahlo Museum, a fascinating repository of her pictures and her collection of Mexican folk art, which conveys a vivid sense of the environment in which this passionate woman spent much of her life. Noted for the panache with which she dressed—generally in elaborate Mexican regional costumes festooned with multicolored embroidery, ribbons, and flowers—Kahlo was friends with many of the most interesting political and artistic figures of the day, including Leon Trotsky, Nelson Rockefeller, the Surrealist leader André Breton, Isamu Noguchi, and Clare Booth Luce.

While Frida Kahlo's portraits are unnerving because of their searing references to physical and psychic pain, Alice Neel's may shock the viewer with her forthright way of presenting such commonplace but rarely depicted subjects as pregnancy (plate 121) and frontal male nudity. Born to a well-off Philadelphia family, Neel rejected her background to marry a Cuban student and embark on a struggling existence in New York's Greenwich Village. Her life was filled with tragedies: the death of a child, a series of disastrous relationships with men, a nervous breakdown, a suicide attempt. And though she began to exhibit her paintings in 1932, her first major retrospective (at the Whitney Museum) was not held until forty-two years later. Despite all this, Neel continued painting, raised two sons, and developed a unique approach to the venerable American tradition of portraiture. Her frank portrayals of family members, famous artists, and anonymous neighbors are invariably startling. Children in strange hats, elderly couples, and nude men-most notoriously, a picture in which the New York poet Joe Gould sports three sets of genitals—fix the viewer with penetrating gazes that demand a stare in return.

Genre scenes had become popular in the United States during the 1840s, when painters such as William Sidney Mount and sculptors such as John Rogers produced works celebrating the simple pleasures of rural life. This tradition continued into the early twentieth century with 121. Alice Neel (19∞–1984) Margaret Evans Pregnant, 1978 Oil on canvas, 57¾ x 38 in. Robert Miller Gallery, New York

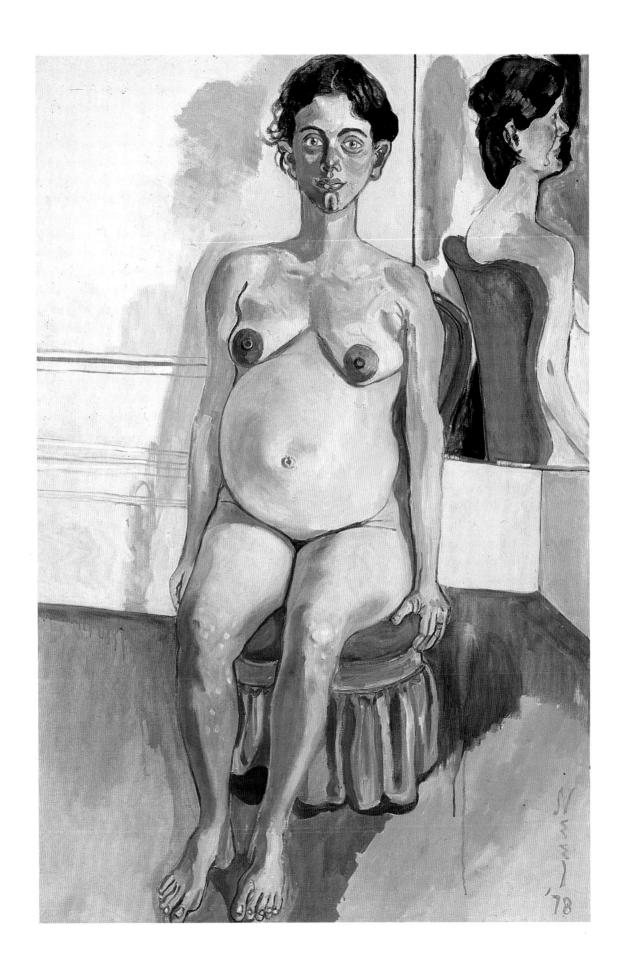

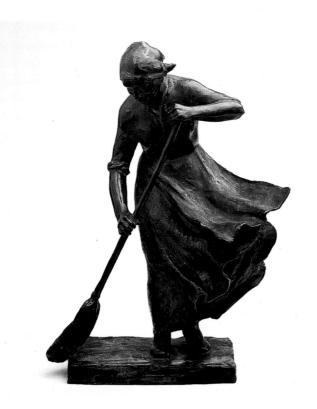

Left
122. Abastenia St. Leger Eberle
(1878–1942)
Windy Doorstep, 1910
Bronze, 13⁵/₈ x 9³/₈ x 6³/₈ in.
Worcester Art Museum,
Worcester, Massachusetts

Below 123. Abastenia St. Leger Eberle, n.d.

Right
124. Isabel Bishop (1902–1988)
Bootblack, 1932
Oil on canvas, 19¾ x 16½ in.
Hirshhorn Museum and Sculpture
Garden, Smithsonian Institution,
Washington, D.C.; Gift of
Joseph H. Hirshhorn, 1966

the work of American genre sculptors such as Abastenia St. Leger Eberle (plate 123) and urban scene painters such as Isabel Bishop.

One of the most popular works by Abastenia St. Leger Eberle is Windy Doorstep (plate 122), a small bronze sculpture modeled at the artist's summer cottage in Woodstock, New York, after she had listened to the local farmers' wives debating the proper techniques for sweeping.²⁰ This piece, which was awarded a prize when it was exhibited at the National Academy of Design in 1910, demonstrates Eberle's ability to convey a sense of movement in three dimensions. The breeze whips the woman's skirt to one side as she concentrates intently on her task, eyes down and elbows locked; the fact that the broom extends beyond the sculpture's base also adds to the feeling of brisk motion. Many of Eberle's other sculptures likewise stress movement, through expressive gestures and daringly open compositions, with arms or legs projecting out into space. Eberle was born in Iowa and raised in Ohio and Puerto Rico. In 1899 she moved to New York, where she studied at the Art Students League. During 1904 Eberle shared a studio with Anna Hyatt Huntington (see chapter 4); the two collaborated on several sculptural groups, Huntington contributing the animals and Eberle the human figures. After trips to Italy and France, in 1914 Eberle settled in Manhattan, where she specialized in sculptures of local children at play.

Isabel Bishop spent more than sixty some years painting the urban landscape of New York. Her pictures neither celebrate nor criticize; they lovingly describe ordinary moments—two women chatting on

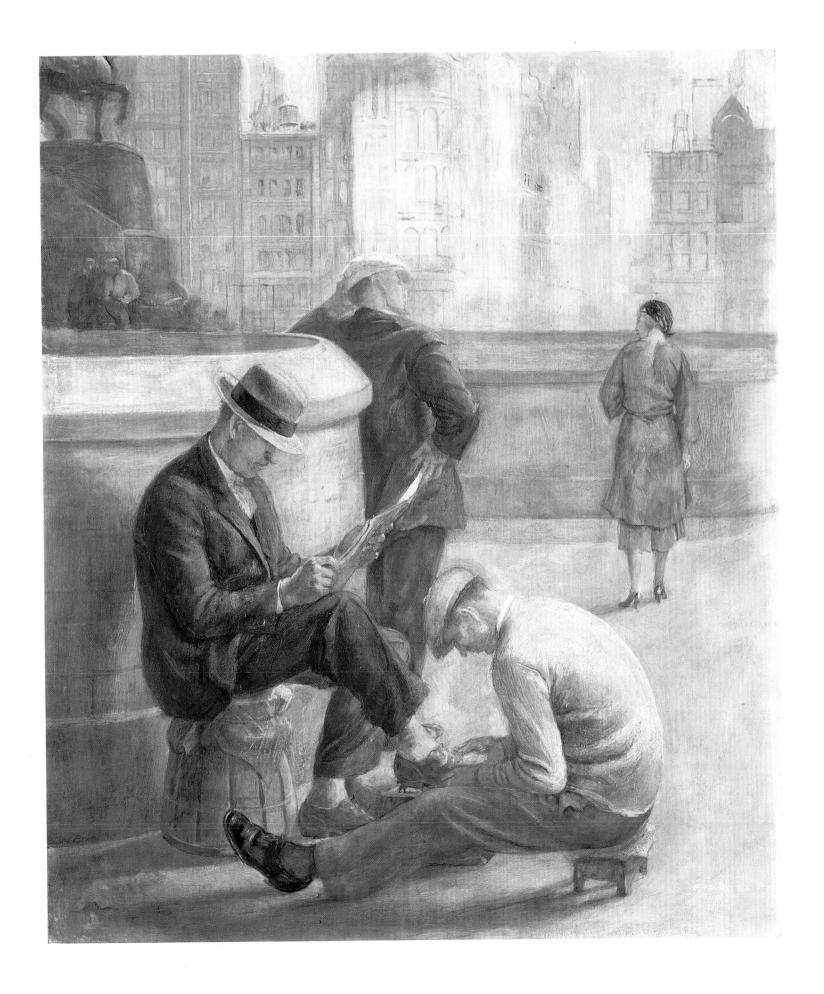

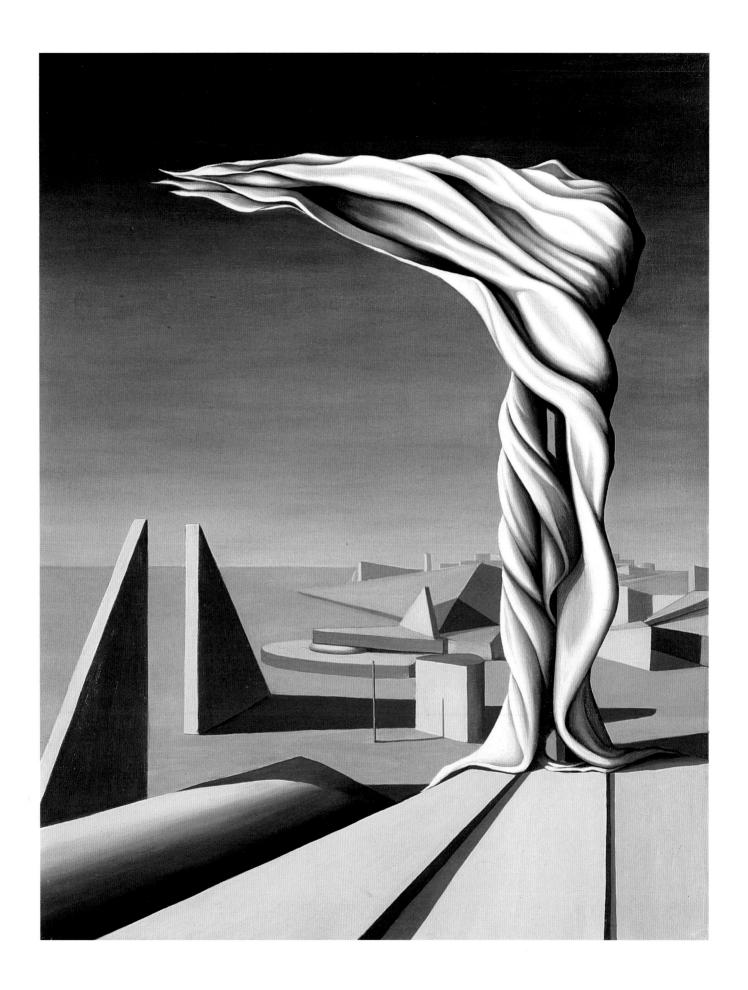

125. Kay Sage (1898–1963)

I Saw Three Cities, 1944
Oil on canvas, 36 x 27% in.
The Art Museum, Princeton
University, Princeton, New Jersey;
Gift of the Estate of Kay Sage
Tanguy

their lunch break, a man getting a shoeshine (plate 124). Bishop was born in Cincinnati and raised in Detroit, where she first studied art. In 1918 she moved to New York; after studying illustration, she enrolled at the Art Students League. Later, Bishop was one of many American artists (forty-one percent of them female) who were employed during the Depression years by various federal art projects. Her work, which has been exhibited regularly since the 1930s, combines an impression of urban activity with a remarkable sense of quiet. Bishop's pictures have been compared with the work of Reginald Marsh, who also painted the New York scene, but in a far more dynamic, sensual, even raucous manner; her muted tone is more closely related to that of Kenneth Hayes Miller, her principal teacher at the League.

During the late 1920s and '30s, Surrealism became a powerful force within the avant-garde, transforming literature and film in addition to the visual arts and influencing culture throughout Europe and the United States. Today Surrealism is associated principally with a group of male writers and painters—André Breton, Salvador Dali, René Magritte, Yves Tanguy, Max Ernst—but several women artists were also active in this movement. ²¹ A basic premise of Surrealism is that the artist should seek inspiration not from the outside world, but within her or his own subconscious. The result is paintings and sculptures that juxtapose unrelated and sometimes unidentifiable objects to produce highly irrational images that are frequently violent or erotic.

The life of the American Surrealist painter Kay Sage was, in itself, surreal. The daughter of a wealthy family in upstate New York, at age twenty-seven Sage married an Italian prince and moved with him to Rome. They were divorced ten years later, at which time Sage began writing and painting; she had her first solo exhibition of paintings in Milan in 1936. While living in Paris, Sage attracted the attention of the Surrealists, including Yves Tanguy, whom she married in 1940. The couple settled in Connecticut and exhibited their paintings, both separately and together, in Europe and America. After Tanguy died in 1955, Sage went through a period of seclusion. Four years later she began losing her eyesight; this caused a severe depression, leading to an unsuccessful suicide attempt in 1959. Sage rallied and put together material for a 1960 retrospective. But the depression recurred, and in 1963 she shot herself through the heart.

I Saw Three Cities (plate 125) demonstrates how Sage both resembles and differs from most of the other Surrealists. Unlike Dali or Magritte, for example, she avoids painting specific dream imagery, living creatures, or complex narratives. Sage's art is closer to that of Tanguy, in that she also created a totally believable, if unfathomable, world in which every geometric shape, every cast shadow, and every mysterious fold of fabric is carefully rendered with just a few cool colors.

Left
126. Dorothea Tanning (b. 1910)
Guardian Angels, 1946
Oil on canvas, 48 x 35 in.
New Orleans Museum of Art;
Museum purchase through the
Kate P. Jourdan Fund

Above 127. Remedios Varo (1913–1963) Creation of the Birds, 1958 Oil on Masonite, 20¹/₁₆ x 24⁵/₈ in. Private collection Another American painter, Dorothea Tanning, was converted to Surrealism when she saw the 1936 exhibition Fantastic Art, Dada, Surrealism at the Museum of Modern Art. Tanning had difficulty convincing her parents that she wanted to become an artist. Despite their objections, in 1935 she moved from Illinois to New York, where she met many of the leading Surrealists. Four years later Tanning arrived in Paris, armed with a letter of introduction to Max Ernst. Because of the threat of war, many artists had left Europe, and Tanning was frustrated in her attempt to join the Surrealist circle. She finally met Ernst three years later, in New York, and married him in 1946. They lived first in Arizona and then in Paris until Ernst died in 1976. Tanning now lives and works in New York.

Tanning's first one-woman exhibition was held at the Julien Levy Gallery in 1944. Many of her pictures from that period feature nightmarish images of female figures in situations that combine eroticism and implied physical violence. *Guardian Angels* (plate 126), more abstract than her usual style, is a singularly ironic image: far from protecting small children, the winged creatures snatch the helpless figures from their beds, flying off with them to some unknown and menacing destination.

The child of a hydraulic engineer, the Spanish painter Remedios Varo (plate 128) often used imagery related to her father's profession. Fantastic vehicles and scientific apparatus recur throughout her work, often related to her studies of alchemical theories and processes. Educated in Spanish convent schools, Varo was married briefly to an art student; her second husband was the Surrealist poet Benjamin Péret, with whom she lived in Paris until 1939, when the war forced them to escape to Mexico, where she remained the rest of her life.

Varo's paintings are full of imagined figures—glowing humanoids, four-legged roosters—in a world where the laws of gravity have been suspended. Along with her good friend the Surrealist painter Leonora Carrington, Varo shared an interest in dream imagery, alchemy, witchcraft, the spiritualism of G. I. Gurdjieff, and a meticulous attention to the craft of painting. In *Creation of the Birds* (plate 127) a mysterious feathered figure combines the pigments distilled by an eccentric machine with sound impulses from a violin and the light of a distant star to paint images that are magically transformed into living birds that fly around her studio.

Whereas Varo's pictures create a universe all their own, Carrington's deal more specifically with elements from her own life. From early childhood Carrington rebelled against the upper-class British society in which her parents expected her to function. The daughter of a wealthy textile manufacturer, she was expelled from several private schools for her unruly behavior. Carrington learned to paint at a boarding school in Florence, then studied at Amédée Ozenfant's London art

Below 128. Remedios Vario, n.d.

Right
129. Leonora Carrington (b. 1917)
Self-Portrait, 1936–37
Oil on canvas, 25½ x 32 in.
Pierre Matisse Gallery, New York

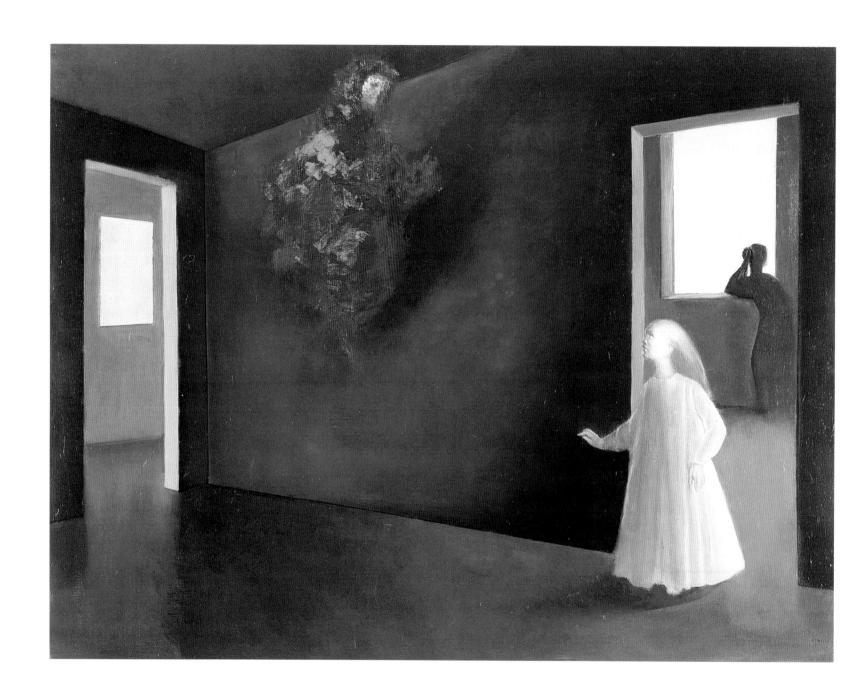

both there and in Germany, at age nineteen she moved to Paris and enrolled at the Académie de la Grande Chaumière. There she met several of the Surrealists and began exhibiting with them in 1933; she also served as the model for many of Man Ray's most intriguing photographs (plate 133). Oppenheim was distressed by the flurry of publicity that was directed at her after the exhibition of her notorious teacup. During the next twenty years she made relatively little art, due to a crisis of self-confidence and a feeling of isolation while living in Switzerland during World War II. However, from the late 1950s until her death, Oppenheim produced and exhibited paintings, sculptures, and Surrealist furniture. Some of her last works, made in Paris and Bern, combine many different materials and levels of reality.

From the Cubist-inspired pictures of Natalya Goncharova and the pioneering abstractions of Georgia O'Keeffe to the Surrealist fantasies of Dorothea Tanning, the innovative art produced by avant-garde women painters and sculptors during the early twentieth century made a tremendous impact on the art worlds of both Europe and America. Other women artists, while less radical in terms of form, made equally significant contributions through their powerful political statements (Kollwitz), their unflinching descriptions of imperfect human bodies (Neel), and their fond evocations of scenes from everyday life (Eberle and Bishop). By the early 1900s artists had achieved an unprecedented degree of freedom to choose their own subjects, materials, and styles. Continuing in that direction, the second half of the century has been marked by still more radical developments and further questioning of the definition—and the role—of art.

Above 133. Man Ray (1890–1977) Méret Oppenheim—Erotique Violée, 1933 Estate of Juliet Man Ray

Right
134. Méret Oppenheim
(1916–1986)
Object (Breakfast in Fur), 1936
Fur-covered cup, saucer, and spoon, overall height: 24% in.
The Museum of Modern Art,
New York; Purchase

as Post-Surrealism, in which carefully chosen symbolic objects were placed within cool-colored spaces to achieve a strange but tranquil effect. Lundeberg's later work includes numerous public murals and award-winning easel paintings that became less and less detailed, with fewer and fewer colors, some with figures, others without. Her recent pictures (plate 132) still radiate the same sense of both mystery and calm that characterized her work from the 1930s.

Although Surrealism is almost always considered in terms of painting, there have also been Surrealist sculptors. One of the most important of these is the Swiss artist Méret Oppenheim, whose furcovered teacup, saucer, and spoon (plate 134) attracted the attention of André Breton when it was exhibited at the Museum of Modern Art in 1937; by now, it has become an icon of Surrealism.

Born in Berlin, at the start of World War I Oppenheim moved with her family to her mother's native Switzerland. After studying art

132. Helen Lundeberg (b. 1908) Tree Shadows, 1982 Acrylic on canvas, 35 x 50 in. Tobey C. Moss Gallery, Los Angeles

Left 130. Leonor Fini (1908–1996) Red Vision, 1984 Oil on canvas, 17 1/8 x 205/8 in.

Below 131. Leonor Fini, 1982

Private collection

academy, where she found the atmosphere too strict. In 1937 Carrington met the Surrealist artist Max Ernst; the two fell in love, he left his wife, and they moved to France together. However, with the outbreak of World War II, Ernst was interned as an enemy alien. Increasingly concerned about his safety, and her own, Carrington fled to Spain, where she suffered a mental breakdown and was institutionalized. By the time she met Ernst again, in Lisbon in 1940, he had become involved with Peggy Guggenheim, whom he married one year later.

Today Carrington divides her time between Mexico and New York and, in addition to painting, she has published two novels, a pair of plays, and several collections of short stories. Painted when she was only twenty, her *Self-Portrait* (plate 129) includes several highly personal images that recur throughout Carrington's painted and written works. Chief among these is the rocking horse, which refers to the one in her childhood nursery. Whitney Chadwick traces the concept of a magical white horse, like the one seen through the window on the left, to the Celtic legends that Carrington learned from her Irish mother.²² The lactating hyena also appears in several Carrington paintings and stories.

Leonor Fini (plate 131) was born in Buenos Aires but raised in Trieste. Interested in painting from childhood, she participated in her first group exhibition at seventeen. Fini met members of the Surrealist group in Paris in 1936, becoming friends with Carrington, Salvador Dali, Max Ernst, and René Magritte, among others. A fiercely independent woman, unwilling to submit either to the group's shared goals or the pronouncements of André Breton, Fini never joined the Surrealists. However, she did take part in their exhibitions, and the irrational elements in many of her paintings are related to the Surrealist sensibility. For example, in *Red Vision* (plate 130), Fini shocks the viewer by introducing an amorphous apparition within a conventional interior space. The contrast between the explosive colors and painterly form of this vision and the carefully modeled, gray-toned little girl who observes it, enhances the feeling of uncanny disjuncture.

Although she was not part of the Surrealist movement, for fifty years Helen Lundeberg has been producing art that is closely related to Surrealism. In fact, the style she cofounded during the 1930s, featuring introspective, enigmatic images portrayed in a carefully ordered, rational-seeming manner, became known as Post-Surrealism. Lundeberg moved with her family from Illinois to Southern California when she was four. In junior college she majored in English, but at age twenty-two she began to study painting. Her first few months at the Stickney Memorial School of Art in Pasadena were uninspiring, until Lorser Feitelson took over her class. A pioneer American modernist who had lived in Paris, where he was strongly influenced by Surrealism, Feitelson was an exciting teacher. He encouraged Lundeberg to exhibit her pictures and eventually became her husband. By 1933 Feitelson and Lundeberg had developed what they called New Classicism and others referred to

MID-CENTURY TO THE MID-1980s

I am never free of the past. I have made it crystal clear that I believe the past is part of the present which becomes part of the future.

—Lee Krasner, 1977

uring the late 1940s and '50s a phenomenon occurred that the art historian Irving Sandler has called "the triumph of American painting." With the development of Abstract Expressionism, for the first time Western Europeans found themselves looking to the United States—and specifically New York—for the lead in artistic innovation. This reordering of the international art world coincided with the emergence of the postwar United States as a world power and led to its prolonged artistic dominance. The evolution of Abstract Expressionism was clearly related to the psychological impact of World War II. Artists questioned what kind of work could be meaningful in a world that had suffered genocide and the atom bomb. Traditional abstraction seemed too cold, and American Scene painting (realistic celebrations of American life, which had been extremely popular during the 1930s and early '40s) too provincial for postwar America. Abstract Expressionism, with its visceral approach to abstraction, was far more relevant. It combined two very different elements: abstraction, which had previously been perceived as predominantly cerebral, and expressionism, which emphasized the emotions of both artist and viewer. The Abstract Expressionists generally worked without preparatory drawings; instead, like their Surrealist predecessors, they painted "automatically," making highly personal marks generated by the subconscious. The results retained a strong element of randomness, with accidental splashes and smudges of paint left undisguised.

The problem with Abstract Expressionism, then and now, is that it has been perceived as a peculiarly male phenomenon. The standard image of the Abstract Expressionist painter—exemplified by Jackson Pollock—is a hard-drinking, chain-smoking, angst-ridden man hanging out with his cronies at the Cedar Bar or savagely flinging paint at an enormous canvas. This image did not accommodate women, especially American women of the 1950s. Ironically, after all the strides made working on federal art projects during the 1930s and doing men's work on the home front during the '40s, in the Eisenhower era American women were given to understand that they belonged back at home,

135. Helen Frankenthaler Before the Caves, 1958 (detail) See plate 142 163

taking care of their families. Nevertheless, a number of women did become Abstract Expressionist painters. Two of the most prominent ones developed careers that were eclipsed for many years by those of their more celebrated spouses. But in the last few decades Lee Krasner (who was married to Jackson Pollock) and Elaine de Kooning (Willem de Kooning's wife) have at last been widely recognized as important artists in their own right.

A member of the first generation of Abstract Expressionist painters. Lee Krasner (plate 136) was determined from an early age to be an artist. Like the children of many Russian-Jewish immigrants, she grew up in Brooklyn speaking four languages. Although her family provided her with a rich cultural background, it could not give her financial support, so after graduating from high school Krasner financed her art classes by working as a waitress and an artist's model. During the late 1920s she studied at Cooper Union and at the National Academy of Design. Finding the latter too restrictive. Krasner was far more inspired by the exhibitions of work by Picasso and Matisse that she saw at the newly opened Museum of Modern Art. Her job painting murals for the WPA earned Krasner a regular salary during the Depression; it also gave her the opportunity to work on a large scale, something that would prove useful for her mature pictures. At this time Krasner joined a number of avant-garde organizations, including the politically active Artists Union and the American Abstract Artists, a group dedicated to promoting nonrepresentational art through regular discussions, lectures, and exhibitions. It was through the AAA that she met the Dutch artist Piet Mondrian, who encouraged Krasner to continue exploring abstraction. From 1938 to 1940 she studied with Hans Hofmann, and it was in his studio that Krasner began to develop the spontaneous, gestural approach that would characterize her Abstract Expressionist works.

Krasner met Jackson Pollock when they were both selected to participate in a 1942 group exhibition; she was impressed by the fusion of abstraction and surrealism in his art, a goal she also had been seeking. The two artists married in 1945 and bought a house in East Hampton, Long Island, where they set up separate studios. It was during the late 1940s that Krasner invented the Little Image paintings, her first important series—thickly painted abstract canvases completely filled with repeated, small-scale calligraphic shapes. With their high energy levels and frenetic visual rhythms, these works are quintessential examples of Abstract Expressionism. Krasner's paintings from the 1950s are big abstract canvases that feature fewer and larger shapes, retaining her typical spontaneity and swirling motion (plate 137). An ardent promoter of her husband's work, Krasner introduced Pollock to prominent New York critics, dealers, and other artists. Ironically, her close identification with his art seems to have made it more difficult for Krasner to establish a separate identity as a painter, even after his death in 1956. Fortunately, a number

Above 136. Lee Krasner (1908–1984) Self-Portrait, 1930 Oil on canvas, 30 x 25 in. Robert Miller Gallery, New York

Right
137. Lee Krasner (1908–1984)
Cornucopia, 1958
Oil on canvas, 90½ x 70 in.
Gordon Hampton

of scholarly monographs and important retrospective exhibitions of her work in recent years have helped to reinforce Krasner's preeminence in the history of American modernism.

A prominent member of the second generation of Abstract Expressionists, Elaine de Kooning was stimulated by her mother's evident enthusiasm for art: Mrs. Fried took her daughter to museums, gave her art books, and suggested that she sketch what she saw. Even before she entered high school, Elaine knew that she wanted to be a painter. She studied at the American Artists School and the Leonardo da Vinci Art School, both in New York. An administrator at the latter introduced her to Willem de Kooning in 1938; she became his student and, five years later, his wife.

The de Koonings were a typical New York artist-couple in the 1940s, struggling with serious financial hardships while producing tremendously innovative work. By the early 1950s Elaine was producing stylized paintings based on news photographs of sports figures; she had been an active athlete as a child, and this interest carried over into her mature painting. Also a perceptive art critic, she wrote early articles for Artnews about Arshile Gorky, David Smith, and other American modernists. Feeling the need to get away from the increasingly competitive, high-pressure New York art world, in 1957 de Kooning went to teach art at the University of New Mexico, where she responded enthusiastically to the intense colors and open spaces of the southwestern landscape. A trip to Juárez, Mexico, inspired a series of paintings based on the bullfights she saw there (plate 138). These pictures display the vigorous brushwork and highly stylized treatment of subject that are typical of de Kooning's art. Back in New York in 1959, she started painting twentyfoot-long canvases featuring the colors and forms of New Mexico.

In one respect de Kooning was very unusual for an Abstract Expressionist: along with her abstract work she developed a reputation as a portrait painter. Her likenesses of artists, writers, and politicians are recognizable but also display the artist's interest in slashing, gestural brushwork. De Kooning received her most important portrait commission in 1962, when she was asked to paint President John F. Kennedy. She was working on thirty-six studies, all at different stages, when Kennedy was assassinated; no final portrait was ever produced.

Another member of Abstract Expressionism's second generation is the New Jersey-born artist Grace Hartigan. She did mechanical drafting in an airplane factory to support herself and her son after her husband was drafted in World War II; at the same time she also began to study painting with Isaac Lane Muse and eventually moved into Manhattan with him. Inspired by the works of Pollock and Willem de Kooning, Hartigan produced her own large, energetic pictures, which moved back and forth between pure abstraction and highly stylized images of life in her Lower East Side neighborhood, from peddlers with

138. Elaine de Kooning (1920–1989) Sunday Afternoon, 1957 Oil on Masonite, 36 x 42 in. Ciba-Geigy Corporation, Ardsley, New York

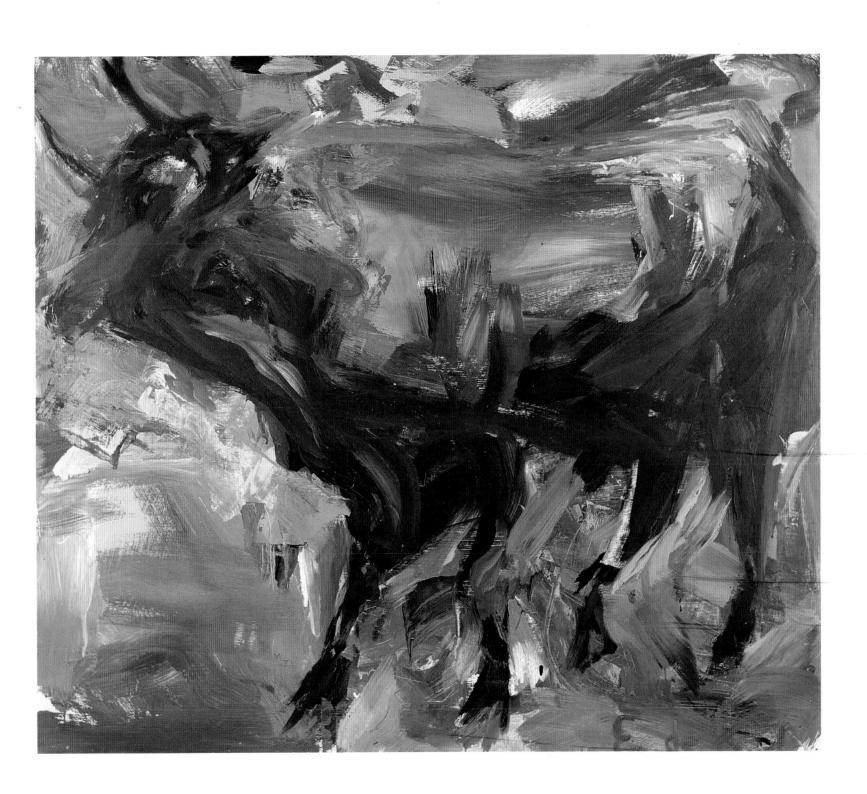

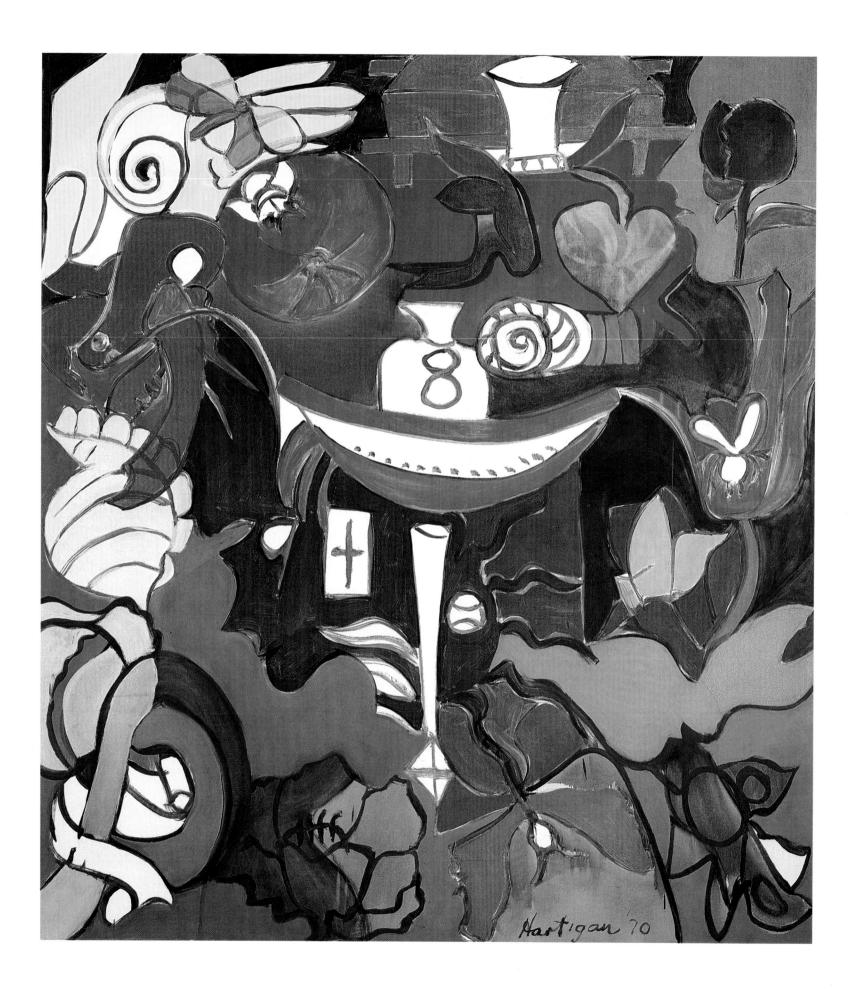

Left 139. Grace Hartigan (b. 1922) The Year of the Cicada, 1970 Oil on canvas, 80 x 72 in. Collection of the artist

Below 140. Helen Frankenthaler in her New York studio, February 1969

pushcarts to bridal parties. By the late 1950s Hartigan's paintings were being acquired by major museums across the country. In 1960 she remarried and moved to Baltimore, where she lives and paints today; Hartigan has also taught for many years at the Maryland Institute of Art. After a period of relative obscurity during the 1960s, there has been a revival of interest in Hartigan's work in the past three decades. Her recent art features boldly outlined forms—many of which are recognizable, others of which are not—and bright, flat, unmodulated areas of color. In *The Year of the Cicada* (plate 139), for example, Hartigan combined specific images—of plants, various insects, a human profile—with more generalized shapes that suggest other living organisms.

Like Hartigan, Joan Mitchell achieved considerable success as an Abstract Expressionist painter in New York during the early 1950s. But rather than remaining in the birthplace of that style, in 1959 she moved to France, where she lived with her then husband, Canadian painter Jean-Paul Riopelle. As a child in Chicago, Mitchell had rejected the upper-middle-class milieu of her family. She started studying painting at the Art Institute of Chicago and in 1948 won a year-long fellowship to France. On her return she established a studio in Greenwich Village in New York and was married briefly to the avant-garde publisher Barney Rosset, founder of Grove Press. Mitchell's work is nonobjective and vigorously calligraphic, but she maintained that many of her huge, often multipart canvases were inspired by the light-filled landscape near her home in Vétheuil, where Claude Monet had once lived (plate 141).

Light and transparency are critical factors in the art of Helen Frankenthaler (plate 140). The youngest child of a New York Supreme Court justice. Frankenthaler attended several private schools in Manhattan before going to Bennington College, where she studied with the Cubist painter Paul Feeley. She was also a pupil of Hans Hofmann, a friend of the influential art critic Clement Greenberg, and was married to the Abstract Expressionist painter Robert Motherwell from 1958 to 1971. Like so many other artists of her generation, Frankenthaler was greatly influenced by Pollock's work, which she saw at a 1950 exhibition at the Betty Parsons Gallery. Two years later Frankenthaler produced Mountains and Sea, an important work fusing the spontaneity of Abstract Expressionism with a revolutionary new technique: stain painting. Working on the floor and using an unstretched, unprimed canvas, Frankenthaler allowed her heavily diluted oil-base pigments to soak directly into the raw fabric. This staining technique had a tremendous influence on other painters, notably Kenneth Noland and Morris Louis.

Frankenthaler's *Before the Caves* (plate 142) illustrates the tremendous energy that characterizes her mature work. Composed of numerous richly layered patches, drips, and swirls of color, the painting's surface implies many levels of space, plus varied textures and vigorous movement.

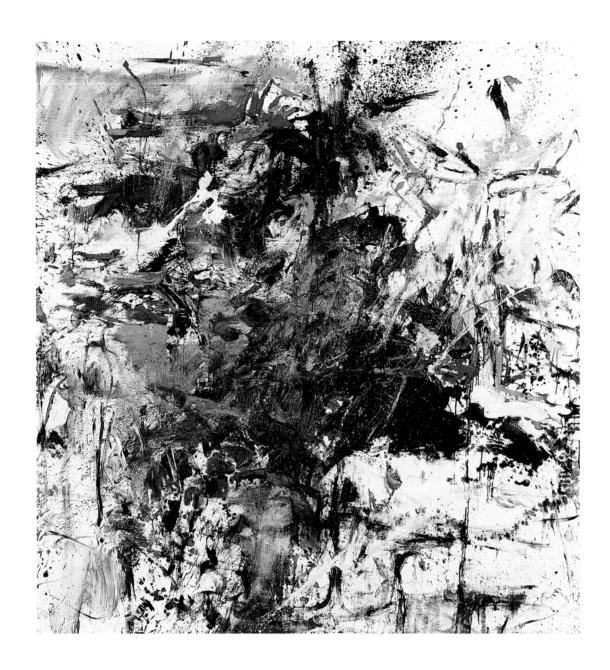

Left
141. Joan Mitchell (1926–1992)
Lucky Seven, 1962
Oil on canvas, 79 x 74 in.
Hirshhorn Museum and Sculpture
Garden, Smithsonian Institution,
Washington, D.C.; Gift of
Joseph H. Hirshhorn, 1966

Right
142. Helen Frankenthaler (b. 1928)
Before the Caves, 1958
Oil on canvas, 102½ x 104½ in.
University Art Museum,
University of California, Berkeley;
Anonymous gift

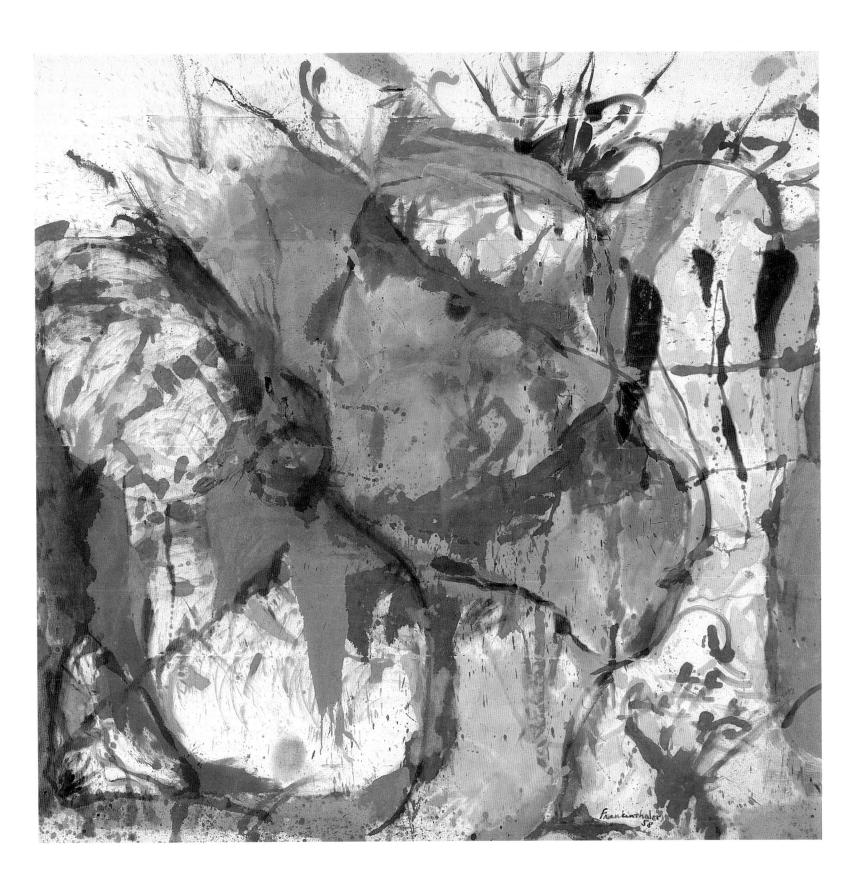

143. Dorothy Dehner (1901–1994) Scaffold, 1983 Fabricated Cor-ten steel, height: 96 in. Twining Gallery, New York

144. Dorothy Dehner, 1986

The sculptural counterparts of Abstract Expressionist paintings are the assembled and welded abstractions produced by the American artist David Smith and his wife, Dorothy Dehner (plate 144). Raised by an aunt in California after the death of her parents and sister, Dehner spent an unhappy year studying theater at the University of California at Los Angeles and then took a year-long trip through Europe, where she was introduced to the most radical new developments in painting, music, and dance. In 1926 she settled in New York, studying painting at the Art Students League. She met David Smith when he moved into the boardinghouse where she lived; they were married the following year and later moved to a farm at Bolton Landing in upstate New York. While Smith concentrated on his sculpture, Dehner—who had no space for a studio of her own—was left with the job of running the farm. Because of those demands on her energy and time and because of what she perceived as Smith's anxiety about potential competition from her art, during the twenty-three years of their marriage Dehner made only paintings—mostly small, deliberately primitive-looking images of their lives together on the farm; she also published some poetry. After their divorce Dehner began to make and exhibit sculptures in cast bronze, carved wood, and Cor-ten steel. The bold and mysterious shapes of many of her works owe something to the spirit of African tribal sculpture, to which Dehner had been introduced by the Russian émigré writer and artist John Graham in the 1920s. In later years Dehner's work became simpler, employing fewer small shapes but retaining its emphasis on tactile surfaces and shaped voids. Scaffold (plate 143), while essentially abstract, nevertheless suggests a multilevel architectural structure. Like many of Dehner's other late sculptures, this one calls to mind the urban environment of Manhattan, where she spent the latter part of her life.

The generation of artists who came to maturity during the 1960s reacted strongly against what they perceived as the emotional excesses of Abstract Expressionism. Some young painters and sculptors remained committed to abstraction but preferred a cooler, cleaner form, characterized by geometric shapes with crisp, hard edges. Others turned to a mass-market, advertising-oriented sort of realism known as Pop art (for "popular culture"). One of the best-known American Pop sculptors was actually born in Paris, of Venezuelan parents. Marisol [Escobar] moved with her family to Los Angeles in 1946; enrolled in the Ecole des Beaux-Arts, Paris, two years later; and by 1950 was living in New York. After studying painting at the Art Students League and with Hans Hofmann, she began to make small clay figures and found sculpture a source of tremendous pleasure. Her first solo show, at the Leo Castelli Gallery in 1959, was well received, and by the early 1960s Marisol had become a prominent artist known for her often biting social and political satires. Her cheerfully painted wooden sculptures, deliberately carved to retain a strong sense of the blocks from which they came, include

Left
145. Marisol (b. 1930)
Women and Dog, 1964
Fur, leather, plaster, synthetic polymer, wood, 72 x 82 x 16 in.
Whitney Museum of American
Art, New York; Purchase with funds from the Friends of the
Whitney Museum of American Art

Right 146. Niki de Saint-Phalle (b. 1930) Black Venus, 1967 Painted polyester, 110 x 35 x 24 in. Whitney Museum of American Art, New York; Gift of Howard and

Jean Lipman Foundation

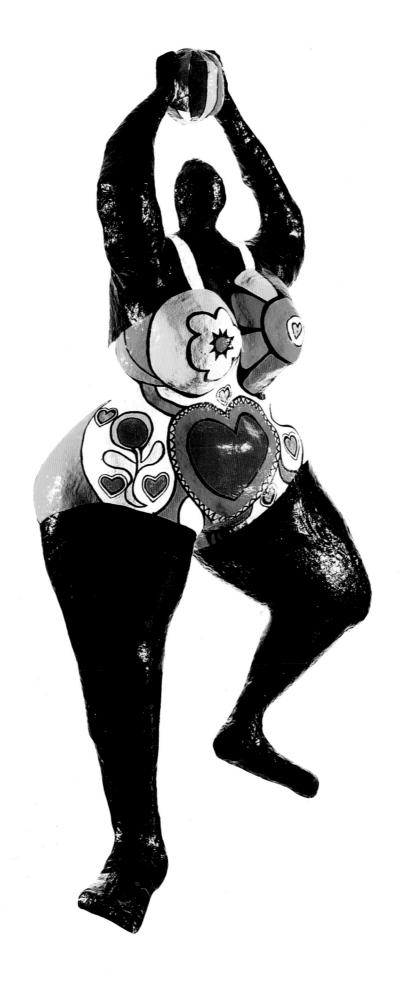

witty portraits of historical heroes, politicos, and Hollywood celebrities, as well as city dwellers shopping, partying, or taking a stroll (plate 145).

In 1963 an 82-foot-long, 20-foot-high hollow sculpture of a woman lying on her back was placed on the floor of Stockholm's Moderna Museet. Visitors entered the figure—which contained a bar, aquarium, planetarium, music rooms, and movie theater—through a door between her legs. The sculpture was Hon (the Swedish word for "she"), designed by the French artist Niki de Saint Phalle.² Born in Paris and raised in New York, Saint Phalle returned to Paris in 1951 and began to paint. By 1956 she was producing her first reliefs, with various humble objects—such as plastic toys and knitting needles—embedded in them; four years later she created various experimental works, including one in which she shot a rifle at plastic bags filled with paint, which then dripped pigment onto the canvases she had set up underneath. During the 1960s Saint Phalle participated in many Happenings throughout Europe and made a number of collaborative works—particularly with the Swiss artist Jean Tinguely, with whom she began living in 1960; she has also made films. Saint Phalle's signature works are her Nanas: large, playful, balloonlike figures of women with their arms outstretched, decorated with gaily painted flowers, hearts, and other folk motifs (plate 146).

Since Abstract Expressionism was a painterly form of abstraction—that is, one in which the pigment and the brushmarks are clearly visible—Post—Painterly Abstraction is the name often given to the style of flat, smooth painting that developed in reaction to Abstract Expressionism. One popular approach to Post—Painterly Abstraction was Op (for "optical") art: abstract paintings that juxtapose vivid colors or black, white, and gray in patterns that seem to vibrate in the viewer's eye. Bridget Riley is one of the acknowledged masters of Op art. Using just a few simple colors and shapes, she manages to create the illusion of three dimensions and motion where neither exists.

After World War II, Riley attended the conservative Goldsmiths' College School of Art in her native London and, in 1952, the Royal College of Art. After graduation she supported herself as a teacher and commercial artist. In the late 1950s an exhibition of Abstract Expressionist painting stimulated her interest in contemporary art outside England. After studying the optical effects of the Neo-Impressionist Georges Seurat, in 1960 Riley began to make the extremely precise pictures for which she is known today. Her participation in *The Responsive Eye*, a 1965 show at the Museum of Modern Art, earned Riley an international reputation. Although Op art went out of fashion very quickly, Riley's work continues to fascinate viewers because of its impeccable technique and sophisticated compositions. The evolution that has occurred in her art is also interesting: Riley's ground-breaking pictures from the 1960s utilized exclusively black, white, and gray and generally repeated one simple form—an oval or a ribbonlike curving line—across

147. Bridget Riley (b. 1931) Recollection, 1986 Oil on linen, 64¾ x 63 in. Juda Rowan Gallery, London

Left
149. Mary Martin (1907–1969)
Compound Rhythms, 1966
Painted wood and stainless
steel on wood and formica,
42½ x 42½ x 4½ in.
Waddington Galleries, Ltd.,
London

Below 150. Eva Hesse, 1965

Page 182
151. Eva Hesse (1936–1970)
Untitled, 1970
Fiberglass over polyethylene
over aluminum wire, 7 units,
height: 74–111 in. each,
circumference: 10–16 in. each
Musée National d'Art Moderne,
Centre Georges Pompidou, Paris

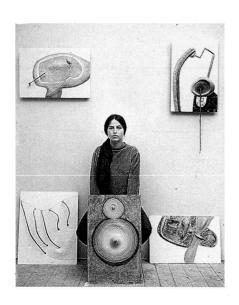

rest of her life. Martin was influenced primarily by two British modernists—Ben Nicholson and Victor Pasmore—and by the abstract constructions of an American, Charles Biederman. However, her work is unique, and its orderly presentation of repeated modular designs is remarkably complex. Although never representational, Martin's reliefs create many illusions, employing colors, mirrored surfaces, and folded forms to create the appearance of motion. In 1956 Martin first collaborated with an architect; the overall rhythms and adaptability of her reliefs, which look good on many different scales, proved quite successful, and Martin went on to execute a number of architectural commissions, including fountains as well as large wall constructions. Martin's work achieved an additional impact when several of her designs were published during the early 1960s; at the same time, she also began to teach. The Tate Gallery presented a retrospective of Martin's work in 1984.

An earlier generation of artists—including Barbara Hepworth, Louise Bourgeois, and Louise Nevelson—had experimented with sculpture as environment. Beginning in the 1960s, a group of women pushed this idea considerably further, creating both interior and exterior sculptural environments made of remarkably varied materials. Many of these works—like Judy Pfaff's—are "site specific," meaning that they are created for a particular location and cannot exist anywhere else; some outdoor pieces—like Beverly Pepper's—are designed to change as the weather changes. Still others—like the public commissons of Nancy Holt—are more traditional in the sense of being permanent structures but are also extremely innovative in the way they combine nontraditional materials, scale, and forms to create an unexpected view of natural and man-made environments.

The sculpture of Eva Hesse (plate 150) combines nontraditional materials with environmental elements. Despite the shortness of her career and her tragic personal life (which included her parents' divorce, her mother's suicide, her own marital breakup, the death of her father, and her own untimely death from a brain tumor at age thirty-four), Hesse managed to produce a significant body of art, the impact of which is still being absorbed today. The German-born artist was only three when her family fled Hitler's regime to settle in New York. She studied art at the Pratt Institute and Cooper Union and received a B.F.A. degree from Yale in 1959. Two years later Hesse married Tom Doyle, also an artist, and soon began to make and exhibit colorful relief collages. She spent 1964 back in Germany with her husband, who had been given financial support to work there for a year. Possibly stimulated by her mixed feelings about returning to the country she had been forced to leave, Hesse developed an entirely new approach to her work that led, on her return to New York, to the eccentric, erotic, organically curving abstractions for which she became known. During the late 1960s Hesse made monochromatic, three-dimensional shapes out of such uncon-

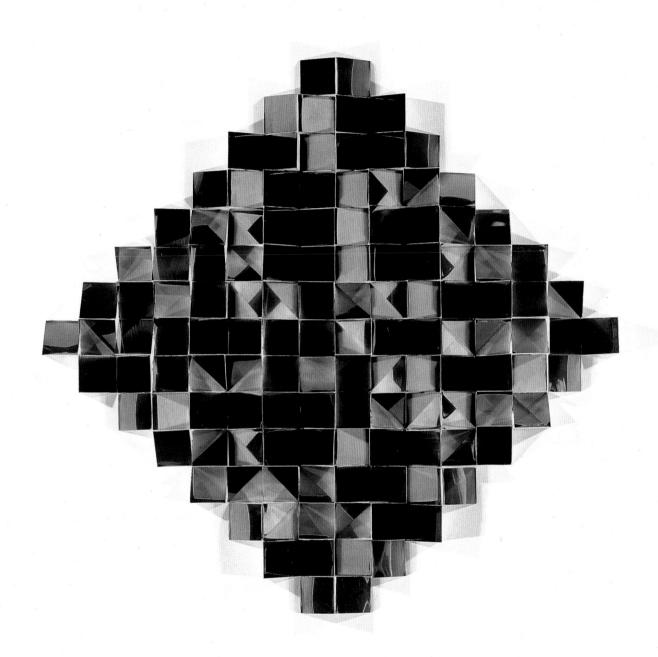

the canvas. Her more recent paintings (plate 147) employ a multicolored palette of powder blues, mustard yellows, oranges, reds, and greens, all relatively close in value, so that her complex interlocking shapes, which resemble woven threads, still produce the illusion of motion but far more subtly than before.

The art of Anne Truitt can be viewed as another sort of reaction to Abstract Expressionism. Her extremely simple compositions—one or two large, smooth wooden rectangles painted with deep, rich colors (plate 148)—are sometimes labeled Minimalist, referring to another movement in nonrepresentational art that began during the 1960s. Minimalist painters and sculptors utilized the absolute minimum number of aesthetic elements—color and form—to produce visually streamlined, often highly cerebral but deceptively simple-looking compositions. Truitt did not begin studying sculpture until the age of twenty-four, after she had received an undergraduate degree in psychology from Bryn Mawr College. Her marriage to the journalist James Truitt took her to various parts of the United States and Japan for twenty years.³ During this peripatetic period of her life, Truitt continued to study and to work, producing drawings, paintings, and sculptures in clay, metal, and wood. The success of her first onewoman show, at the André Emmerich Gallery in New York in 1963, led to other exhibitions, including retrospectives at the Whitney Museum and the Corcoran Gallery of Art. Since the late 1960s Truitt has lived in Washington, D.C.; until her retirement in 1996, she was a professor of art at the University of Maryland.

In her critically acclaimed journals, three volumes of which have now been published,⁴ Truitt explains that she waits until the image of a given sculpture is complete within her mind and then executes it fairly rapidly, re-creating that mental image in physical reality. Her columnar constructions exude such a strong sense of dignity and strength that writers have repeatedly referred to them as "icons." The artist is also concerned with the subtle changes of color and light, both actual and implied, that affect her sculptures as daylight comes and goes and as the viewer moves to observe the works from different angles.

The sculptor Mary Martin also worked with simple geometric forms but, unlike Truitt, she combined a greater variety of sizes and materials within a given piece (plate 149). Martin was born in Kent and trained in London at the Goldsmiths' College School of Art and the Royal College of Art, where she specialized in painting. In 1930 she married Kenneth Martin, a fellow artist, with whom she had two children, one of whom—Paul Martin—also became a professional artist. The turning point in her career came in 1950, when she joined her husband and several other British contemporaries in switching from figurative to abstract art. Her new paintings were simple arrangements of geometric shapes; these soon led Martin to explore relief sculpture, the form with which she became identified and which she continued to explore for the

148. Anne Truitt (b. 1921) King's Heritage, 1973 Painted wood, 96 x 19 x 8 in. André Emmerich Gallery, New York

Below
152. Alice Aycock (b. 1946)
The Savage Sparkler, 1981
Steel, sheet metal, heating coils, fluorescent lights, motors, fans, 10 x 14 x 8 ft.
Plattsburgh State Art Galleries, Permanent Art Collection, SUNY-Plattsburgh, Plattsburgh, New York

ventional materials as rubber tubing, string dipped in fiberglass, and papier-mâché (plate 151). Suspended in series from the gallery walls and ceilings and laid out across the floor, these unique forms became part of the viewer's space. Hesse exhibited regularly during her final years, participating in several important group shows of abstract sculpture. Even as her health deteriorated she continued producing art with the help of assistants; a memorial exhibition of her work was held at the Solomon R. Guggenheim Museum in New York in 1972.

Unlike Hesse's clustered organic constructions, the sculptures of Alice Aycock resemble huge, complex machines, whose precise functions remain tantalizingly unclear (plate 152). Although the works of this

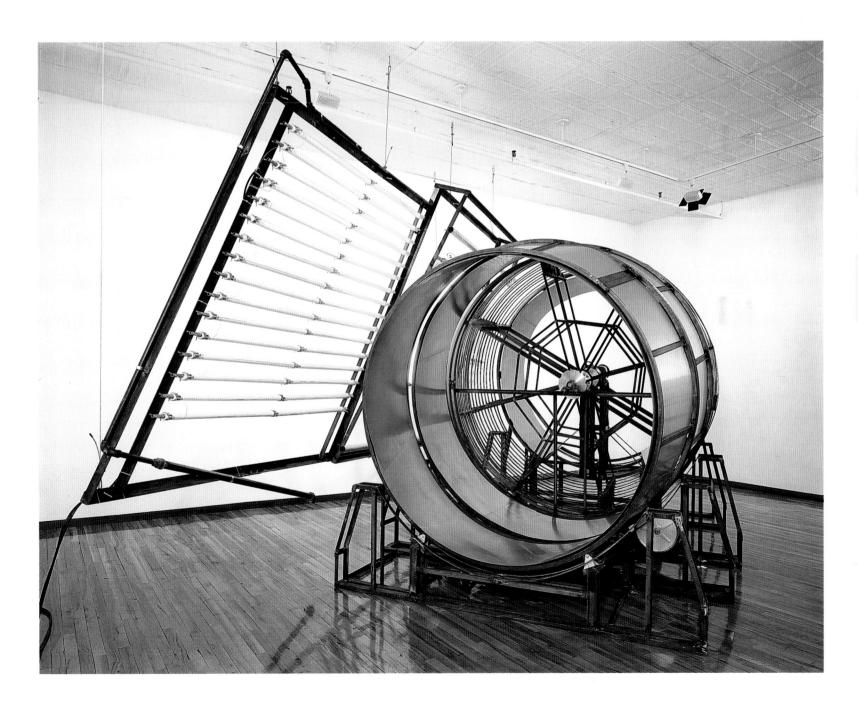

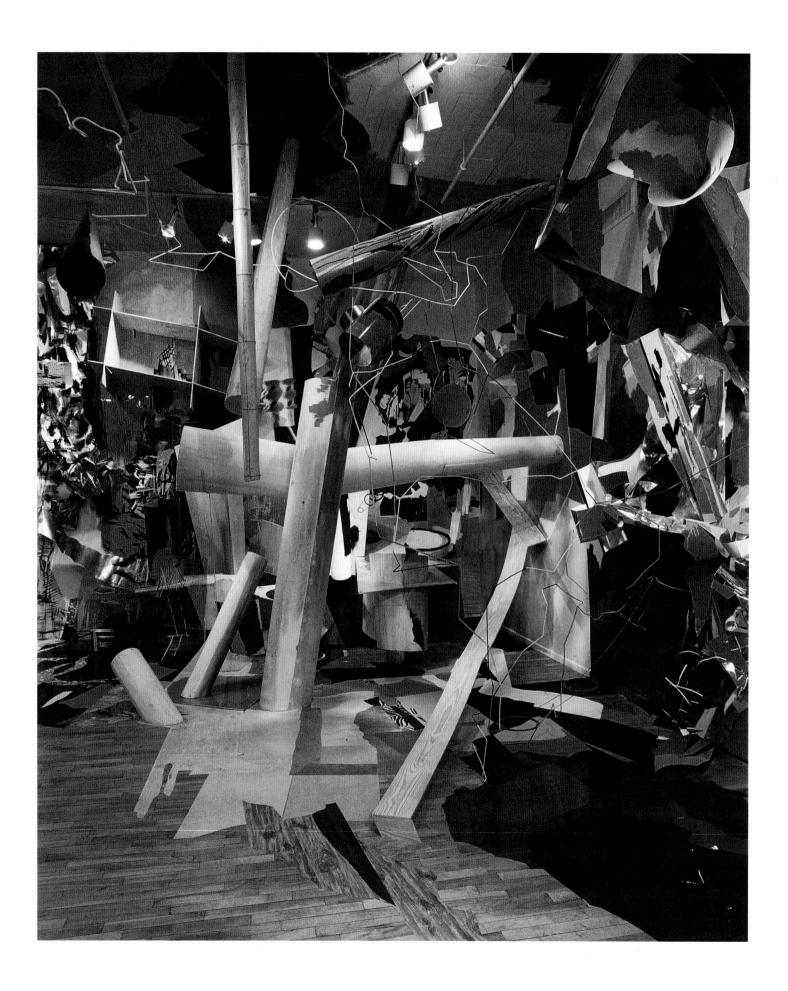

Left 153. Judy Pfaff (b. 1946) 3-D, 1983 Mixed-media installation in a 22 x 35 ft. room Holly Solomon Gallery, New York

Top 154. Judy Pfaff, 1985

Above 155. Beverly Pepper at work on Sand Dunes, 1985 Pennsylvania-born artist typically utilize such standard industrial materials as sheet metal, electric motors, fans, and fluorescent lights, Aycock also has a decidedly spiritualist side. Many of her designs are based on Tantric diagrams, and often her titles, such as *How to Catch and Manufacture Ghosts*, suggest other levels of existence. Aycock's indoor works usually incorporate moving parts, flashing lights, and loud sounds, suggesting the threat of physical violence. The phrase "dimensions variable" applies to many of her sculptures, meaning that their parts have no fixed relationship and can be adjusted to suit each installation.

Judy Pfaff's playfully exuberant environments are also site specific. Her vivid mixed-media shapes made of found materials may fill a given gallery or museum room, forcing the viewer to walk through, peer around, and crouch under the sculpture. During the early 1980s Pfaff constructed a number of installations inspired by her experiences of swimming in the Caribbean ocean; many of her curving, reedlike shapes resemble underwater life forms and seem to float within the exhibition space. Some of her more recent work involves comparatively regimented, geometric elements (plate 153).

Environmental art is often sculpture that creates its own environment within a preexisting interior space. But the term can also refer to art placed in the natural environment, so that it directly affects, and is affected by, the physical aspects of its surroundings. An example of the latter is the recent work of Beverly Pepper (plates 155, 156). Change is an important aspect of these pieces; Pepper's permanent site works change both their color and texture in different seasons.

Pepper received her B.A. degree in industrial and advertising design from Pratt Institute. After a brief marriage that produced one son, she became a successful art director for several Manhattan advertising agencies but quit in 1948 to study painting in France. After marrying the journalist Bill Pepper, she began traveling extensively in Europe and the Far East. Since 1972 she has lived with her husband in a fourteenth-century castle in Todi, Italy. After experimenting with Social Realist painting, at age thirty-eight Pepper became a sculptor, working in carved wood and then welded steel—still an unusual specialty for a woman. Pepper's large, abstract outdoor sculptures were an immediate critical success and can be seen in many locations around the world.

Nancy Holt also makes outdoor environmental sculpture, but unlike Pepper's generally solid forms, Holt's are typically enormous concrete, brick, and steel constructions with openings through which people can both look and walk. The emphasis in these works, which are located in both desert and urban settings, is on the relationship of interior and exterior spaces and the relativity of scale. Holt was born in Worcester, Massachusetts, and educated at Tufts University. In 1963 she married Robert Smithson, also an environmental artist, who died in 1973. Since 1960 Holt has lived in New York, where, in addition to her

156. Beverly Pepper (b. 1924)
Sand Dunes, 1985
Mylar over wood, approximately
100 ft. long
Temporary installation for the
Atlantic Center for the Arts,
New Smyrna Beach, Florida

Left
158. Magdalena Abakanowicz
(b. 1930)
Catharsis, 1985
Cast bronze, 33 figures,
height: 108 in. each; 9 different
models repeated, individual
handmade interiors
Giuliano Gori

Above 159. Magdalena Abakanowicz, 1969 site works, she has produced films, videotapes, and a book entitled *Ransacked* (1980). Holt's most intriguing works are her public commissions, including several urban parks. Between 1979 and 1984 she designed and supervised the construction of *Dark Star Park* (plate 157) in Rosslyn, Virginia, set on two-thirds of an acre of land near the intersection of several major roads in suburban Washington, D.C. This park combines several huge concrete spheres poised mysteriously on the edges of shallow circular pools, with an enormous section of pipe forming a tunnel within a curved ramp of earth (the tunnel form appeals to Holt because of its symbolic references to birth and death). Asphalt paths, sod, and various plants complete the work, and the repeated curves of all the elements make a lovely and unified design when seen from the air.

While these artists have been exploring the potentials of environmental sculpture, a whole host of other women have remained concerned with the more traditional notion of sculpture as a discrete object, or series of objects. These late twentieth-century object sculptors have taken innovative approaches to the subject matter, scale, materials, and techniques used in their art. For example, the Polish sculptor Magdalena Abakanowicz (plate 159) works with fiber as well as bronze. Originally a weaver, since the early 1960s she has concentrated on large, nonfunctional organic forms made of burlap, rope, and thread, which are generally displayed on gallery floors. Abakanowicz is attracted to the flexible nature of her materials, which can be woven and sewn together to make flat surfaces, compressed into dense, narrow cylinders, or knotted to form bulky sculptural masses. She considers it essential to shape her materials with her own hands, using no additional tools. The irregular, tactile surfaces that result are important to her as well. While many of Abakanowicz's works are purely abstract, her most haunting sculptures represent fragmented human figures. Such works as Heads (1975), a group of ovoid burlap shapes, each four feet high, placed on end on a gallery floor, or Seated Figures (1974-79), a row of eighteen headless burlap bodies, reflect a curious combination of savagery and calm. Their crudely sewn seams and escaping stuffing underscore the impression of violence. (The artist maintains that the interiors of her pieces, though hidden, are just as important as their exteriors.) One of Abakanowicz's most moving sculptural series is her Backs and the related bronze figures of Catharsis (plate 158). The expressive quality of these simple, stylized shapes, which seem to be waiting or in mourning, is quite remarkable.

Like Abakanowicz, Lee Bontecou uses fabric in her sculptures, but the effect is entirely different. She began studying sculpture with the American carver William Zorach at the Art Students League, making large abstractions of plaster and clay. Awarded a Fulbright Fellowship for Art in 1957, she spent two years in Rome, where she developed the technique for welding steel frames that became the basis for her

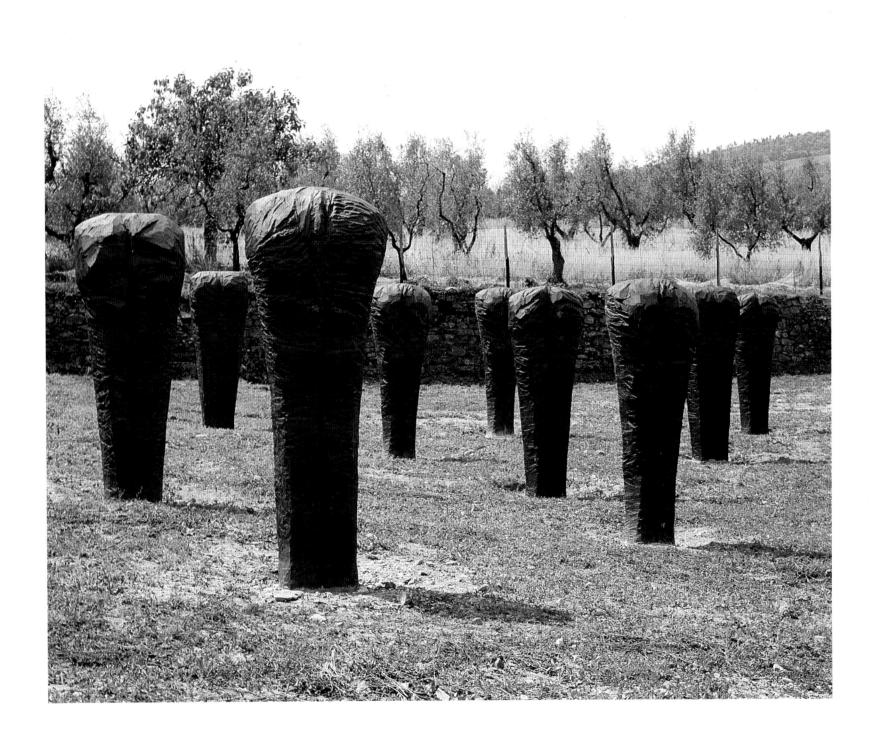

157. Nancy Holt (b. 1938) Dark Star Park, 1979–84 Concrete, steel, water, earth, ½ of an acre, diameters of spheres: 8 ft. and 6½ ft.; pools: 18 ft. and 15 ft.; large tunnel: 10 x 25 ft. Rosslyn, Virginia

Left
160. Lee Bontecou (b. 1931)
Untitled, 1961
Canvas and welded steel,
77 x 661/4 x 26 in.
Whitney Museum of American Art,
New York; Purchase

Above 161. Chryssa working on The Gates to Times Square, 1962 best-known works. After experimenting with several different materials, including terra-cotta and thin sheets of metal, for filling the spaces outlined by these frames, Bontecou appropriated the stained canvas conveyor belts that had been discarded by the laundry beneath her apartment. The resulting steel-and-canvas reliefs (plate 160) established her reputation. Most are constructed around several round or oval voids that add visual interest and a sense of mystery to the spatially complex and highly textured compositions; they are also impressive because of their scale, usually between four and twenty feet high.

The decade of the 1960s, with its psychedelic images and Day-Glo colors, saw the development of neon sculpture. Long employed in advertising, neon tubing was used by such artists as Dan Flavin and Chryssa for its aesthetic characteristics rather than its cultural associations. Born in Athens, Chryssa [Vardea] (plate 161) studied in Paris at the Académie de la Grande Chaumière and at the California School of Fine Arts, San Francisco, before moving to New York in 1955. There she produced abstract plaster reliefs and a series of works made of bronze and plastic letters in shallow boxes. Inspired by the garish signs in Times Square, Chryssa began working with neon tubing in 1962. She has continued to experiment with this medium ever since, combining it with various other materials; sometimes incorporating automatic timers to turn the lights on and off, to form fascinating relief and freestanding sculptures that range from a few feet to eighteen feet in height (plate 162).

Barbara Chase-Riboud (also sometimes known as D'Ashnash-Tosi) creates startling, ten-foot-tall sculptures that combine powerful cast-bronze abstract shapes with veils of fiber ropes made from silk and wool (plate 163). Born to a middle-class Philadelphia family, Chase-Riboud was taking art lessons by age seven; at eight she won her first prize, and by the time she graduated from high school she had sold some of her woodcuts to the Museum of Modern Art. Chase-Riboud was the only black student in the art school affiliated with Temple University and, later, the only one in Yale's School of Art. A fellowship year in Rome and a subsequent trip to Egypt stimulated her interest in life outside the United States. She met the photo-journalist Marc Riboud in Paris and married him in 1961; they were divorced in 1981, and she now lives in Paris. Since the mid-1960s Chase-Riboud has focused her attention on the contrasts of color and texture between the metal and fiber components of her sculptures. Based on the tribal masks that she saw on several trips to Asia and Africa, which juxtapose carved wooden elements with soft, hanging fibers, these nonrepresentational sculptures evoke a sense of mystery; in some cases their titles suggest more specific meanings, as in her series honoring Malcolm X. In addition to making sculpture, Chase-Riboud is a writer; she has published a collection of poetry, From Memphis to Peking (1974), and two novels: Sally Hemings

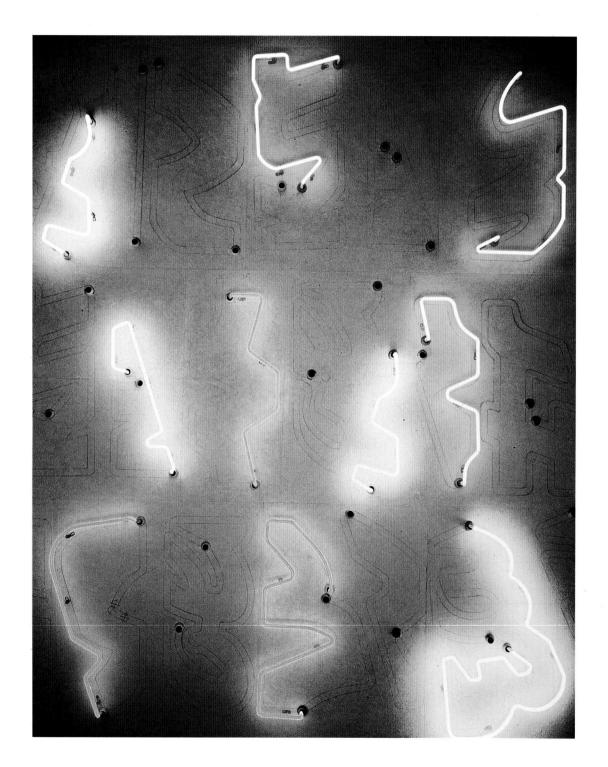

Left
162. Chryssa (b. 1931)
That's All
(center part of Triptych), 1970–73
Neon, plexiglass, electrodes,
asbestos, paper, 108 x 96 in.
The Metropolitan Museum of Art,
New York; Gift of Nathan Brody,
1977

Right
163. Barbara Chase-Riboud
(b. 1939)
The Cape, 1973
Multicolored bronze and hemp
rope on welded aluminum and
steel support, 72 x 58 in.
The Lannan Foundation,
Los Angeles, California

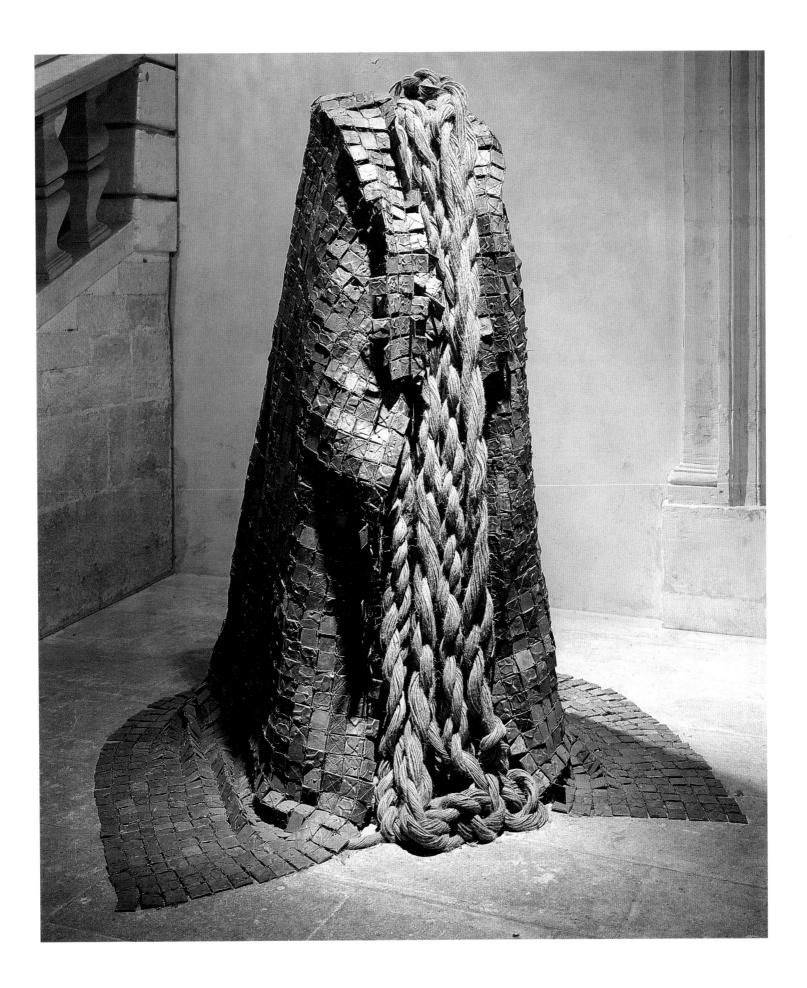

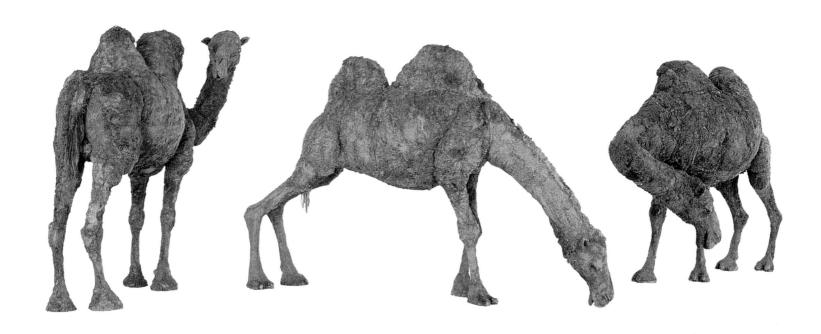

(1979), about the slave who was Thomas Jefferson's mistress, and *Valide*: A *Novel of the Harem* (1986).

In 1969 Nancy Graves caused a sensation in the art world with her first solo show, held at the Whitney Museum. Featured in this exhibition were her newest creations: a group of life-size Bactrian camels (the two-humped Asiatic type) (plate 164), supported by wood and steel armatures, covered with animal skins, stuffed with polyurethane, and tinted with oil paint. These huge, eerily lifelike sculptures—produced at a time when Minimalist abstraction was predominant—elicited mixed critical response, but the Camels were immediately acquired by important museums and private collectors. These works illustrate the artist's lifelong interest in both science and art and her obsessive attention to detail: to prepare for this series, Graves studied the anatomy of camels by visiting libraries, natural history museums, and slaughterhouses; she also filmed the beasts in their natural habitat.⁵

Originally trained as a painter, the Massachusetts-born artist spent a Fulbright year living in Paris, with subsequent travels through Italy, North Africa, and the Near East. During the early 1970s she changed her focus from the exterior to the insides of camels and other creatures. Her works from this period include fabricated animal "bones" made of steel, wax, and marble dust that hung from the ceiling, stood upright on metal posts, or lay scattered across the floor as though part of an archaeological site. She also constructed a group of freestanding, multipart, abstract forms related to the totems and rituals of tribal societies, notably Northwestern American Indians. In 1976 Graves began making both paintings and sculptures, adding three-dimensional elements to the former and surface colors to the latter, so that the distinction between the two became less and less clear. Her most intriguing works of the last decade are brightly colored bronze sculptures assembled from casts of a vast inventory of found objects ranging from flowers to dead frogs and potato chips. Neither abstract nor representational, these heavy bronze pieces seem both weightless and airy, with graceful metal tendrils spiraling off into space.

During the early 1970s a series of gleefully tasteless advertise-ments appeared in *Artforum* and other major art magazines for exhibitions of sculpture by Lynda Benglis.⁶ The images in these ads, which were not related to the sculptures they promoted, were purposefully controversial and provoked a tremendous outcry. One featured a photograph of the artist with her short hair slicked back, dressed in mannish clothes and dark glasses, leaning punkishly against a car; in another, she appeared as an updated Betty Grable pin-up, her blue jeans bunched around her ankles; the most shocking of the series showed Benglis, nude and in full color, posturing astride an enormous artificial phallus.

The object of all this media attention had trained at Newcomb College in New Orleans, Yale Summer Art School, and the Brooklyn

Left
164. Nancy Graves (1940–1995)
Camels VI, VII, VIII, 1969
Wood, steel, burlap, polyurethane, animal skin, wax, oil paint,
VI: 7½ x 12 x 4 ft.,
VII: 8 x 9 x 4 ft.,
VIII: 7½ x 10 x 4 ft.
National Gallery of Canada,
Ottawa; Gift of Mrs. Alan Bronfman
(VII and VIII)

Below 165. Lynda Benglis wearing gas mask installing Adhesive Products, 1971

Left
166. Lynda Benglis (b. 1941)
Heraklion, 1978
Chicken wire, cotton, plastic, gesso, gold leaf,
47 x 26 x 11½ in.
John Rogers

Right 167. Judy Chicago (b. 1939) Natalie Barney (plate from The Dinner Party), 1979 Chino-paint on porcelain, diameter: 14 in. Private collection

Museum School. During the late 1960s she produced garishly colored organic abstractions by pouring liquid latex and foam directly onto gallery floors (plate 165). By the 1970s, however, Benglis was working on the walls, making metalized knots of cotton, plastic, and gesso laid over chicken-wire armatures and covered with gold leaf (plate 166). This unlikely combination resulted in some remarkably graceful shapes; their shiny, irregular surfaces reflect the light in myriad directions.

Although trained as a painter, Judy Chicago is best known for her innovative use of traditional women's crafts, such as weaving, sewing, embroidery, and china painting, in ambitious collaborative ventures involving hundreds of artisans. The most famous of these projects is *The Dinner Party*, a five-year undertaking using a mixture of fine arts and crafts to embody women's history. At the triangular table are custommade ceramic place settings for thirty-nine prominent women from ancient and recent history (plate 167). Another 999 women's names are inscribed on the porcelain floor tiles below. Chicago also directed *The Birth Project*, another collaborative work, which interpreted the experience of childbirth in a large group of textile pieces based on Chicago's designs and executed by a group of skilled needlewomen.⁷

Originally named Judith Cohen, Chicago took the name of the city where she was born. After receiving her undergraduate and graduate degrees in art from the University of California at Los Angeles, she became a college art teacher. In 1970 Chicago and Miriam Schapiro organized the first feminist art program in the United States, at the California Institute of Arts in Valencia. This program involved the collection and dissemination of information about the history of women artists as well as various consciousness-raising activities for members of the West Coast art community. One of the program's most influential projects was *Womanhouse* (1972), a collaborative work in which Chicago, Schapiro, and their students renovated an abandoned house. The group then created various mixed-media constructions inside the structure, commenting ironically—and sometimes savagely—on traditional female domestic roles.

Born in Toronto, Miriam Schapiro studied painting at colleges in New York and Iowa. In 1946 she married Paul Brach, also an artist. Schapiro worked at a series of odd jobs until she became a full-time artist in 1955, originally painting in an Abstract Expressionist style. As Schapiro's commitment to feminism grew during the 1960s, her art changed. Soon she developed her own highly personal approach to collage—which she calls "femmage"—combining such unlikely elements as lace and fabric scraps, sequins, buttons, rickrack, and tea towels. These colorful, commonplace materials, so much a part of an old-fashioned feminine world and so alien to high art, are transformed into highly sophisticated compositions that often imply multiple layers of both space and meaning. Many of Schapiro's recent large works (plate 168)

168. Miriam Schapiro (b. 1923) High Steppin' Strutter I, 1985 Acrylic on paper, 85 x 51 in. Bernice Steinbaum Gallery, New York

Page 200, top 169. Eleanor Antin (b. 1935) Loves of a Ballerina, 1986 Filmic installation Ronald Feldman Gallery, New York

Page 200, lower left 170. Eleanor Antin as Eleonora Antinova in "Swan Lake," shown in Loves of a Ballerina

Page 200, lower right 171. Eleanor Antin as Eleonora Antinova in "The Ballerina and the Poet," shown in Loves of a Ballerina

juxtapose intricately patterned abstract backgrounds with stylized human figures in motion—whether falling or dancing—made of brightly colored paper.

During the 1970s a new category known as Performance art developed. Based on the Happenings of the previous decade which, in turn, had their roots in the Dada activities of the 1910s, Performance art has no strict definition: it can involve live or tape-recorded movements, spoken words or music; it can be presented on a stage or in any other setting, performed by the artist alone or with audience participation, according to a set script or totally improvised. The main characteristic of Performance art is that it uses the artist's own body as its principal expressive medium. In her witty performances Eleanor Antin concentrates on exploring varied aspects of her personality. Born in New York, Antin attended the High School of Music and Art; after graduation she studied philosophy and creative writing and worked for two years as a professional stage and television actress. Antin's Performance art remains highly theatrical; since the early 1970s she has been producing a series of plays and films starring herself in one of four guises that she refers to as personal archetypes: The King, The Black Movie Star, The Nurse, and The Ballerina. A recent large-scale installation featured an old-fashioned movie theater in which were screened silent films of The Ballerina, Eleanora Antinova, dancing the roles that had made her famous (plates 169–71).8

Like their counterparts working in sculpture, collage, and Performance art, recent twentieth-century women painters have explored new visual territory by continuing to develop fresh approaches to traditional subjects, from still life to landscape. Their work displays exaggerated degrees of both realism and abstraction, plus the use of new materials and techniques—including aluminum tiles and airbrushes—and innovative variations on such basic aesthetic elements as repetition and scale.

We have already seen *vanitas* paintings created by such disparate artists as Clara Peeters and Lilly Martin Spencer. Audrey Flack has added another dimension to this venerable tradition, with her Photo-Realist still life *Marilyn (Vanitas)* (plates 172, 173). A lifelong New Yorker, Flack determined at age five to become an artist. She studied at Cooper Union and Yale and for a time was an Abstract Expressionist painter, but she decided that realism would better serve her desire for mass communication. Flack's works from the early 1960s focused on social and political themes: street people, civil rights marches, President Kennedy's assassination. But in 1969 she became one of the first Photo-Realists, painstakingly composing and taking her own color slides of still-life arrangements, projecting and tracing the outlines from these slides onto enormous canvases, and filling in the colors with an airbrush. Unlike most Photo-Realist works, Flack's pictures often clearly express

Below 172. Audrey Flack with Marilyn (Vanitas), 1977

Page 202 173. Audrey Flack (b. 1931) Marilyn (Vanitas), 1977 Oil over acrylic on canvas, 96 x 96 in. Private collection

Page 203 174. Janet Fish (b. 1938) Black Vase with Daffodils, 1980 Oil on canvas, 66 x 50 in. Private collection

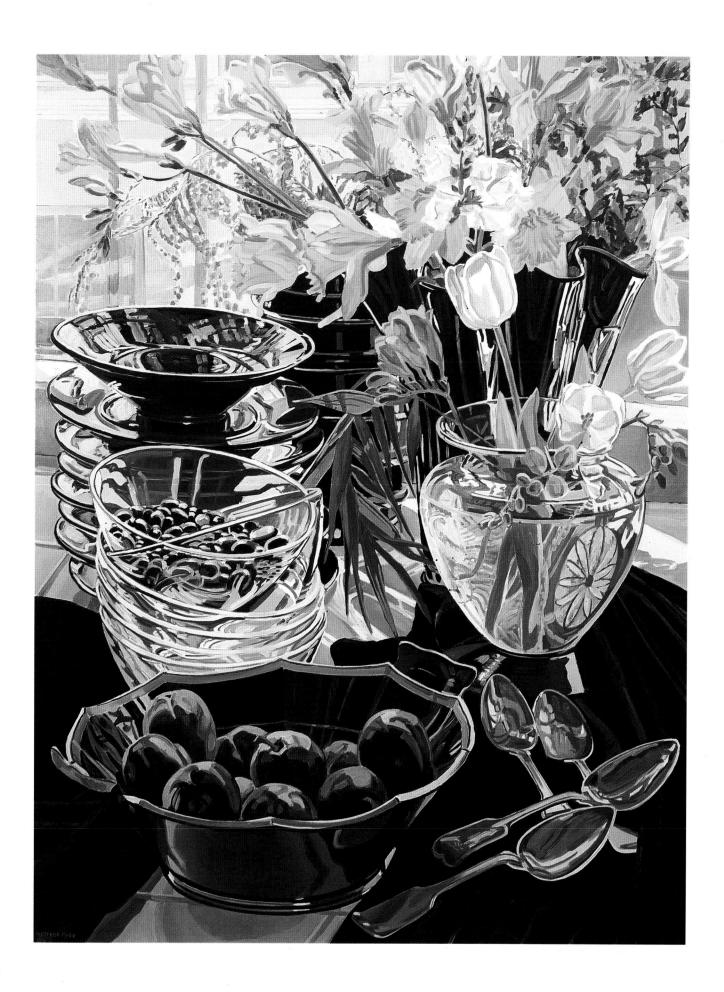

an emotional content, as is particularly evident in her paintings of Monroe and of World War II concentration camp inmates; in others she makes specific references to art history.

In *Marilyn*, Flack used a large scale (the canvas is eight feet square) to increase the dramatic impact of the meticulously rendered objects. Like a seventeenth-century Dutch still life, this one juxtaposes opulence and sensuality with reminders of death. The velvet and satin fabrics, the rose, jars of makeup, cut-glass perfume bottle, shiny silver beads, and an elaborate gold mirror frame all fit in with the black-and-white image of Monroe, perhaps the ultimate modern sex goddess, looking lovely and healthy, flashing a broad smile. But Monroe is also one of this culture's most powerful symbols of exploitation, suffering, and early death, so Flack includes here cut fruit that is beginning to dry out, a pocket watch, an hourglass, a burning candle, and a paint brush—mysteriously floating in mid-air—from which fall droplets of red paint, like tears or blood.⁹

The still lifes of Janet Fish make no art historical references; neither do they evoke strong emotions. Instead, they concentrate on the visual excitement created by light filtering through and bouncing off the artist's inventive arrangements of glass vessels. Fish graduated from Smith College and Yale, where, like Flack, she found herself at odds with the prevailing interest in hard-edged, Bauhaus-inspired abstraction. Initially interested in sculpture, at school she switched to painting in the Abstract Expressionist style. By the mid-1960s, however, Fish had determined that she preferred realism—not the careful, trompe-l'oeil illusionism of the Photo-Realists, but a relatively loose, painterly realism that combines the sensuous, active surface quality of Abstract Expressionism with specific, recognizable subject matter. In the example reproduced here (plate 174), Fish demonstrated her impressive technical command, distinguishing between clear and colored glassware and between containers filled with water and those holding food. This informal composition of ordinary household objects has tremendous visual richness and a pleasingly contemplative quality.

While Flack and Fish continue to generate excitement with their contemporary still lifes, a significant number of younger women painters remain fascinated with the possibilities of nonrepresentational art. Since her first one-person show in 1974, Elizabeth Murray has been recognized as an important abstract painter. A Chicago native, Murray was educated at that city's Art Institute and received her M.F.A. degree from Mills College in California. During the 1960s she made Pop-style paintings incorporating three-dimensional relief elements, but in the following decade she stripped her work down to a few simple, repeated forms. Often painted on shaped canvases, Murray's large abstract oils sometimes comprise as many as twenty separate pieces. The irregular, curving shapes of her pictures and their painterly quality add an element

175. Elizabeth Murray (b. 1940) Join, 1980 Oil on canvas, 133 x 120 in. Security Pacific Corporation, Los Angeles

207

176. Susan Rothenberg (b. 1945) IXI, 1977 Flashe and acrylic on canvas, 771/4 x 104 in.

Mr. and Mrs. Richard Hedreen

of dynamism to Murray's works. The painting illustrated here (plate 175) is made up of just a few powerful forms depicted on a grand scale (eleven by ten feet). Especially intriguing is the way in which Murray—following the lead of such modern European masters as Cézanne and Matisse—implies the illusion of three-dimensional space (as in the way the thin vertical white line weaves in front of and then behind the undulating red shape on the left), while simultaneously denying the existence of any space (through her emphatic refusal to use different values of gray, pink, or red to model these shapes). The visual interest inherent in this work is enhanced by the tension created between the two halves of the overall form, the unmatched edges of which are very close to each other but still separated.

Susan Rothenberg's paintings are sometimes so heavily impastoed that it is difficult to make out any image, but the image is there: a horse, a man's hat, a half-length figure, a series of blue bars. Rothenberg's art is big and aggressive, full of ideas suggested but never made clear. After graduating from Cornell University with a degree in sculpture and spending a few years in Washington, D.C., the Buffalo native moved to Manhattan in 1969. There, during the early 1970s, she developed her series of horse pictures—highly stylized equine profiles that took up entire canvases, sometimes overpainted with a large slashing X (plate 176) or placed against a two-color background. One of the best known of the so-called "New Image" painters, who has been attracting attention with her one-person shows for more than a decade, Rothenberg creates pictures that fall somewhere between pure abstraction and traditional representation. Their obsessively reworked surfaces, restricted palettes, and unexpected scales make a powerful impression on the viewer.

Like Rothenberg, Jennifer Bartlett (plate 178) works in series, and that use of series, as well as her preference for vivid color, intense light, and broken brushwork recalls the work of the Impressionists. This former cheerleader (at Long Beach High School in Southern California) startled the New York art world with her 1976 show at the Paula Cooper Gallery, which consisted of just one work, Rhapsody: stylized images of houses, trees, mountains, and ocean, painted in Testor's enamel (the kind used for model airplanes) on 988 twelve-inch-square steel plates fastened to the wall. Since then, Bartlett's multipart pieces have become enormously popular with both private and corporate patrons. In 1979 she agreed to trade houses with a French writer—her SoHo loft for his villa in Nice. But the combination of dreary winter weather and her ignorance of French made Bartlett miserably unhappy. Nevertheless, the view through her borrowed dining room of a small garden and a cracked swimming pool became the inspiration for hundreds of new drawings, paintings, and other works (plate 177). In some of these the garden is easy to identify, while in others foliage, concrete, water, and

177. Jennifer Bartlett (b. 1941) Boy, 1983 Oil on canvas, 7 x 15 ft. Nelson-Atkins Museum of Art, Kansas City; Gift of the Friends of Art

178. Jennifer Bartlett, 1985

sky all merge into a single complex form. Like Monet's late series, Bartlett's Gardens were painted at different times of the day, from diverse perspectives, and on varied scales, with materials ranging from paper and canvas to steel plates. Having long since made the change from the West to the East Coast, the artist now divides her time between New York and Paris.

As this chapter clearly demonstrates, by the mid-1980s it was no longer uncommon for women painters and sculptors to command high prices for their work, to win major commissions, to have retrospective exhibitions in prestigious museums, or to attract considerable media attention. Women artists, working in a variety of media and techniques—whether in the United States, England, or Poland—had become far more numerous, and more visible, than ever before. Despite the continuation of certain age-old obstacles, and the introduction of several new ones, further progress was to come in succeeding years.

Things aren't what they used to be in the art world. . . . These days . . . even some of the most prominent galleries whose shows had long been predominantly white and male seem to be more sensitive to the absence of female or darker faces in their stables and more aware that it is increasingly fashionable and maybe profitable, as well as fairer and more interesting, to show nonwhite and female artists. -Roberta Smith, "The Gallery Doors Open to the Long Denied," New York Times, May 26, 1996

n July 27, 1988, the New York Times announced that a panel of seven curators and critics had unanimously chosen Jenny Holzer to represent the United States at the 1990 Venice Biennale. The Italian installation by this controversial "media artist" (plate 181) was intriguing for many reasons, not the least of which was the fact that it represented the first time in the ninety-three-year history of this prestigious international exhibition that a woman artist's work had filled the United States Pavilion.¹ The symbolic value of Holzer's breakthrough—coming at the shaky start of the 1990s, a time marked by widespread political turmoil and financial distress, the growing tragedy of AIDS, and an increasingly conservative attitude toward the arts—should not be underestimated. Certainly women artists continue to face many inequities, but their art is harder and harder to ignore.

Because of the powerful messages it conveys and the eyecatching ways they are presented, the art of Jenny Holzer (plate 180) is virtually impossible to ignore. Barely forty, Holzer has had fourteen years of solo shows (all over her native United States and in numerous other countries), and in recent years she has been featured on the covers of various major art magazines.² She is best known for her signs—huge, computerized, light-emitting-diode (LED) signs that have been springing up in art galleries, and on city streets, since 1983.

Born and raised in rural Ohio, Holzer thought of herself as an artist from early childhood but began formal study only in college—earning a B.F.A. from Ohio University, Athens, and an M.F.A. from the Rhode Island School of Design, in 1977. That same year she moved to New York and enrolled in the Whitney Museum's Independent Study Project, which has provided the inspiration for virtually all her mature work. As Holzer tells the story, she was so fascinated and so overwhelmed by the project's massive reading list (a basic "great books" survey) that she decided to distill the basic tenets of the books into a series of aphorisms. This became Truisms (1977–79), which consists of such comments as "Money Creates Taste" and "Abuse of Power Comes as No Surprise." These provocative statements are presented in a vi-

sually neutral way: typeset in plain black letters on sheets of white paper, unsigned, with no explanations or identifying comments of any kind. The artist then pasted them up all over New York.

Holzer's art functions on many levels. Her three-dimensional works have been called a kind of "post-modern religious art"⁴; other works have been labeled "pessimistic," "meditative," "urgent," and "subversive." Some critics find her statements profound, some dismiss them as superficial.⁵ In numerous interviews Holzer has indicated that the ambiguous tone and often-contradictory content of her messages are intended to elicit the strongest possible response from her viewers.

With the Truisms she wanted to make busy New Yorkers stop and pay attention to yet another bunch of words staring out at them from a message-laden wall, and to do that she had to say something startling in a unique format. And from the start she received a lot of feedback in the form of messages written on her posters and inquiries from art dealers. To make her statements accessible to the largest possible number of people, Holzer also printed them on baseball caps and T-shirts and put them up as billboards. For her gallery and museum exhibitions she began to carve her messages on wall plaques, stone benches, and sarcophagi made of black granite or white marble. And she designed displays for enormous electronic signboards in shopping centers, at sports stadiums, in the middle of Times Square, outside the Caesar's Palace casino in Las Vegas—in any number of visually overloaded settings where her unexpected, pseudo-public service announcements would be likely to cause a stir.

Like Christo and other artists who involve individuals and institutions in their projects, Holzer sometimes works collaboratively. This occasionally results in disaster, as in 1982, when she submitted her first official public project (a two-hundred-statement work) to the Marine Midland Bank in New York City. Understandably dismayed by one of her more specifically anticapitalist aphorisms—"It's not Good to Live on Credit"—bank officials refused to display the work. Undaunted, she continues to reach large audiences outside the confines of art museums, most recently through her several books and videos.

Another of the many prominent American women artists working in an overtly political mode that emphasizes language is Barbara Kruger. Like Holzer, she presents inflammatory statements about current American sociopolitical realities, but her words are combined with found or fabricated images.

At the age of twenty-two Kruger was working in New York as the graphic designer of *Mademoiselle*, despite the fact that she had not graduated from college or had any formal training in design. But she did have a good eye and quickly developed a knack for choosing and arranging pictures in a way that would catch the readers' attention—a skill that has contributed to the power of her fine art. After a few years with

Above 180. Jenny Holzer, 1990

Right

181. Jenny Holzer (b. 1950) Untitled installation at the United States Pavilion, Venice Biennale, 1990 Electronic LED signs and marble floor, each sign: 12 ft. 9 in. x 5½ in. x 4 in.; floor: 32 x 22 ft.; tablet: 8 ft. 8 in. x 5 ft. 10 in. Courtesy Barbara Gladstone Gallery, New York

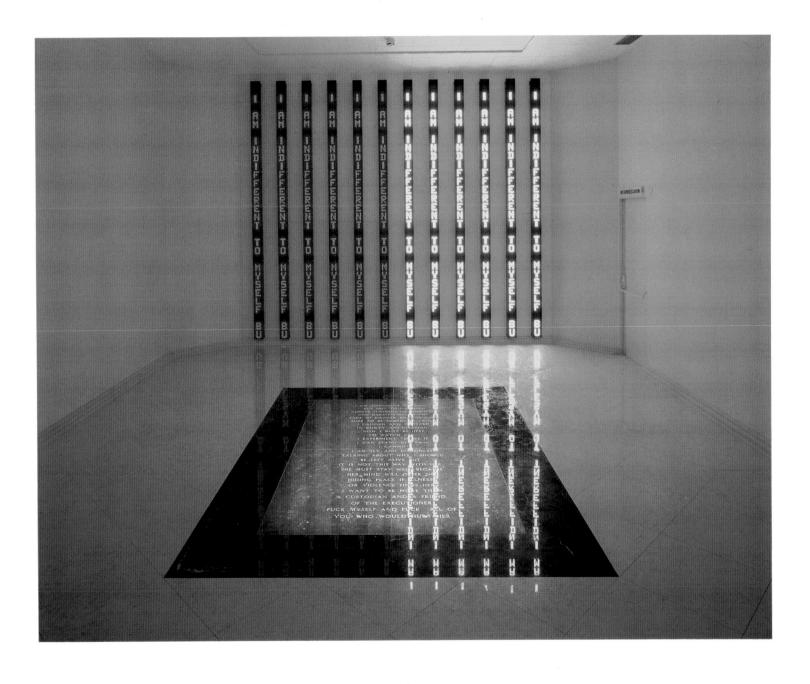

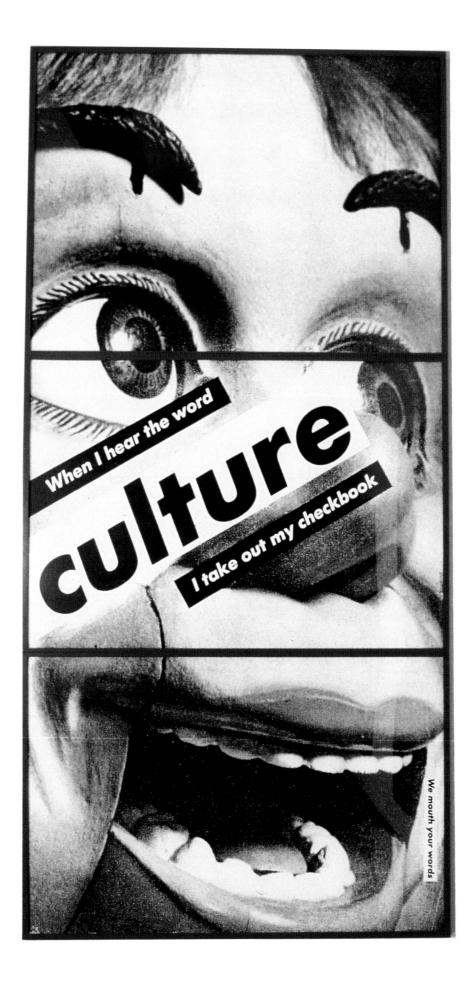

cities. 12 This piece features Anderson's mature performance persona—an intense, androgynous figure dressed in a man's suit, her voice electronically distorted to further blur her age, gender, and personality. Like both Holzer and Kruger, Anderson combines patently absurd texts with pointed commentary on various aspects of the postmodern world. Also like them, she avoids attempting to explain the specific meanings of her works. The principal difference is that Anderson delivers this complex amalgam in person, onstage.

Much of Rebecca Horn's work is also a kind of performance art: the artist wears objects she has designed and fabricated, using her body to manipulate them. Cornucopia: Séance for Two Breasts (1970) consists of black fabric forms attached to the artist's breasts, coming together in a single point at her mouth and held in place by straps on the face and chest. In Finger-Gloves: An Instrument to Extend the Manual Sensibilities (1972), a long, spiky black stick was attached to each finger, allowing the subject to touch and even to grasp objects, but not to get close to them. Custom-tailored to fit the artist, her friends, or strangers drafted to participate in her performances, these are intimate, inward-looking forms. A similar sense of eroticism, mystery, and physical cruelty, mixed with lyricism and ironic humor, recurs throughout her oeuvre, which—in addition to the body sculptures—includes drawings, videos and films, and startling installations. Careful Property of the performance of the body sculptures—includes drawings, videos and films, and startling installations.

Born in the southern part of what was then West Germany, Horn went north to Hamburg to study art during the late 1960s. She later spent time in several other cities, winning fellowships to work in both London and West Berlin and living for several years in New York City. ¹⁶ While still in her early twenties Horn began making large sculptures from polyester resins—a practice that almost ended her career, and her life. The toxic fumes made her so ill that she had to stop working for nearly a year, and this experience is frequently cited as a catalyst for her mature work. Like many who have suffered near-death experiences, Horn says that she has since felt a heightened sensitivity both to herself and to the world around her. ¹⁷

Horn's surreal body sculptures, begun in 1968 and continued through the early 1970s, established her reputation. She has been widely recognized in Europe ever since 1972, when she was invited to exhibit at Documenta, the prestigious international festival in Kassel, West Germany. Her first one-woman show took place the next year, followed by many more, in eight different nations. Despite her early successes in New York—a solo show in 1976 and a 1974 retrospective of her videos at the Museum of Modern Art—she has become well known in the United States only since the late 1980s, largely because of winning the Grand Prize at the 1988 Carnegie International Exhibition. (She was the first woman to do so since the American painter Cecilia Beaux, eightynine years earlier.)

185. Laurie Anderson (b. 1947) Performance at the Museum of Modern Art, New York, January 8, 1991

During the early 1980s Horn's body works evolved into performerless "sensibility machines." Suspended from the ceiling or selfsupporting on a gallery floor, these pieces reflect the same themes that are obsessively repeated in Horn's other art. The installation that won the Carnegie prize for Horn was Hydra Forest: Performing Oscar Wilde (plate 186). The piece, set up in a dimly lit room, consisted of seven pairs of steel and copper rods hung from the ceiling. Periodically, these rods generated four hundred sixty thousand volts of electricity, producing bright bolts of artificial "lightning" and accompanying sounds. On the floor beneath the rods were a pair of men's shoes and six inverted glass cones filled with various natural substances. Hydra Forest makes several literary references—to a short story by the German writer Heiner Müller, to the Hercules legend, and of course to Wilde himself. The electricity and the materials in the glass cones allude to alchemical transmutations; the empty shoes and the unpredictable violence of the light and sound may refer to the tortured nature of Wilde's final years. 18

Horn's emotionally evocative works belong to the tradition of German Expressionism. The aesthetic and philosophical contributions made by Germany's Expressionists in the 1910s, by the American Abstract Expressionists who followed their lead during the 1950s, and by the German and Italian Neo-Expressionists of the 1970s have long been acknowledged. However, until recently, the artists working in an expressionist mode outside those countries have been overlooked. Not until the 1980s did a spate of American and British exhibitions begin to focus attention on the young artists of Australia, for example, many of whom feature expressionist elements in their work.

For many decades artists working in Australia had little direct knowledge of contemporary art in the United States. But in 1967 an exhibition entitled *Two Decades of American Painting*, organized by New York's Museum of Modern Art, went to Melbourne and Sydney, providing the first chance for most Australians to see original examples of important American art from the 1950s and '60s. This show sparked new interest in abstraction, which had never been a leading trend in Australia. Then, two years later, Christo wrapped the coast of Little Bay, Sydney. This piece, the first environmental work made in Australia by a major European avant-garde artist, inspired much of the experimental art—including videos, installations, conceptual works, and performance pieces—that proliferated there throughout the 1970s. ¹⁹

Mandy Martin is among the most interesting of the Australian artists who began their careers during the 1980s, a period marked by a resurgence of interest in Australia's own twentieth-century tradition of figure and landscape painting.²⁰ An Adelaide native, Martin was trained at the South Australia School of Art. After graduating she worked briefly in 1975 as a commercial artist and established a screenprinting workshop;

186. Rebecca Horn (b. 1944) Hydra Forest: Performing Oscar Wilde, installation at Carnegie International, Carnegie Museum, Pittsburgh, 1988 Electrical devices, glass, mercury, shoes, and coal Courtesy Marian Goodman Gallery, New York

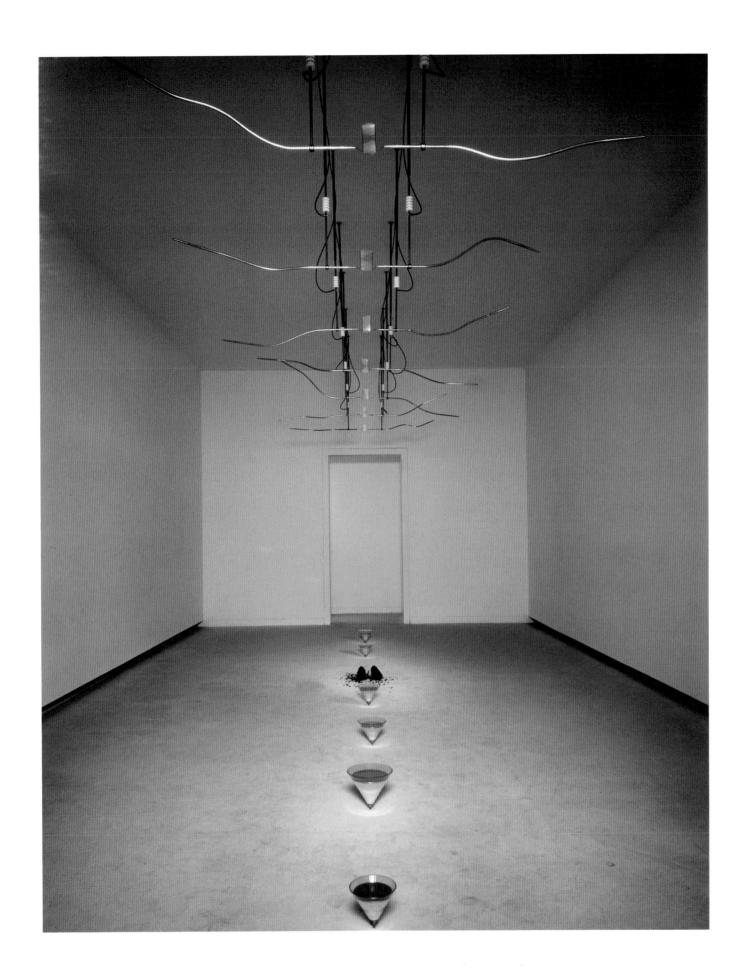

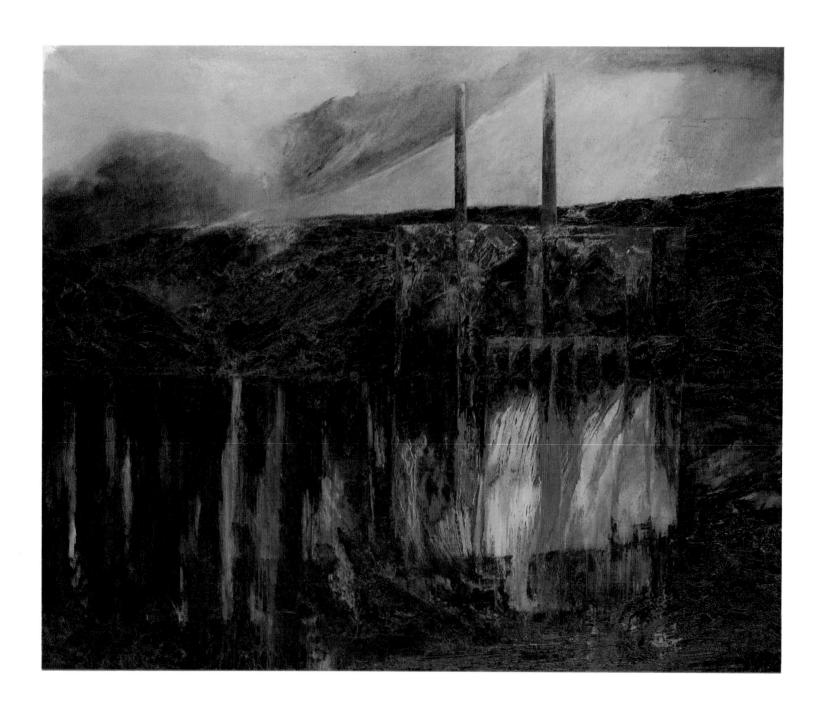

187. Mandy Martin (b. 1952) Powerhouse, 1988 Oil on linen, 90½ x 110¼ in. (230 x 280 cm) Heide Park and Art Gallery,

Melbourne

since 1978 she has taught printmaking at the Canberra School of Art. The recipient of several grants and prizes, Martin had her first one-woman exhibition in Sydney in 1977; since then she has shown widely, throughout Australia, Europe, and the United States.²¹ As an active member of the Earthworks Poster Collective (based in Sydney) and of Adelaide's Progressive Art Movement, Martin has worked for years in collaboration with other artists, producing silkscreen prints dealing with topical political and social issues, which are made in large, affordable editions aimed at the general public. Like Holzer, Kruger, and Joyce Kozloff (plate 191), Martin has exhibited her work in nontraditional venues, participating in group shows held at factories and supermarkets.

Martin's dramatic paintings (plate 187)—oils on canvas, each roughly five by seven feet or larger—make an immediate impression of raw power and intense emotion. Combining sensuous, painterly textures with rigid geometric or architectural forms, she creates a frightening world in which factories spew torrents of thick, toxic smoke. In these works Martin mixes rich passages of black with slashes of red, orange, and yellow, in a scathing commentary on the widespread environmental destruction caused by Australia's mining industry. Even her titles—Powerhouse, Spearhead, Barricade—convey a sense of boldly facing up to the tough realities of late twentieth-century industrialized life.

Whereas Martin uses lusciously painted industrial landscapes to respond to the ills of modern society, Cindy Sherman (plate 189) makes her visual comments on modern living via the supposedly neutral mechanism of the camera. Interpretations of her work vary widely, but there is no doubt that she caught the eye of the public, and the critics, remarkably fast. To put her career in perspective: the Pulitzer Prizewinning American poet Wallace Stevens published his first book at fortyfour, and Grandma Moses was seventy-eight when she painted her first picture. By the tender age of thirty-three Cindy Sherman was already having a retrospective of her work, at the Whitney Museum of American Art, in New York. 22 Sherman's extraordinary, and extraordinarily early, success is all the more remarkable because she works exclusively with photography, which until recently has been regarded as a far less important medium than painting, sculpture, or printmaking.

The youngest of five children, Sherman was raised on Long Island, New York, in what she has described as a typically surburban American lifestyle. Initially interested in painting, Sherman enrolled in the State University of New York, at Buffalo, in 1972. There she became active in the local avant-garde scene and especially in Hallwalls, an artist-run alternative exhibition space. In one of those ironies that so delight biographers, Sherman flunked her first college course in photography. But she got through the second and quickly abandoned painting. Meanwhile, she had been amassing a collection of odd clothing, accessories, makeup, and wigs that she would wear to art openings, saying

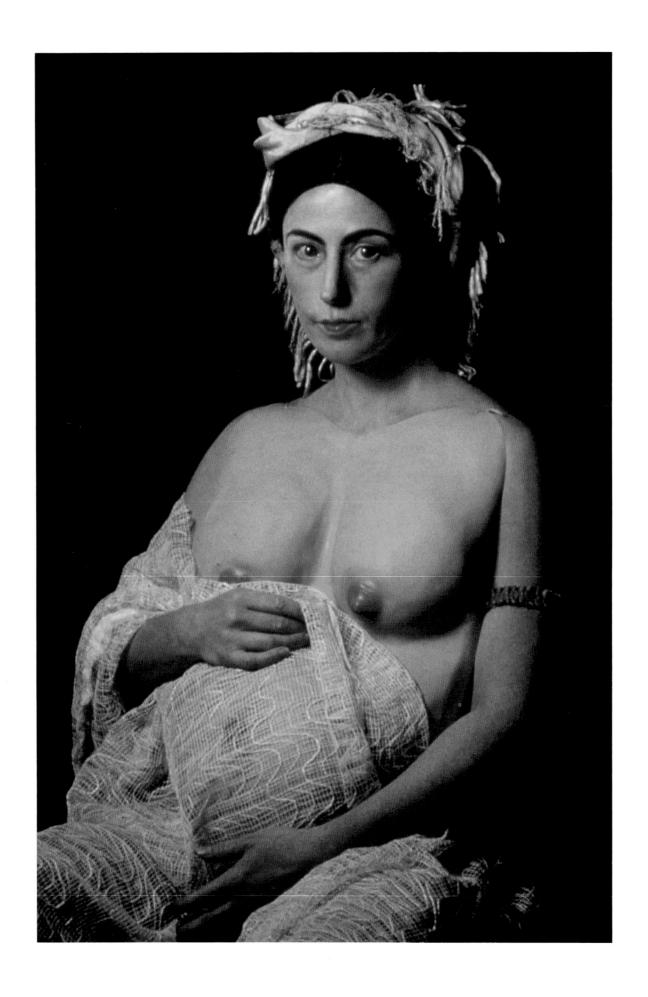

Left
188. Cindy Sherman (b. 1954)
Untitled, 1989
Color photograph, 61½ x 48¼ in.
Courtesy Metro Pictures,
New York

Above 189. Cindy Sherman, 1987 that she wanted to see how "transformed" she could look. For a 1975 school assignment Sherman produced a series of photographs of herself documenting this process of transformation. The curator Linda Cathcart saw the pictures at Hallwalls and put them in a show at the Albright-Knox Art Gallery. Sherman, then a junior, was twenty-one.

Soon after graduation Sherman moved to Manhattan and began her first series, the Untitled Film Stills (1977–80), all taken using a remote shutter-release, with herself as a model. These black-and-white photos were purposely grainy, since Sherman wanted them to look like cheap publicity stills. These early works explored various stereotypical female roles: we see Sherman as clean-scrubbed ingenue, Sherman as seductive vamp, Sherman as mischievous tomboy. The artist's manipulations of lighting, makeup, and dress make it difficult to believe that all these disparate creatures are indeed the same person. In her elaborately staged works Sherman was not performing for a live audience, or even working collaboratively (she processes her own film and does not employ assistants); rather, she was like a child playing dress-up alone in her parents' attic—except that she recorded the results with the highly critical eye of an adult artist.

These solitary tours de force soon attracted attention. In 1980 Sherman had her first New York solo shows, at both an alternative space (The Kitchen) and a commercial gallery (Metro Pictures). The early 1980s were marked by almost constant exhibitions of, and critical attention to, the Film Stills and the 2-by-4-foot color pictures she had recently begun producing of herself dressed in designer clothes. Suddenly, Cindy Sherman was hot, with major shows in the United States, France, Germany, and Japan. In September 1983 she was featured on the cover of *Artnews*; that same year she received a Guggenheim fellowship—rare for such a young artist, especially a photographer.

By 1987 Sherman had largely abandoned the color fashion images. Her Whitney retrospective of that year introduced a very different Sherman type: patently artificial scenes of mayhem and squalor; viscerally disturbing (though clearly staged) images of putrefied "corpses," modeled by Sherman; and human body parts buried in heaps of rotting garbage. These large, garishly colored photographs are obviously related to low-budget horror films. By the early 1990s Sherman had tired of mining popular culture for these shocking images, turning to art history for inspiration. The result was a series of photographic portraits of herself, transformed by her usual false noses, bosoms, and so forth, into both male and female figures as painted by various old masters of Western painting. Her 1990 show at Metro Pictures starred Sherman as everything from an Italian Renaissance noblewoman (plate 188) to an eighteenth-century French fop.²³

The meanings of Sherman's photographs have long been debated, and the artist seems reluctant to enter the fray. Her doggedly neutral titles offer few clues, and much of her work is clearly intended to be ambiguous. Her pictures have been interpreted as feminist indictments of gender stereotyping, but Sherman insists she is not "political." Perhaps most intriguing is her consistent denial of the label most commonly applied to artists' images of themselves: self-portraits. As she correctly points out, none of these photographs shows what Cindy Sherman "really looks like" they are not based on her actual physical appearance, or her personal fantasies; instead, they are highly theatrical explorations of the ever-changing face of the human condition.

The specific political content may sometimes prove elusive, but it is nonetheless clear that the work of Holzer, Kruger, Anderson, and Sherman confronts and criticizes modern society. Considerably less aggressive, but no less "political," is the art of Joyce Kozloff (plate 191). She generally eschews words, and her deceptively quiet art is usually abstract. But the fact that she paints intricate, brilliantly colored designs, repeated over and over in ever-more elaborate interrelationships, and the fact that she paints in watercolors and on ceramic tiles makes a political statement—rejecting many of the principles central to the art world of twentieth-century America.

Left 190. Joyce Kozloff (b. 1942) Topkapi Pullman, 1985 Mosaic installation at One Penn Plaza, Suburban Station, Philadelphia, approximately 13 x 16 ft.

Above 191. Joyce Kozloff, 1978

A native of Somerville, New Jersey, Kozloff (née Blumberg) was educated at the Carnegie Institute of Technology (B.F.A., 1964) and Columbia University (M.F.A., 1967), with additional study in Italy. During the late 1960s she worked as a teacher and produced a series of Minimalist abstractions.²⁵ Despite considerable success—she received fellowships and grants for both printmaking and painting and had her first one-woman show at age twenty-eight—by the mid-1970s Kozloff was becoming disenchanted with the reductive aesthetics of Minimalism. A 1973 trip to Mexico, where she sketched the decorations on ancient Mayan temples, had stimulated her interest in architectural patterns. Soon Kozloff was covering entire canvases with abstract decorations, many of them derived from the decorative-arts traditions of various cultures, including Moroccan tilework; ancient Sumerian carvings; Celtic manuscript illuminations; Gothic architecture; colonial American quilts; Persian carpets; and French lace. This "pattern painting," espoused by Kozloff, Miriam Schapiro (see chapter 6), and several other artists (male and female), was dismissed by the art establishment because it featured apparently nonintellectual, eclectic, and suspiciously "beautiful" forms more closely identified with crafts than the fine arts. Feminists, including Kozloff, were quick to point out the absurdity of criticizing artists for reveling in the sensual pleasures of colors, textures, and patterns. And Kozloff continued questioning the traditional boundaries between high and low art as she moved, in 1977, from painting on canvas to painting ceramic tiles, which she then placed in architectural settings.

The desire to communicate with as wide an audience as possible has made many artists push past the traditional confines of galleries and museums. Holzer, Kruger, and Anderson have opted to speak to large numbers of people through outdoor billboards and the concert stage. For Kozloff, rejecting the elitism of the modern art world led to a fascination with public art, in the more traditional sense of that term. For more than a decade now she has been producing art on a grand scale—physically and emotionally accessible art that the general public encounters on a daily basis. During the 1980s she was commissioned by public and private institutions to design permanent installations in seven major American cities. All are in subway stations or other sites related to urban transportation; all had to fit into unusual, and unusually challenging, settings; and all are relatively large-scale. ²⁶

To encourage travelers to explore various passages within her works and to reward them with discoveries each time they do, Kozloff has given free rein to her love of complex patterns, varied textures, and a complicated palette, with richly vivid hues and highlights of glittering gold. To relate each project to its particular site—and to further arouse the interest of commuters—she has incorporated designs of local relevance: Seneca Indian patterns for a Buffalo, New York, subway station,

and tiles painted with images of quilts, weathervanes, and other traditional New England decorative arts for the station at Harvard Square.

For One Penn Plaza, in Philadelphia, Kozloff created two separate mosaic murals. On one side of the entrance lobby (which leads to the city's Suburban Train Station) is Galla Placidia in Philadelphia, whose elaborate architectural patterns and colors wittily refer to the mosaic-filled interior of a fifth-century mausoleum built in Ravenna, Italy. Instead of the biblical figures that are interspersed with the abstract decorations at Ravenna, Kozloff's variation features a silhouette of William Penn, holding the charter of the Commonwealth of Pennsylvania. Topkapi Pullman (plate 190), on the opposite wall, is another amalgam of the exotic and the familiar: Kozloff's source for the background is the decorative tilework in Istanbul's Topkapi Palace; the train comes from a 1929 Art Deco poster advertising the Orient Express.

Like Kozloff, Howardena Pindell (plate 192) has always been fascinated by the sensual appeal of diverse colors and complex yet delicate textures. Also like Kozloff, Pindell has often seen her work disdained as "merely decorative" by other artists and critics. As a black woman artist working in an unfashionable style, for many decades Pindell has experienced personal and professional rejection by conservatives and radicals alike. In 1980 her frustration found expression in a videotape called *Free*, *White*, *and* 21. The video indicts the rigidity of supposedly liberal arts groups that refuse to consider the merits of work they considered politically incorrect and vents Pindell's anger at being constantly exploited as the "token" black woman, whose presence in a group is believed to eliminate the need to reach out to other persons of color.

Pindell was born in Philadelphia to parents who strongly encouraged her interest in art and higher education. She made her first oil painting at the age of twelve, then went on to earn a B.A. from Boston University (1965) and an M.F.A. from Yale University (1967). At Yale, under the influence of Josef Albers, Pindell turned from painting urban landscapes to exploring pure abstraction. Wanting to teach but unable to find a job, Pindell moved to New York. In 1967 she was hired as a curatorial assistant at the Museum of Modern Art. For the next twelve years she worked full-time at the museum (where she was eventually promoted to associate curator of prints), doing her own work at night. During the 1970s Pindell began to visit other countries, partly because of her curatorial duties and partly because of a lifelong passion for travel. Having already spent time in Mexico and Europe, she expanded her itinerary to include Egypt and several other countries in Africa. In 1974 she received a French government grant to work in Paris; she also went to Brazil and made several visits to India and Japan.

Pindell's pictures from the early 1970s combine pale, subtle colors and rich, tactile surfaces. First she sprayed her canvases with pigment, then glued on many layers of tiny paper circles. During the

Above 192. Howardena Pindell, 1990

Right
193. Howardena Pindell (b. 1943)
Temple, part of India:
Memory Series, 1984
Gouache, tempera, watercolor,
postcards, and acrylic on museum
board, 32 x 20 x 3 in.
Private collection, Detroit

1970s she also explored many other materials and techniques: she experimented with soft sculpture, stain paintings, and "video drawings" (inked images on acetate screens stretched over television monitors). ²⁸ In 1978 she developed her signature style—delicate mixed-media works comprising pieces of unstretched canvas sewn together and decorated with bits of colored paper, hair, string, glitter, sequins, or talcum powder.

In 1979 Pindell left the museum to take a teaching job at the State University of New York at Stonybrook, where she is currently a tenured full professor (a position still rarely achieved by women). Also in 1979 she was involved in an automobile accident that caused her to suffer partial memory loss. To recapture her memories, Pindell concentrated on looking at picture postcards of familiar places, sent by family and friends. Three years later these cards turned up in her art, cut into strips, fanned out, and glued onto museum board, with paint in the spaces between (plate 193).

In her 1990 essay "Through the Path of Echoes: Contemporary Art in Mexico," Elizabeth Ferrer provides a useful context for Mexican art of the 1980s and '90s. She notes that efforts to define a truly "Mexican" form of art, in the wake of the Mexican Revolution (1910–17), resulted in the development of the influential muralist movement, led by Diego Rivera, José Orozco, and David Siqueiros. Closely linked with socialist theories and a powerful nationalism, these dramatic narrative paintings, on public buildings throughout the country, dominated Mexican art through the 1930s and '40s. A radical break from this tradition occurred with the appearance of the international student movement of the 1960s, which rejected the murals as melodramatic, provincial, and crude, substituting for them an interest in the visual and emotional restraint of geometric abstraction. The generation of the 1080s in Mexican art encompasses as diverse a range of media and styles as can be found anywhere in the world, but Ferrer has identified certain traits shared by these young men and women artists—including emphasis on figuration, references to traditional Mexican religious iconography, and a tendency to combine numerous forms within the same picture which seem to signal a return to their shared cultural heritage.²⁹

These traits are especially clear in the art of Rocío Maldonado (plate 195). Born in Tepic, halfway down the western coast of Mexico, Maldonado studied in Mexico City, at the Escuela Nacional de Pintura y Escultura La Esmeralda in 1977–80; she also worked for a time in the studios of two Mexican printmakers. In 1980 she traveled in the United States, visiting New York, Philadelphia, Boston, and Washington, D.C. That year she had her first solo exhibition, in Querétaro, north of Mexico City. Maldonado's work subsequently appeared in important group shows in Mexico, Spain, and Australia; it has also been seen in California and New York.³⁰

Like her fellow Mexicans Georgina Quintana and German Ve-

Above 194. Rocío Maldonado, 1986

Right 195. Rocío Maldonado (b. 1951) Portrait of Raul, 1988 Oil on canvas, 50½ x 60% in. Private collection, Mexico

negas (both born 1956), Maldonado borrows aspects of her style from the European Neo-Expressionists. ³¹ The work by all three artists is painterly, solid, richly colored, and emotionally intense. But Maldonado differs in that many of her images refer to specifically Mexican themes—most notably, the Virgin of Guadalupe, whose portrait appears everywhere in Mexico, from church walls to taxis, as well as the pierced and bleeding hearts and thorn-covered roses that are so popular in Mexican folk art. Maldonado surrounds many of her works with a beveled wooden frame, thus enhancing the illusion of looking through a window at the painted scene. At the same time, the fact that she extends her painted images onto the narrow wooden borders tends to flatten the pictorial space. The dreamlike nature of her pictures is intensified by her tendency to crowd numerous images onto each canvas—planets and shooting stars, figures on horseback, fragmented male and female torsos, babies, stones, more roses. Size adds to the powerful impact of Maldo-

nado's work—many of her canvases measure 4 by 5 feet, and she has made a number of ink-on-paper pieces that are nearly 6½ feet square.

Two women sculptors who have received considerable international acclaim over the past dozen years are a Spaniard and a Briton—Susana Solano and Alison Wilding, respectively. Both create simple, highly evocative abstract shapes using unconventional combinations of relatively mundane materials.

Susana Solano is Catalan, and hence raised with a different language and a different cultural heritage than those familiar to people from Málaga or Madrid. ³² Her hometown of Barcelona has a long tradition of producing leaders in the visual arts, including the painter Joan Miró and the visionary architect Antonio Gaudí. Born, raised, and currently residing in Barcelona, Solano was trained at that city's School of Fine Arts during the late 1970s, initially as a painter. Around 1978 she became interested in sculpture, and almost immediately her work began appearing in exhibitions all over Europe, South America, Japan, and the United States, attracting a great deal of critical attention. Like several of the other artists in this chapter, Solano made a swift rise to fame. She had her first solo show in 1980, and seven years later she was one of only two artists chosen to represent Spain in that year's Documenta; she also participated in the São Paulo Bienal that year and in the Venice Biennale the next.

Solano's earliest sculptures are a group of hanging canvas forms, which have generally been interpreted as a transition between her paintings and her mature, truly three-dimensional work. She is best known for her sculptures from the late 1980s—large, often partially transparent, open shapes made of iron, lead, wood, glass, and plaster. These works frequently suggest poetic or religious meanings—La Bella Dormiente (Sleeping Beauty; plate 196) resembles an empty, massproduced crib; and the plastic-covered iron table called Bon Appétit, Messieurs (1989) inevitably calls to mind an altar. Certain basic shapes—cribs and tables, cages and arches—recur throughout Solano's oeuvre. They seem to invite the viewer to enter her silent worlds, but at the same time they keep visitors out, through a system of metal bars or some other physical barrier. The swimming pool—hardly a standard sculptural subject—is another of Solano's favorite motifs. Impluvium (1987), for example, is a rectangle of silvery-bright galvanized iron plates placed flat on the floor, surrounded by a dull-hued iron border and a metal fence suspended from eight upright poles.

There is no specific narrative content in Solano's sculptures, but their titles and forms suggest many associations. *Espai Ambulant* (which means "movable space" in Catalan; 1986) is a shape that the artist has said derives from circus-animal cages; it has reminded some writers of a church sanctuary screen. *Bany Rus* (Russian Bath; 1988) in some ways does suggest a public bathhouse made of wire mesh and sheet-

196. Susana Solano (b. 1946) *La Bella Dormiente*, 1986 Iron and lead, 26% x 40½ x 23 in. Private collection, Madrid

metal cubicles; it also resembles a prison.³³ Solano's art has been compared with that of her countryman Julio González, since both work primarily in iron—a typically Catalan material. It has also been compared with work by Constantin Brancusi—in terms of their shared tendency to reduce forms to an essence—and with the Minimalist sculpture of the 1960s and '70s—although, as several writers have pointed out, her work is far warmer and more approachable, with intentionally imperfect surfaces and not-quite-parallel lines.³⁴

The art of Alison Wilding is also Minimalist and also related to Brancusi's sculpture. 35 Like Solano, Wilding makes simple, three-dimensional abstractions. The work of both artists is typically described as "enigmatic" and "poetic"; both use open forms that add to the sense of mystery; both explore the aesthetics of contrast by combining various materials, textures, and colors; and both choose titles that only hint at possible meanings. In general, Wilding's work seems lighter, more potentially active than Solano's emphatically earthbound constructions. Also, Solano's pieces are essentially, if inconsistently, geometric, whereas Wilding's are more organic, with rounded edges. Moreover, Solano's works seem more specific and more resonant with other objects from the worlds of architecture, engineering, and design.

Born in Lancashire, in northwestern England, Wilding studied in London, at the Ravensbourne College of Art (1967–70) and the Royal College of Art (1970–73). The official focus of her studies was sculpture, but during the early 1970s she produced conceptual multimedia installations incorporating texts and music. She had her first solo show in 1976, and two years later she began experimenting with the kinds of simple, spare forms for which she is now known. The early 1980s marked the beginning of Wilding's prominence as an international presence: she exhibited in the 1982 Paris Biennale and the São Paulo Bienal of 1983. During the next few years she showed work in Italy, Hungary, Portugal, Spain, Poland, Australia, Sweden, and the United States.

Wilding's mature work incorporates few physical forms, but she pays a great deal of attention to their surfaces. She waxes her wooden pieces or rubs them with pigments and linseed oil; she also works oil and pigment into her steel surfaces. When Wilding chooses to emphasize dramatic contrasts, she makes them both visual and visceral, as in *Nature: Blue and Gold* (plate 197), one of her numerous bipartite sculptures. Here the smaller, denser form is made of light-absorbing, dark blue—tinted wood. The larger form, cut from metal, is reflective and bright, its polished surface given an irregular, organic texture by the addition of metal rivets and the splaying of one end.

Working without preparatory drawings, Wilding allows the material to suggest its ultimate form. Many of her recent sculptures have been designed to hang on gallery walls; others remain on the floor, including Slow Core (1985–87), a vertical metal construction, open in the center, with a flat rubber oval as its "base." Like most of Wilding's works, this one suggests various interpretations (is the rubber oval a cast shadow? a liquid pool?) without resolving them.

"Visual Astonishments" are what Kathy Rose creates, according to *New York Times* critic Jack Anderson.³⁶ Using just her body, two projectors, and a tape recorder, Rose manages to convince audiences that she is interacting with a chorus of other people, wading through water, or modeling an endless wardrobe—when in fact she is alone, on a bare stage, wearing a single costume. By turning her body into a screen onto which she projects her witty, mysterious, and sensual animated films, for the last decade and a half Rose has been performing theatrical works that are difficult to label³⁷ but wildly popular with audiences from her native New York City to Germany, Wales, and Japan.

Rose says she started drawing at age three; as a young woman she received emotional and financial support from her family, all of whom were arts professionals.³⁸ Throughout her twenties Rose moved back and forth between her interests in dance and film, studying and performing with Group Motion—a multimedia troupe inspired by the German modern dancer Mary Wigman—while she was earning her B.F.A. in film at the Philadelphia College of Art. A 1970 workshop with Alwin Nikolais, an

197. Alison Wilding (b. 1948) Nature: Blue and Gold, 1984 Brass, ash, oil, and pigment, 18½ x 43 x 8½ in. British Council Collection; courtesy Salvatore Ala Gallery, New York

American choreographer noted for his use of electronic music plus innovative lighting and costumes, had a strong influence on Rose. She later enrolled at the California Institute of the Arts, where she earned her master's in animation in 1974. By 1978 Rose had created ten animated shorts and won several important film awards. But she missed performing. Aided by the first of seven grants from the National Endowment for the Arts and inspired by Abel Gance's silent film *Napoleon* (1927)—presented in 1980 with a live symphony orchestra to sellout crowds at New York's Radio City Music Hall—Rose invented her own hybrid art form. This led to *Primitive Movers* (1983), Rose's first signature work combining film animation and live dance (plate 198).

Here, and in the eleven other performance pieces she has completed during the intervening years, Rose refers to the dance traditions of many countries, including Spain, Mexico, Bali, and Japan. She has made a serious study of several of these forms—notably flamenco, elements of which find their way into such pieces as *Az-Tech*, a wildly improbable

198. Kathy Rose (b. 1949) performing *Primitive Movers*.

science-fiction sketch with additional choreography by the noted Spanish dancer Luís Montero.³⁹ Several of Rose's pieces also echo the early twentieth-century explorations of ancient Egyptian and other exotic cultures made by the American dancers Ruth St. Denis and Ted Shawn and their protégée Martha Graham. The title *Primitive Movers* recalls a classic Graham composition (*Primitive Mysteries*, 1931), and Rose's stage persona was clearly influenced by Graham's—white face, blood red lips, glossy black hair, and form-fitting costumes.⁴⁰

That Rose is truly a visual artist is demonstrated in *Syncopations*, a fifty-minute work that took her two years to complete. In it, Rose's filmed image and those of seven other dancers form the backdrop for her live performance. But the filmmaker fragments these images, then reconstructs and multiplies them to create a fascinating series of abstract designs that are surprisingly erotic. (As one writer said, "It looks like sex underwater." Rose's sophisticated use of fabrics—she designs her own costumes—and her quirky sense of humor ally her with other solo performers such as Pat Oleszko and Paul Zaloom. But Rose also belongs in the company of female animators, and she is continuing to expand the parameters of her work. In 1994 Rose helped launch the advertising campaign for a new men's cologne, and she has expressed interest in making music videos, staging fashion shows, and otherwise blurring the traditional boundary between the fine/performing arts and the commercial art world.

As the twentieth century draws to a close, more and more artists seem to be creating work that cannot be described by a single, conventional label. Sandy Skoglund is a photographer who also makes the sculpture from which she fashions her installation pieces; she exhibits both these three-dimensional constructions and the two-dimensional records she makes of them. The people in Skoglund's tableaux never seem to notice that anything odd is going on. Although surrounded by hordes of impossibly bright blue dogs, hot pink squirrels, or neon orange fish swimming through thin air, these ordinary-looking humans appear oblivious to the chaos in their cozy, middle-class suburban houses. Skoglund's funny yet horrifying visions have been seen as everything from scathing indictments of the American bourgeoisie to superficially amusing scenes better suited to department-store windows. Like so many in her generation, Skoglund says she prefers to leave specific interpretations of her art to others. But it clearly works on many levels.

Skoglund makes the familiar unfamiliar.⁴³ What was familiar to her, growing up in 1950s America, was the series of New England states where her father's job took the family.⁴⁴ She ended up spending her late teen years in a very different environment—California—and quickly realized that the sterility of suburbia was essentially the same both east and west. After completing a traditional liberal arts education (Smith College, class of '68), Skoglund moved to the Midwest, where she earned her M.F.A. at the University of Iowa. At Iowa she studied painting, printmaking, and—

her real love—film. Since she could not afford to attend film school, Skoglund settled for spending her junior year in Paris, where she became enamored of French New Wave films.

Back in the United States, Skoglund moved to New York City in 1972 and experimented for a few years with then-fashionable Conceptual art. However, her innate sense of the absurd soon resurfaced, and beginning in the late 1970s she produced her first group of color photographs: still lifes of frozen food. These distinctive works, inspired by commercial photographs, feature arrangements of peas and carrots, corn kernels, or luncheon meat set out on brightly patterned paper plates that in turn rest on garish checked or flowered tablecloths. The result is eye-popping and, depending on your point of view, either insulting (to the advertising industry, the American concept of cuisine, the Pattern and Decoration

movement) or hilarious. Already Skoglund was demonstrating her interest in artificial-looking colors and the deadpan presentation of patently ridiculous situations.

Skoglund's food pictures sold well—through New York's prestigious Castelli Gallery—and in 1980 she began producing her characteristic tableaux (plate 199). For nearly twenty years these complex works have constituted Skoglund's equivalent to making movies. In them she found a way to combine many of her related interests—sculpture, set design, lighting, and photography. Each scene, which takes about six months to complete, begins with Skoglund modeling multiples of whatever animal she will be featuring, in clay, over a metal armature; the sculptures are then cast in polyester resin. Meanwhile, she goes on a careful search for the perfect props—clothing, furniture, and so on. She arranges the component parts, paints them whatever strange hues she has decided on, positions her human actors, lights the scene, and photographs it. Skoglund's physical installations are only temporary, although they can be re-created in more than one setting; but the photographs—limited-edition, large-format Cibachrome prints—remain.

In addition to these tableaux, Skoglund has exhibited drawings and a series of photocollages; she has also held teaching positions at a number of United States colleges. Over the years Skoglund's work has received a significant amount of attention; it appeared, for example, in the 1981 Whitney Biennial and a 1992 retrospective and has been acquired by many major museums. But scholars are only beginning to take Skoglund's art seriously. This reluctance is unfortunate but understandable, since the underlying meaning of Skoglund's work is so difficult to pin down. Beneath its humorous surface, the work appears to address a number of important issues—from the encroachment of suburbia to the increasing inability of human beings to control our own environments. But the artist skillfully keeps her tableaux ambiguous—and it is this uneasy balance between its humorous and ominous qualities that makes Skoglund's art so compelling.

Like Skoglund, Carrie Mae Weems often sets up and photographs elaborate tableaux. Both artists seduce the viewer into contemplating scenes that become increasingly disturbing the longer one looks at them. But whereas Skoglund's images seem playfully surreal, Weems's are designed to shock. By combining her gorgeously printed images with provocative, challenging texts, Weems confronts stereotypes about race, gender, and class that remain pervasive in late twentieth-century America.

Weems did not start exhibiting her photographs until the comparatively advanced age of twenty-seven; her earlier life had little to do with visual art.⁴⁵ Born and raised in a working-class section of Portland, Oregon, she left home as a teenager and took a series of odd jobs on farms, in factories, and with feminist political organizations. In 1976 a friend gave her a camera; three years later Weems enrolled at the California Institute

199. Sandy Skoglund (b. 1946). Gathering Paradise, 1991. Color Cibachrome photograph, edition of 30, 50 x 70 in. Collection of the artist. © 1991 by Sandy Skoglund.

241

200. Carrie Mae Weems (b. 1953). Black Woman with Chicken, 1987. Silver print, 14½ x 14½ in. Courtesy P.P.O.W. Gallery, New York.

of the Arts, from which she graduated in 1981 with a B.F.A. in photography. The work she produced there and later, at the University of California, San Diego—where she received her master's—dealt primarily with the theme that remains her focus: the experience of black Americans, particularly women, both historically and in the present day. Weems had her first one-person show in 1984 and has exhibited regularly since then, in North America, Europe, and Korea. In addition, she has produced many artist's books, taught at several universities, and received numerous honors, including a Smithsonian Institution Fellowship (in 1987) and a Louis Comfort Tiffany Award (1992).

Family Pictures and Stories (1978–84) combines captioned, 35mm black-and-white photographs of Weems's relatives—carefully staged to look like candid snapshots—with audiotapes of her own voice reminiscing about the people in the prints. With this series, Weems challenged the tradition of the "objective" documentary photographer exploring an alien culture as an outsider. Weems is bluntly honest, describing both happy and distressing moments in her family's history. This contrasts with her Untitled (Kitchen Table Series) of 1990—a highly evocative fictional narrative based on twenty black-and-white photographs with related text written by Weems. 46

In the mid-1980s Weems started graduate studies in African-American folklore at the University of California, Berkeley. This inspired her to collect examples of stories, songs, folk sayings, riddles, jokes, and memorabilia, which in turn led to American Icons (1988–89), Weems's series of photographs of domestic interiors featuring ashtrays, saltshakers, and other bric-a-brac made in forms that caricature blacks. Her series called Colored People (1989–90) plays on the terms used to describe the innumerable variations in skin tones of "black" people. Black-and-white photographs are colored with a wash of yellow-brown, for example, for *Honey Colored Boy*, or indigo, for *Blue Black Boy*—the titles of which appear in large block letters across the bottom of each work.

Although disquieting, neither American Icons nor Colored People is as upsetting as Ain't Jokin (1987–88), in which Weems juxtaposes mildly stereotypical phrases or viciously racist jokes and children's rhymes with monochrome photographs. In *Black Woman with Chicken* (plate 200), Weems demands that viewers consider the implications of associating certain types of food—or, by extension, certain attitudes or behaviors—with particular racial or ethnic groups. Other works in this series pose riddles then require visitors to slide back panels beneath the photo to reveal the punch lines; the viewer's discomfort is intensified by having to interact physically with these objects.⁴⁷

Weems has sometimes been accused of heavy-handedness in her work, but she makes no apologies for its content. A 1991 piece, And 22 Million Very Tired and Very Angry People, based on a 1941 photo-essay by Richard Wright and Edwin Rosskam, is a direct call to political action.

Untitled (Sea Island Series) (1991–92) explores the survival of African cultural elements among the descendants of slaves now living on the coasts of South Carolina and Georgia. In 1995 Weems commented: "I want to make things that are beautiful, seductive, formally challenging, and culturally meaningful. . . . I'm also committed to radical social change . . . the battle against all forms of oppression keeps me going and keeps me focused."⁴⁸

Like Weems, Alison Saar (plate 201) makes art that deals with her identity as a black American woman. But Saar's exposure to art began much earlier, and her work reflects a growing trend among young American artists of various ethnicities—perhaps influenced by the recent popularity of "outsider" art—to create sophisticated sculpture and painting that superficially resemble folk art.⁴⁹ Growing up in southern California, she helped her mother, the noted sculptor and printmaker Betye Saar (b. 1926), gather materials for her found-object assemblages. Alison later spent eight years as an apprentice to her father, Richard Saar, in his art conservation laboratory; and her two sisters, Lazley and Tracye, became a visual artist and a writer, respectively.

Influences from various cultures are apparent in Saar's art, mirroring both her family's heritage and her own formal training in art and art history (Saar earned her bachelor's degree at Scripps College in 1978 and her M.F.A. at Otis Institute in Los Angeles, three years later; she had her first one-person show at the age of twenty-six). Like Weems and several of the artists discussed below, Saar has long been concerned with questions of racial and ethnic identity. Her mother is of African-American, Irish, French, and Native American background; her father's ancestors were from Germany and Scotland. Although she considers herself black, Saar is light skinned and often assumed to be Caucasian.

Snake Charmer (plate 202) is a typical example of Saar's mature work. Its intentionally crude carving, polychromy, and decorative use of recycled metal and bits of shell recall folk art from many societies.⁵⁰ Saar made this piece while artist in residence at the Roswell Museum in New Mexico. She has indicated that the sculpture's color scheme reflects the southwestern desert landscape and that her interest in Native American artifacts led to her use of turquoise; in addition, she has cited Navajo and Zuni traditions as sources for this sculpture, which might also refer to the traditional Hopi snake dance.⁵¹

The most striking part of *Snake Charmer* is, of course, the snake—a greenish creature with red rhinestone eyes, painted pink on the bottom and inside its mouth, with turquoise diamonds along its back. Although the snake has no visible teeth, it still seems daring for the man to hold it in his mouth (the artist has commented that the snake has been "hypnotized"⁵²). Certainly, neither it nor the carved man seems to be struggling. Snakes have been worshiped as deities, reviled as embodiments of evil, and equated with sexuality all over the world, from Egypt to Haiti. They appear in several other works by Saar. For example, *Black Snake in*

Below 201. Alison Saar. Photo © Timothy Greenfield-Sanders.

Right 202. Alison Saar (b. 1956). Snake Charmer, 1985. Wood, tin, paint, and found objects, 21 x 261/4 in. Hirshhorn Museum and Sculpture Garden, Smithsonian Institution, Washington, D. C.; Gift of Merry Norris, 1993.

My Bed (1986; private collection, Los Angeles) depicts a red-haired woman, asleep and thus unaware of the enormous serpent—carved in high relief—that is curling around her, smiling. And Mamba Mambo (1985; collection of Susan Bush and Warren Saks) conflates a nude woman (representing a Haitian vodun priestess, or "mamba") with the popular Cuban dance called the "mambo."⁵³

In other sculptures by Saar, the symbolism is clear. For instance, *Strange Fruit* (1985; Baltimore Museum of Art), the carved wooden figure of a nude woman suspended by a rope tied around her ankles, refers specifically to the song of that name, made famous in 1939 by Billie Holiday. The song describes a horrifying image: black people who have been lynched and left hanging on trees, their bodies "swinging in the southern breeze." At the same time *Strange Fruit* encompasses multicultural and art historical references. The figure's pose recalls the classical type known as the Venus Pudica (modest Venus), an often-copied nude sculpture from ancient Greece, with one hand shielding her breasts and the other covering

her genitals; a cavity inside the figure's stomach recalls the traditional practice among Kongo sculptors in Zaire of inserting healing herbs and other substances into hollows within their sculptures.

Like African tribal sculpture, the traditional art forms of Latin America have had an increasingly powerful influence on artists living in the United States. Much has been said in recent years about the rapid growth of the Latino population in the United States and its effects on every aspect of American life, from advertising to education and politics. During the last two decades more and more Latinos have achieved national recognition in all fields, including the arts; this is especially true for Chicanos (people whose roots are in Mexico), who constitute the largest Hispanic group in this country.

The Chicana painter Carmen Lomas Garza uses her cultural identity as the subject of all her work. But rather than taking a polemical approach, Lomas Garza has adopted the style and technique of folk art to acquaint viewers with the details, and the flavor, of her early life. 55 She was raised in a bilingual household, in the south Texas town of Kingsville. In school she had to deal with racial epithets from fellow students plus intolerance from the administration—Lomas Garza recalls being physically punished for speaking Spanish and not being allowed to listen to Tejano music. Nonetheless, when she decided to become an artist at age thirteen, she began by copying her mother's traditional paintings. Later inspired by the Chicano rights movement of the late 1960s—she decided to depict her memories of everyday life, as a way to help heal the wounds within the Hispanic community and also make non-Hispanics more aware of her experiences. This approach to art invited ridicule, both from other artists and from critics, who chastised her for painting in a selfconsciously "primitive" manner that they thought avoided dealing with the bitter realities of her early life.⁵⁷ In fact, Lomas Garza's work is just as political as Saar's or Weems's; like those artists, she forces mainstream viewers to acknowledge the existence, and the validity, of another kind of culture; she simply does it in a different way.

Although Lomas Garza followed her parents' advice and got a solid education, which included two master's degrees and a Texas Teachers Certification, she has never had to fall back on academic jobs. She had her first solo exhibition in 1972, the same year she finished her undergraduate studies, and has continued to show her work on a regular basis, receiving two fellowships from the National Endowment for the Arts, plus numerous other awards. She has also completed several public commissions and written a bilingual children's book, *Family Pictures/Cuadros de familia* (1990). Although most of her work consists of oil paintings on canvas, copper, or wood, she has also produced numerous watercolors, lithographs, and etchings, as well as works in cut paper and steel.

Some of Lomas Garza's works have specifically Chicano subjects—for example, images of senior citizens harvesting fruit from the

203. Carmen Lomas Garza (b. 1948). Empanadas (Turnovers), 1991. Gouache on paper, 20 x 28 in. Courtesy the artist.

prickly pear cactus or of a *curandera* (a traditional healer) pouring flaming medicine into a man's ear. But others—especially those depicting celebrations or families gathered in the kitchen to prepare a special meal—are simply Chicano variations on universal human themes. In a work such as *Empanadas* (*Turnovers*) (plate 203), Lomas Garza combines the all-too-"American" fashions of the 1950s with standard genre elements—like the cat begging for food in one corner and the little boy grabbing some in another. However, the family's nonmainstream identity is announced by such details as the ancient Mayan pyramid depicted on the wall calendar and the type of food being made. Here, as in most of her other pictures, Lomas Garza used "conceptual" perspective, tilting all the surfaces forward so that everything can be clearly seen. Even such apparently "high-tech" works as her laser-cut steel panels are based on the colorful cut-paper banners made for birthdays and other celebrations in her hometown. Not everything in her world is completely innocent. Consider, for example, her

paintings of Chicana gang members hiding razor blades in their elaborate hairdos; the emphasis on bloodstains and scattered feathers that accompanies the killing of a rabbit or a chicken for the family dinner; and her allegorical vision of heaven and hell.

For the last eight years Kiki Smith's work has been at the forefront of the genre known as "body art"—that is, art that takes as its subject the biological workings of the human body. Smith (plate 204) has had innumerable solo exhibitions all over the United States and Europe; she was included in the 1991 and 1993 Whitney Biennials and the 1993 Venice Biennale; she has been the subject of a feature article in *Artnews*, an *Art in America* cover story, and two prominent articles in the *New York Times*—in short, Kiki Smith has been hard to miss. ⁵⁸ Her work has been so prominent because—like Andres Serrano's notorious photographs of religious statuettes immersed in body fluids—it has consistently violated some of society's most fundamental taboos.

Born in Nuremberg, Germany, but raised in suburban South Orange, New Jersey, Smith comes from an arts-minded family. Her father was Tony Smith, a noted Minimalist sculptor; her mother is an opera singer and actor; and her sister Seton is a visual artist. As a child Kiki helped out with her father's work but seemed not to want a career in the studio. She rejected academic training, dropping out of the Hartford Art School, and—in marked contrast to many of the other women discussed in this chapter—has never had much contact with the university system. By her late teens and early twenties Smith had done many things, but making visual art was not one of them: she performed with a traveling puppet show and in one of Meredith Monk's experimental theater pieces; she worked as an electrician's apprentice; she studied industrial baking. After moving to New York City in 1976, Smith joined an artists' collective and collaborated on book and film projects while continuing to support herself with odd jobs. As late as 1985, three years after her first one-person gallery show, Smith's career path remained decidedly unconventional: she was certified to be an emergency medical technician, which qualified her to drive an ambulance. This move clearly reflected her preoccupation with the body, which she traces to her Roman Catholic upbringing and to the numerous tragedies in her family (including her father's early demise and the death of her second sister, Beatrice, of AIDS in 1988).

Smith has said, "I chose the body as a subject . . . because it is the one form that we all share." ⁵⁹ Certainly, everyone can identify with her life-size figures and body parts made from a broad range of materials, including cast paper, iron, bronze, wax, and glass. But Smith's sculpted bodies lack the civilized veneer we have come to expect from the statues in museums. Instead, like real bodies Smith's figures perform the most intimate biological processes—giving birth, lactating, urinating, ejaculating, vomiting, menstruating. Moreover, her sculptures also represent the substances that result from these processes (curling paper scrolls of

204. Kiki Smith, New York, January 15, 1994.

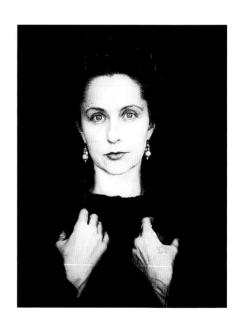

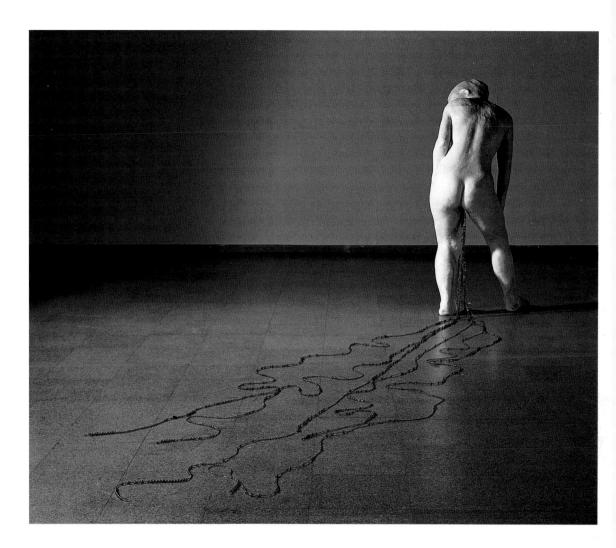

205. Kiki Smith (b. 1954). *Untitled (Train)*, 1993. Wax with beads, 53 x 55 x 168 in. Private collection; Courtesy PaceWildenstein, New York.

"vomit," crystal "sperm"). Unlike Serrano, who makes photos in which body fluids are taken out of context and so abstracted that they would be unrecognizable without their titles, Smith favors a literalness that remains startling, even at the end of the supposedly jaded twentieth century.

Elizabeth A. Brown asks, of Smith's *Untitled (Train)* (plate 205): "Can you take a subject that is widely, perhaps 'universally,' considered repulsive and make it precious and beautiful?" The answer varies with each viewer and with each work, but at the very least Smith has created arresting visual designs. Here she contrasts the irregular surface of the pale pink wax figure with graceful lines of glittering red glass beads. Effective from several different angles, the composition may refer to earlier art historical sources (again, the Venus Pudica) and to religious symbolism, such as the bleeding associated with the sign of the stigmata. Formalist and iconographic analysis aside, however, this is a sculpture about menstrual flow—a subject that still causes tremendous embarrassment in our culture. Smith consistently denies trying to shock, with this or any of her other works. And, though she admits that such a subject "can seem humiliating and frightening," she adds, "On the other hand, you can look at it [the

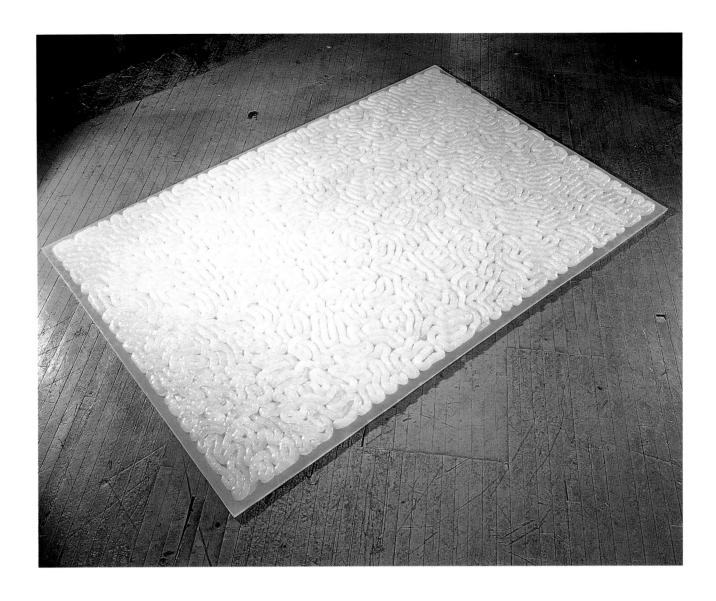

depiction of intimate physical processes] as a kind of liberation of the body."⁶¹ Or, as another writer sees it, in Smith's works "the body's vulnerability and mortality become both a source of pain and an affirmation of our common humanity."⁶²

Physical and emotional suffering, as an integral part of the human experience, also informs the art of Mona Hatoum. But, whereas Kiki Smith's sculpture emphasizes universal physical processes, Hatoum's work focuses on the particular kinds of pain experienced by certain groups. She says, "My work is about my experience of living in the West as a person from the Third World." More specifically, Hatoum's art deals with her identity as a Palestinian Arab woman in exile. Born and educated in Beirut, Hatoum went to London for further study (first at the Byam Shaw School and later at the Slade School of Art), then was prevented from returning home when civil war broke out in Lebanon in 1975. As a native of the Middle East, Hatoum falls outside the geographical boundaries of this book. However, having spent more than two decades—half her life—in England, she makes work that is much more closely allied to

developments in late twentieth-century Western art than it is to either the historical or the contemporary art of the Middle East.⁶⁴

Thus far, Hatoum's art has gone through two distinct phases. Her pieces from the early 1980s are overtly political video and performance works, which use her body as a vehicle to show her personal pain and frustration and to comment on international events. In a 1983 performance, *The Negotiating Table*, Hatoum lay still on a table for three hours, wrapped in a bloodstained body bag covered with entrails (a recurring motif in her work), while taped news accounts of Middle Eastern wars and related peace talks were played. The artist says this tableau vivant was the only piece she made that "referred specifically to the invasion of Lebanon. . . . I made this work right after the . . . massacres in the camps which for me was the most shattering experience of my life." A video from the same year, *There's So Much I Want to Say*, features a close-up of the artist's face with an unidentified pair of hands covering her mouth to keep her from talking, in a literal illustration of political repression.

At the end of the 1980s Hatoum began constructing installations and sculptural objects that lacked any specific references to the human body but were based on viewer participation. She had her first solo show in 1983; since then she has exhibited her art all over the world. A retrospective of her work is scheduled to open at the Museum of Contemporary Art. Chicago, in July 1997. Although essentially abstract, Hatoum's works from the early 1990s threaten visitors with actual physical danger, generally related to themes of imprisonment, torture, or death. The title of *Electric* Chair (1991) is self-explanatory; Light Sentence (1992) consisted of a room filled with a stack of wire-mesh cages illuminated by a bare bulb. More menacing are such installations as The Light at the End (1989), a dark tunnel with six seductive-looking red lights at one end. As the viewer approaches the lights, she slowly realizes that they are heating elements, forming a kind of suspended grill. Likewise, Hatoum's 1992 Untitled installation forced visitors to walk down a narrow passage between two parallel sets of taut piano wires, set at ankle and groin height.⁶⁶

Two of Hatoum's most recent works are sculptures created in 1995 in collaboration with the Fabric Workshop of Philadelphia. Both objects take the form of carpets—which, as Neal Benezra has pointed out, are particularly resonant symbols for someone from a part of the world where hand-knotted rugs play an integral part in both religion and commerce. Fin Carpet consists of some 700,000 brass straight pins pushed through a heavy fabric backing, with a brass compass set into its center—indicating where East is, so a Muslim worshiper would know which way to face during prayer. Like many of Hatoum's installations, this work combines a sense of visual delight with a tangible physical threat: the bristling and shimmering surface invites yet also repels touch. Nor would one be tempted to stroll across the mass of slippery, glistening intestines that Hatoum calls Entrails Carpet (plate 206). This piece, of molded silicone

206. Mona Hatoum (b. 1952). Entrails Carpet, 1995. Silicone rubber, edition of 3; $2\frac{1}{2}$ x 129 x 78 in. Created in collaboration with the Fabric Workshop and Museum, Philadelphia.

rubber, has "a beautifully translucent surface," 68 yet some viewers who find it difficult to separate form from content may not appreciate the work's aesthetic merits. Whereas Kiki Smith often sculpts bodies that are in the process of expelling trails of blood, feces, or—in one especially powerful example—a fetus, still attached to its mother by the umbilical cord (*Untitled*, 1989; collection of Eileen and Michael Cohen), Hatoum sets her sculpted "entrails" into a neatly framed rectangular format, like an actual, textured rug. There is no specific human body associated with these entrails, but *Entrails Carpet* inevitably conjures up images of eviscerated corpses and thus is directly related to Hatoum's earlier works.

Although their work never represents the human body, both Brazilian sculptor Jac Leirner and her English counterpart Rachel Whiteread create abstract art emphasizing objects and spaces that were once used or inhabited by people. In that sense, their sculptures resonate with a kind of implied human presence—or, more accurately, absence which can be surprisingly affecting. Until recently it has been difficult for American art lovers, curators, and scholars to learn about artists living in the Third World. South America has been particularly neglected by the United States art establishment, and the women artists there have been even more overlooked than their male counterparts. ⁶⁹ Within the last few years, however, galleries and museums in this country have finally begun taking a serious look at the work of a new generation of South American women artists with rapidly growing international reputations. One of the most interesting of these is the Conceptual/Minimalist sculptor Jac (short for Jacqueline) Leirner (plate 207). Thoroughly versed in the traditions of American and European modernism, Leirner creates art that also reflects her roots in a rich and complex, often contradictory culture, one known to most outsiders almost exclusively in terms of rain forests, string bikinis, and the samba. To create her visually arresting and thought-provoking installations, she collects detritus—cellophane wrappers from cigarette packages, used envelopes, plastic shopping bags. She combines these humble materials in unexpected ways, transforming them into designs that satirize today's throwaway society, make pointed criticisms of Brazil's ever-chaotic economy, and impress viewers with their unexpected beauty.⁷⁰

Born in São Paulo, in 1984 Leirner received her undergraduate degree from that city's College of Fine Arts at Fundação Armando Alvares Penteado; between 1987 and 1989 she served on the faculty of her alma mater. In 1990 Leirner was a visiting fellow at Oxford University; the following year she was artist in residence at the Walker Art Center in Minneapolis. Her first one-person show was held in 1982; since then she has exhibited at the 1989 São Paulo Bienal, the 1990 Venice Biennale, and Documenta IX (in 1992), plus numerous other venues, from Boston to Glasgow. These days Leirner, who continues to reside in São Paulo, is one of the few women regularly included on lists of important Latin American artists.⁷¹

Below 207. Jac Leirner.

Right 208. Jac Leirner (b. 1961). Corpus Delicti, 1992. Mixed media, dimensions variable. Galerie Lelong, New York.

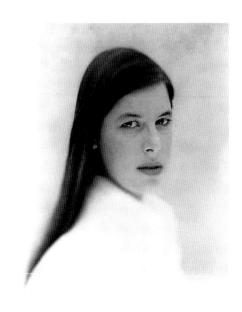

Os Cem (1985–87) typifies Leirner's approach to making art. She spent three years gathering approximately 70,000 well-used Brazilian banknotes (\$100 cruzeiros), then strung them together into long horizontal stacks that snaked around the floors, or cascaded down the staircases, of the space where the work was exhibited. These simple, flat pieces of paper were turned into three-dimensional forms, taking on a new physical substance and a visual rhythm all their own. But there is another, ironic meaning to this piece—one not readily apparent to non-Brazilians. In the late 1980s, when Leirner was making this work, \$100 cruzeiro notes were so devalued (due to rampant inflation) as to be virtually worthless.

Leirner's *Corpus Delicti* (plate 208) was five years in the making and can also be read on several different levels. ⁷² It consists of items gathered by the artist on her many international plane trips. Torn boarding passes, metal ashtrays, airsickness bags, and in-flight toiletries kits are all meticulously arranged, strung together on a thin silver chain, mounted between two large rectangular sheets of glass, and displayed on a pair of low plinths. In a whimsical variation on this theme, *Vol—Corpus Delicti* (1993), Leirner folded a set of square linen airplane napkins and hung them—with points facing down—on a steel cable, to simulate the flapping wings of birds flying overhead.

While Leirner makes her art out of small, often nondescript items, Rachel Whiteread (plate 209) turns large objects—from mattresses to entire buildings—into sculpture. Because she has chosen such unlikely subjects and treated them in such an unconventional manner, for some years Whiteread has been the subject of enthusiastic positive, and negative, publicity. This ambivalence is best illustrated by a recent pair of events. On November 23, 1993, at London's Tate Gallery, Whiteread received \$30,000 for the prestigious Turner Prize, designating her "the best English artist of the year." Two hours later, on the steps of the Tate, Whiteread accepted twice as much money from the K Foundation for being "the worst artist in England." Whiteread's work has been generating contradictory responses ever since her first solo exhibition in 1988.

The art that has sparked such high passions seems far removed from the body sculptures of Kiki Smith or the racially charged photographs by Carrie Mae Weems. Whiteread's work is subtle, consisting primarily of monochrome casts of the insides—or the undersides—of domestic objects and structures. But her simple geometric forms, like Leirner's assembled ephemera, evoke powerful thoughts about the people who might once have used those objects and lived in those spaces.

A London native, Whiteread studied painting at Brighton Polytechnic, then completed her formal education (in sculpture) at the Slade School of Art in London, from which she graduated in 1987.⁷⁴ The next year Whiteread inaugurated a busy exhibition schedule, and she has become even more active during the following years. Her early works are re-creations in plaster, rubber, or wood of furnishing fragments—a mantelpiece, a

Above 209. Rachel Whiteread.

Right 210. Rachel Whiteread (b. 1963). House, 1993. Site-specific installation made of building materials and plaster, height: approximately 32½ ft. Commissioned by Artangel Trust and Beck's, at the corner of Grove Road and Roman Road, London. Demolished in 1994.

254

or a breeding ground for demons. *Ghost* (1990) is a good example of Whiteread's later works, made from a typical "bed-sitter" in an abandoned Victorian terrace in north London. Whiteread cast the whole interior space of the room, cutting the hardened plaster into blocks and carefully reassembling them inside a London gallery. After receiving decidedly mixed reviews, *Ghost* was purchased by Charles Saatchi, a prominent English collector of contemporary art.

Inspired by the success—and notoriety—of *Ghost*, three years later Artangel (a London-based organization known for supporting avant-garde art) commissioned Whiteread to cast an entire house. After considerable research she chose 193 Grove Road, an abandoned three-story row house in London's economically depressed East End (plate 210). Completed on October 25, 1993, *House* was a temporary project—number 193 was the last building standing on a block that had been condemned to make way for a public park. It was an impressive undertaking: teams of construction workers sprayed the inside of the house with concrete and, once it was stable, removed the exterior walls to expose the cast. As one critic said, it had been "mummified . . . a house replaced by a negative of itself."

It was *House* that won Whiteread the Turner Prize, the K Foundation's award, and international notoriety. In the wake of the media blitz it spawned, people came from all over to view this curious monument—one reporter estimated there were eight hundred visitors a day. Reactions to *House* covered a predictably broad range—from those who called it "an eyesore," "a monstrosity," and an "utterly depressing . . . three-storey lump of concrete," to others for whom it represented "one of the most extraordinary and imaginative public sculptures created by an English artist in this century." *House* generated so much excitement that, within one twelve-hour period, over thirty-five hundred people signed a petition demanding that it be allowed to stand permanently. It did stay up two months longer than planned, but on January 11, 1994, *House* was demolished.

Although Whiteread has generally avoided explaining her work, she has admitted that *House* was partly a political statement. On the one hand, she said, "It's just a typical Victorian house [of the type] most people in England have lived in at some time or other." Yet it also has to do with what she sees as "the state of housing in England—the ludicrous policy of knocking down homes like this and building badly designed tower blocks which themselves have to be knocked down after 20 years." Even more significantly, *House* affected a great many people in the surrounding neighborhood, and beyond. As in Christo's ambitious temporary projects, such community involvement is an integral part of Whiteread's work. A British journalist commented that *House* "has already transformed the way a lot of people who have never set foot in a gallery see the mundane street in which it stands." ⁸⁰

As the examples presented in this chapter make clear, during the past decade women artists throughout the Western world have

mattress, a table leaf. There is something inherently intriguing about seeing nonfunctional stand-ins for objects we all live with displayed in a gallery or museum.⁷⁵ And viewers have been fascinated by Whiteread's more recent approach—casting these objects (or, more typically, the spaces around and inside them) in plaster or concrete.⁷⁶ In 1988 Whiteread exhibited a concrete cast of the inside of a closet, triggering contradictory childhood associations—of the closet as a safe place to hide

become more active, successful, and visible than ever before. But the most important point made in these seven chapters is that the current work by women artists has not been made possible only because of recent legal and social changes in the West. Women artists have always been there; their numbers include anonymous medieval nuns making manuscript illuminations, international art celebrities in the Renaissance and Baroque eras, eighteenth- and nineteenth-century court painters, and pioneers in all the major modernist movements. Women artists still face some of the same problems as their predecessors—insufficient and uncertain incomes, the conflicting demands of domestic and professional life—and these problems, which reverberate far beyond the art community, may never be solved. The important thing is that women artists keep working and that their work, and that of the women artists who came before them, become a universally recognized part of our culture.

NOTES

PREFACE (pages 7–8)

1. A copy of his unpublished manuscript ("Woman as Artist: A Pictorial Survey of Art by Women Artists," by Jules Heller, 1968) is in the library of the National Museum of Women in the Arts, Washington, D.C. I wish to thank my father for introducing me to the topic of women artists and for generously sharing his research and photographs with me.

2. The National Museum of Women in the Arts opened to the public April 7, 1987. Analogous developments have been taking place in related fields—indicated, for example, by the publication of *The Norton Anthology of Literature by Women*, ed. Sandra M. Gilbert and Susan Gubar (New York:

W. W. Norton, 1985).

3. The full citations are as follows: Ann Sutherland Harris and Linda Nochlin, Women Artists: 1550-1050 (Los Angeles: Los Angeles County Museum of Art; New York: Alfred A. Knopf, 1976); Elsa Honig Fine, Women and Art: A History of Women Painters and Sculptors from the Renaissance to the 20th Century (Montclair, N.J.: Allanheld and Schram, 1978); Germaine Greer, The Obstacle Race: The Fortunes of Women Painters and Their Work (London: Secker and Warburg; New York: Farrar, Straus and Giroux, 1979); Eleanor Munro, Originals: American Women Artists (New York: Simon and Schuster, 1979); Karen Petersen and J. J. Wilson, Women Artists: Recognition and Reappraisal from the Early Middle Ages to the Twentieth Century (New York: New York University Press, 1976); and Eleanor Tufts, Our Hidden Heritage: Five Centuries of Women Artists (New York: Paddington Press, 1974). Much of the biographical and critical information in the present volume is based on these books; they will hereafter be cited by the authors' last names. The most important earlier surveys of this subject are Clara Erskine Clement ("Mrs. Clement"), Women in the Fine Arts: From the 7th Century B.C. to the 20th Century A.D. (Boston: Houghton Mifflin Company, 1904; reprinted in 1974 by Hacker Art Books, New York); Elizabeth Fries Ellet ("Mrs. Ellet"), Women Artists in All Ages and Countries (New York: Harper and Brothers, 1859); and Walter Shaw Sparrow, Women Painters of the World: From the Time of Caterina Vigri (1413-1463) to Rosa Bonheur and the Present Day (London: Hodder and Stoughton, 1905; reprinted in 1976 by Hacker Art Books, New York).

- 4. Nonetheless, this represented a considerable improvement over the first and second editions of Ianson's book, which included no examples of work by women artists. Of the nearly four hundred artists represented in Frederick Hartt's Art: A History of Painting, Sculpture, and Architecture (3d ed.; Englewood Cliffs, N.J.: Prentice-Hall: New York: Harry N. Abrams, 1989), twenty-one are women; Gardner's Art Through the Ages, by Horst de la Croix and Richard Tansey (8th ed.; New York: Harcourt, Brace, Jovanovich, 1986), contains illustrations of works by twelve female artists.
- 5. Charlotte Streifer Rubinstein, American Women Artists: From Early Indian Times to the Present (Boston: G. K. Hall, 1982), p. 375. For some other illuminating sta-

tistics, see Fine, p. 146. In one of their information packets the "Guerrilla Girls," an anonymous New York-based group dedicated to calling attention to unequal treatment of women artists, noted that during the 1985-86 season only one of the solo exhibitions presented at the Museum of Modern Art and none of those at the Guggenheim Museum, the Whitney Museum of American Art, or the Metropolitan Museum was by a woman. See also "Career Markers" by Ferris Olin and Catherine C. Brawer, in Making Their Mark: Women Artists Move into the Mainstream, 1970-85 (New York: Abbeville Press, 1989), pp. 203-30.

INTRODUCTION (pages 11–13)

- 1. Most books on the subject ignore the issue of artists' identities, although in Everyday Life in Prehistoric Times (rev. ed., New York: G. P. Putnam's Sons, 1963), p. 79, Marjorie and C.H.B. Quennell note that, because life in the Upper Paleolithic was easier than in previous eras, "Man and perhaps woman began to draw. . . .' It is also instructive to consider such cases as the village of Mithila in northeastern India, where for hundreds of years brilliantly colored scenes from the Ramayana have been painted exclusively by women. For further information see Yves Véquaud, Women Painters of Mithila, trans. George Robinson (London: Thames and Hudson,
- 2. Ann Harris notes (Harris and Nochlin, p. 36) that it is extremely unlikely that any such fraud occurred in this case, suggesting that the Academy members' ac-

257

tions may have been motivated by

professional jealousy.

3. I would like to thank Marjorie Venit of the University of Maryland (College Park) for taking the time to discuss this example with me. According to Dr. Venit, recent scholarship suggests that this scene may depict a metalworkers' studio rather than a ceramics workshop,

as previously assumed.

4. Two illustrations of Thamar are published in Millard Meiss, French Painting in the Time of Jean de Berry: The Late Fourteenth Century and the Patronage of the Duke (London: Phaidon Press, 1967), vol. 2, figs. 287–92. I am grateful to Dr. Jean Caswell of the University of Maryland (College Park) for bringing this source to my attention.

5. The Elder Pliny's Chapters on the History of Art, trans. K. Jex-Blake (Chicago: University of Chicago Press, 1968), p. 171. While the battle painting mentioned by Pliny has been lost, the "Alexander mosaic," an ancient Roman composition based on it, is in the Museo Archeologico Nazionale, Naples. Although severely damaged, the mosaic remains a powerful image. Some scholars (see Frederick Hartt, Art: A History of Painting, Sculpture, and Architecture [2d ed.; Englewood Cliffs, N.J.: Prentice-Hall; New York: Harry N. Abrams, 1985], vol. 1, p. 189) attribute the original painting to Philoxenos, rather than Helen. The Italian poet Boccaccio used Pliny's accounts as a source for his treatise On Famous Women (De Claris Mulieribus) of 1370. Other Greek women artists mentioned by ancient writers include the painter Kallo and a sculptor named Kora, who is traditionally credited with having invented relief sculpture.

6. According to James Douglas Farquhar (Creation and Imitation: The Work of a Fifteenth-Century Manuscript Illuminator [Fort Lauderdale, Fla.: Nova/NYIT University Press, 1976], p. 28), by the 1480s membership in the Bruges painters' guild was approximately twenty-five percent female. Caterina dei Vigri, whom Ann Sutherland Harris describes as "the best-documented Italian nun-artist of the fifteenth century," was a well-educated, noble-born woman who became a Franciscan nun. Some of her paintings are said to have produced miraculous cures which contributed to her canonization as Saint Catherine of Bologna in 1712—but it is generally agreed that her art is otherwise undistinguished. For additional information, see Fine, pp. 6–7, and Harris and Nochlin, pp. 20–21.

7. For an illustration of the works once attributed to Sabina, see Petersen and Wilson, p. 20. Harris (Harris and Nochlin, p. 25 n. 63) explains that this confusion derives from an inscription recording a donor named Sabina. She also points out (p. 14 n. 6) that there are records of several female sculptors working in Paris in the thirteenth and fourteenth centuries.

1. THE RENAISSANCE

(pages 15-27)

- 1. Instead, Asdrubale went into business and held a number of local political offices. Greer points out (p. 182) that Amilcare Anguissola was being prudent by having his daughters learn the art of painting, as befitted a man who would have to provide six dowries. While fathers and siblings generally make it into the biographies of female artists, their mothers, ironically, are often left out. For the record, Sofonisba Anguissola's mother was Bianca Ponzona, Amilcare's second wife.
- 2. The length of her stay in Madrid is a matter of some scholarly debate; evidently it lasted between ten and twenty years. In 1561 Pope Pius IV asked her for a portrait of Queen Mary I; for the English text of his

flattering thank-you letter, see Giorgio Vasari, The Lives of the Painters, Sculptors, and Architects, trans. A. B. Hinds (London: J. M. Dent and Sons, 1963), vol. 3, p. 320.

3. Many sources give the date of her marriage as 1580, but Harris and Nochlin (p. 107) cite evidence that the earlier year is correct.

4. Anguissola told van Dyck that she was ninety-six, but all sources agree that this was an exaggeration. His notes appear, translated, in Fine, p. 10, and Tufts, p. 24.

5. This painting, dated 1555, is in the Museum Narodowe, Poznan,

Poland.

6. I would like to thank Elizabeth Churchill Cattan, coordinator of public affairs for the National Museum of Women in the Arts, for sharing with me her research on these portraits; Cattan is preparing a master's thesis on Sofonisba Anguissola for Southern Methodist University.

7. Vasari, Lives of the Painters, vol. 3, p. 319. For the comments of Baldinucci and later writers, see Harris

and Nochlin, pp. 106–7.

- 8. Many scholars believe that her popular drawing of a boy pinched by a crayfish (illustrated by Tufts, fig. 2) may have inspired Caravaggio's Boy Bitten by a Lizard. Recent scholarship indicates that it is unclear which Anguissola sister painted a number of canvases. For further information, see Sylvia Ferino-Pagden and Maria Kusche, Sophonisba Anguissola: A Renaissance Woman (Washington, D.C.: National Museum of Women in the Arts, 1995).
- 9. The portrait of a nun painted by Sofonisba, now in the City of Southampton Art Gallery, England, may be a likeness of Elena. Biographical information on the Anguissola sisters is taken primarily from Harris and Nochlin.
- 10. Harris and Nochlin, pp. 109-10. Harris suggests that the sitter may actually have been Pietro Martire, Lucia's maternal grandfather.
- 11. Interestingly, several writers have

pointed out that Fontana often used a very different arrangement for her portraits of men; the example illustrated in Harris and Nochlin (p. 113) and the group portrait in Tufts (p. 35) both feature dramatic views into far-distant rooms

12. Harris and Nochlin, pp. 111–12.

- 13. In a recent catalog, John T. Spike suggests that Galizia's still lifes may contain some elements of symbolism. For example, he cites her tendency to include cut or slightly bruised fruit, plus fallen leaves and blossoms, as an indication of the stages of the life cycle, analogous to the insects, clocks, and other elements characteristic of Dutch vanitas paintings (Italian Still-Life Paintings from Three Centuries [Florence: Centro Di, 1983], pp. 31–32).
- 14. Vasari, vol. 4, p. 197.

15. Ibid., vol. 2, p. 326.

- 16. Harris gives the best introduction to this issue, noting that approximately ten female artists were active in Flanders before 1600 (Harris and Nochlin, pp. 25–26).
- 17. For an excellent concise introduction to the subject of miniature painting, see Daphne Foskett, *A Dictionary of British Miniature Painters* (New York: Praeger Publishers, 1972), vol. 1, pp. 123–27.
- 18. In some cases, whole families of miniature painters were brought to England—as was true of Susanne Horebout (the subject of Dürer's quotation cited at the beginning of this chapter). Other women mentioned in this context include Katharine Maynors, Alice Carmillion, and Ann Smiter (Tufts, p. 43).
- 19. Fine states that she also painted full-size portraits (pp. 27–28), but Harris insists that Teerlinc was known to produce only miniatures (p. 102). Harris nonetheless calls Teerlinc the Flemish counterpart of Sofonisba Anguissola, in that she was a successful court painter who served as inspiration for other Northern European women artists.

2. THE SEVENTEENTH CENTURY (pages 29–51)

- 1. For the most complete and up-todate treatment of this artist and her oeuvre, see Mary D. Garrard, Artemisia Gentileschi: The Image of the Female Hero in Italian Baroque Art (Princeton, N.J.: Princeton University Press, 1989).
- 2. Harris points out that Tassi had previously been convicted of arranging his wife's murder causing one to doubt the wisdom of Orazio's choice (Harris and Nochlin, p. 118). Transcripts of this trial still exist, but according to Greer (p. 192) they are difficult to decipher. For further information see R. W. Bissell, "Artemisia Gentileschi-A New Documented Chronology," Art Bulletin 50 (1968): 153-68. I am grateful to Frima Fox Hofrichter for directing me to this valuable source in her article, "Artemisia Gentileschi: Judith and a Lost Rubens," Rutgers Art Review 1 (January 1980): 9–15.
- 3. Susanna and the Elders, 1610, is in a German private collection; illustrated in Harris and Nochlin, p. 119.
- 4. *Judith*, 1596, is in the Ringling Museum, Sarasota, Florida; illustrated in Petersen and Wilson, p. 29.
- 5. Judith is in the Walters Art Gallery, Baltimore; illustrated ibid. Bissell ("Artemisia Gentileschi") cites five additional paintings of this subject by Gentileschi.
- 6. One is in the Detroit Institute of Arts: the other is in the Pitti Palace, Florence. Several writers have suggested that being raped as a teenager may have been the motivation for Gentileschi's savage treatment of the Judith story. (See, for example, Bissell, "Artemisia Gentileschi," p. 156.) In her Rutgers Art Review article cited above, Hofrichter makes a convincing case for the influence of a lost painting by Peter Paul Rubens on both the composition and the shocking aspect of Gentileschi's *Iudith.* (I am thankful to Dr. Hofrichter for providing me with

a copy of this article.)

7. David and Bathsheba is in the Columbus Gallery of Fine Arts, Columbus, Ohio; illustrated in Harris and Nochlin, p. 124.

8. Fine, p. 19.

9. For example, her Saint Anthony of Padua (1666), although terribly sweet for modern tastes, contains many impressive still-life passages, and the cherubs have believably babyish anatomies. But her Mary Magdalene of 1660 is not especially successful: the saint's body seems disjointed, and the incorporation of winged cherub heads floating above her in the wilderness seems ill-advised. (Both works are in the Bolognese Pinacoteca.)

I am grateful to several members of my seminar on women artists (at Georgetown University, fall 1996) who called to my attention the fact that the individuals in the background of Sirani's *Porcia* are other women, not men (see my text, p. 34). This point is also made by Whitney Chadwick in *Women*, *Art*, *and Society* (London: Thames and Hudson, 1992, p. 92).

10. For a marvelous selection of color illustrations of Garzoni's work see Silvia Meloni, "The Gentle Genre: Giovanna Garzoni," FMR America 11 (May 1985): 105–24.

- 11. According to Christopher Wright, The French Painters of the Seventeenth Century (Boston: Little, Brown, 1985), p. 232; several other authors are similarly lavish with their praise. Greer (p. 135) notes that in 1973 a Moillon painting sold for \$120,000 at Sotheby Parke Bernet.
- 12. Harris and Nochlin, p. 34. Moillon was not elected, Harris surmises, because her best work had been produced in the years before the Academy was founded. The first woman elected to the Academy was a flower painter: Catherine Duchemin, in 1663.
- 13. Christopher Wright, Masterpieces of Reality: French Seventeenth-Century Painting (New Walk, Leicester, England: Leicestershire

Museum and Art Gallery, 1985), entry for figure 5a.

14. The only significant information appears in Harris and Nochlin

(pp. 131-33).

15. This vanitas theme remains popular today, notably in the works of American women painters such as Audrey Flack and Pat Steir.

16. Tufts, p. 34.

- 17. The story is told by several writers (including Harris and Nochlin, p. 137) that Leyster's reputation was revived when the Louvre determined that one of its Hals pictures was actually by Leyster. However, Frima Fox Hofrichter asserts that the Louvre staff knew perfectly well that The Carousing Couple, dated 1630 and signed with Leyster's monogram, was by her when they acquired it from a private collector in 1914. This information comes from Dr. Hofrichter's letter to me of January 30, 1987, in which she generously shared some of the extensive research she had done for her monograph *Iudith Leyster*: A Woman Painter in Holland's Golden Age (Doornspijk, Netherlands: Davaco, 1989). I would like to thank Dr. Hofrichter for kindly reading my entire Baroque chapter, offering several illuminating comments and corrections. Levster's work has been confused with that of Frans Hals and of her husband. It is an index of how far her reputation has risen again that Levster is one of only two female artists (the other is Rachel Ruysch) mentioned in the standard reference book for this period: Jakob Rosenberg, et al., Dutch Art and Architecture, 1600-1800, rev. ed. (Baltimore: Penguin Books, 1972).
- 18. Several sources say that they had only three children, but Dr. Hofrichter's research has revealed the existence of two more.

19. See Tufts, p. 72; Fine, p. 32.

20. Harris and Nochlin, p. 137. In "Judith Leyster's 'Self-Portrait': 'Ut Pictura Poesis,'" Frima Fox Hofrichter discusses the subtle levels of meaning in this apparently straightforward painting (in Essays in Northern European Art Presented to Egbert Haverkamp-Begemann on His Sixtieth Birthday [Doornspijk, Netherlands: Davaco, 1983], pp. 106–11).

21. This painting is discussed in considerable detail by Hofrichter in "Judith Leyster's *Proposition*—

Between Vice and Virtue," *Feminist Art Journal* 4 (fall 1975):

22-26.

22. Fine notes (p. 68) that Lely painted a portrait of Beale; she also repeats the undocumented story that Lely and Beale were lovers.

23. 'The Excellent Mrs. Mary Beale' (London: Geffrye Museum, 1975),

p. 22

24. Fine, p. 68; Greer (p. 256) spells her last name "Curtis." For illustrations of Beale's work, see "The Excellent Mrs. Mary Beale."

- 25. Her name is sometimes also written as "Rose." The information here is derived from Daphne Foskett, A Dictionary of British Miniature Painters (New York: Praeger Publishers, 1972), vol. 1, pp. 191 and 481; see Foskett, vol. 2, for illustrations.
- 26. Ibid., vol. 1, p. 125. Foskett also notes (p. 481) that Rosse's parents, who were both dwarfs, had nine normal-sized children, of whom four survived.
- 27. Although Petersen and Wilson (p. 168 n. 26) cite a book listing the names of "over 150 Spanish women painters," Chris Petteys says Ayala and Roldán were the only two female artists recorded in the Iberian peninsula before the eighteenth century (Dictionary of Women Artists: An International Dictionary of Women Artists Born before 1900 [Boston: G. K. Hall, 1985], p. 32).
- 28. She is listed in several sources, including Greer (pp. 235–36), as Josefa de Obidos, after the Portuguese city where she worked and died.
- 29. Later, Luisa's son also helped to

polychrome her sculptures. By far the best source of information on this artist is Beatrice Gilman Proske's three-part article, "Luisa Roldán at Madrid," published in *Connoisseur* in February, March, and April 1964. Despite Roldán's obvious significance, Fine does not mention her at all, and Petersen and Wilson give her only a brief discussion. This may reflect the relatively lowly position still held by sculptors who work principally in clay.

30. Proske, February, pp. 728–30.

31. The twentieth-century American Photo-Realist painter Audrey Flack (see chapter 6) was so impressed when she first saw La Roldana's sculptures on a trip to Spain in 1970 that she made a series of paintings based on them. In particular, Flack has noted the "overwhelming" experience of encountering Roldán's Macarena Esperanza, based on the city's patron saint, in a small church in Seville (Audrey Flack on Painting [New York: Harry N. Abrams, 1981], pp. 32–43).

3. THE EIGHTEENTH CENTURY (pages 53-71)

- An excellent introduction to this period can be found in Fine, pp. 39–43. Much of the information noted here comes from that source.
- During the Revolution there was even an independent political party for women—the Société des Républicaines, established in 1793.
- 3. Many writers, including Tufts and Fine, suggest that she was taught by the Venetian painters Giuseppe Diamanti and Antonio Balestra, but Harris questions this (Harris and Nochlin, p. 161).
- 4. There are indications that she suffered periodic depressions at other times in her life, and one source states that Carriera had switched from miniatures to pastels largely

because of problems with her eye-

sight (Fine, p. 20).

5. She often signed her name "Kauffman," but most writers use the double *n*. Petersen and Wilson say that her first commissioned portrait was done when she was eleven (p. 44); Fine (p. 72) says twelve; and Harris notes a self-portrait painted at thirteen (Harris and Nochlin, p. 41).

 It was especially ambitious for Kauffmann to paint such pictures in England, where they had not yet become popular (Harris and

Nochlin, pp. 74–75).

7. As in Paris, the female members of the Academy in London had severely restricted privileges. No other women were admitted until Dame Laura Knight became the third member in the 1920s.

8. Fine, p. 118.

- 9. Fortunately, the only English edition of Vigée-Lebrun's autobiography (Memoirs of Madame Vigée-Lebrun, trans. Lionel Strachey, 1903) was reissued by George Braziller in 1989. A two-volume paperback edition of her diaries was recently issued in French: Claudine Herrmann, ed., Elisabeth Vigée-Lebrun: Souvenirs (Paris: Des Femmes, 1984).
- 10. Joseph Baillio, Elisabeth-Louise Vigée-Lebrun (1755–1842) (Fort Worth: Kimball Art Museum, 1982), p. 6. He also deals with the thorny issue of attributions.

11. Ibid., p. 7.

12. This painting, dated 1783, is in the collection of Princess von Hessen und bei Rhein, Darmstadt; see Baillio (p. 63) for an illustration. Vigée-Lebrun painted several other variations of this portrait.

 Her husband, from whom she had been estranged for some time, remained in France. They were divorced in 1794.

14. David Wakefield, French Eighteenth-Century Painting (London: Gordon Fraser, n.d.), p. 77.

15. "Vigée-Lebrun vs. Labille-Guiard: A Rivalry in Context," lecture by Danielle Rice for the National Museum of Women in the Arts, 1986. Typescript on file in the museum's library. An abridged version was published in the *Proceedings of the Eleventh Annual Meeting of the Western Society for French History*, John F. Sweets, ed. (Lawrence, Kans.: University of Kansas, 1984), pp. 130–38. I would like to thank Dr. Rice for graciously providing me with a copy of her paper. In any event, Labille-Guiard never approached the degree of celebrity attained by Vigée-Lebrun.

16. She had been married as a young woman to a financial clerk, Louis-Nicolas Guiard, from whom she was separated in 1779 (Harris and

Nochlin, p. 185).

17. Benoist was born M. G. Leroulx de la Ville and is thus listed in several sources, including Greer.

18. Harris and Nochlin, p. 49.

19. Fine, p. 76.

- 20. Gervase Jackson-Stops, ed., The Treasure Houses of Britain: Five Hundred Years of Private Patronage and Art Collecting (Washington, D.C.: National Gallery of Art; New Haven, Conn.: Yale University Press, 1985), p. 301. Walpole also compared her work to Praxiteles' and bequeathed her his home, Strawberry Hill.
- 21. The four works known to be by Duparc are all in the Musée des Beaux-Arts, Marseilles.
- 22. Information here is from French Painting, 1774–1830: The Age of Revolution (Detroit: Detroit Institute of Arts; New York: Metropolitan Museum of Art, 1974), pp. 440–43. See also George Levitine, "Marguerite Gérard and Her Stylistic Significance," Baltimore Museum Annual 3 (1968), pp. 21ff.

23. Mayer is listed in the *Dictionnaire* universel de l'art et des artistes (Paris: Fernand Hazan, 1967), vol. 2, p. 493, as Marie-Françoise-Constance Lamartinière-Mayer.

24. Some sources say that Mme. Prud'hon was in a mental institution; Greer (p. 37) indicates that she was in prison.

- 25. The color schemes and the gravity of Vallayer-Coster's more humble still lifes have inspired comparisons with Chardin. In fact, the still-life expert Charles Sterling has ranked her "after Chardin and Oudry, the best French still-life painter of the 18th century" (Still Life Painting from Antiquity to the Present Time, rev. ed., trans. James Emmons [New York: Universe Books, 1959], p. 89).
- 26. Harris and Nochlin, p. 180.

4. THE NINETEENTH CENTURY (pages 73–111)

- 1. An excellent introduction to this subject appears in Harris and Nochlin, pp. 50–55. Nochlin points out that women art students remained in separate classes, with inferior facilities, through most of the century. Generally they were not allowed to draw nude models—male or female—until the end of the 1800s.
- 2. This painting marked Grandpierre-Deverzy's Salon debut; she later exhibited three other versions of the same subject.
- 3. For more information about the Sharpleses, see Charlotte Streifer Rubinstein, American Women Artists: From Early Indian Times to the Present (Boston: G. K. Hall, 1982), pp. 40–42 (hereafter cited as Rubinstein). Ellen Sharples's diary provides much useful material about the family.
- 4. No Walk Today was included in the exhibition *The Treasure Houses* of *Britain*, held at the National Gallery of Art, Washington, D.C., in 1985–86.
- 5. A fine example is *Mrs. Sturgis and Her Children*, reproduced in color in Harris and Nochlin, p. 88.

6. Ibid., pp. 54-55.

7. Patience Lovell Wright (1725–1786) was the first professional sculptor in America, specializing in wax busts and full-length, lifesize figures of prominent politicians. Wright also spent a great

deal of time at the court of King George III, from whence she conveyed secret dispatches—concealed inside her sculptures—to friends back home. Her dual career is discussed by Charles Coleman Sellers in *Patience Wright: American Artist and Spy in George III's London* (Middletown, Conn.: Wesleyan University Press, 1976). Her son, Joseph Wright, became a painter, and her daughter married an English portraitist (Fine, p. 98).

8. For a good summary of early American life and art, see ibid., pp.

89–96.

9. For further information, see Robin Bolton-Smith and William H. Truettner, *Lilly Martin Spencer* (1822–1902): *The Joys of Sentiment* (Washington, D.C.: Smithsonian

Institution Press, 1973).

- 10. There are many theories about the reason for Spencer's refusal. Rubinstein suggests it may have been related either to the long time that Longworth expected his protégés to study in Europe (seven years) or to the desire of some American artists to eschew European influence in an attempt to develop a more "American" approach to their work (p. 51).
- 11. The 1987 edition of this book reproduced a different painting by Sarah Miriam Peale, Children of Commodore John Daniel Daniels (sometimes listed as Danels), c. 1826, in the Maryland Historical Society, Baltimore. Although Peale's claim to this work had long been accepted by scholars, the picture is unsigned, which had left the matter open to reinterpretation. This painting has recently been reattributed to Robert Street (1796-1865), a native of Germantown, Pennsylvania, who was living in Baltimore (home of the Daniels family) by 1822. For additional information concerning this reattribution, see the catalog entry by Claudia Vess in Guy C. McElroy, Facing History: The Black Image in American Art, 1710–1940

(Washington, D.C.: Corcoran Gallery of Art; San Francisco: Bedford Arts, 1990), p. 17.

12. In fact, Nochlin suggests that the sword may be the one presented to Ney by Napoleon as a wedding gift (Harris and Nochlin, p. 216).

- 13. The Reverend R. B. Thurston, writing about Harriet Hosmer in James Parton et al., Eminent Women of the Age: Being Narratives of the Lives and Deeds of the Most Prominent Women of the Present Generation (Hartford, Conn.: S. M. Betts, 1868), p. 566.
- 14. Her collection, *Poems*, was published in 1859.
- 15. Petersen and Wilson say that she carried a pistol to defend herself walking to and from these classes (p. 80). She was also an avid mountain climber; Mount Hosmer in Missouri is named after her.
- 16. She is also known as Mary Edmonia Lewis. Her birth date is uncertain (1843, 1844, and 1845 have all been cited), and her date of death is unknown. For more information, see the *Dictionary of American Negro Biography*, ed. Rayford W. Logan and Michael R. Winston (New York: W. W. Norton, 1982), p. 395.
- 17. Eleanor M. Tufts, "Edmonia Lewis: Afro-Indian Neo-Classicist," *Art in America* 62 (July-August 1974): 71–72. She was enrolled in the Preparatory Department.

18. Logan and Winston, Dictionary of American Negro Biography, p.

394.

Remarkably, Lewis's Cleopatra was rediscovered, at the bottom of a garbage dump in a Chicago suburb, in the mid-1980s. In 1994 it was given to the Smithsonian Institution's National Museum of American Art, which spent \$30,000 and two years restoring the sculpture. In the summer of 1996, it was displayed to the public for the first time in over a hundred years.

19. A Woman of the Century: 1487 Biographical Sketches Accompanied by Portraits of Leading American Women in All Walks of Life, ed. Frances E. Williams and Mary Livermore (Buffalo: Charles Wells Moulton, 1893; reprinted by Gale Research Co., Detroit, 1967), pp. 398–99. Rubinstein says she received this commission at eighteen (p. 83).

20. For additional information, see Marjory Goar, Marble Dust: The Life of Elisabeth Ney, An Interpretation (Austin: Eakin Press, 1984).

21. According to Goar (chapter 6), by this time Schopenhauer was a difficult, aging man with a reputation for misogyny.

22. These were her brothers Isidore and Auguste and her sister Juliette. Both of Juliette's sons also became

artists.

23. This painting is in the Louvre; see Fine (p. 58) for an illustration.

- 24. The Horse Fair also toured America for three successful years. Bonheur's triumph in England was especially satisfying, given the long English tradition of animal art. Queen Victoria even employed several painters—including Maud Earl and Gertrude Massey—as portraitists of the royal pets. For related information, see Robert Rosenblum and H. W Janson, Nineteenth-Century Art (New York: Harry N. Abrams, 1984), pp. 465–68.
- 25. Butler's sister, Alice Meynell, became a noted writer.
- 26. Harris and Nochlin, p. 54.
- 27. Eugène was an amateur artist and an ardent supporter of his wife's work. According to Petersen and Wilson (p. 91), he once challenged a critic to a duel in response to some disparaging remarks about Morisot's painting.
- 28. Morisot's grandfather was an architect, and her father studied at the Ecole des Beaux-Arts before going into government work. A long-assumed relationship to Jean-Honoré Fragonard has recently been disproved by Suzanne Lindsay in her research for Charles F. Stuckey et al., Berthe Morisot, Impressionist (New York: Hudson Hills Press, 1987).

29. She abstained in 1879, when she was pregnant with her only child,

a daughter.

30. Haystacks, Giverny is in a private collection. For a color reproduction, see William H. Gerdts, American Impressionism (New York: Abbeville Press, 1984), plate 89. For more information, see Meredith Martindale, Lilla Cabot Perry: An American Impressionist (Washington, D.C.: National Museum of Women in the Arts, 1990).

31. Related works from the turn of the century include *L'Edition de luxe* by Lillian Westcott Hale and *Leisure* by William Worcester Churchill. For illustrations, see Patricia Hills, *The Painter's America: Rural and Urban Life*, 1810–1910 (New York: Praeger Publish-

ers, 1974).

- 32. The Man with a Cat is now in the National Museum of American Art, Smithsonian Institution, Washington, D.C.; A New England Woman is in the Pennsylvania Academy of the Fine Arts. For illustrations of both, see Frank H. Goodyear, Jr., Cecilia Beaux: Portrait of an Artist (Philadelphia: Pennsylvania Academy of the Fine Arts, 1974).
- 33. For a complete Beaux chronology, see ibid.
- 34. Susan P. Casteras and Seymour Adelman, Susan Macdowell Eakins, 1851–1938 (Philadelphia: Pennsylvania Academy of the Fine Arts, 1973).
- 35. She is also known as Mrs. William Crowthers Fitler, according to an unlabeled Xerox copy in the vertical file, National Museum of Women in the Arts.
- 36. A complete English edition now exists—The Journal of Marie Bashkirtseff, trans. Mathilde Blind (London: Virago, 1985). A theatrical version of this work, entitled Le Journal de Marie Bashkirtseff, adapted and directed by Victor Viala, opened in Paris at the Théâtre Essaïon in September 1984.
- 37. For more information, see Robert

Wernick, "Camille Claudel's Tempestuous Life of Art and Passion," *Smithsonian* 16 (September 1985): 57–62; and Reine-Marie Paris, *Camille Claudel* (1864–1943) (Paris: Editions Gallimard, 1984). A film about her life, starring Isabelle Adjani and Gérard Depardieu, was released in 1988.

 Claudel's relationship with Rodin is said to have inspired Henrik Ibsen's final play, When We Dead

Awaken

39. For additional information, see

Rubinstein, pp. 186–90.

- 40. For several examples, see A Dancer in Relief: Works by Malvina Hoffman (Westchester, N.Y.: Hudson River Museum, 1984); Malvina Hoffman, Heads and Tales (New York: Scribner's, 1936), pp. 57–68; and Linda Nochlin, "Malvina Hoffman: A Life in Sculpture," Arts Magazine 59 (November 1984): 106–10.
- 41. She also published two other books: Sculpture Inside and Out (New York: W. W. Norton, 1937); and Yesterday Is Tomorrow: A Personal History (New York: Crown, 1965).
- 42. For more information about Brookgreen see A. Hyatt Mayor's introduction to A Century of American Sculpture: Treasures from Brookgreen Gardens (New York: Abbeville Press, 1981).

5. THE EARLY TWENTIETH CENTURY (pages 113–61)

1. For further information, see Fine,

pp. 142–49.

2. For example, the National Association of Women Artists was established in 1889 and the New York Society of Women Artists in 1925 (Fine, p. 145). Amy J. Wolf organized an exhibition of work by the original members of the latter group, held at the ACA Galleries, New York, in March 1987.

She also taught her illegitimate son, Maurice Utrillo, how to paint, in a futile attempt to curb his

- alcoholism.
- 4. Within the three chapters on the twentieth century, individual artists are discussed in roughly chronological order based on the period in which their work had its first impact. In some cases, when particularly fine examples of the artists' work from subsequent periods became available, the later examples have been chosen for reproduction here.
- 5. English-language scholarship on the history of Russian modernism has increased tremendously in recent years. Two useful sources are Camilla Gray's *The Russian Experiment in Art:* 1863–1922 (New York: Harry N. Abrams, 1972); and John Bowlt, ed., *Russian Art of the Avant-Garde: Theory and Criticism*, 1902–1934 (New York: Viking Press, 1976).

 Petersen and Wilson, p. 113. After living together fifty-five years, Goncharova and Larionov were married on her seventy-fourth birthday. He died in 1964.

- 7. Exter lived in Paris with her second husband, the Russian actor Gregory Nekrasov, who managed her career. Other important pioneering Russian female artists include Liubov Popova, Olga Rozanova, and Nadezhda Udaltsova.
- 8. One reviewer called these huge flowers "primordially libidinous" (Jo Gibbs, "The Modern Honors First Woman—O'Keeffe," Art Digest 20 [June 1946]: 6). The tradition of women flower painters goes back at least as far as the seventeenth century. It also extends up to the present day, with artists such as Pat Steir (see, for example, her series based on seventeenth-century Dutch flower pieces, illustrated in Carter Ratcliff, Pat Steir: Paintings [New York: Harry N. Abrams, 1986]).
- Several pictures in the Jack-in-thepulpit series (numbers II–VI) are reproduced in color in *Georgia* O'Keeffe (New York: Viking Press, 1076).
- 10. This excellent one-hour film by

Perry Miller Adato (Georgia O'Keeffe, 1977) is now available on

videocassette.

- 11. See Åke Fant, "The Case of the Artist Hilma af Klint," in Maurice Tuchman et al., The Spiritual in Art: Abstract Painting, 1890–1985 (Los Angeles: Los Angeles County Museum of Art; New York: Abbeville Press, 1986). Her papers and work are preserved in the Stiftelsen Hilma of Klintsverk, Jarna, Sweden.
- 12. Pereira's books include: The Nature of Space, Light and the New Reality; The Transformation of "Nothing" and the Paradox of Space; The Crystal of the Rose; The Simultaneous Ever-Coming "To Be"; and The Finite versus The Infinite.

13. For a detailed chronology see Jacques Lassaigne and Guy Weelen, Vieira Da Silva (New York:

Rizzoli, 1979).

14. Plastique, established in 1937. One of her best-known projects is the design for L'Aubette, a caférestaurant in Strasbourg, designed in collaboration with Theo van Doesburg and Jean Arp in 1927–28.

15. She married Bourdelle's assistant, a Swiss sculptor named Otto Bänninger, from whom she was later divorced. In 1955 she married a French writer, René de Solier (Tufts, pp. 224, 227).

16. Rubinstein, pp. 312–13.

17. For color photos of the latter see John Richardson, "High Life in the Doll's House," Vanity Fair, December 1986, pp. 109-17.

18. Her unpublished diaries are in Yale's Beinecke Rare Book and Manuscript Library (Harris and

Nochlin, p. 266).

- 19. John left more than one hundred portrait drawings of one of her favorite cats, a female named Edgar Quinet after the street on which John lived at the time (see Mary Taubman, Gwen John: The Artist and Her Work [Ithaca, N.Y.: Cornell University Press, 1985]).
- 20. Louise R. Noun, Abastenia St. Leger Eberle, Sculptor (1878–1942)

(Des Moines, Iowa: Des Moines Art Center, 1980).

- 21. The first extensive study of this subject was Whitney Chadwick's book Women Artists and the Surrealist Movement (Boston: New York Graphic Society, 1985). Surrealist imagery often seems actively misogynist, combining as it does eroticism with a violence generally directed against women; the same can be said for many of the works created by female Surrealists.
- 22. Ibid., p. 78.

6. MID-CENTURY TO THE MID-1980s (pages 163-209)

- 1. Irving Sandler, The Triumph of American Painting: A History of Abstract Expressionism (New York: Praeger Publishers, 1970). Principal sources for the biographical information presented in this chapter are Rubinstein, Fine, and Munro.
- 2. She was assisted in making this work by Jean Tinguely and Per Olof Ultvedt.
- The couple had three children and were later divorced.
- They are Daybook: The Journal of an Artist (New York: Pantheon Books, 1982); Turn: The Journal of an Artist (New York: Viking Press, 1986); and Prospect: The Journal of an Artist (New York: Simon and Schuster, 1996).
- Several writers have suggested that the inspiration for these, and for many of Graves's other works, came from hours spent as a child in the Pittsfield Natural History Museum, where her father was assistant to the director.
- 6. For the "punk" ad see Artforum, April 1974; the Betty Grable-esque one appears in Artforum, May 1974; the dildo ad in Artforum, November 1974. For a sample of the reactions to the ads, see "Letters," Artforum, December 1974. These shows were all held at the Paula Cooper Gallery in New York. Benglis has explained that

the motivation for the dildo ad, in particular, came from her desire to mock the feelings of sexual self-consciousness that she perceived as being strong in herself and in the rest of the country during the early 1970s, as well as from the general climate of uneasiness and doubt that had resulted from the recent resignation of President Nixon (Lynn Gumpert, Ned Rifkin, and Marcia Tucker, Early Work: Lynda Benglis, Joan Brown, Luis Jimenez, Gary Stephan, Lawrence Weiner [New York: New Museum, c. 1982, p. 14).

Both The Dinner Party and The Birth Project have been extensively documented in books and films. Chicago's next major undertaking was the Holocaust Project.

- Antin has also written a book documenting some of her experiences as Eleanora Antinova: Being Antinova, published in 1983 by Astro Artz in Los Angeles. For related information see Moira Roth, ed., The Amazing Decade: Women and Performance Art in America, 1970–1980 (Los Angeles: Astro Artz, 1983).
- Since the mid-1980s, Flack has devoted herself to producing sculpture, primarily monumental polychrome bronzes of heroic female figures.

7. NEW CURRENTS

(pages 211-255)

- 1. The U.S. Pavilion at the previous Biennale had featured the work of the long-established master Jasper Johns, which suggests just how big a change the choice of Holzer represented. In 1993 Louise Bourgeois became the second woman to represent the United States at the Venice Biennale.
- 2. See, for example, Art in America 74 (December 1986) and Artnews 87 (summer 1988).
- 3. See the extensive interviews with Holzer by Bruce Ferguson in Art in America 74 (December 1986):

- 109–114 ff, and John Howell in *Artnews* 87 (summer 1988): 123–27.
- 4. Roberta Smith, New York Times, March 10, 1989.
- 5. For an example of the latter see Robert Hughes's review of the Biennale in *Time*, July 30, 1991, p. 66.

6. See Carol Squiers's cover story on Kruger in the February 1987 issue of *Artnews* for a thorough discussion of Kruger's life and work.

- 7. Messager's first solo show in this country was held in 1978, at the Holly Solomon Gallery, New York. Messager later exhibited at alternative spaces in New York, California, and elsewhere. There are no significant Englishlanguage publications yet available on Messager. However, see Mo Gourmelon, "Arbitrated Dissections: The Art of Annette Messager," trans. Seth Eagen, Arts Magazine 65 (November 1990): 66–71.
- 8. Artists who have made related work include Eleanor Antin and Vito Acconci.
- For a discussion of the nineteenthcentury roots of Messager's *Chimeras*, see Gourmelon, "Messager," p. 6.
- 10. Les précieuses (literally, the precious ones) have long been disregarded by literary critics because of their exceedingly self-conscious, affected use of language. According to Gourmelon (ibid., p. 71), Messager is attempting with her works to rehabilitate the reputation of de Scudéry and her peers by working in a parallel fashion. Just as the *précieuses*, through their use of patently artificial writing styles, removed themselves and their readers from the unpleasant excesses of actual love, so does Messager distance herself, and us, from the reality of the human body, by fragmenting, distorting, and isolating its component parts.
- 11. Anderson's albums include *Big Science* (1982), *Mister Heartbreak* (1984), *United States* (a five-record set), *Home of the Brave* (the sound-

- track for her first movie, made in 1986), and *Strange Angels* (1989); all were produced by Warner Brothers Records. A helpful overview of the artist's work is available in the exhibition catalog by Janet Kardon, *Laurie Anderson: Works from* 1969 to 1983 (Philadelphia: Institute for Contemporary Art; University of Pennsylvania, 1983).
- 12. Ibid., pp. 22–31. In Randy Rosen and Catherine C. Brawer, et al., Making Their Mark: Women Artists Move into the Mainstream, 1970–85 (New York: Abbeville Press, 1989), p. 150, Anderson notes the political importance, for her, of working with advanced technology and of understanding that technology well enough to repair her own equipment.
- 13. There are several excellent articles in English on Horn and her work. Two particularly illuminating examples are Mina Roustayi, "Getting under the Skin: Rebecca Horn's Sensibility Machines," in Arts Magazine 64 (May 1989): 58–68, and Michael Bonesteel, "The Plumed Machine," Art in America 72 (May 1984): 147–51.
- 14. Finger-Gloves seems a likely source for the 1990 film Edward Scissorhands.
- 15. Horn has produced film and videotaped documentation of virtually all her works. Her best-known feature films are *Der Eintänzer* (1978) and *La Ferdinanda* (1981), both of which are emphatically surreal, juxtaposing unrelated characters and objects with nonlinear plots that allude to eroticism and death.
- 16. In 1974 Horn served as a visiting instructor in California. Since 1981 she has resided in Bad König-Zell, Germany.
- 17. Several writers have noted the similar sentiments voiced by the German artist Joseph Beuys, who nearly died in an airplane crash. Horn often cites Beuys as an important influence on her work; others include Marcel Duchamp, Oscar Wilde, and Buster Keaton,

- who also apparently liked to construct huge and threatening machines (see Bonesteel, "Plumed Machine," p. 151).
- 18. For a fuller discussion of *Hydra Forest* see Roustayi, "Horn's Sensibility Machines," pp. 67–68. Both she and Bonesteel also provide information concerning Horn's use of synaesthesia (the bringing together of several human senses), plus her recurring references to various forms of dance, voyeurism, and bird imagery.
- 19. For information on Australian art history and that country's impressive record regarding women's rights, see the essay by Nancy D. H. Underhill, in Eureka! Artists from Australia (London: Arts Council of Great Britain, 1982), p. 46; Australia: 9 Contemporary Artists (Los Angeles: Los Angeles Institute for Contemporary Art. 1984); Diane Waldman, "Impressions of Australia," in Australian Visions: 1984 Exxon International Exhibition (New York: Solomon R. Guggenheim Museum, 1984), p. 10; Field and Figuration: Australian Art, 1960-1986 (Adelaide, Australia: National Gallery of Victoria, 1987); and Half the Sky: An Exhibition of Works on Paper by Australian Women Artists (Adelaide: Art Gallery of South Australia, 1985).
- 20. This tradition had developed during the 1940s in the work of such painters as Arthur Boyd, Sidney Nolan, John Percival, and Albert Tucker (Waldman, "Australia," p. 10). For a discussion of the remarkable activity in Australian feminist circles during the 1970s, see Underhill, Eureka.
- 21. Between 1979 and 1980, and then again in 1982, Martin spent time traveling in the United States and Europe. She now lives in the Australian capital, Canberra.
- 22. For further information on the artist, see Peter Schjeldahl and I. Michael Danoff, *Cindy Sherman* (New York: Pantheon Books, 1984).

23. For illustrations see the New York Times, January 12, 1990, and February 1, 1990. That year Sherman's photos were selling for up to twenty-five thousand dollars

apiece.

24. After walking through a large exhibition of Sherman's works, it is startling to realize that one still could not recognize her on the street. Again, interpretations of this point vary: because she photographs herself exclusively, some writers assume that Sherman is morbidly self-absorbed; others believe that she hides behind these elaborate disguises because she has no sense of her own identity.

25. For more than twenty years Kozloff (who married the art critic and photographer Max Kozloff in 1967) taught all over the country-first in local elementary and secondary schools, and then at colleges and art schools. An excellent source of information on Kozloff is the catalog Joyce Kozloff: Visionary Ornament, by Patricia Johnston et al. (Boston: Boston University Art Gallery, 1986). Another useful source, from which much of my factual information on Kozloff was derived, is Sally Webster, "Pattern and Decoration," Art in America 75 (February 1987): 118-25.

26. Kozloff's architectural projects are in Cambridge, Massachusetts; Wilmington, Delaware; Buffalo, New York; Los Angeles; San Francisco; Philadelphia; and Detroit. The tile mural at the Harvard Square subway station measures 8 by 83 feet, and the San Francisco Airport project covers a 10-by-51-

foot wall.

27. A helpful source of information on Pindell is the exhibition catalog Howardena Pindell: Odyssey (New York: Studio Museum in Harlem, 1986). Pindell was an early member of AIR, an influential feminist cooperative gallery in New York, and she continues to be active on behalf of feminist and other civil-rights causes.

Unfortunately, despite her enormously impressive credentials, Pindell's work is still not receiving the attention it deserves.

28. Pindell has also made handsome prints that combine etching and lithography techniques. For illustrations, see Richard S. Field and Ruth E. Fine, A Graphic Muse: Prints by Contemporary American Women (New York: Hudson Hills Press, 1987), pp. 130, 131.

29. See Alberto Ruy-Sánchez, "New Forms for a Century's End," and Elizabeth Ferrer, "Through the Path of Echoes: Contemporary Art in Mexico," in the exhibition catalog of the same title (New York: Independent Curators Incorporated, 1990). All texts in this catalog are in both English and Spanish.

30. Maldonado currently lives in Mexico City, where she exhibits regularly at the Galería OMR. Works by Maldonado were included, simultaneously, in two recent New York exhibitions: Through the Path of Echoes (see note 29), at El Museo del Barrio, and Women in Mexico, at the National Academy of Design.

31. As Ferrer points out ("Path of Echoes," p. 41), a related source for this approach is work by the Mexican painter Maria Izquierdo (1902–1955). Also, for some illuminating comments on Frida Kahlo's influence on Maldonado's generation, see ibid., pp. 10 and 40.

32. Two of the most helpful sources on Solano in English are Gloria Moure, "An Encounter with a Secret: The Sculpture of Susana Solano," Artforum 26 (September 1987): 100–104, and Phyllis Rosenzweig's text in the brochure for the exhibition Directions: Susana Solano, at the Hirshhorn Museum and Sculpture Garden, Washington, D.C., 1989.

33. Solano's frequent use of the Catalan language is politically significant, since it—along with the rest of traditional Catalan culture was banned during the years of the Franco dictatorship.

34. See, for example, Paul Richard, "The Planes of Susana Solano's Spain," Washington Post, Novem-

ber 27, 1989, B1, B8.

35. For more information on Wilding, see Beatrice Kernan's text for the Wilding "Projects" show at the Museum of Modern Art, New York, 1987, and the essay by Lynne Cooke in Alison Wilding (London: Serpentine Gallery, 1985).

36. Jack Anderson, "Dance in Review," New York Times, November 15,

1993, C16.

37. Rose has said she "does performance, with media" (telephone interview with the author, Novem-

ber 27, 1996).

38. Her father and mother were, respectively, a commercial photographer and an arts administrator, and her brother Peter Rose is an experimental film and video maker. (This, and much of the other biographical material given here, is from John Canemaker, "Cross Over Art," Print 49 (January–February 1995): 90-95ff.

39. In addition to the animated dancers with whom she performs, Rose occasionally works with one or two other flesh-and-blood individuals, especially since founding the KabukiMenco Visual Theater in

1990.

40. Rose says she was inspired by a book of Barbara Morgan's photographs of Graham (Canemaker, "Cross Over Art," p. 95). She notes that her current work in progress, Kleopat'ra (which she expects to complete sometime in 1998), is based on the Egyptian Book of the Dead and the theatrical works of Antonin Artaud and Jean Cocteau.

42. Noteworthy women animators, who have won numerous awards for their innovative work, include Yvonne Andersen, Joan Gratz, Emily Hubley, Faith Hubley, Amy Kravitz, Caroline Leaf, Joanna Priestly, Sheila M. Sofian, and Stacev Steers.

43. Anne H. Hoy, Fabrications:

Staged, Altered, and Appropriated Photographs (New York: Abbeville

Press, 1987), p. 37.

44. Much of the information given here on Skoglund's life and work comes from Nan Richardson. "Sandy Skoglund: Wild at Heart," Artnews 90 (April 1991): 115–19.

45. For additional biographical information, plus informative essays on the artist's work, see the catalog for her retrospective exhibition, Andrea Kirsh and Susan Fisher Sterling, Carrie Mae Weems (Washington, D.C.: National Museum of Women in the Arts, 1993). Also see bell hooks, "Carrie Mae Weems: Diasporic Landscapes of Longing," in Inside the Visible: In, of, and from the Feminine, ed. M. Catherine de Zegher (Boston: Institute of Contemporary Art; Kortrijk, Belgium: Kanaal Art Foundation; and Cambridge, Mass.: MIT Press, 1994).

46. Influences often cited for Weems's early series include the pioneering African-American photographers James Van der Zee (1886–1983) and Roy DeCarava (b. 1919). Both enjoyed great success taking formal and informal portraits of the people and cityscapes of New York's Harlem; DeCarava was the first African American to win a Guggenheim Fellowship, in 1952.

47. Text has been an integral part of visual artworks since the classical world. For centuries painters in Western Europe included signatures, dates, and short explanatory comments as compositional elements in their canvases or panels. Although such texts went out of favor for several hundred years, they reappeared and proliferated in our own century—in Picasso's early Cubist collages; in René Magritte's Surrealist visual and verbal wordplay from the late 1920s; in the Pop icons by Robert Indiana and Bruce Nauman's neon "signs," made in the 1960s; and, more recently, in the aphorisms of Jenny Holzer. During the last half-dozen years text has

become a major element—indeed, often the only element—in work by young artists like Jack Pierson (b. 1960), Christopher Wool (b. 1955), and Glenn Ligon (b. 1960). But Weems's use of text comes closer to that of two women photographers—Barbara Kruger (plate 182) and Lorna Simpson (b. 1960). As seen earlier in this chapter, by 1978 Kruger had developed her signature method of critiquing society by combining simple, clichéd phrases appropriated from the mass media with apparently unrelated photographs. In the late 1980s Simpson began exhibiting her large-format photos, which typically juxtapose the image of a black woman—seen from above, from the back, or from some other odd viewpoint that makes her difficult to recognize—with an engraved plastic plaque that purports to label her. Simpson's ironic references to a white-dominated society's attitude toward minority women, her interest in African folklore and the traditions of storytelling, and her background in documentary photography all link her art closely to Weems's. Another obvious comparison is with the work of Adrian Piper (b. 1948), an African-American woman artist whose video installations deal-often quite aggressively—with gender- and race-based stereotyping.

48. Weems, interview with Thomas W. Collins, Jr., in the brochure for the Museum of Modern Art's Projects Series-#52, Carrie Mae Weems, New York, 1995.

49. For additional information, see Judith Wilson, "Down to the Crossroads: The Art of Alison Saar," Third Text: Third World Perspectives on Contemporary Art and Culture 10 (spring 1990): 25-44; and Mary Jane Hewitt, "Alison Saar: The Persistence of the Figurative," International Review of African American Art o (October 1990): 4-11. Alison Saar has exhibited jointly with her

- mother, as in their traveling show of 1991 entitled Secrets, Dialogues, Revelations.
- 50. According to Sidney Lawrence, this work is "sometimes mistaken for a portrait of rock star Grace Jones" (from the unpaged brochure for Directions: Alison Saar, Washington, D.C.: Hirshhorn Museum and Sculpture Garden, Smithsonian Institution, 1993). See Lawrence's essay for a good, condensed survey of Saar's oeuvre. Her work also calls to mind pseudoprimitive painted wood sculptures made by the German artist Stephan Balkenhol (b. 1957).

51. From page 2 of the transcript of Saar's appearance on the Charlie Rose television show, broadcast on WETA, Washington, D.C.,

April 5, 1993.

52. Charlie Rose transcript, p. 2. It is also daring, in a purely structural sense, to risk making such a long, thin form that projects, unsupported, on both sides of the head.

- 53. More specifically, Saar has identified this figure with Freida Ezurli, a popular Haitian "love goddess." The title may also allude to the green mamba, a highly venomous African snake. (Some commentators have even mentioned a possible link to striptease artists who use boa constrictors in their acts.)
- 54. See the wall text and vertical file on Saar at the Baltimore Museum of Art, which recently acquired this work. Both the lyrics and the music for "Strange Fruit" were composed by Lewis Allen. This song has also inspired many other artworks, including Kiki Śmith's Strange Fruit (1985), three small sculpted figures that hang from hooks; Glenn Ligon's 1993 installation featuring an audiotape of the Billie Holiday recording; and pieces by Leon Golub, Bruce Nauman, and Lorna Simpson.

55. The best source on Lomas Garza's art and life is Amalia Mesa-Bains, A Piece of My Heart/Pedacito de Mi Corazón: The Art of Carmen Lomas Garza (New York: New

Press, 1991). The artist currently lives in San Francisco.

56. Unpaged brochure for Directions: Carmen Lomas Garza (Washington, D.C.: Hirshhorn Museum and Sculpture Garden, Smithsonian Institution, 1995).

57. See, for example, Paul Richard's condescending review of her Hirshhorn show, in the Washington Post, December 3, 1995, G5.

58. For additional information on Smith, see Michael Boodro, "Blood, Spit, and Beauty," Artnews 93 (March 1994): 126-31; also see Elizabeth A. Brown's illuminating essav in Kiki Smith: Sojourn in Santa Barbara (Seattle and London: University of Washington Press, 1995).

59. Smith, in "An Interview with Kiki Smith by Robin Winters," in Kiki Smith (Amsterdam: Institute of Contemporary Art; The Hague: Sdu Publishers, 1990), p. 132.

60. Brown, Sojourn in Santa Barbara, pp. 14-15.

61. Smith, in Winters, "Interview," p. 127.

62. Eleanor Heartney, "Kiki Smith at Joe Fawbush," Artnews 91 (September 1992): 113.

63. Hatoum, in Neal Benezra, "Mona Hatoum: Direct Physical Contact," in Neal Benezra and Olga M. Viso, Distemper: Dissonant Themes in the Art of the 1990s (Washington, D.C.: Hirshhorn Museum and Sculpture Garden, Smithsonian Institution, 1996),

p. 49. 64. Salwa Mikdadi Nashashibi, editor of Forces of Change: Artists of the Arab World (Washington, D.C.: National Museum of Women in the Arts, 1994) has also commented on this. She notes (p. 54) that Hatoum and another Palestinian, Samia Halaby, while "conscious of their origins . . . see themselves not as members of a particular region, race or gender, but as artists pursuing the serious causes of art itself."

65. Hatoum, in Benezra, "Hatoum," p. 49. This piece is also closely related to the antiwar classic The Green Table, a modern dance work that savagely satirizes the diplomatic process, choreographed by the German innovator Kurt Joos in

66. For illustrations and more detailed descriptions of these works, see Benezra, "Hatoum," and Desa Philippi, "Mona Hatoum: Some Any No Every Body," in Inside the Visible, pp. 363–69.

67. Benezra, "Hatoum," p. 55.

68. Ibid.

69. There have been some exceptions to this rule—including the pioneering work done by the Hispanic Society of America, New York; the Museum of Modern Art of Latin America, Washington, D.C.; and the art and art history departments of several United States universities. To get an overall sense of this general neglect, see the introductory essay in the exhibition catalog Latin American Women Artists, 1015–1005, ed. Geraldine P. Biller (Milwaukee Art Museum, 1995).

70. Clearly, Leirner is working in the tradition of Kurt Schwitters, the German artist who began his Merzbau series (collages made of discarded paper, wood, and other materials) in the early 1920s; her work has also been compared to the Arte Povera movement of the 1960s and 70s.

71. Her countrywoman Leda Catunda, another São Paulo native born the same year as Leirner, makes "sculptural paintings" and also appears on many of these lists. For further information about Leirner, see Robin Cembalest, "Critics" Choice," Artnews 92 (summer 1993): 140-41; and the exhibition catalog David Elliott, Iac Leirner (Oxford, England: Museum of Modern Art, 1991).

72. Corpus Delicti was exhibited at Documenta IX in 1992; various other versions of it have been displayed at other venues.

73. Michael Kimmelman, "Turning Things Inside Out," New York Times, February 5, 1995, B1. Whiteread

accepted the K Foundation's money only because they had threatened to burn it if she did not. She donated part of the prize to a housing charity and the rest to other artists.

74. For additional information on Whiteread, see the essay by David Batchelor in Rachel Whiteread: The Plaster Sculptures (New York: Karsten Schubert; Luhring Augustine Gallery, 1993).

75. Consider, for example, the chair Transformations by Lucas Samaras and Donna Dennis's architec-

tural miniatures.

76. As many writers have pointed out, other artists—notably Bruce Nauman-had experimented with similar ideas as early as the mid-1960s. Recently a young American woman sculptor, Jeanne Silverthorne, has also been exhibiting casts of untraditional spaces.

77. John McEwen, London Sunday Telegraph, October 24, 1993; reprinted in James Lingwood, ed., Rachel Whiteread: House (London: Phaidon Press, 1995), p. 132.

78. For the full texts of these and other responses, see ibid.

79. Whiteread, in McEwen, Sunday Telegraph.

80. Deyan Sudjic, Guardian (London), November 25, 1993; reprinted in Rachel Whiteread: House. Whiteread's involvement in controversial projects continues. See the New York Times, October 28, 1996, C15, regarding her winning proposal for a Holocaust memorial that may, or may not, be erected in Vienna.

GENERAL BOOKS

American Association of University Women. Outstanding Women Artists of America. Le Mars, Iowa: Le Mars Daily Sentinel, 1975.

SELECTED BIBLIOGRAPHY

Bachmann, Donna G., and Sherry Piland. Women Artists: An Historical, Contemporary and Feminist Bibliography. Metuchen, N.J., and London: Scarecrow Press, 1978.

Behr, Shulamith. Women Expressionists. New York: Rizzoli, 1988.

Biller, Geraldine P. Latin American Women Artists, 1915–1995. Milwaukee: Milwaukee Art Museum, 1995.

Broude, Norma, and Mary D. Garrard. Feminism and Art History: Questioning the Litany. New York: Harper and Row, 1082.

——. The Expanding Discourse: Feminism and Art History. New York: HarperCollins, 1992.

Brunsman, Laura, and Ruth Askey. *Modernism and Beyond:* Women Artists of the Pacific Northwest. New York: Midmarch Arts Press, 1993.

Burke, Janine. *Australian Women Artists*, 1840–1940. Victoria, Australia: Greenhouse Publications, 1980.

Chadwick, Whitney. Women, Art, and Society. New York: Thames and Hudson, 1990.

——. Women Artists and the Surrealist Movement. New York: Thames and Hudson, 1991.

Clement, Clara Erskine ("Mrs. Clement"). Women in the Fine Arts: From the 7th Century B.C. to the 20th Century A.D. Boston: Houghton Mifflin Company, 1904; reprinted 1974 by Hacker Art Books, New York.

Cole, Doris. From Tipi to Skyscraper: A History of Women in Architecture. Boston: i press, 1973.

Collins, Jim, and Glenn B. Opitz, eds. Women Artists in America, 18th Century to the Present, rev. ed. Poughkeepsie, N.Y.: Apollo, 1980.

Dewhurst, C. Kurt; Betty MacDowell; and Marsha Mac-Dowell. Artists in America: Folk Art by American Women. New York: E. P. Dutton, 1979.

Ellet, Elizabeth Fries ("Mrs. Ellet"). Women Artists in All

Ages and Countries. New York: Harper and Brothers, 1850.

Field, Richard S., and Ruth E. Fine. A Graphic Muse: Prints by Contemporary American Women. New York: Hudson Hills Press, 1987.

Fine, Elsa Honig. Women and Art: A History of Women Painters and Sculptors from the Renaissance to the 20th Century. Montclair, N.J.: Allanheld and Schram, 1978.

Faxon, Alicia, and Sylvia Moore, eds. *Pilgrims and Pioneers:* New England Women in the Arts. New York: Midmarch Arts Press, 1987.

Garb, Tamar. Women Impressionists. New York: Rizzoli, 1086.

Gerdts, William H. Women Artists of America, 1707–1964. Newark, N.J.: Newark Museum, 1965.

Greer, Germaine. The Obstacle Race: The Fortunes of Women Painters and Their Work. London: Secker and Warburg; New York: Farrar, Straus and Giroux, 1979.

Harris, Ann Sutherland, and Linda Nochlin. *Women Artists*: 1550–1950. Los Angeles: Los Angeles County Museum of Art; New York: Alfred A. Knopf, 1976.

Hedges, Elaine, and Ingrid Wendt. *In Her Own Image:* Women Working in the Arts. Old Westbury, N.Y.: Feminist Press; New York: McGraw-Hill, 1980.

Heller, Jules. "Woman as Artist: A Pictorial Survey of Art by Women Artists." Unpublished manuscript, 1968, on file in library, National Museum of Women in the Arts, Washington, D.C.

Heller, Jules, and Nancy G. Heller, eds. North American Women Artists of the Twentieth Century: A Biographical Dictionary. New York: Garland Press, 1995.

Hess, Thomas B., and Elizabeth C. Baker, eds. Art and Sexual Politics: Women's Liberation, Women Artists, and Art History. New York: Macmillan Publishing Co., 1973.

Hill, Vicki Lynn, ed. Female Artists, Past and Present. Berkeley, Calif.: Women's History Research Center, 1974.

Iliopoulou-Rogan, Dora. *Three Generations of Greek*Women Artists. Athens: Greek Ministry of Culture;
Washington, D.C.: National Museum of Women in the Arts, 1989.

Kirker, Anne. New Zealand Women Artists. Auckland, New Zealand: Reed, Methuen, 1986.

Krull, Edith. Kunst von Frauen: Die Berufsbilder bildenden Künstlerinnen in vier Jahrhunderten. Frankfurt-am-Main, Germany: Weidlich, 1984.

Lippard, Lucy R., ed. From the Center: Feminist Essays on Women's Art. New York: E. P. Dutton, 1976.

Lyle, Cindy, et al. Women Artists of the World. New York: Midmarch Associates, 1984.

Marsh, Jan, and Pamela Gerrish Nunn. Women Artists and the Pre-Raphaelite Movement. London: Virago Press, 1080.

Moore, Sylvia, ed. No Bluebonnets, No Yellow Roses: Essays on Texas Women in the Arts. New York: Midmarch Arts Press, 1988.

——. Yesterday and Tomorrow: California Women Artists. New York: Midmarch Arts Press, 1989.

Munro, Eleanor. Originals: American Women Artists. New York: Simon and Schuster, 1979.

Munsterberg, Hugo. A History of Women Artists. New York: Clarkson N. Potter, 1975.

Nochlin, Linda. Women, Art, and Power—and Other Essays. New York: Harper and Row, 1988.

Nunn, Pamela Gerrish. Victorian Women Artists. London: Women's Press, 1987.

Parker, Rozsika, and Griselda Pollock. Old Mistresses: Women, Art and Ideology. New York: Pantheon Books, 1081.

Petersen, Karen, and J. J. Wilson. Women Artists: Recognition and Reappraisal from the Early Middle Ages to the Twentieth Century. New York: New York University Press, 1976.

Petteys, Chris. Dictionary of Women Artists: An International Dictionary of Women Artists Born before 1900. Boston: G. K. Hall, 1985.

Rosen, Randy, Catherine C. Brawer, et al. Making Their Mark: Women Artists Move into the Mainstream, 1970–85. New York: Abbeville Press, 1989.

Rosenblum, Naomi. A History of Women Photographers. New York: Abbeville Press, 1994.

Roth, Moira, ed. *The Amazing Decade: Women and Performance Art in America*, 1970–1980. Los Angeles: Astro Artz, 1983.

Rubinstein, Charlotte Streifer. American Women Artists: From Early Indian Times to the Present. Boston: G. K. Hall, 1982.

Slatkin, Wendy, ed. *The Voices of Women Artists*. Englewood Cliffs, N.J.: Prentice-Hall, 1993.

Sparrow, Walter Shaw. Women Painters of the World: From the Time of Caterina Vigri (1413–1463) to Rosa Bonheur and the Present Day. London: Hodder and Stoughton, 1905; reprinted 1976 by Hacker Art Books, New York.

Tufts, Éleanor. Our Hidden Heritage: Five Centuries of Women Artists. New York: Paddington Press, 1974.

——. American Women Artists, Past and Present: A Selected Bibliographic Guide. New York and London: Garland Publishing, 1984.

Witzling, Mara R., ed. Voicing Our Visions: Writings by Women Artists. New York: Universe Books, 1991.

Yablonskaya, M. N. Women Artists of Russia's New Age, 1900–1935. Translated by Anthony Parton. New York: Rizzoli, 1989.

GENERAL PERIODICALS

Feminist Art News

Heresies: A Feminist Publication on Art and Politics

Matriart

Woman's Art Journal

MONOGRAPHS

Magdalena Abakanowicz

Jacob, Mary Jane, Magdalena Abakanowizc, and Jasia Reichardt. *Magdalena Abakanowicz*. New York: Abbeville Press, 1982.

Rose, Barbara. *Magdalena Abakanowicz*. New York: Harry N. Abrams, 1994.

Laurie Anderson

Anderson, Laurie. Laurie Anderson: Stories from the Nerve Bible—A Retrospective, 1972–1992. New York: Harper Perennial, 1994.

Kardon, Janet. Laurie Anderson: Works from 1969 to 1983. Philadelphia: Institute for Contemporary Art; University of Pennsylvania, 1983.

Sophonisba Anguissola

Ferino-Pagden, Sylvia, and Marie Kusche. Sophonisba Anguissola: A Renaissance Woman. Washington, D.C.: National Museum of Women in the Arts, 1995.

Jennifer Bartlett

Goldwater, Marge, Roberta Smith, and Calvin Tomkins. Jennifer Bartlett. New York: Abbeville Press, 1990.

Cecilia Beaux

Tappert, Tara Leigh. Cecilia Beaux and the Art of Portraiture. Washington, D.C.: Smithsonian Institution Press, 1995.

Vanessa Bell

Spaulding, Frances. *Vanessa Bell*. San Diego: Harcourt Brace Jovanovich, 1985.

Lvnda Benglis

Krane, Susan. *Lynda Benglis: Dual Natures*. Atlanta: High Museum of Art, 1991.

Isabel Bishop

Lunde, Karl. *Isabel Bishop*. New York: Harry N. Abrams, 1975.

Yglesias, Helen. Isabel Bishop. New York: Rizzoli, 1989.

Rosa Bonheur

Ashton, Dore. Rosa Bonheur: A Life and a Legend. New York: Viking Press, 1981.

Louise Bourgeois

Kotik, Charlotta, et al. Louise Bourgeois: The Locus of Memory, Works 1982–1993. New York: Harry N. Abrams, 1994. Wye, Deborah. Louise Bourgeois. New York: Museum of Modern Art, 1982.

Romaine Brooks

Breeskin, Adelyn Dohme. *Romaine Brooks*. Washington, D.C.: Smithsonian Institution Press, 1986.

Emily Carr

Shadbolt, Doris. *The Art of Emily Carr.* Seattle: University of Washington Press, 1979.

Leonora Carrington

Emerich, Luís Carlos, and Lourdes Andrade. *Leonora Carrington: Una retrospectiva*. Texts in Spanish and English. Monterrey, Mexico: Museo de Arte Contemporáneo de Monterrey, 1994.

Mary Cassatt

Breeskin, Adelyn Dohme. *Mary Cassatt: A Catalogue Raisonné*. Washington, D.C.: Smithsonian Institution Press, 1970.

Judy Chicago

Chicago, Judy. Beyond the Flower: The Autobiography of a Feminist Artist. New York: Penguin Books, 1996.

Chryssa

Hunter, Sam. Chryssa. New York: Harry N. Abrams, 1974.

Camille Claudel

Paris, Reine-Marie. *Camille Claudel* (1864–1943). Paris: Editions Gallimard, 1984.

Dorothy Dehner

Marter, Joan. *Dorothy Dehner: Sixty Years of Art.* Katonah, N.Y.: Katonah Museum of Art, 1993.

Elaine de Kooning

Bledsoe, Jane K. Elaine de Kooning. Athens: University of Georgia, 1992.

Sonia Delaunay

Buck, Robert T. Sonia Delaunay: A Retrospective. Buffalo: Albright-Knox Art Gallery, 1980.

Cohen, Arthur A. Sonia Delaunay. New York: Harry N. Abrams, 1975.

Susan Macdowell Eakins

Casteras, Susan P., and Seymour Adelman. Susan Macdowell Eakins, 1851–1938. Philadelphia: Pennsylvania Academy of the Fine Arts, 1973.

Abastenia St. Leger Eberle

Noun, Louise R. Abastenia St. Leger Eberle, Sculptor (1878–1942). Des Moines, Iowa: Des Moines Art Center, 1980.

Leonor Fini

Galleria Civica d'Arte Moderna. *Leonor Fini*. Bologna: Edizioni d'Arte, 1983.

Janet Fish

Henry, Gerrit. *Janet Fish*. New York: Burton and Skira Co., 1987.

Audrey Flack

Flack, Audrey. Audrey Flack on Painting. New York: Harry N. Abrams, 1981.

Gouma-Peterson, Thalia, et al. Breaking the Rules: Audrey Flack, A Retrospective, 1950–1990. New York: Harry N. Abrams, 1992.

Lavinia Fontana

Cantaro, Maria Teresa. *Lavinia Fontana, bolognese "pittore singolare,"* 1552–1614. Milan: Jandi Sapi, Editori, 1989. Text in Italian.

Helen Frankenthaler

Elderfield, John. *Helen Frankenthaler*. New York: Harry N. Abrams, 1989.

Fede Galizia

Caroli, Flavio. Fede Galizia. Turin, Italy: Umberto Allemandi, 1989. Text in Italian.

Giovanna Garzoni

Casale, Gerardo. *Giovanna Garzoni*: "Insigne miniatrice," 1600–1670. Milan: Jandi Sapi, Editori, 1991. Text in Italian.

Artemisia Gentileschi

Garrard, Mary D. Artemisia Gentileschi: The Image of the Female Hero in Italian Baroque Art. Princeton, N.J.: Princeton University Press, 1989.

Natalya Goncharova

Chamot, Mary. Goncharova: Stage Designs and Paintings. London: Oresko Books, 1979.

Eva Gonzalès

Sainsaulieu, Marie-Caroline, and Jacques de Mons. Eva Gonzalès, 1849–1883: Etude critique et catalogue raisonné. Paris: La Bibliothèque des Arts, 1990. Text in French.

Nancy Graves

Carmean, E. A., et al. *The Sculpture of Nancy Graves: A Catalogue Raisonné*. New York: Hudson Hills Press, 1987. Cathcart, Linda L. *Nancy Graves: A Survey*, 1969–1980. Buffalo: Albright-Knox Art Gallery, 1980.

Grace Hartigan

Mattison, Robert Saltonstall. *Grace Hartigan: A Painter's World.* New York: Hudson Hills Press, 1990.

Barbara Hepworth

Bowness, Alan, ed. *The Sculpture of Barbara Hepworth*. New York: Praeger Publishers, 1971.

Curtis, Penelope, and Alan G. Wilkinson. *Barbara Hepworth: A Retrospective*. London: Tate Gallery, 1994.

Eva Hesse

Cooper, Helen A. Eva Hesse: A Retrospective. New Haven, Conn.: Yale University Press, 1992.

Lippard, Lucy. Eva Hesse. New York: New York University Press, 1976.

Jenny Holzer

Auping, Michael. *Jenny Holzer*. New York: Universe Books, 1992.

Rebecca Horn

Celant, Germano, et al. *Rebecca Hom.* New York: Guggenheim Museum, 1993.

Harriet Hosmer

Sherwood, Dolly. *Harriet Hosmer: An American Sculptor*, 1830–1908. Columbia: University of Missouri Press, 1991.

Vinnie Ream Hoxie

Hall, Gordon Langley. Vinnie Ream: The Story of the Girl Who Sculptured Lincoln. New York: Holt, Rinehart and Winston, 1963.

Gwen John

Langdale, Cecily. Gwen John: With a Catalogue Raisonné of the Paintings and a Selection of the Drawings. New Haven, Conn.: Yale University Press, 1987.

Taubman, Mary. Gwen John: The Artist and Her Work. Ithaca, N.Y.: Cornell University Press, 1985.

Lois Mailou Jones

Benjamin, Tritobia Hayes. *The Life and Art of Lois Mailou Jones*. Rohnert Park, Calif.: Pomegranate Art Books, 1994.

Gaither, Edmund Barry. Reflective Moments: Lois Mailou Jones, a Retrospective Exhibition, 1930–1972. Boston: Museum of the National Center of Afro-American Artists and Museum of Fine Arts, Boston, 1973.

Frida Kahlo

Herrera, Hayden. Frida: A Biography of Frida Kahlo. New York: Harper and Row, 1983.

Angelica Kauffmann

Mayer, Dorothy Moulton. *Angelica Kauffman*, RA, 1741–1807. Gerrards Cross, Buckinghamshire, England: Colin Smythe, 1972.

Roworth, Wendy Wassung, ed. Angelica Kauffman: A Continental Artist in Georgian England. London: Reaktion Books, 1992.

Hilma af Klint

Fant, Åke, and Raster Forlag. *Hilma af Klint*. Stockholm: Bildtryck AB, 1989. Text in Swedish.

Käthe Kollwitz

Kearns, Martha. Käthe Kollwitz: Woman and Artist. Old Westbury, N.Y.: Feminist Press, 1976.

Prelinger, Elizabeth. *Käthe Kollwitz*. Washington, D.C.: National Gallery of Art, 1992.

Joyce Kozloff

Johnston, Patricia, et al. *Joyce Kozloff: Visionary Ornament*. Boston: Boston University Art Gallery, 1986.

Lee Krasner

Landau, Ellen G. *Lee Krasner*: A Catalogue Raisonné. New York: Harry N. Abrams, 1995.

Rose, Barbara. Lee Krasner: Á Ketrospective. New York: Museum of Modern Art, 1983.

Barbara Kruger

Linker, Kate. Love for Sale: The Words and Pictures of Barbara Kruger. New York: Harry N. Abrams, 1990.

Adélaïde Labille-Guiard

Passez, Anne-Marie. Adélaïde Labille-Guiard, 1749–1803: Biographie et catalogue raisonné de son oeuvre. Paris: Arts et Métiers Graphiques, 1973. Text in French. Judith Levster

Hofrichter, Frima Fox. *Judith Leyster: A Woman Painter in Holland's Golden Age*. Doornspijk, Netherlands: Davaco, 1989.

Carmen Lomas Garza

Mesa-Bains, Amalia. A Piece of My Heart/Pedacito de Mi Corazón: The Art of Carmen Lomas Garza. New York: New Press, 1991. Text in English.

Helen Lundeberg

Moran, Diane Degasis. Lorser Feitelson and Helen Lundeberg: A Retrospective Exhibition. San Francisco: San Francisco Museum of Modern Art, 1980.

Mary Martin

Compton, Michael, et al. *Mary Martin*. London: Tate Gallery, 1984.

Maria Sibylla Merian

Merian, Maria Sibylla. Flowers, Butterflies and Insects: All 154 Engravings from "Erucarum Ortus." New York: Dover Publications, 1991.

Joan Mitchell

Bernstock, Judith E. *Joan Mitchell*. New York: Hudson Hills Press, 1988.

Pleynet, Marcelin, et al. *Joan Mitchell: Choix de peintures* 1970–1982. Paris: A.R.C. and Musée d'Art Moderne de la Ville de Paris, 1982.

Paula Modersohn-Becker

Perry, Gillian. *Paula Modersohn-Becker: Her Life and Work.* New York: Harper and Row, 1979.

Berthe Morisot

Higonnet, Anne. *Berthe Morisot*. New York: Harper and Row, 1990.

Stuckey, Charles F., et al. *Berthe Morisot, Impressionist.*Washington, D.C.: National Gallery of Art; New York: Hudson Hills Press, 1987.

Gabriele Münter

Hoberg, Annegret, and Helmut Friedel. *Gabriele Münter*, 1877–1962: *Retrospektive*. Munich: Prestel-Verlag, 1992. Text in German.

Elizabeth Murray

Smith, Robert, et al. Elizabeth Murray: Paintings and Drawings. New York: Harry N. Abrams, 1987.

Alice Neel

Hills, Patricia. Alice Neel. New York: Harry N. Abrams, 1983.

Louise Nevelson

Lisle, Laurie. Louise Nevelson: A Passionate Life. New York: Washington Square Press, 1990.

Elisabet Ney

Goar, Marjory. Marble Dust: The Life of Elisabet Ney, An Interpretation. Austin: Eakin Press, 1984.

Georgia O'Keeffe

Castro, Jan Garden. *The Art and Life of Georgia O'Keeffe*. New York: Crown Publishing, 1985.

Peters, Sarah. Becoming O'Keeffe: The Early Years. New York: Abbeville Press, 1991.

Meret Oppenheim

Burckhardt, Jacqueline, and Bice Curiger, et al. *Meret Oppenheim: Beyond the Teacup*. New York: Independent Curators, 1996.

Curiger, Bice. Meret Oppenheim. Zurich: ABC, 1982.

Sarah Miriam Peale

King, Joan. Sarah Miriam Peale: America's First Woman Artist. Boston: Branden Publishing Co., 1987.

Clara Peeters

Decoteau, Pamela Hibbs. *Clara Peeters*, 1594–ca. 1640. Cologne: Luca Verlag, 1992. Text in German.

Beverly Pepper

Krauss, Rosalind, E. Beverly Pepper: Sculpture in Place. New York: Abbeville Press, 1986.

Irene Rice Pereira

Bearor, Karen A. *Irene Rice Pereira*: Her Painting and *Philosophy*. Austin: University of Texas Press, 1993.

Lilla Cabot Perry

Martindale, Meredith. *Lilla Cabot Perry: An American Impressionist.* Washington, D.C.: National Museum of Women in the Arts, 1990.

Howardena Pindell

Howardena Pindell: Odyssey. New York: Studio Museum in Harlem, 1986.

Susan Rothenberg

Simon, Joan. Susan Rothenberg. New York: Harry N. Abrams, 1991.

Rachel Ruysch

Grant, Colonel M. H. *Rachel Ruysch*, 1664–1750. Leigh-on-Sea, England: F. Lewis, Publishers, 1956.

Kay Sage

Krieger, Régine Terrier. *Kay Sage* (1898–1963). Ithaca, N.Y.: Herbert F. Johnson Museum of Art, 1977.

Niki de Saint Phalle

Hulten, Pontus. *Niki de Saint Phalle*. Amsterdam: Verlag Gerd Hatje, 1992. Text in English.

Miriam Schapiro

Gouma-Peterson, Thalia, ed. Miriam Schapiro: A Retrospective, 1953–1980. Wooster, Ohio: College of Wooster, 1980.

Cindy Sherman

Felix Ždenek, and Martin Schwander, eds. *Cindy Sherman: Photographic Work*, 1975–1995. Translated by Michael Roberts. Munich: Schirmer Art Books, 1995.

Kiki Smith

Stoops, Susan L. Kiki Smith: Unfolding the Body: An Exhibition of the Work in Paper. Waltham, Mass.: Brandeis University Art Gallery, 1992.

Lilly Martin Spencer

Bolton-Smith, Robin, and William H. Truettner. *Lilly Martin Spencer* (1822–1902): *The Joys of Sentiment*. Washington, D.C.: Smithsonian Institution Press, 1973.

Florine Stettheimer

Bloemink, Barbara J. *The Life and Art of Florine Stet- theimer.* New Haven, Conn.: Yale University Press, 1995.

Davis, Howard. *Florine Stettheimer.* New York: Columbia
University Press, 1973.

Sophie Taeuber-Arp

Lanchner, Carolyn. Sophie Taeuber-Arp. New York: Museum of Modern Art, 1981.

Dorothea Tanning

Bailly, Jean Christophe, and Robert C. Morgan. *Dorothea Tanning*. New York: George Braziller, 1995. Plazy, Gilles. *Dorothea Tanning*. New York: U.E.M., 1979.

Anne Truitt

Hopps, Walter. Anne Truitt: Sculpture and Drawings, 1961–1973. Washington, D.C.: Corcoran Gallery of Art, 1974.

Helen M. Turner

Rabbage, Lewis Hoyer. *Helen M. Turner* (1858–1918): A *Retrospective Exhibition*. Cragsmoor, N.Y.: Cragsmoor Free Library, n.d.

Suzanne Valadon

Warnod, Jeanine. Suzanne Valadon. New York: Crown Publishers, 1981.

Remedios Varo

Kaplan, Janet A. *Unexpected Journeys: The Art and Life of Remedios Varo.* New York: Abbeville Press, 1988.

Maria Elena Vieira da Silva

Weelen, Guy, and Jean-François Jaeger. *Vieira da Silva*. Vol. 1: Catalogue Raisonné; vol. 2: Monograph. Geneva: Editions d'Art Albert Skira, 1993. Text in French.

Marie-Louise-Elisabeth Vigée-Lebrun Baillio, Joseph. *Elisabeth-Louise Vigée-Lebrun* (1755–1842). Fort Worth: Kimbell Art Museum, 1982.

Carrie Mae Weems

Kirsh, Andrea, and Susan Fisher Sterling. *Carrie Mae Weems*. Washington, D.C.: National Museum of Women in the Arts, 1993.

Rachel Whiteread

Lingwood, James, ed. Rachel Whiteread: House. London: Phaidon Press, 1995.

Alison Wilding

Hilty, Greg. *Alison Wilding: Immersion/Exposure*. London: Tate Gallery, 1991.

Marguerite Thompson Zorach

Tarbell, Roberta K. Marguerite Zorach: The Early Years, 1908–1920. Washington, D.C.: Smithsonian Institution Press, 1973.

ACKNOWLEDGMENTS

his book reflects the time, energy, and expertise generously provided by a host of individuals. Chief among them are Nancy Grubb, executive editor at Abbeville Press, whose boundless patience and keen critical eye helped shape an amorphous idea into concrete reality: and Serena Wilkie, Maya Kaimal, and Naomi Ben-Shahar, the tireless Abbeville photo researchers who located and secured the many reproductions illustrated here. The reference staffs at several Washington-area art museums were extremely helpful, notably Anna Brooke, librarian of the Hirshhorn Museum and Sculpture Garden; Lamia Doumato, head of the reference department at the National Gallery of Art's library; and Krystyna Wasserman, librarian for the National Museum of Women in the Arts. I would also like to express my appreciation to the reference departments of the Gelman Library at George Washington University: the University of Maryland (College Park) Art Library; the American Association of University Women's library; and the Arlington County (Virginia) Central Library, which never ceases to amaze me with the breadth of its holdings and the superb quality of its staff. Several former colleagues from the University of Maryland went out of their way to offer assistance—in particular, I would like to thank professors Jean Caswell, Marjorie Venit, and Josephine Withers; Lisa Hartjens, another former Marylander, offered some very useful suggestions; and Kathy Wirtala, formerly photo-archivist for the National Museum of American Art, guided me through the Peter A. Juley and Son collection of artists' photographs.

For their invaluable suggestions concerning the revised edition of this volume I would like to add my thanks to the following: the British painter Derek Hirst; Phyllis Rosenzweig, associate curator, and James W. Mahoney, registration assistant, for the Hirshhorn Museum and Sculpture Garden; Sara J. MacDonald, reference librarian, and the late John M. Caldwell, music specialist and slide coordinator, both at the University of the Arts; and my colleagues in the University of the Arts' Humanities Division.

Heartfelt thanks are also due to the many friends with whom I discussed various aspects of this project, especially Judith R. Close, Elizabeth Millspaugh, Alan Fisher, and Phyllis Altman. Nancy Luria offered her valuable professional opinions on several thorny issues; and Lila Snow, a gifted visual and performance artist, helped me put things into perspective. Dame Marina Keet, and all the members of the Spanish Dance Society, gave me something else to obsess about; and Robert G. Regan made the whole enterprise far more bearable.

Most of all, I want to thank my sister, Jill, and my parents. It was my father who first got me interested in the subject of women artists, more than twenty years ago, and my sister and mother who provided inspiring role models. Their unfailing enthusiasm and continued emotional support were instrumental in the completion of this project.

INDEX

Page numbers in italics refer

to illustrations Abakanowicz, Magdalena, 188, 189, 189, 215 Abraham Lincoln (Hoxie), 87, Adam and Eve (Valadon), 114, After the Meeting (Beaux), 102, 103 Ain't Jokin (Weems), 241 Albers, Joseph, 228 American Icons (Weems), 241 Anastaise, 13 Anderson, Laurie, 217-19, 217, 218, 226, 227 Anderson, Sophie, 76, 76 And 22 Million Very Tired and Very Angry People (Weems), 241 Angel of the Waters (Stebbins), 86, 87 Anguissola, Elena, 15, 19 Anguissola, Lucia, 15, 18, 19 Anguissola, Sofonisba, 15–16, 17, 19, 22, 80 Ann Hall, Mrs. Henry Ward. and Henry Hall Ward (Hall), 82, 82 Annunciation, The (Roldán), Antin, Eleanor, 200, 201, 217 Apollo and Daphne (del Pò), 6, 48 Argument (Messager), 216 Arp, Jean, 132 Arthur Schopenhauer (Ney), 89, 89 Auguste Rodin (Claudel), 107,

108

Az-Tech (Rose), 236-37 Bany Rus (Solano), 233 Barricade (Mandy Martin), Bartlett, Jennifer, 207, 208, 200, 200 Bashkirtseff, Marie, 106, 106 Bastien-Lepage, Jules, 106 Batman, The (Richier), 137, 137 Beale, Mary, 46, 47 Beaux, Cecilia, 101-2, 102, 103 Before the Caves (Frankenthaler), 162, 169, 171 Bell, Vanessa, 144, 145, 145 Bengali Woman (Hoffman), 108, 110, 111, 111 Benglis, Lynda, 195, 195, 196, 198 Benoist, Marie-Guillemine, 63-64, 63 Bernini, Gianlorenzo, 48, 64 Berthe Morisot Painting (Edma Morisot), 94 Birth Project, The (Chicago), 198 Bishop, Isabel, 151, 153, 161 Black Mask with Rose (Münter), 117, 119 Black Snake in My Bed (Alison Saar), 242-43 Black Vase with Daffodils

(Fish), 203, 204

175, 176

Black Venus (Saint Phalle),

Black Woman with Chicken

(Weems), 240, 241

Ayala, Josefa de, 48, 49

Avcock, Alice, 183, 183, 185

Blind Leading the Blind, The (Bourgeois), 138, 139 Blue Black Boy (Weems), 241 Boat and the Town, The (Exeter), 125, 125 Bon Appétit, Messieurs (Solano), 233 Bonheur, Rosa, 90-91, 90-91, 111 Bontecou, Lee, 189, 190, 191 Bootblack (Bishop), 151 Bourdelle, Antoine, 137 Bourgeois, Louise, 138, 139, 139, 181 Boy (Bartlett), 207, 208 Braque, Georges, 114, 122, 123 Breton, André, 148, 153, 159, 160 Brooks, Romaine, 145-47, 145, 146 Butler, Lady Elizabeth, 11, 91-94, 92-93 Calder, Alexander, 134 Calling the Roll after an

Calder, Alexander, 134
Calling the Roll after an
Engagement, Crimea
(Butler), 91–94, 92–93
Camels (Graves), 194, 195
Cape, The (Chase-Riboud),
191, 193
Caputi Hydria (The
Leningrad Painter), 12
Caravaggio, Michelangelo
Merisi da, 29, 30, 32, 44
Carr, Emily, 118, 119–20, 119
Carriera, Giovanna, 55
Carriera, Rosalba, 54, 55–56, 80
Carrington, Leonora, 156, 157, 159
Cassatt, Mary, 66, 94, 97, 98–99, 99

catafalque design for Elisabetta Sirani, 34, 34 Catharsis (Abakanowicz), 188, 189 Chardin, Jean-Baptiste-Siméon, 66, 71 Charles Sumner (Whitney), 84-85, 85 Chase-Riboud, Barbara, 191, 193, 195 Chicago, Judy, 197, 198 Chimeras (Messager), 217 Christ Bearing the Cross (Roldán), 51 Christo, 212, 221, 254 Chryssa [Vardea], 191, 191, 192 Claricia, 12 Claudel, Camille, 106-8, 107, Cloakroom of the Clifton Assembly Rooms (Sharples), 74, 75 Colored People (Weems), 241 Compound Rhythms (Mary Martin), 180 Corner of the Artist's Room in Paris, A (John), 141, 143, 144 Cornucopia (Krasner), 164, 165 Cornucopia: Séance for Two Breasts (Horn), 219 Corpus Delicti (Leirner), 251, 252 Countess Golovin (Vigée-Lebrun), 60, 61 Creation of the Birds (Varo), 155, 156 Curties, Sarah, 47 Cushman, Charlotte, 86

Damer, Anne Seymour, 64,

65, 84

Dark Star Park (Holt), 187, 189 D'Ashnash-Tosi. See Chase-Riboud, Barbara David, Jacques-Louis, 58, 64 David and Bathsheba (Gentileschi), 32 Death of Cleopatra (Lewis), Death of Saint Mary Magdalene, The (Roldán), 50, 51 Degas, Edgar, 98, 98, 99, 114 Dehner, Dorothy, 172, 173, 173 de Kooning, Elaine, 164, 166, 167 de Kooning, Willem, 164, 166 Delacroix, Eugène, 73, 90 Delaunay, Sonia Terk, 122-23, del Pò, Teresa, 6, 48 Derain, André, 114, 123 Dinner Party, The (Chicago), 107, 108 Drawings for the Temple (af Klint), 129 Duparc, Françoise, 64, 66, 67 Eakins, Susan Macdowell, 102, 104, 105

Eakins, Thomas, 102 Eberle, Abastenia St. Leger, 111, 150, 150, 161 Education of the Virgin, The (Roldán), 51 Effigies (Messager), 217 Electric Chair (Hatoum), 249 Electric Prisms (Delaunay), 2, 122, 123 Emile d'Erlanger, La Baronne (Brooks), 146, 146 Empanadas (Turnovers) (Lomas Garza), 245, 245 Ende, 12 Entrails Carpet (Hatoum), 248, 249-50 Ernst, Max, 153, 156, 159 Escobar, Marisol. See Marisol [Escobar] Espai Ambulent (Solano), 233 Eva Gonzalès (Manet), 94 Exter, Alexandra, 123, 125-26,

Family Pictures and Stories (Weems), 241 Feitelson, Lorser, 159 Ferrer, Elizabeth, 230 Fétiches, Les (Jones), 121, 121 Fighting Stallions (Huntington), 10 Finger-Gloves: An Instrument to Extend the Manual Sensibilities (Horn), 219 Fini, Leonor, 158, 159, 159 Fish, Janet, 203, 204 Flack, Audrey, 201, 201, 202, 204 Flower Still Life (Ruysch), 28, Flute Players, The (Leyster), Fontana, Lavinia, 14, 19, 20, 20, 21, 22, 24, 32 Forest, British Columbia (Carr), 118, 120 Forever Free (Lewis), 86 Frankenthaler, Helen, 162, 169, 171 Free, White, and 21 (Pindell), 228

Galizia, Fede, 20, 22, 22, 30 Galla Placidia in Philadelphia (Kozloff), 228 Garden of Tenderness (Messager), 217 Garrison, William Lloyd, 86 Garzoni, Giovanna, 35–36, 35, Gathering Paradise (Skoglund), 230 Gentileschi, Artemisia, 29–32, 34, 51 Gentileschi, Orazio, 29-30 Gérard, Marguerite, 66, 68 Géricault, Théodore, 73, 90 Ghost (Whiteread), 254 Gibson, John, 85, 86 Godefroid, Marie-Eléonore, 82-83, 83 Goncharova, Natalya, 112, 123-24, 123, 124, 125, 161 Gonzalès, Eva, 72, 94, 94, 95, 98 González, Julio, 234 Grandpierre-Deverzy, Adrienne-Marie-Louise, 73, Grant, Duncan, 145, 145 Graves, Nancy, 194, 195

Guardian Angels (Tanning),

154, 156

Guda, 12

Hall, Ann, 82, 82 Hals, Frans, 44 Нарру Mother, The (Mayer), 60 Harnett, William Michael, 105 Hartigan, Grace, 166, 168, 169 Hatoum, Mona, 248-50, 248 Haverman, Margareta, 12 Haystacks, Giverny (Perry), 99 Heads (Abakanowicz), 189 Helen of Egypt, 12 Hemessen, Caterina van, 24-26, 25 Hepworth, Barbara, 134, 136, 137, 139, 181 Heraklion (Benglis), 196, 198 Hesse, Eva. 181, 181, 182, 183 High Steppin' Strutter I (Schapiro), 198, 199, 201 Hirst, Claude Raguet, 105, 105 Hoffman, Malvina, 108, 110, 111, 111 Hofmann, Hans, 164, 169, 173 Holbein, Hans, 26 Holt, Nancy, 185, 187, 189 Holzer, Jenny, 211-12, 212, 213, 215, 217, 218, 223, 226, 227 Hon (Saint Phalle), 176 Honey Colored Boy (Weems), 241 Horn, Rebecca, 219-20, 221 Horse Fair, The (Bonheur), 90, 90-91 Hosmer, Harriet, 85-86, 85 House (Whiteread), 253, 254 How to Catch and Manufacture Ghosts (Avcock), 185 Hoxie, Vinnie Ream, 11, 87, Huntington, Anna Hyatt, 10, 111, 150 Hydra Forest: Performing Oscar Wilde (Horn), 220, Illustrated London News, 74,

Illustrated London News, 74, 74 Impluvium (Solano), 233 I Saw Three Cities (Sage), 152, 153 I Shop Therefore I Am (Kruger), 215 Italian Music Hall Box, The

(Gonzalès), 72, 94, 95

IXI (Rothenberg), 206, 207

Joan of Arc (Huntington), 111
John, Gwen, 141, 143, 144–45
Johnston, Henrietta, 78
John Wilkins DD (Beale), 46,
47
Join (Murray), 205, 207
Jones, Lois Mailou, 120–22,
120, 121
Joseph and Potiphar's Wife
(Rossi), 23–24, 23
Judith Beheading Holofernes
(Gentileschi), 30, 31, 32

Kahlo, Frida, 147, 147, 148
Kandinsky, Wassily, 118, 123
Kauffmann, Angelica, 52, 55, 56, 57, 58, 80
King's Heritage (Truitt), 178, 179
Klint, Hilma af, 128, 129
Kollwitz, Käthe, 139–41, 139, 140, 161
Kozloff, Joyce, 210, 226–27, 227, 228
Krasner, Lee, 164, 164, 165, 166
Kruger, Barbara, 212, 214, 215, 217, 219, 223, 226, 227

La Bella Dormiente (Solano),

232, 233

Labille-Guiard, Adélaïde, 60, 62, 63 Lady Catherine Grev (Teerlinc), 26, 27 Lamentation: In Memory of Ernst Barlach (Kollwitz), la Tour, Maurice Quentin de, 55, 60 Leirner, Jac, 250-52, 250, 251 Leningrad Painter, The, 12 Leroulx de la Ville, Marie-Guillemine. See Benoist, Marie-Guillemine Lewis, Edmonia, 86-87, 86, Leyster, Judith, 44-46, 45 Light at the End, The (Hatoum), 249 Light Sentence (Hatoum), Linen (Goncharova), 112, 124, Lomas Garza, Carmen, 244-46, 245 Longhi, Barbara, 22, 23

Louise-Elisabeth of France
(Labille-Guiard), 60, 62, 63
Loves of a Ballerina (Antin),
200
Lucky Seven (Mitchell), 169,
170
Lundeberg, Helen, 159, 160
Lydia in a Loge, Wearing a
Pearl Necklace (Cassatt),
97, 98–99
Lytton Strachey (Bell), 144, 145

Lytton Strachey (Bell), 144, 145 Madonna and Child (Anguissola), 19 Madonna and Child (Longhi), 23 Magritte, René, 153, 159 Maldonado, Rocío, 230-31, 230, 231, 232 Mamba Mambo (Alison Saar), 243 Man among the Redwoods (Zorach), 119, 120 Manet, Edouard, 94, 94, 98 Man Ray, 161, 161 Man with a Cat, The (Beaux), 102 Map of Tenderness (Messager), 217 Margaret Evans Pregnant (Neel), 148, 149 Marie Antoinette, Queen of France, 59, 60, 71 Marilyn (Vanitas) (Flack), 201, 201, 202, 204 Marisol [Escobar], 173, 174, Martin, Mandy, 221, 222, 223 Martin, Mary, 179, 180, 181 Mary, Queen of Hungary, 24 Mary Cassatt (Degas), 98, 98 Matisse, Henri, 116, 164, 207 Mayer, Constance, 68–69, 69, 71, 106-7 Meeting, A (Bashkirtseff), 106, 106 Men I Love, The (Messager), Méret Oppenheim - Erotique (Man Ray), 161 Merian, Maria Sibylla, 36–37, 36 Messager, Annette, 215-17, 216 Metamorphosis insectorum Surinamensium (Merian), 36, 37 Michelangelo, 15, 46

Mirror Shadow II (Nevelson), 134, 135 Mitchell, Joan, 169, 170 Modersohn-Becker, Paula, 114, 116, 116 Moillon, Louise, 37-38, 39, 41 Monet, Claude, 99, 169, 209 Moon Garden Plus One (Nevelson), 134 Moore, Henry, 134 Morisot, Berthe, 94, 94, 96, 98 Morisot, Edma, 94, 94, 98 Morning News (Turner), 99, 101 Moser, Mary, 56 Motherhood (Gérard), 66, 68 Mountains and Sea (Frankenthaler), 169 Münter, Gabriele, 116, 117, 118-110 Murray, Elizabeth, 204, 205, Music: Pink and Blue (O'Keeffe), 127, 128 My Approaches (Messager), My Collection of Proverbs (Messager), 216 My Jealousies (Messager), 216 My Little Effigies (Messager), Mystical Marriage of Saint Catherine, The (Ayala), 48,

Nameless and Friendless (Osborn), 77–78, 77 Natalie Barney (Chicago), 197, 198 Nature: Blue and Gold (Wilding), 234, 235 Neel, Alice, 148, 149, 161 Negotiating Table, The (Hatoum), 249 Netscher, Constantijn, 41 Nevelson, Louise, 132, 133-34, 135, 139, 181 New England Woman, A (Beaux), 102 "New Image" painters, 207 Ney, Elisabet, 89, 89

No Walk Today (Sophie

Anderson), 76, 76

Mystical Marriage of Saint

My Trophies (Messager), 217

Catherine, The (Roldán), 51

Obidos, Josefa de. See Ayala,
Josefa de
Objects (Breakfast in Fur)
(Oppenheim), 160, 161
O'Keeffe, Georgia, 126, 126,
127, 128, 133, 161
Old Cobbler, The (Perry), 99,
100
Old Indian Arrowmaker and
His Daughter, The (Lewis),
86–87, 87
Oosterwyck, Maria van, 41, 43,
44
Oppenheim, Meret, 160–61,
161
Orozco, José, 230
Osborn, Emily Mary, 77–78,
77
Os Cem (Leirner), 252

Peale, Margaretta Angelica,

Peale, Sarah Miriam, 80, 81

Peeters, Clara, 38, 40, 40, 41,

80, 80, 81, 105

Pepper, Beverly, 185, 185, 186 Pereira, Irene Rice, 130, 130 Perry, Lilla Cabot, 99, 100 Pfaff, Judy, 184, 185, 185 Picasso, Pablo, 114, 120, 122, 123, 164 Pierre-Noël, Louis Verniaud. Pietro Maria, Doctor of Cremona (Lucia Anguissola), 18, 19 Pin Carpet (Hatoum), 249 Pindell, Howardena, 228, 228, 229, 230 Plate of White Beans (Garzoni), 35-36, 35 Ploughing in Nivernais (Bonheur), 90 Pollitzer, Anita, 126 Pollock, Jackson, 163, 164, 169 Porcia Wounding Her Thigh (Sirani), 33, 34 portrait medal of Lavinia Fontana, 20, 20 Portrait of a Lady (Hemessen), 24, 25 Portrait of a Lady with a Lapdog (Fontana), 14, 20, 21 Portrait of a Negress (Benoist), 63, 63 Portrait of Raul (Maldonado), 231

Portrait of the Artist's Sister
Minerva (Sofonisba
Anguissola), 16, 17
Powerhouse (Mandy Martin),
222, 223
Primitive Movers (Rose), 236,
236, 237
Proposition, The (Leyster), 46
Proske, Beatrice Gilman, 50–51
Prud'hon, Pierre-Paul, 68–69
Puck (Hosmer), 86

Quintana, Georgina, 231

Rachel Ruysch in Her Studio (Netscher), 41, 41 Recollection (Riley), 177, 179 Rectangular Relief with Cutout Circles, Painted and Cutout Squares, Rising Cubes and Cylinders (Taeuber-Arp), 133, 133 Red Vision (Fini), 158, 159 Rhapsody (Bartlett), 207 Rice, Danielle, 60 Richier, Germaine, 137, 137, 139 Riley, Bridget, 176, 177, 179 Rivera, Diego, 134, 148, 230 Rodin, Auguste, 107–8, 137, 145 Roldán, Luisa Ignacia ("La Roldana"), 50-51, 50, 84 Rose, Kathy, 235-37, 236 Rosse, Susan Penelope, 47-48, 48 Rossi, Properzia de', 23-24, 23, 32, 84 Rothenberg, Susan, 206, 207 Ruysch, Rachel, 28, 41, 42, 44

Saar, Alison, 242-44, 242, 243 Saar, Betve, 242 Sage, Kay, 152, 153 Saint Michael (Roldán), 51 Saint Phalle, Niki de, 175, 176 Sand Dunes (Pepper), 186 Savage Sparkler, The (Aycock), 183, 183 Scaffold (Dehner), 172, 173 Schapiro, Miriam, 198, 199, 201, 227 Seated Figure (Abakanowicz), 189 Self-Portrait (Brooks), 145 Self-Portrait (Carrington), 157, 159

Self-Portrait (Kahlo), 147, 148 Self-Portrait (Krasner), 164 Self-Portrait at Table by Lamplight (Kollwitz), 139 Self-Portrait Holding Portrait of Her Sister (Carriera), 54 Self-Portrait with Her Daughter (Vigée-Lebrun), 59, 59 Senator Thomas Hart Benton (Sarah Miriam Peale), 80, Sharples, Rolinda, 74-75, 75 Sherman, Cindy, 223, 224, 225-26, 225 Single Form (Memorial to Dag Hammarskjöld) (Hepworth), 137, 137 Siqueiros, David, 230 Sirani, Elisabetta, 30, 32-34, 33 Sirani, Giovanni Andrea, Sir Ioseph Banks (Damer), 65 Skoglund, Sandy, 237-39, 238 Slow Core (Wilding), 235 Smith, David, 173 Smith, Kiki, 246-48, 246, 247, 250, 252 Snake Charmer (Alison Saar), 242, 243 Solano, Susana, 232, 233-34 Sons of Marshal Ney, The (Godefroid), 82, 83 Spearhead (Mandy Martin), Spencer, Lilly Martin, 78, 79, Spring Sale at Bendel's (Stettheimer), 141, 142 Stebbins, Emma, 86, 87 Steinbach, Sabina von, 13 Stettheimer, Florine, 141, 142 Stieglitz, Alfred, 126, 128 Still Life (Hirst), 105, 105 Still Life (Peeters), 38, 40 Still Life with Blue and White Porcelain (Modersohn-Becker), 116, 116

Still Life with Cherries (Moillon), 37-38, 39 Still Life with Peaches in a Porcelain Bowl (Galizia), 22. 22 Still-life with Round Bottle (Vallayer-Coster), 70, 70 Still Life with Watermelon and Peaches (Margaretta Angelica Peale), 80, 80 Stones (Vieira da Silva), 131, Stoning of Saint Stephen, The (Fontana), 20 Strange Fruit (Alison Saar), 243-44 Studio of Abel Pujol, The (Grandpierre-Deverzy), 73, Sunday Afternoon (de Kooning), 166, 167 Susanna and the Elders (Gentileschi), 30

Szenes, Arpad, 131–32

Taeuber-Arp, Sophie, 132–33, 132, 133

Tanning, Dorothea, 154, 156, 161

Teerlinc, Levina, 26, 27

Temple (Pindell), 229

Thamar (Timarete), 12

Thamar Paints a Picture (anonymous), 12

That's All (Chryssa), 192

There's So Much I Want to Say (Hatoum), 249

Thompson, Elizabeth. See Butler, Lady Elizabeth 3-D (Pfaff), 184

Titanic Memorial (Whitney),

Topkapi Pullman (Kozloff),

Tree Shadows (Lundeberg),

108, 109

160, 160

210, 226, 228

Syncopations (Rose), 237

Truisms (Holzer), 211–12 Truitt, Anne, 178, 179 Turner, Helen M., 99–101, 101 *Two Sisters* (Susan Eakins), 102, 104

Unhappy Mother, The

(Mayer), 69, 69 United States (Laurie Anderson), 218-19 Unknown Boy (William Wentworth) (Rosse), 48, 48 Untitled (Bontecou), 190 Untitled (Hatoum), 249 Untitled (Hesse), 182, 183 Untitled (Pereira), 130 Untitled (Smith), 250 Untitled Film Stills (Sherman), 225 Untitled installation at the United States Pavilion, Venice Biennale (Holzer), 211, 213 Untitled (Kitchen Table Series) (Weems), 241 Untitled (No Radio) (Kruger), 215 Untitled #1 (af Klint), 129, 129 Untitled (Sea Island Series) (Weems), 242 Untitled (Train) (Smith), 247-48, 247 Untitled (When I Hear the Word Culture I Take Out My Checkbook) (Kruger), 214, 215

Valadon, Suzanne, 114, 115 Vallayer-Coster, Anne, 70, 71 Vanessa Bell (Grant), 144 van Hemessen, Caterina. See Hemessen, Caterina van Varo, Remedios, 155, 156, 156 Vasari, Giorgio, 16, 22–24 Vase of Tulips, Roses, and Other Flowers with Insects (Oosterwyck), 43 Venegas, German, 231
Victoria, Queen of England, 90, 93
Vieira da Silva, Maria Elena, 131–32, 131, 137
Vigée-Lebrun, Julie, 59
Vigée-Lebrun, Marie-Louise-Elisabeth, 55, 58–60, 59, 61, 63, 64, 66
Vigri, Caterina dei, 32
Virgil Writing His Own
Epitaph at Brundisium
(Kauffmann), 52, 56, 57, 58
Vol—Corpus Delicti
(Leirner), 252

Weaver's Uprising, The (Kollwitz), 140 We Both Must Fade (Spencer), 78, 79 Weems, Carrie Mae, 239-42, 240, 244, 252 Whiteread, Rachel, 250, 252-54, 252, 253 Whitney, Anne, 84–85, 85 Whitney, Gertrude Vanderbilt, 108, 108, 109 Wilding, Alison, 233, 234-35, Windy Doorstep (Eberle), 150, Womanhouse (Schapiro), 198 Woman Knitting (Duparc), Women and Dog (Marisol), Wright, Patience Lovell, 78

Year of the Cicada, The (Hartigan), 168, 169 Young Girl by the Window (Berthe Morisot), 94, 96

Zenobia in Chains (Hosmer), 85, 86 Zorach, Marguerite Thompson, 119, 120 The photographers and the sources of the photographic material other than those indicated in the captions are as follows (numerals refer to plate numbers):

Jon and Anne Abbott: 186; ACA Galleries, New York: 167; Acquavella Contemporary Art, New York: 176; Marianne Barcellona © 1985: 178; Alex Beatty: 55; Peter Bellamy © 1986, Robert Miller Gallery, New York: 111; Bibliothèque Marguerite Durand, Paris: 81; Dawoud Bey © 1991: 192; Courtesy Mary Boone Gallery, New York: 182; Boston Athenaeum: 57; Courtesy Chryssa: 161; Geoffrey Clements: 166; Laura Cohen: 194; Paula Court: 184, 185; Cragsmoor Free Library, New York: 73; D. James Dee: 169, 193; Chris Eden: 94; Claudio Elizabetsky: 207; Fabric Workshop and Museum, Philadelphia: 206; Charlotte Fairchild: 82; Ronald Feldman Gallery, New York: 170, 171; Field Museum of Natural History, Chicago: 85; James Fischer: 62; Courtesy Audrey Flack: 172; Xavier Fourcade, Inc., New York: 158; Abe Frajndlich: 180, 189; Yves Gallois, Marseilles: 39; Lynn Gilbert, Pace Gallery, New York: 105; Laura Gilpin Collection, Amon Carter Museum, Fort Worth, Texas: 99; Jim Gorman: 90; Carmelo Guadagno: 102; Ernst Haas: 140; Courtesy Denise Browne Hare: 64; Hessmayling Corporation, Brussels: 163; Illustrated London News Picture Library: 46; Alex Jamison: 83; Courtesy Janet Kaplan: 128; Friedrich Kaulbach: 61; Max Kozloff: 191; Nicholas Kuskin: 108; Manolo Laguillo: 196; Salvatore Licitra: 181; © 1991 Carmen Lomas Garza: 203; © Holister Lowe, courtesy PaceWildenstein, New York: 204; George M. Loring: 73; Courtesy Luhring-Augustine Gallery, New York: 210; Mannheim Kunsthalle: 159; P. Migeat: 183; Robert Miller Gallery, New York: 136, 137, 174; Sara Cedar Miller, Central Park Conservancy, New York: 58; Eugene Mopsik: 179, 190; Musées de la Ville de Paris: 80; Musées Nationaux, Paris: 34, 36, 37, 41, 42, 68, 79; Museum of the National Center of Afro-American Artists, Boston, and Lois Mailou Jones Pierre-Noël, Washington, D.C.: 93; New York Public Library, Astor, Lenox and Tilden Foundations: 123; From Emily Carr: A Biography by Mary Tippett © Oxford University Press, 1979, used by permission: 91; Courtesy PaceWildenstein, New York: 204; Pennsylvania Academy of the Fine Arts: 75; Judy Reed: 203; Dirk Reinartz/Visum: 209; Courtesy Kathy Rose: 198; Courtesy Roslyn Oxley 9 Gallery, Sydney: 187; Kevin Ryan: 148; Scala/Art Resource, New York: 16, 19, 32; Lee Stalsworth: 126, 141, 202; Strigelli-Grimolizzi: 197; Eric Sutherland, Walker Art Center, Minneapolis, and Paula Cooper, New York: 165; Texas State Library, Archives Division, W. H. Kuhlman Collection: 61; Courtesy Manfred Tischer, Düsseldorf: 150; Arthur Tress, Twining Gallery, New York: 144; Courtesy Eleanor Tufts: 18, 96; Eileen Tweedy, London: 14; John Weber Gallery, New York: 152; Whitney Museum of American Art Archives: 82.

Works by the following artists are copyright © 1987 Scala/Art Resource, New York: Giovanna Garzoni, Artemisia Gentileschi, Rosalba Carriera. Works by the following artists are copyright © 1987 SPADEM, Paris/Ars, New York: Marie Bashkirtseff, Marie Benoist, Camille Claudel, Françoise Duparc, Natalya Goncharova, Eva Gonzalès, Eva Hesse, Adélaïde Labille-Guiard, Constance Mayer, Suzanne Valadon, Elisabeth Vigée-Lebrun. Work by Romaine Brooks is copyright © Jean-Pierre Prévost/Pascal Legrand. Work by Sonia Terk Delaunay is copyright © 1987 ADAGP Paris/Ars, New York. Work by Sophie Taeuber-Arp is copyright © 1987 COSMOPRESS, Geneva.